Photoshop® CS3
Restoration and
Retouching Bible

Photoshop® CS3 Restoration and Retouching Bible

Mark Fitzgerald

Wiley Publishing, Inc.

Photoshop® CS3 Restoration and Retouching Bible

Published by
Wiley Publishing, Inc.
10475 Crosspoint Boulevard
Indianapolis, IN 46256
www.wiley.com

Copyright © 2008 by Wiley Publishing, Inc., Indianapolis, Indiana

Published simultaneously in Canada

ISBN: 978-0-470-22367-3

Manufactured in the United States of America

10 9 8 7 6 5 4 3 2 1

For general information on our other products and services or to obtain technical support, please contact our Customer Care Department within the U.S. at (800) 762-2974, outside the U.S. at (317) 572-3993 or fax (317) 572-4002.

Library of Congress Control Number: 2008921683

To my wife, and best friend, Julia,
who has always given me her unconditional support.

About the Author

Mark Fitzgerald is a Photoshop teacher and consultant who specializes in helping professional photographers thrive in the digital age. He has taught hundreds of photographers how to smooth out their workflow and get the most from their important images—through private training, classes, and workshops. Mark is an Adobe Certified Photoshop Expert and an Adobe Certified Photoshop Instructor. He and his wife Julia (with their two dogs, Ruby and Hazel) live in Portland, Oregon, where Mark owns a consulting business called The Digital Darkroom.

Credits

Associate Acquisitions Editor
Courtney Allen

Project Editor
Martin V. Minner

Technical Editor
Mike Hagen

Copy Editor
Gwenette Gaddis Goshert

Editorial Manager
Robyn Siesky

Business Manager
Amy Knies

Sr. Marketing Manager
Sandy Smith

**Vice President and
Executive Group Publisher**
Richard Swadley

Vice President and Executive Publisher
Bob Ipsen

Vice President and Publisher
Barry Pruett

Project Coordinator
Erin Smith

Graphics and Production Specialists
Elizabeth Brooks, Stacie Brooks,
Carrie A. Cesavice, Shane Johnson,
Jennifer Mayberry

Quality Control Technicians
Cynthia Fields, John Greenough,
Caitie Kelly

Proofreading
Christopher M. Jones

Indexing
WordCo Indexing Services

Cover Design
Michael Trent

Cover Illustration
Joyce Haughey

Contents at a Glance

Contents

Preface

You may be asking why the topics of photo restoration and retouching are being covered together in the same book. That's a reasonable question, considering that on the surface the goals of these two processes seem quite different. The goal of restoration with just about anything — old cars, antique furniture, and so on — is to repair and refurbish something until it resembles mint condition. In the case of old photos, the goal is to erase the years and return the photos to what they looked like when they were new.

The goal of retouching, on the other hand, is to take the original image to a higher level by enhancing its positive aspects and reducing or removing the distracting elements. The finished product becomes something more valuable than the original image because of those enhancements.

Though these two goals seem at odds, the truth is many of the same Photoshop tools and techniques are used to achieve both goals. So it doesn't make sense to discuss one of these subjects without discussing the other. It also doesn't make sense for you, as a student of Photoshop, to learn to use these tools and techniques for only restoration or retouching. You never know when you may want to try something new. If you take the time to learn everything in this book now, you'll be ready to handle just about any image editing challenge you're likely to encounter.

What's in This Book?

This book is divided into four main parts. Part I deals with the fundamentals as they apply to restoration and retouching. This is where I show you how to create a solid foundation that supports all of the subsequent work that's done with an image file.

Part II concentrates on the Photoshop tools and techniques that are used in the restoration and retouching processes. We focus on what are called Photoshop's retouching tools, comparing and contrasting them. As we work with these tools and techniques together, I offer conceptual insight into why one way of doing things is often better than another.

In Part III, we focus on applying everything you learned in Parts I and II to the subject of photo restoration. I begin by showing you how to get the most from your scanner. Then I show you how to repair typical problems and add finishing touches to an image. We finish up with a hands-on restoration project that we do together — from beginning to end so that you can experience the entire workflow. By the end of this section, you'll know everything you need to know to begin restoring your own old photos.

Part IV is all about retouching. This is where I put all the pieces together from the preceding three parts and show you how to use Photoshop to take your images to the next level. I discuss some of the conceptual issues surrounding retouching, including workflow. Then I show you how to solve some special retouching problems like glass-glares and skin smoothing. We finish off this part with two hands-on retouching projects where we work side-by-side from beginning to end with sample files. The first one is a typical portrait retouching project. The second is an architectural retouching project. By the end of Part IV, you'll have all the tools you need to do just about anything to fine-tune an image.

As we explore these subjects together, I make every attempt to explain the theory behind the things I show you. In some cases, I demonstrate the practical applications of that theory with real-world images and step-by-step examples. In other cases, we work together on sample files that can be downloaded from the Web site. In these hands-on projects, you have the opportunity to follow along with me, working with the same files I used to create the book. You can find the sample files at www.wiley.com/go/restoration.

Who Should Read This Book?

Photoshop CS3 Restoration and Retouching Bible is intended for anyone who wants to know how to restore old photos and/or retouch new ones. You don't have to be an accomplished Photoshop user, but it is helpful if you have some experience with the software. With that said, even a beginner benefits from reading this book. It just may take a little longer to get up to speed with the basics.

This book is not intended as a comprehensive guide to all things Photoshop. My intention is to give you the things you need to accomplish these processes, without distracting you with what you don't need. There are times when I'd like to go into deeper detail, but I can't because those details are outside the scope of the book. If I don't cover some topic in detail and you want to know more about it, find a resource to help you explore it. Wiley publishes a book titled *Photoshop CS3 Bible* by Laurie Ulrich Fuller and Robert C. Fuller. It's an excellent Photoshop reference book. It goes into many of the details I can't cover here. Another useful resource is Photoshop's Help menu.

How to Use This Book

To get the most from this book, start at the beginning and go through it sequentially. This allows you to experience this learning process in the way I envision it. In many cases, ideas in one chapter build on information introduced in previous chapters. This amplification process won't make as much sense if experienced out of order. Also, take the time to read each chapter, even if you think you already understand its subject. You never know when you'll turn up a nugget that will completely change the way you work with your images.

Download all the sample files from the Web site. Most of them are fairly small files. If you have a slow Internet connection, borrow a friend's connection and download them all at once. After we go through a hands-on process together, take the time to explore those new processes with some of your own photos. I know from my own experience that working with personal files makes a big difference in the learning process. This is where you'll find the time to go as deep as you need to go while exploring the content of this book.

After you've been through the book from front to back, you can use it as a reference guide to help you solve your own restoration and retouching problems. When a specific issue pops up, find the relevant references in the book and review them as needed.

Conventions Used in This Book

I'm big on using keyboard shortcuts in my own workflow, but I won't be stressing them much here because there are potentially hundreds of shortcuts in Photoshop and I don't want to confuse you with them. The other thing is that I think it's more important that you know where to find a command in the menus, rather than the fastest way to execute it.

With that said, I do think you should begin getting used to the idea of keyboard shortcuts. So I will share some of the more useful shortcuts. When I first introduce the most common tools and commands, I give you their keyboard shortcuts in parentheses like this: the Lasso tool (L).

NOTE If you want to know all the keyboard shortcuts, choose Edit ➪ Keyboard Shortcuts and click the Summarize button.

Because this book was written on two Macs, all the screenshots are from the Mac version of Photoshop CS3. That shouldn't make much difference, because almost everything is the same in the Mac and Windows versions of the software. If you're using a Windows machine, the only real differences are the keyboard modifier keys.

Macs use the Option (Alt) key and the Command (Apple) key as modifiers, and Windows machines use the Alt key and the Ctrl key for the same functions. (This is all the more confusing because a standard Mac keyboard has a Control key on it that has a completely different function!)

- Mac Option (Alt) key = Windows Alt key
- Mac Command (Apple) key = Windows Ctrl key

Because every modern Mac keyboard I've seen has an Alt label on the Option key, I refer to this key as Alt, which should be straightforward. When I need to mention the other set of modifier keys, I say Command/Ctrl. The only reason I'm putting the Mac command first is to be consistent with the screenshots.

Should You Use a Mac or Windows Machine?

This is a question many people, especially photographers, ask themselves. Back in the olden days of digital photography, the answer to this question would have had a serious impact on a photographer's ability to do what he or she needed to do. At that time, the Mac was a superior platform to Windows primarily because of its more intelligent way of dealing with color. However, that difference disappeared long ago. When it comes to Photoshop CS3, a modern version of either platform works quite well.

I've used personal computers since their earliest days. Many of the computers I used during that time were Windows-based machines. For the last few years, I've used Macs because I work with many professional photographers who use the platform. I switched to it so that I would be more comfortable in their environment. (I would say that my current client base is split 50/50 on the platforms.) I have both types of machines in my office, and I commonly use both Mac and Windows machines during a typical day. I like some things about each platform. In a perfect world, I could combine all those things to create the perfect operating system.

The subject of Mac versus Windows comes up in my seminars and training quite often. When it does, I explain it like this: Deciding between Mac and Windows is like choosing Canon or Nikon, (or any other camera system). Both systems are great. If you buy a quality system from either manufacturer, you should be happy. Your decision as to which to buy should be based on how you like a particular system. Does it feel good in your hands? Are the controls easy to understand? Is it the same system your friends are using so that they can help you when you have questions? After you make a choice and begin buying lenses for one of those camera systems, you'll probably want to stay with it for a while. This is the same as software. After you spend a few thousand dollars on software for one platform, it's not likely that you'll want to switch anytime soon, because you'll have to buy all new software

No matter which computer system you decide to go with, be sure that the system is up to snuff. If your system is more than five years old, you may be disappointed in the performance of Photoshop CS3, especially when we begin doing some of the things we're going to do in this book. Ideally you should have a machine with a fairly fast processor. A dual processor is even better because Photoshop is designed to take advantage of two processors. Photoshop is a real RAM hog, so you'll want to have at the very least 1GB of system memory and preferably 2. If you have both these bases covered, then it won't matter if you're running a Mac or a Windows machine.

New Features in Photoshop CS3

Adobe has upped the ante with the release of Photoshop CS3. Several useful new tools and commands have been introduced that affect the restoration and retouching processes. I point out those new features along the way.

Adobe also made a couple of major changes to the Photoshop interface. For one thing, a new system for minimizing the palettes allows for stacking and hiding palettes so the screen real estate is maximized. Another interface change relates to the toolbar. Now it's possible to change the customary double-column toolbar into a single-column toolbar. Again, this provides slightly more viewing area. It also brings the toolbar into line with the way it appears in other Adobe applications. Throughout this book, I reference the single-column toolbar. To switch your toolbar to single-column, simply click the small double arrows at the top of the toolbar.

Another major change was the introduction of two editions of Photoshop: Photoshop CS3 and Photoshop CS3 Extended. The Extended version has some added capabilities that allow people like architects, engineers, and medical researchers to analyze images. Many of these features are in a menu called Analysis. Because I used Photoshop CS3 Extended to write this book, you may notice the Analysis menu in some screenshots. Don't worry if you don't have it. Most of the photographers I know don't need the added features of the Extended version, so I usually recommend that they save money and purchase the standard version.

Products Mentioned in this Book

On several occasions I recommend products I use or like. I want you to know that I do not have relationships with any of the companies that sell these products. These companies do not sponsor me. The only reason I endorse these products is that I think knowing about them will make your Photoshop experience more enjoyable.

One Last Thing

I tried very hard to make sure everything in this book is 100 percent accurate. However, I may have missed something. If you notice any errors or omissions, please let me know by e-mailing me at books@ddroom.com. That way, I can fix them in future editions.

Acknowledgments

I would like to thank my family, my friends, and most importantly, my clients for allowing me to "disappear" while writing this book. Your understanding and flexibility took much of the stress out of my taking on such a big project.

I also want to thank the following photographers for letting me use their images:

- Emily Andrews, Emily Andrews Portrait Design: `emilyandrews.net`
- Jerry Auker, Jerry Auker Photography: `net-seniors.com`
- Dan Christopher, Dan Christopher Photography: `danchristopherphotography.com`
- David Hitchcock, Hitchcock Creative Photography
- John McAnulty, Inner Focus Photography: `pro.corbis.com` (search for John McAnulty)
- Ted Miller Jr.: `mrmontana.blogspot.com`
- Carl Murray, Seattle Photography, Inc.: `seattlephotography.com`
- Denyce Weiler, Something Blue Photography: `somethingbluephotography.com`

This book would have been difficult to write without the sample images these photographers so generously provided. Please visit their Web sites to see more of their work.

A special thank-you goes to Denyce Weiler's assistant, Beverly Gray, for "volunteering" to come to work on her birthday to pose for some of the special samples I needed for this book. (Thank you, Denyce, for shooting those samples.)

I also want to thank all the other people who allowed me to use images of them. Most of them had no idea they'd end up in a book when they had their pictures taken.

Thank you to Louis Haslett, General Manager of Springhill Suites by Marriott in downtown Seattle, for allowing me to use a photo of the hotel, which is my favorite place to stay in Seattle.

Thanks to Jim Geringer, who is a top-notch copyright and patent attorney, for taking time to share his insights for the section on copyright in Chapter 9.

Special thanks to the editing team at Wiley: copyeditor, Gwenette Gaddis Goshert, who made my sometimes clumsy words sound so eloquent; technical editor, Mike Hagen, who took time out of his busy schedule to lend his extensive expertise; and project editor Martin V. Minner, who acted as chief wrangler on this project. Thanks, Marty, for always being there to answer my questions with clear explanations.

Acknowledgments

I would especially like to thank Courtney Allen, associate acquisitions editor for Wiley Publishing, who so kindly invited me into the Wiley fold. Without her, this book would never have become a reality. Thanks, Courtney!

Finally, I want to thank my friend and neighbor, Gary Hoselton, for being the first person to introduce me to Photoshop so many years ago. With that introduction, photography became fun again and my life changed forever.

Part I

Digital Image Fundamentals

Before we jump into learning how to use Photoshop to solve interesting restoration and retouching problems, we need to consider the fundamental issues that affect every image.

On the most basic level we're talking about brightness, contrast, and color. No image can be edited seriously until these three variables have been evaluated and adjusted, if necessary.

The type of file you're working on can have a significant effect on the outcome of brightness, contrast, and color adjustments. Some image files, *high-bit* files, contain a great deal more data that is used to record the image. This extra information can come in quite handy when you're forced to do some heavy lifting in Photoshop.

The concept of multiple image layers is extremely important in restoration and retouching. When editing complex images, every important image adjustment is done on a separate layer, creating a great deal of flexibility and control.

Another fundamental issue that affects the entire workflow is organization. A digital workflow without a clean organizational methodology invites wasted time and effort. What's the use of working your magic on a special image if you can't find the file later? If you take time in the beginning to establish organizational rules and procedures that you'll use consistently, you'll always be able to find what you want when you want it.

Chapter 1

Adjusting Image Brightness and Contrast

The foundation of a solid digital image begins with the tonal qualities of the file — the brightness and contrast. If these are not adjusted correctly, the rest of the process suffers. That's why our workflow begins here. Even if you already feel comfortable adjusting the tones in your images with these tools, you may want to look at this chapter. In addition to covering the basics, I show you some cool things that are new in Photoshop CS3.

Understanding Histograms

The primary tool that's used to evaluate the tones in a digital image is the *histogram*. A histogram is a graphical representation of the distribution of the tones in an image. It consists of a graph that ranges from pure black on the left to pure white on the right. In between are all the shades of gray from almost black to almost white.

Imagine 256 side-by-side columns, one for each of the individual tonal value that a histogram represents. The columns start with black (0) on the left and end with white (255) on the right. In between are 254 other columns representing all the shades of gray between black and white. Together these 256 levels equal the sum total of the tones in an image.

The height of a column is governed by the number of pixels in the image having that particular tone. If the image includes lots of neutral tones, then the columns around the middle of the histogram are taller. Because these columns are standing right next to each other, they form a graph when viewed as a group. This graph is our histogram, as shown in Figure 1.1.

FIGURE 1.1

The range of tones in an image is represented in the histogram. All tonal ranges are represented, from black (0) on the left to white (255) on the right. (For the sake of this discussion, we don't care about the statistics that appear below the graph.)

 Figure 1.1 is the expanded view of the Histogram palette. The view can be changed in the Histogram Palette Menu that is accessed by clicking the three horizontal bars just below the "X" at the top right. A palette's menu is always the place to go to modify the palette or to find hidden commands. (It's also where you can turn off the statistics that show below the histogram by unchecking Show Statistics.)

To see the Histogram palette, go to Window ➪ Histogram. If you leave this palette open, you'll be able to see the histogram for any open image. This is handy when making adjustments because the display in the Histogram palette updates as you move the sliders in the adjustment tools, allowing you to monitor changes as you make them.

The shape of the histogram's middle region doesn't matter as much as what's going on at its ends. If an image has full tonal range with detail in the shadows and highlights, the graph covers most of the space between 0 and 255, as shown in the first set of images in Figure 1.2. Each end comes to a stop before hitting the end. If an image is underexposed, then all the tones move to the left and all the tones that used to describe the dark shadows are *clipped* off the end forcing them to pure black, as show in the second set of images in Figure 1.2. If an image is overexposed, the opposite happens. The histogram moves to the right. All the tones describing bright highlights get clipped and become pure white, losing all detail, as shown in the third set of images in Figure 1.2.

FIGURE 1.2

When checking exposure, always pay attention to the endpoints of the histogram. A normal exposure provides a full range of midtones, as shown in the first set of images. An underexposure shifts the histogram to the left, clipping shadows, as shown in the second set of images. An overexposure shifts the histogram to the right, clipping highlights as shown in the last set of images.

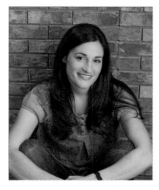
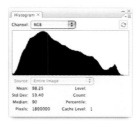

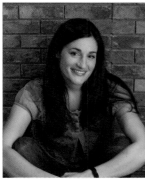
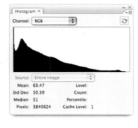

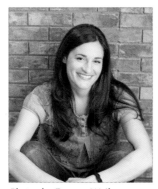
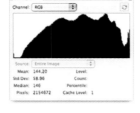

Photos by Denyce Weiler

Whether you're using a digital SLR camera or a scanner, you need to pay attention to histograms. Many DSLR cameras have a feature that you can turn on to display a histogram every time you take a photo. This can be a great way to evaluate an exposure as soon as you shoot it. You don't even need to see the image preview to know whether your exposure is good. All you need to see is the histogram — which is great on a bright day when it's hard to see the image preview on the camera.

Not all scanner software provides a live histogram, but it's pretty easy to look at the histogram in Photoshop after the scan is done. In either case, if you see clipping in the shadows or highlights, you can make immediate adjustments and rescan.

One more thing to consider when evaluating a histogram is the tonal key of the image. When an image is a bright scene (high-key) or a dark scene (low-key), the histogram can fool us. Figure 1.3 shows two photos and their accompanying histograms. At first glance, the histogram for the top set of images appears normal, and the histogram for the darker, bottom set of images appears to be underexposed. The first clue to indicate this isn't the case is that we don't see any shadow clipping in the second histogram.

In fact, both of these images were made with exactly the same exposure. The difference in the histograms is from the differences in subject matter. The second portrait contains more dark tones while the first portrait contains mostly medium tones. I can prove they were exposed the same by drawing a similar selection around the same areas of both faces. When I do that, the histogram displays information only about the tones inside the selections. (We take a close look at selections in Chapter 7.)

Figure 1.4 shows a closeup of the selections and their resulting histograms. Now we can be sure that these two images have the same exposure. The dark tones were throwing off the histogram. This technique is useful any time you want to evaluate the main subject tones in an image.

> **TIP** You may be asking "What's up with that little exclamation icon in the Histogram palette?" I get that question often. What it means is that the currently displayed histogram is being created with cached information — not the latest info. Click the icon, and the histogram updates so it's using the most current information.

Even with the best exposure, the scene may not contain the darkest and brightest tones we would like to see. In these cases, it becomes necessary to adjust the histogram of the image. You can do this in a couple of ways: using the Levels command and using the Curves command.

FIGURE 1.3

When evaluating a histogram, consider the tonal content of the image. These images were exposed exactly the same. The image with the darker content has a histogram that is weighted to the left.

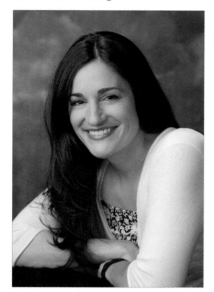

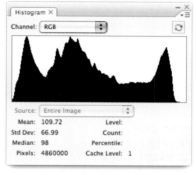

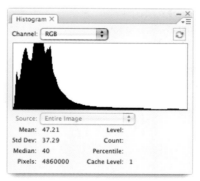

Photos by Denyce Weiler

FIGURE 1.4

Using a selection to isolate important information allows us to effectively evaluate the tones in an image because the histogram displays information only inside of the selection.

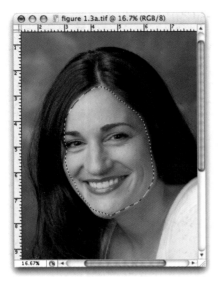

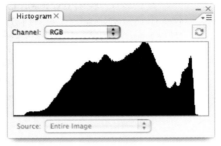

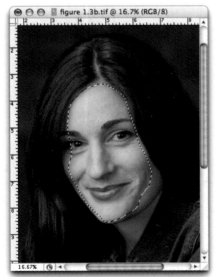

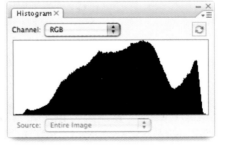

Adjusting Brightness and Contrast with Levels

The Levels command is one of the primary tools for tonal adjustment in Photoshop CS3. It allows you to pinpoint the darkest and lightest tones in an image. That way, you know whether you're losing detail in a highlight or a shadow, and you also know exactly where it's happening in the image.

The first thing you notice about the Levels command is that it uses the histogram to display information about the image, as shown in Figure 1.5. The small triangles below the histogram at each end allow you to control where the ends of the histogram stop. The numbers below the sliders tell you exactly which tones are being affected. These triangles are called *input sliders*. When you click and drag them inward, you modify the histogram by moving the endpoint. Look at the Histogram palette, and you see the effects that your changes have on the histogram as you make adjustments to the Levels Input sliders.

FIGURE 1.5

The Levels command allows you to modify the histogram by clicking and dragging the Input sliders.

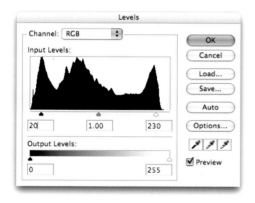

> **CAUTION** The Levels window includes another set of sliders at the bottom. These sliders are called *output sliders* because they're used to limit the tones in an image for specific printing scenarios (output). We normally don't use them for image adjustment at this point.

When the black and the white Input sliders are moved, they have a similar effect on their respective endpoints. The black slider controls what the darkest tone in the image is — a value of 0, or pure black. The white slider controls what the lightest tone in the image is — a value of 255, or pure white. This means that whatever values these sliders are set on become the new blackest black (the black-point) and the whitest white (the white-point).

In Figure 1.6, the black and the white Input sliders have been moved inward. The black slider is set at 26, and the white slider is set at 232. If you click OK at this point, the current tone of 26 becomes 0 and the current tone of 232 becomes 255. This can be verified by looking at the display in the Histogram palette that shows us what the resulting histogram is going to look like.

FIGURE 1.6

The Histogram palette displays an updated histogram as the Levels Input sliders are moved. The new histogram is the gray one in the background.

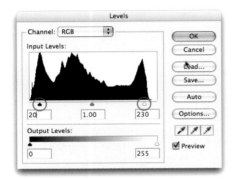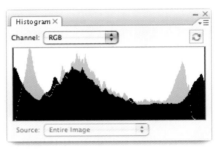

If we looked at the resulting image, we would see that it looks contrastier — the darkest tones are too dark, and the lightest tones are blown out, losing all detail. This is because we eliminated tonal information from the image by moving the sliders inward. This is called *clipping:* We clipped information from the extreme tonal ranges of our image. In this case the resulting effect is not really desirable, although sometimes it can be.

Let's take the Levels command for a spin so you can get a feel for the three main sliders:

1. Open the practice file titled snow_dog.tif from the downloadable practice files on the Web site.

NOTE Remember, all of the practice files used in the hands-on exercises can be downloaded from the Web site.

2. Open Levels, Image ⇨ Adjustments ⇨ Levels. You also may access the Levels dialog box by pressing Command/Ctrl+L.

 The histogram for snow_dog clearly shows that the image includes no deep black or bright white; the histogram data does not extend all the way to either end. This is borne out in the image. Its contrast is flat, and the overall brightness is a little dark.

 If the Histogram palette isn't showing on your desktop, go to Windows ⇨ Histogram.

3. Click and drag the black Input slider until the value is 23.

4. Click and drag the white Input slider until the value is 226.

 Notice how much richer the image looks. The blacks have been punched up, and the whites look much cleaner.

5. Now click and drag the black slider to 45 and the white slider to 200.

 Notice how the image's contrast has gone too far. The darkest tones and the lightest tones are losing detail because tonal information is being clipped.

6. Click Cancel.

When we work with Levels, we need to be careful about clipping shadows and highlights when moving the endpoints. It's not only important to know when clipping is happening; it's also important to know where it's happening in the image.

Let's try adjusting snow_dog again. This time I show you a way to target the clipping in your image. Follow these steps to clip the image in just the right places:

1. Open snow_dog again. If it's already open, be sure that no previous Levels adjustments have been applied.

2. This time hold down the Alt key before clicking and sliding the black slider. The first thing you notice is that the image goes completely white. Keep dragging the slider until you see some detail appear in the image, as shown in the first frame of Figure 1.7.

 The areas that begin to appear are what will become the darkest tones in the image if you stop as soon as you see them. If these pure black tones are in an important part of the image, you want to stop just before you see them so that you know that the darkest tones still have some detail.

3. Move the black slider back to the left until the preview just becomes completely white, and release the mouse button.

4. Do the same thing with the whites. Hold the Alt key, and drag the white slider inward. Notice that the screen goes black. Keep dragging until some detail appears in the image, as shown in the second frame of Figure 1.7.

 The areas that begin to appear are the brightest tones in the image. If they are showing in the preview, then you know you're beginning to blow out the highlights.

5. Move the white slider back to the right until the preview just becomes completely white, and release the mouse button.

 Now you can be confident that the image has a full range of tones from almost pure white to almost pure black.

6. Uncheck the Preview box on the Levels window so that you can compare before and after. Be sure to recheck the box before clicking OK later.

TIP **Our brains get used to what's in front of them pretty fast. The Preview option in most Photoshop dialog boxes helps us to "remember" what an image looked like before any changes were made. This is a great way to see whether you're on the right track with your adjustments.**

FIGURE 1.7

Preview clipping by holding down the Alt key when adjusting the black and white Input sliders in Levels. The top image shows the clipping preview when adjusting shadows. The bottom image shows the highlight preview.

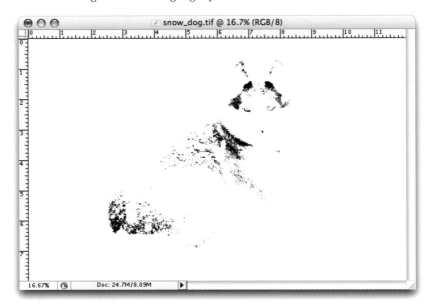

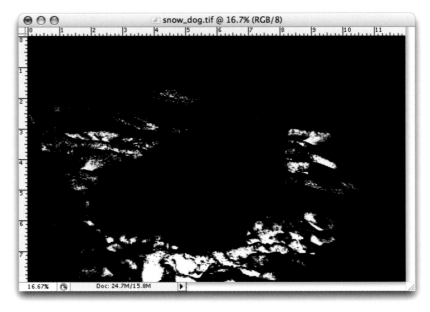

7. The contrast of the image looks good, but the overall brightness is still a bit too dark. Click the middle Input slider. It's between the white Input slider and the black Input slider. Just below it is a readout displaying 1.00. Slide it to the left to lighten the image, and slide it to the right to darken.

 Holding down the Option/Alt key here has no effect. Just move the slider until you like what you see.

8. Click OK.

Now the image has had its brightness and contrast fine tuned. We know where the darkest and lightest parts of the image are, and we know that we're holding detail in them. This valuable information is provided by the clipping preview function in the Levels command.

NOTE When I use the terms "brightness" and "contrast," I'm not referring to the Brightness/Contrast command in Photoshop. Instead, I'm referring to the qualities of the image. Most Photoshop teachers will advise you to stay away from the Brightness/Contrast command and use the more powerful Levels command instead.

Sometimes, I let the shadows of an image clip if I think it makes the image look better by providing deeper blacks. I just make sure that those shadows are not in my main subject. In this example, any detail loss in the shadows is in the dog's fur — which would be unacceptable to me. If it were in a dark background, I might let it go if I thought it gave the image a little more snap. However, I'll almost never allow a highlight to blow out if I can prevent it. When a highlight is blown out and it gets printed, it becomes the color of the paper it's printed on.

So here's the lowdown on Levels. When adjusting an image with Levels, always start with either the black slider or the white slider. Do both ends, and get the black-point and the white-point set before adjusting the image's brightness with the gray slider in the middle. If you begin with the gray slider before working with the ends, you'll most likely have to revisit it later to readjust it.

Adjusting Brightness and Contrast with Curves

If the Levels command is a chisel for refining an image's tonal range, then the Curves command is a scalpel. With Curves, you can target small ranges of an image's tonal qualities with much more control than the Levels command. Figure 1.8 shows the Curves dialog box.

Curves works along the same lines as Levels. You set the black point and the white point and then adjust midtone values. The main difference with Curves is that you have much greater control when adjusting midtone values.

The interface can be intimidating, but after you understand what the various adjustments do, it begins to make sense. Let's give it a try with these steps:

FIGURE 1.8

The updated Curves dialog box in Photoshop CS3 sports a number of improvements like Show Clipping and a histogram overlay. To see all the options, be sure to click Curve Display Options at the bottom left of the dialog box.

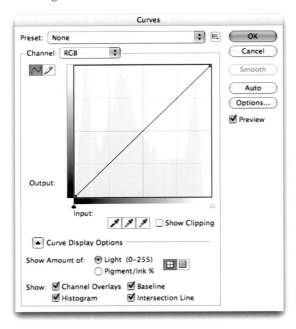

1. Open the snow_dog practice file again.

2. Open the Curves command by choosing Image ➪ Adjustments ➪ Curves. You also may access the Curves dialog box by pressing Command/Ctrl+M.

 Make sure that Light (0-255) is checked under Show Amount of: in the Curve Display Options. That way, the Curves dialog box will be oriented the way I have it in Figure 1.8.

3. Grab the black Input slider on the left, and drag it horizontally toward the middle. Notice that the blacks get blacker just like the black slider in Levels.

4. Grab the white Input slider on the right, and slide it horizontally toward the middle. The whites get whiter just like the white slider in Levels.

5. Click the check box next to Show Clipping to turn on the clipping preview.

NEW FEATURE In earlier versions of Photoshop, there was no way to preview clipping while using Curves. Because of that, in versions of Photoshop prior to CS3, it was best to set black and white points with Levels before moving to Curves to work on the midtones.

6. Slide the black and white sliders inward until you almost see clipping in the preview. (Remember that it can be okay to clip shadows a bit to get richer blacks, but you never want to clip highlights if you can help it.) After you have both sliders set to where you want them, uncheck the Show Clipping box to return the image to its normal appearance. In my case, I ended up with a black value of 23 and a white value of 226, as shown in Figure 1.9.

FIGURE 1.9

Here are the black-point and white-point adjustments using Curves. Notice that the points are dragged straight to the side horizontally. To preview clipping in Curves, check Show Clipping.

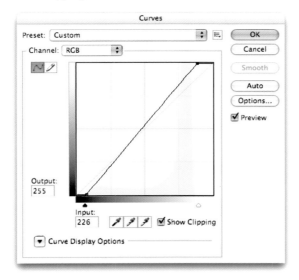

7. To lighten the image, click the middle of the diagonal line to place a point. Then drag that point straight up. To darken, drag the point downward.

This point is like the gray slider in the Levels command. It represents the tones in the middle of the image. The big difference, however, is in the effect that adjustments have on this point as compared to the Levels command. When we move the gray slider in the Levels command, the effect on the tones around it is linear. With the Curves command, the effect of the adjustment is stronger on tones that are close to the point and weaker on tones that are further away. That's why the command is called Curves — because the adjustment slopes away.

TIP If you want to nudge the settings on the black and white sliders, you can use the up and down arrows on the keyboard to move them one point at a time after you make them active by clicking them. This works with almost any slider in Photoshop, including Levels.

Notice how much steeper the diagonal line in the Curves dialog box is now that we moved the endpoints inward. Something to be aware of with the Curves command is that the steeper the diagonal line is, the more contrast the image has. Keep that in mind as we look at the midtones.

Now that the overall tonal range of the image has been established with the Input sliders, we want to unleash the real power of the Curves command. Whereas the Levels command has only two endpoint sliders and one grayscale slider in the middle, the Curves command allows up to 14 different adjustment points to be placed onto the curve line — although you rarely need more than a few.

To add an adjustment point to the diagonal line, simply click it. The higher up on the line you place the point, the lighter the tones that will be adjusted. To lighten the tones around the point, drag the point upward. To darken that region, drag the point downward.

Because the points represent tonal regions in our image, we want to be informed about the tones they represent before placing them. The best way to see how the tones of your image correspond to the points on the curve is to click the image while the Curves dialog box is open. When you do so, small circles temporarily appear on the Curves line to indicate where the tones you're clicking are located on the line. To place one of these preview points on the curve, Command/Ctrl-click the tone in the image.

TIP To remove a point from the Curves line, click it and drag it out of the Curves window, or click it and press the Delete key on your keyboard.

Typically, the Curves command is used to increase midtone contrast. This is done by increasing the slope of the middle of the curve line where most of the midtone detail is located. A side effect of this is that we flatten out the curve on the toe (shadows) and the shoulder (highlights), and reduce contrast in those areas. The result of this type of adjustment is called an S-curve, as shown in the top set of images in Figure 1.10.

Follow these steps to clip the image using the Curves dialog box:

1. Open snow_dog.jpg one more time. Open the Curves dialog box, and drag the black and white Input sliders inward until you almost see clipping.

 You may notice that the new input values are similar to the values you used for black and white input values with the Levels command (23 and 226, in my case).

2. Start clicking in the darker regions of the fur on the dog's hip. When you get an input value near 55, Command/Ctrl-click to place a point on the line. This point represents the lower end of the darker regions that we want to adjust in the midtones.

3. Now click the side of the dog's face until you find an input value close to 150. When you do, Command/Ctrl-click to set a point on the Curves line. This represents the upper end of the highlights that we want to adjust. We don't want to go much higher than 150 because we don't want to have too great of an effect on the snow, which is mostly in the range of 200 and above.

4. Carefully drag the upper point that represents 150 straight up until the value for the output is 160. Drag the lower point that represents 55 down until its output value is 40.

 The midtone contrast has increased slightly, just enough to add some snap to the midtones while the snow retains most of its detail. Try dragging the two points even further. Notice how easy it is to go too far.

FIGURE 1.10

With a typical S-shaped curve, midtone contrast is increased while shadow and highlight contrast is slightly reduced, as shown in the top set of images. An inverted S-curve decreases midtone contrast, as shown in the bottom set of images.

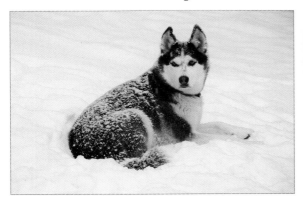
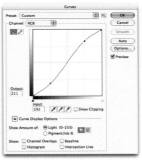

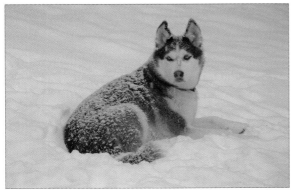
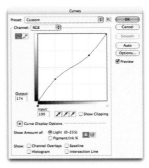

NOTE **The Output value in the Curves dialog box is what the Input becomes when the OK button is clicked. In this case, the dark region around 55 becomes 40 (darker), and the light region around 150 becomes 160 (lighter). If we make the darker regions of the midtones darker and the lighter regions lighter, then it makes sense that we're increasing midtone contrast because we're pulling the tones between 55 and 150 apart so that they now cover the area between 40 and 160.**

I'm sure you've already figured this out by now — just as an S-curve increases midtone contrast, an inverted S-curve decreases midtone contrast (refer to the bottom set of images in Figure 1.10), because it reduces the slope in the midtones.

Now that we've taken a good look at the Curves command, there's something I need to tell you. You can do most of your tonal adjustment with the Levels command. Quite often, you may not even need Curves. When you're first starting out with Photoshop, you should master the Levels command before going too deep into the Curves command. For that reason, we'll use the Levels command as our tonal adjustment tool of choice until we get to Chapter 16.

Remember when I said that the Curves command is like a scalpel? Well, a scalpel in the hands of someone who doesn't know how to use it can make a real mess. The same is true for Curves. If you aren't careful, you can do more harm than good with the Curves command. So take it easy with Curves, and begin by making small adjustments until you become more comfortable and confident with this powerful tonal adjustment tool.

Balancing Dynamic Range with the Shadow/Highlights Command

Sometimes, we can make a perfect exposure, but the *dynamic range* of the scene being photographed is too wide for us to get an exposure that looks good in the shadows and highlights. Dynamic range refers to the distance between the brightest tones and the lightest tones. We often run into this scenario when we photograph a scene with bright backlighting where the main subject is in a shadow. Usually, the best way to solve this problem is to use a fill flash on your camera when you shoot the original scene so that you fill in the shadows with some light. Sometimes, though, a flash isn't an option, and we have to deal with what we have.

When editing a file that suffers from this problem, making the image look its best with Levels or Curves can be hard. That's why Adobe introduced a new command a few years ago in Photoshop CS. The command is called Shadows/Highlights, and it's used to balance discrepancies between extreme shadows and highlights. Figure 1.11 shows the Shadows/Highlights dialog box.

The first thing you notice in Figure 1.11 is that the Shadows/Highlights command allows you to work on the shadows and highlights independently via the two areas marked Shadows and Highlights. Each of these areas is controlled by three sliders labeled Amount, Tonal Width, and Radius. Let's look at what each of these sliders is used for:

FIGURE 1.11

The Shadows/Highlights command with Photoshop's default settings. To see all the options shown, be sure to check the Show More Options box at the bottom left.

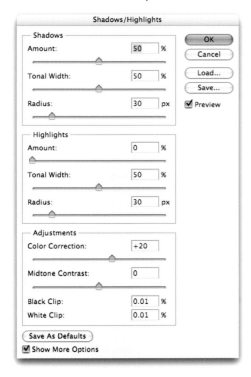

- **Amount** controls the amount of adjustment. Higher values in Shadows lighten the shadows more. Higher values in Highlights darken the highlights more.

- **Tonal Width** controls the range of tones that are affected by changes in amount. Higher settings in Shadows affect a larger range of shadow tones. Lower settings affect a narrower range. The opposite happens when adjusting Tonal Width in the Highlights; higher values affect larger ranges of highlight tones, and lower values affect smaller ranges of tones.

- **Radius** works like this: When the Shadows/Highlights command looks at an image, it decides whether a pixel is a shadow or a highlight by evaluating its surrounding pixels. The Radius slider allows us to fine tune this decision-making. Lower values restrict the area that is looked at when evaluations are made, and higher settings expand that range. Too large of a setting darkens or lightens the entire image rather than the area you are working on.

> **TIP** If you start seeing halos around dark or light edges, you need to lower the Tonal Width setting for the respective halos — Shadows for dark tone halos and Highlights for light tone halos.

In addition to the Shadows and Highlights areas on the Shadows/Highlights command, there is an area labeled Adjustments. Here we have additional sliders that help to undo any unwanted shifts that might occur when the shadows and highlights are adjusted. We're most interested in these three:

- **Color Correction:** When tonal values are changed, colors can shift. For example, when shadows are lightened, a color that was dark before becomes lighter. The Color Correction slider allows you to control color *saturation* — the intensity of the color. Increasing the value of the Color Correction slider tends to increase saturation, and lowering it tends to decrease saturation. This command is available only when working on color images.

 Keep in mind that the Color Correction affects only portions of the image affected by the Shadows and Highlights sliders. When those adjustments are more extreme, the range of adjustment to Color Correction is greater.

- **Brightness:** This command is available only when working on grayscale images. It works something like the Color Correction slider. Moving the slider to the right lightens, and moving it to the left darkens the affected areas in the image.

- **Midtone Contrast:** Slider movement to the right increases midtone contrast, and movements to the left reduce it.

 In most cases, I'd rather change this with a Curves adjustment. However, if you're working quickly on some images, it may be faster to take care of it here.

Let's take a look at how all this works:

1. Open the practice file titled bike_racing.tif from the downloadable practice files on the Web site, as shown in the first frame of Figure 1.12.

 This exposure isn't bad, but it could be better. I want to lighten the faces of the riders and darken the track in the background.

2. Choose Image ➪ Adjustments ➪ Shadows/Highlights.

 When the dialog box opens, it most likely will have the default settings shown back in Figure 1.11. These tend to be way over the top, and you'll notice that the adjustment in the shadows is too strong. Also, the track is still too light.

> **TIP** The default settings on the Shadows/Highlights command tend to be too strong in the shadows and too weak in the highlights. After you've used the command a couple of times, you'll get a feel for the kinds of settings you like. When you do, open the command and dial in the settings you like. Then click the Save As Defaults button on the lower left of the dialog box. The next time you open the Shadows/Highlights command, you can begin with more normal settings as a starting point.

FIGURE 1.12

Before and after using the Shadows/Highlights command. In the second image the highlights are darker and the shadows are lighter, completely changing the feel of the image.

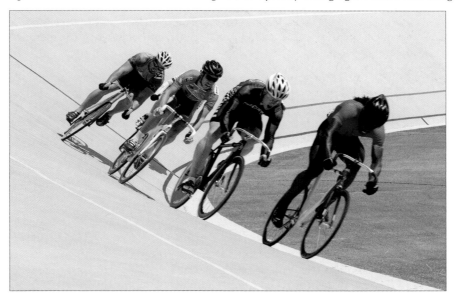

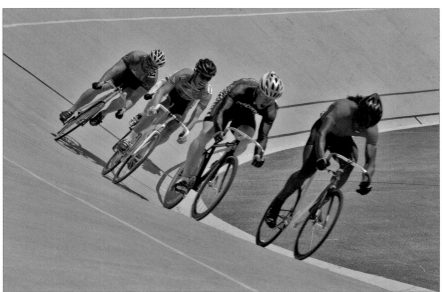

3. Let's adjust the Shadows first. Start with the Radius slider. Move it to the right until you see the shadows begin to look more realistic. Moving it to the right limits the range of tones being affected. I moved it to 190px.

4. Now adjust the Amount in Shadows. I moved it down to 35% to back it off a bit.

5. Try experimenting with Tonal Width to see the effect this slider has on the image. I left it at 50%.

6. Now that the shadows are looking pretty good, let's address the highlights. Go down to the Highlights area, and move the Amount slider to the right until the track darkens. I stopped at 60%.

 If you notice any haloing around the riders, try adjusting the Radius slider in the Highlights area. If you decrease the Radius to 0px, the haloing goes away, but the image takes on a flat, fake look. Instead, try raising the Radius. I turned it up to 95px. There is still a slight haloing effect, but I like the way it looks.

7. Again, try experimenting with Tonal Width here. I left it at 50%.

8. Click the Preview check box a couple of times to toggle back and forth between before and after. If you want to fine tune your adjustments, do so now.

9. Now let's look at the Color Correction slider. Try moving it to the left. As you do so, pay attention to the colors on the riders' jerseys. When you get close to a value of 0, the colors on the chests of riders 1 and 3 are *desaturated*—the colors lose some of their richness. Values of much less than 0 have little more effect. If you move the slider to the right, the colors on riders 1 and 3 chests get more saturated.

 Notice that the effect of saturating and desaturating with the Color Correction slider affects only the areas that were affected by adjustments in the Shadows portion of the Shadows/Highlights command.

10. When you like what you see, click OK, as shown in the second frame of Figure 1.12.

CAUTION The Black Clip and White Clip boxes are used to clip shadow and highlight tones. Increasing these settings causes the image to become more contrasty. Generally, I would prefer to use the Levels or Curves commands to better control clipping.

Be sure to look for two side effects when using the Shadows/Highlights command. The first is that your image can become flat in contrast if you overdo it. If this happens, try making a Levels or Curves adjustment to compensate for it. In fact, if you think you'll need to make a tonal adjustment with the Levels or Contrast commands, try to do it after using the Shadows/Highlights command.

The second side effect is that when you open up shadows with any tonal adjustment tool, you reveal noise because noise tends to live in the shadows. If you watch for this as you adjust the Shadows sliders, you know when to take it easy on areas of extreme noise.

Summary

After you know how to read a histogram, you can make sense of the tonal values in an image. Dark tones are on the left, and light tones are on the right. The most important part of a histogram is what's going with its endpoints. The main thing we want to avoid with a histogram is having the data graph stop abruptly against either end. When we see this, we know we're clipping shadow or highlight information.

The Levels and Curves commands allow us to shape the histogram of an image so we take advantage of its tonal strengths. With these command, we can accurately set the black and white points and adjust midtone brightness and contrast. With the advent of Photoshop CS3, we can preview clipping in either Levels or Curves. The Curves command is a very powerful one. Like any powerful tool, it can be destructive in the untrained hand. Learn to master Levels before moving to Curves. When you do begin to use Curves, do it with a light hand.

The Shadow/Highlight command gives us a different approach for tonal adjustment. This command is perfectly suited to bringing deep shadows and bright highlights into parity. Use the Shadow/Highlight command before using the Levels or Curves commands to get the most from it.

Chapter 2

Working with Color

After an image's tonal qualities are adjusted, you're ready to address any fundamental issues with color. In the beginning, color can be a complex concept to get your head around. The complexity grows when we add all the ways that we can deal with color in Photoshop CS3. In this chapter, I explain what color is, tell you how to set up color management in Photoshop CS3, and give you the primary tools to use when working with it. By the end of this chapter, you'll have the knowledge you need to begin taking control of color in your Photoshop workflow.

Calibrating Your Monitor

Before we get down to the nuts and bolts of color, we need to be sure that we're all seeing things the same. Think about this for a moment: You've seen banks of televisions in electronics stores where every TV is displaying the same channel in different colors. When you buy a TV, you don't really worry about those differences. You simply want a TV that looks good when you get it home. No one will be comparing your TV to his and wondering why they don't look the same.

We run into the same phenomenon when dealing with digital images: Not all computer monitors display tonal information and color the same. Unlike TV sets, this can be problematic. What's the use of tweaking an image in Photoshop if the color is going to look different as soon as it's viewed somewhere else?

Back in the days of film, we didn't run into this problem as much. If a photographer was shooting slide film, the colors in the slide became the true

colors — the reference point to which everything else was compared. Any reproductions strived to match the original.

Everything's different with digital. Digital files are viewed on a wide range of equipment. Predicting what an image will look like when someone else sees it in his particular viewing environment can be difficult.

If I send a sample of an edited file to someone in New York, how do I know he is seeing the same thing I am when he opens the file in New York? If I'm sending a file out for printing, how can I feel confident that the photo lab and I are on the same page when it comes to color? Even though we can't control the variables in all these scenarios, we can control the biggest variable — our own computer monitors. That's why monitor calibration is the first step to color management.

The idea behind monitor calibration is to establish some standards and get everyone to use them. These standards refer to the color temperature, brightness, and contrast the monitor displays. The standards are shared when we all use devices to measure and calibrate our monitors. This way, we can create custom *profiles* that describe the changes necessary to make a particular monitor work within the standardized environment.

NOTE Think of a profile as a language interpreter — just like an interpreter at the United Nations. In the case of the color profile, color is the language that's being interpreted. Profiles allow all the devices in a digital workflow to interpret and understand color. Cameras, monitors, and printers all have color profiles.

A number of monitor calibration devices are available on the market. I have experience with the ColorVision Spyder2 Pro and the Greytag McBeth Eye-One Display 2, as shown in Figure 2.1. Each of these devices currently retails for about $250. Either does a decent job.

These devices work a little differently from one another, but for the most part they're used in the following manner:

1. Install the software that comes with the calibration device.

2. Plug the device into a USB port on your system — preferably a port on the back of your machine, not a USB hub.

3. Launch the software, and tell it to calibrate and profile your system.

 Calibration allows you to adjust your system so that your display is ready to profile. Profiling creates a snapshot of your display that describes it to other devices.

4. The software takes you through some preliminaries and asks you a couple of questions.

 Pay special attention to the questions about color space and gamma. Choose 6500k for color temperature and 2.2 for gamma as your starting points to be consistent with most of the rest of the world.

CAUTION Many Mac users believe they're supposed to choose 1.8 as their gamma because 1.8 is known as a Mac setting. In the very early days, 1.8 was a gamma setting for Macs. It was created so that those displays would match the limitations of an early Apple dot-matrix printer. Today, 2.2 is the standard gamma setting for computer displays. The 1.8 setting is no longer necessary and can actually cause problems if used.

FIGURE 2.1

Here we see the Greytag McBeth Eye-One Display 2 monitor calibration device in position for calibration.

5. When the calibration software is finished, it prompts you to save the newly created profile and make it your default.

6. The profiling software also reminds you to recalibrate at certain intervals so that your viewing environment stays consistent.

This interval is set in the preferences. All my systems are set to remind me every two weeks. I don't always recalibrate every two weeks, but I do try to do it every month with my main systems.

TIP If you're planning to move from a CRT monitor to an LCD display (as many people are doing) and you have an older calibration device, think about upgrading to the newer generation of devices. When I moved from CRT to LCD, my older device didn't do a very good job on the LCDs. When I bought a newer model, all my systems came into balance.

Don't go crazy over calibration and profiling. You can reach a point of diminishing returns when striving for perfect color — especially when you're dealing with outside printing sources. Make an effort to get calibrated, but don't worry if you are not getting a perfect match to your prints. Lots of variables can affect printing. I discuss some of them in Chapter 12.

Understanding Color Theory

One of the first things to understand about color is that it's personal. Everyone has his own preferences. When I worked in a professional photo lab, we had a lab standard for skin-tone colors. However, we had certain customers who wanted the skin tones in their prints to have a particular tint. Even though we didn't like the color the customer liked, we did everything in our power to make them happy.

Some of this bias relates to personal taste, and some of it is more related to actual color perception. Not everyone sees color the same. In fact, your own color perception can shift as blood sugar levels go up and down. Some people are deficient in seeing color on a red-green axis; others are deficient on a blue-yellow axis. However, few people are completely color blind.

NOTE Here's an interesting fact—more men are affected by color blindness than women.

Even though our experience of color can be highly subjective, the physics behind color theory is rock solid. The main distinction we need to make when we begin talking about color is whether we are talking about *additive color* or *subtractive color:*

- **Additive color** describes the way light waves combine to create color. This is the way we see things, and it's how most color adjustment happens in Photoshop CS3. It's called additive because equal amounts of pure red, green, and blue light added together create white.

- **Subtractive color** describes the way pigments work together. If you add equal amounts of red, green, and blue paint together, you get something pretty far from white—more of a muddy gray. In order to get white with pigments in subtractive color, you subtract colors.

 Inkjet printers use pigment inks to print on white paper. When you print an image with pure white in it, the white is the color of the paper because it doesn't have any ink on it. Even though inkjet printers use subtractive dyes and inks, we still use additive color in Photoshop to prepare files for printing on them. The printer drivers take care of any conversion necessary.

Our discussion here is going to center around additive color and the six colors that are used when discussing color in digital photography: red and its opposite—or *complementary color*—cyan; green and its complement magenta; and blue and its complement yellow. Figure 2.2 shows these colors and where they meet. When you have equal amounts of complementary colors, you end up with gray—in other words, they cancel each other out color-wise.

We're talking about only three *primary colors* here: red, green, and blue (RGB). These three colors combine in countless ways to form all the colors that a human eye is capable of seeing. It's just easier to work with and combine these colors if we have a way of expressing their opposites or complements: cyan, magenta, and yellow.

FIGURE 2.2

We use six colors to create color in Photoshop: red, cyan, green, magenta, blue, and yellow. Notice the colors that are created where any two colors overlap.

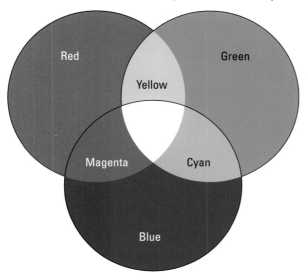

NOTE Color is a science with, theoretically, many ways to model colors and their relationships. RGB (red, green, and blue) is just one of these *color models.* Others are CMYK (cyan, magenta, yellow, and black) and HSV (hue, saturation, and value).

The relationship among these colors gets even more interesting because each of these six colors is composed of two component colors. The two components of any color are two of the other five colors.

Here's how the colors break down into components:

- Red is composed of magenta and yellow.
- Green is composed of cyan and yellow.
- Blue is composed of cyan and magenta.
- Cyan is composed of green and blue.
- Magenta is composed of red and blue.
- Yellow is composed of red and green.

This may seem confusing at first, like an endless shell game — especially if you're used to thinking about the way pigments such as paint combine. But Figure 2.3 shows an easy way to remember

these relationships: The primary colors — red, green, and blue — are directly above their complementary colors (the ones that cancel them out) — cyan, magenta, and yellow. Here's the trick to understanding this: The two component colors of any color are the two colors that are not directly across from it. For example, red is composed of magenta and yellow. Cyan can't be a component of red because it's the opposite of red.

FIGURE 2.3

Component colors of any one color are the two colors that are not directly across from it on this chart. Complementary colors can't be components of their complement because they are opposites.

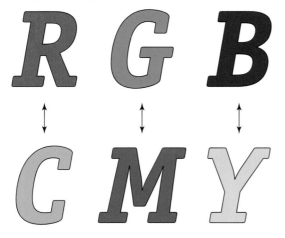

When I discovered this many years ago, it completely changed the way I thought about colors and their components. All I have to do now is visualize this simple chart, and I know how all the colors relate to one another — which colors are complements and which are components.

Comparing Color Spaces

Red, green, and blue are the colors of a *color model* we call RGB. A color model is an abstract way of mathematically describing colors. We need a common vocabulary when we discuss specific RGB colors within that model. Otherwise, when I say "red," how do I know you're thinking about the same color that I'm thinking about?

We further classify colors into *color spaces*. A color space, among other things, defines the *gamut* of color that a device is capable of capturing or reproducing. For example, my monitor is capable of displaying only a certain palette of colors. Many of the colors I can see out in nature can't be displayed on my monitor. However, my monitor can display colors that can't be printed on my inkjet

printer. The monitor's gamut isn't as large as the spectrum that a human eye can see, but in some cases it's larger than the gamut of the printer. These kinds of color spaces — monitor and printer — are called *device-dependent* color spaces. A device-dependent color space describes the range of colors that a particular device can see and/or reproduce.

NOTE Devices can be sub-categorized into input and output devices. A digital camera is an input device, and a printer is an output device.

The second type of color space is *device-independent* color space. These color spaces are used to describe the range of colors in color *editing spaces*. An editing space describes the total palette, or *gamut*, of colors available when editing a photo in Photoshop. A device-independent color space is not limited by the gamut of any particular device. The two most common editing spaces in PhotoshopCS3 are Adobe RGB (1998) and sRGB:

- **Adobe RGB (1998)** is a large color space that is more applicable to high-end printing and reproduction.
- **sRGB** is a limited color space that is intended to be common to a wide range of devices.

The main difference between these two editing spaces is that Adobe RGB (1998) is larger than sRGB. It has a wider range of colors and more extreme colors in some cases.

Think about it this way: Imagine that I have two boxes of crayons. One box has 24 different colors, and the other box has 120 colors. Suppose we both want to do a drawing of the same scene outside. If I gave you the 120-count box and kept the 24-count box, the results of our drawings would be quite different. The greens and browns in my trees would be more limited than yours because I don't have the same range of greens and browns to work with as you do.

This is sort of the way it works in Photoshop. When we edit digital files, we need to standardize the way color is managed in our Photoshop workflow. We can choose to work in a smaller color space like sRGB, or we can work in a larger color space like Adobe RGB (1998). The graphics in Figures 2.4 and 2.5 were created in ColorThink software, a product of Chromix in Seattle, and depict the color gamuts of Adobe RGB (1998) and sRGB.

NOTE A third editing space is gaining popularity in Photoshop. It's called ProPhoto RGB. Its color gamut is even larger than Adobe (1998). Currently, few output devices support such a large gamut, but that will change as technology moves forward. In the meantime, it's better to stay away from ProPhoto because converting images for output on some devices results in unpredictable color shifts.

At first it seems like a no-brainer to choose to work in a larger color space so that you're working with more colors, but that's not always the case. When we consider working spaces, we also must think about device color spaces — devices such as printers. Even though a working space may be device-independent, the files we edit will eventually come into contact with some kind of device. Usually that device's limited gamut is much smaller than the working space, which means that some of the colors you see on your monitor are not printable, leading to disappointments at printing time.

FIGURE 2.4

This graph compares the color gamuts of Adobe RGB (1998) (the wireframed shape) and sRGB (the solid shape). Notice that the Adobe RGB (1998) gamut is much larger in some areas, like the yellows. This graph was created with ColorThink software by Chromix.

The real key to deciding which color space to use as your main Photoshop working space is how you plan to output your files. If you're using a commercial photo lab, ask what color space the lab prefers. Most will tell you that their equipment works in the sRGB color space. If you plan to do most of your printing at this lab, use sRGB as your working space. Some labs do work in the Adobe RGB (1998) color space. If your lab is one of them, take advantage of the larger color space.

This is even more important when preparing photos for the Web. The sRGB color space is ideal for the Web. In fact, it was created with the Internet in mind. Back in the mid-90s, Microsoft and Hewlett-Packard proposed a new standard color space that was best suited to the limited gamuts of cameras, printer, and monitors. With a common color space, users could have more confidence that when they placed photos on the Web, people who viewed the images would see them the way they were intended to be seen. (Naturally, monitor calibration comes into play here.)

> **TIP** Some labs provide a profile that describes their particular printer. Having one of these allows you to preview your image onscreen with the colors that the lab's printer is capable of reproducing.

Many people prefer to use inkjet printers for their output. Most inkjet printers work with a limited gamut of color. However, this can be misleading because the gamut isn't limited in every color of the spectrum. Figure 2.5 shows the color profile of an inkjet printer, (the solid shape), compared to the sRGB and Adobe RGB (1998) color spaces, (the wireframe shape). In the first image of Figure 2.5, you can see that the printer is capable of printing yellows that are well outside the limits of sRGB. In the second image, you can see that Adobe RGB (1998) contains most of the yellows that the printer can print, although it's capable of printing some extreme yellows that are outside the gamut of Adobe RGB (1998). If I were photographing a yellow Corvette and planning to print it on this printer, I would edit it in the larger Adobe RGB (1998) space.

You must think about these sorts of things as you consider which working space to use in Photoshop. Your working space choice really does depend on what you plan to do with files in the future. With that in mind, here's the bottom line:

- Use sRGB when you know that all of your workflow is oriented to producing images for the Web or for photo labs with printing equipment that is limited to sRGB. Doing this helps you to better predict what your color will look like when it's time to view online or print.
- Use Adobe RGB (1998) when you're dealing with a lab that uses the larger color space, when outputting to an inkjet printer, or when you just aren't sure what you're going to do and you want to keep your options open.

When you tell Photoshop which working space to use, you can set preferences so that Photoshop allows you to make the decision on the fly as you open files. That way, you can decide on a file-by-file basis.

FIGURE 2.5

The first image compares the inkjet (solid) to the sRGB working space (wireframe). The second image shows that the Adobe RGB (1998) working space (wireframe) comes closer to the gamut of the printer.

Choosing a Color Working Space in Photoshop CS3

Now that we know about color spaces, we need to tell Photoshop how we want it to handle color for us: which color space to use and what to do when our color profiles don't match. Do that by following these steps:

1. Open the Color Settings dialog box, and choose Edit ➪ Color Settings.

2. Click the pull-down menu in the Settings box, and select North America Prepress 2. This configures the color settings with the best starting points, as shown in Figure 2.6.

3. If you plan to use Adobe RGB (1998) as your working space, then you're finished. Click OK. If you plan to use sRGB, then click the pull-down menu in the RGB slot under Working Spaces. Select sRGB IEC61966-2.1, and click OK.

FIGURE 2.6

In the Color Settings dialog box in Photoshop CS3, click North American Prepress 2 and then decide which RGB Working Space you want to have as your main working space.

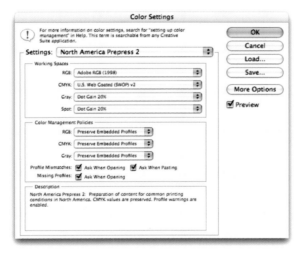

We don't really care about the other working spaces (CMYK, Gray, and Spot) right now, so leave them as they are.

I encourage people to configure the Color Settings dialog box by selecting North American Prepress 2 because this setting checks all the boxes under Profile Mismatches and Missing Profiles. When these boxes are checked and Photoshop finds a discrepancy between the color space you're using and the color space of a file you're opening, it refers to the Color Management Policies boxes to resolve the *profile mismatch*, as shown in Figure 2.7.

FIGURE 2.7

Photoshop's Color Management Policies in the Color Settings dialog box allow you to set up Photoshop CS3 to inform you of color profile mismatches and missing profiles.

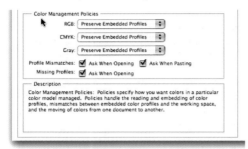

If you open a file with a color space that doesn't match your working space, Photoshop prompts you to make a decision about how you'd like to handle the issue, as shown in Figure 2.8. These are your choices:

- **Use the embedded profile:** Opens the image in its own color space.

- **Convert document's colors to the working space:** Moves the file into your working space by mapping its colors to the appropriate equivalents in your color space.

- **Discard the embedded profile:** Strips the image of any color profile. This usually isn't a good idea — though I have used it when experimenting.

FIGURE 2.8

The Embedded Profile Mismatch dialog box allows you to manage on the fly the color space conversion of files that don't match.

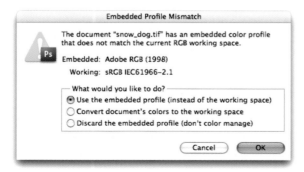

Don't bother trying to convert a file that's in the smaller sRGB color space into the larger working space of Adobe RGB (1998). When you begin with a small gamut, you pretty much have to live with it. The range of the original colors doesn't expand and change when the image is converted to a larger color space.

However, if you're opening a file with Adobe RGB (1998) into a working space of sRGB and you know that you need a smaller color space for output, converting an Adobe RGB (1998) file to sRGB before editing it is a good plan; that way, you'll see only colors that are reproducible.

TIP If you're using a digital SLR camera, you can set your preferences to tell your camera which color space to use for capturing images. I recommend that you set this preference on Adobe RGB (1998). This way, you can decide to work on photos in a smaller space or leave them their larger native color space when you open them in Photoshop.

After you get a handle on what's happening with profile mismatches and you get tired of being asked the same question every time you open a file, you can uncheck the question box in the Color Settings dialog box. I generally recommend against this, but I know that you may have reasons to make this choice.

Every once in a while, you get a file that doesn't have a profile—you don't know what color space it was created in. When this happens in Photoshop CS3 and you have the Color Settings set up the way I suggested earlier, you get a Missing Profile warning dialog box, as shown in Figure 2.9. You have no way of knowing what color space the file was created in, so you have to make assumptions about how Photoshop should handle the remapping process. This would be the same as a representative from a new nation showing up at the United Nations without an interpreter. You might be able to make some guesses about what this person is saying, but if you aren't careful, some of those guesses could get you into trouble.

FIGURE 2.9

When a file is missing the color profile, you can assign the profile of your choice in the Missing Profile dialog box.

The best way to handle a missing profile is to make an educated guess about the lineage of the file. If you think it began as an Adobe RGB (1998) file, then you can convert it to that color space. If you're already working in Adobe RGB (1998), select Assign working RGB in the Missing Profile dialog box. If you aren't already working in Adobe RGB (1998), select Assign profile and select Adobe RGB (1998) from the selection box. Also check the box next to "and then convert document to working RGB," as shown in Figure 2.10. If sRGB suits your needs better, choose it as your color space instead.

NOTE Digital SLR cameras always assign a profile to the photos they create. Usually, you encounter files without profiles only when they're coming from a scanner that hasn't been set up to *tag* the files it creates with color profiles.

Now that we have Photoshop's Color Settings and Color Management Policies set up the way we want them, let's look at how color works in Photoshop CS3.

Understanding Color Channels in Photoshop CS3

Because we're working with an RGB color model, our images are composed of three separate color channels. One channel represents the red content of the image, the second channel represents the green content of the image, and the third channel represents the blue content of the image. Here's the weird part: Each of these channels is composed of *grayscale* data—all the tones are gray. The best way to understand what's going on here is to look at the channels in an image. Follow these steps:

NOTE Other color models also use channels. CMYK uses four channels: cyan, magenta, yellow, and black. LAB uses three channels: lightness, a, and b.

1. Open the practice file titled spring_tulips.tif from the downloadable practice files on the Web site.

2. Find the Channels palette on your desktop; it's usually nested with the Layers and Paths palettes. If you don't see the Channels palette, go to Window ➪ Channels.

3. Click the red channel icon. This hides the other two channels so that you see only the red data in your image preview, as shown in Figure 2.10. Notice that everything with red in it looks really light.

4. Click the green channel icon. Now the greens are lighter, and the deep reds at the top are quite dark.

5. Click the blue channel icon. Now just about all the flowers are dark except for a few pinkish flowers at the top.

 Notice that in all three channels the tonality of the fence stays about the same. That's because its color is mostly neutral.

FIGURE 2.10

The Channels palette in Photoshop CS3 displays the three individual color channels. To view a single channel, click its thumbnail.

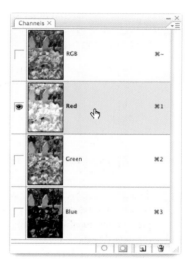

6. To get back to full color, click the composite channel, labeled RGB, at the top of the stack. Notice that all three channels become visible again because the little eye icons next to them are turned on.

> **TIP** If you're having trouble isolating a channel by clicking it, use the little eyeball icons beside each color channel. Clicking the eyeball turns off the channel's visibility. Clicking the eyeball again turns the channel's visibility back on.

7. Even though each of these channels is a grayscale image, when combined, they create color. To see how it happens, start with only one channel visible. Then turn on the visibility of another channel by clicking the eyeball next to it. Notice how these two grayscales combine to create a limited amount of color. When the third channel is added, all the colors appear.

In Chapter 11, we talk about using this information to create black and white photos. For now, the main thing to get from this discussion is that when you're working in an RGB color model, every digital image is composed of three individual channels, one for each primary color.

Evaluating Color with the Info Palette and the Color Sampler Tool

Photoshop provides two useful tools for evaluating color in your digital images: One is the Info palette, and the other is the Color Sampler tool. In combination, these two tools allow you to monitor and measure each color channel as you make adjustments to your image. Let's look at the Info palette first. Follow these steps:

1. Open the file titled spring_tulips.tif from the enclosed CD.

 If you still have it open from the preceding exercise, return it to its opening state by clicking the image icon at the top of the History palette.

2. Click the Info palette; it's usually nested with the Navigator and Histogram palettes. If you don't see the Info palette, go to Window ➪ Info.

3. Move your cursor over the white horizontal fence section between the two vertical slats on the left. Look at the RGB readout on the Info palette while doing this. The three channels are very close in value — in the low 220s, as shown in Figure 2.11. That means the color of the fence in that spot is a very light shade of gray.

FIGURE 2.11

The Info palette provides us with lots of information about an image. Notice that the RGB readings change as you move the cursor because the sample below the cursor is continually updating. Even though this is an RGB image, we can still see the comparable CMYK values. Below these two readouts are fields for taking measurements and finding other general information.

4. Now move the cursor over some of the flowers. Notice that the red flowers at the top have high values in the red channel and low values in the green and blue channels. The yellow flowers in the foreground have readings that are high in the red and green channels and low in the blue channel.

5. Move the cursor over the middle vertical slat. Notice that it has a high red value and a low blue value. That's because it's reflecting the red and yellow flowers in the foreground.

TIP Here's another way to put theory into action and see how various color channels combine to create the color we see in an image: Practice looking at a color and guessing its RGB values.

Having the ability to measure color is cool, but we can make this feature even cooler by adding the Color Sampler tool to the mix. The Color Sampler tool is stacked beneath the Eyedropper tool, near the bottom of the toolbar, as shown in Figure 2.12.

FIGURE 2.12

The Color Sampler tool is hidden beneath the Eyedropper tool, near the bottom of the toolbar. To reveal it, click and hold the Eyedropper tool until a side-menu pops up with all the tools stacked there. Hover the cursor over the tool you want and release the mouse button to select it. (The toolbar here is in the single-column mode, as discussed in the Preface.)

With the Color Sampler tool, we can place up to four "sticky" sample points anywhere in an image. A *sample point* can be used to monitor tonal adjustments while the adjustments are being made. After tonal adjustment is complete, the sample points can be permanently removed. This powerful feature is easy to use. Just follow these steps:

1. Select the Color Sampler tool from the toolbar.

2. Before you use it, you need to configure it. Go to the Tool Options bar at the top of the screen and change the setting from point sample to at least 5 by 5, as shown in Figure 2.13.

 This tells the tool to sample a grid of pixels that is 5 by 5 instead of a single point. This assures that some "renegade" pixel that can't be seen isn't being sampled alone. When you choose 5 by 5, 25 pixels are measured and averaged.

FIGURE 2.13

Change the Sample Size on the Tool Options bar at the top of the screen. Choose at least 5 by 5 Average. To remove sample points from the image preview, click the Clear button.

NEW FEATURE In Photoshop CS2, the only options for Sample Size were point, 3 by 3, and 5 by 5. Photoshop CS3 has additional averaged sample sizes for sampling larger areas up to 101 by 101.

3. Open the practice file titled spring_tulips.tif again. Go back to the horizontal area we first measured in the preceding example. Find a spot that looks white, but where the three channels are not quite the same. This time, click instead of just hovering. When you do this, a measuring point is placed on the image with the number 1 beside it. Numbers that correspond to the RGB values at that point are added to the Info palette with #1 beside them.

4. Add another sample point to the same area you measured on the middle slat in Step 5 from the preceding exercise. Its values also are added to the Info palette.

TIP After you place a point, you can move it somewhere else by clicking and dragging it. To delete it, click it and drag it out of the image frame. To clear all sample points, click the Clear button on the Tool Options bar.

5. Now open the Levels command — Image ➪ Adjustments ➪ Levels (Command/Ctrl+L). Grab the middle gray input slider, and drag it to the left while watching the Info palette. Notice that a second row of numbers appears next to the sample values. These new numbers change as you move the gray slider.

 The Info palette is providing you with before and after information for your sample points, allowing you to see the effects a correction has on the color channels in an image.

6. Click OK. The second set of numbers disappears, but their values become the new sample points.

7. We use this image again in just a moment. Click Command/Ctrl+Z to undo the Levels adjustment you just did. (This is the same as going to Edit ➪ Undo.)

The ability to sample a particular area of the image and measure any changes can be very useful. This is especially the case when you know that something in the image should have a neutral color balance: All three color channels have the same value.

Now that we know how to evaluate color, let's look at what we can do to change it if we don't like it.

Adjusting Color

After the brightness and contrast of an image are evaluated, it's time to look at the image's color. We can adjust color in Photoshop CS3 in several ways. In this section, we look at the main color correction tools in Photoshop CS3 and some methodologies for using them.

Removing a color cast with Levels

While using the Levels command, you may have noticed that the Levels command has its own set of three eyedroppers:

- **The Black Point Eyedropper** is used to assign a black point to the darkest part of the image. If you know where the darkest area of the image is, click it with this tool to set the black point and convert that spot to 0 red, 0 green, and 0 blue (the default setting). Any tones that are darker than the tone you click are clipped.

- **The Gray Point Eyedropper** is used for creating a neutral gray; the RGB values become the same anywhere you click.

- **The White Point Eyedropper** works just like the Black Point Eyedropper except that it's used to set the white point in the image. When you click the lightest part of the image, this tool sets it as the white point and converts that tone to 255 red, 255 green, and 255 blue (the default settings). Any tones that are lighter than the tone you click are clipped.

The tonal values that the Black Point Eyedropper and the White Point Eyedropper use for clipping points can be modified so that they don't clip to pure black (0) and pure white (255). For example, you can set them to clip at 15 and 240. This allows you to leave some room for printing processes that don't handle extreme shadows and highlights very well, such as newspaper. You can modify them by double-clicking the eyedroppers and setting the RGB values to the value you want to call pure white or black.

Although this sounds useful, I have never found much use for the Black Point Eyedropper and White Point Eyedropper tools. The biggest problem with them is that you need to know where the lightest and darkest areas in an image are. I would rather handle clipping manually with clipping preview in Levels or Curves where I have more control. So I won't spend more time on the Black Point and White Point tools. Instead, let's focus on the middle tool here, the Gray Point Eyedropper.

> **NOTE** The Gray Point Eyedropper is designed for color correcting; therefore, it is available only when editing color images.

The Gray Point Eyedropper is designed to neutralize the color wherever you click with it. It does this by setting the values to the red, green, and blue channels to the same value. This new value is an average of the three original values unless a huge correction is being applied. It can be used anytime you know that a certain area of an image should be neutral in color. Follow these steps:

1. Go back to the image you were using in the preceding example. If that image is not open, open it and repeat Steps 1 through 4 from the previous exercise.

2. Open the Levels command — Image ➪ Adjustments ➪ Levels (Command/Ctrl+L).

 When you use the Gray Point Eyedropper, it affects any other Levels adjustments from that Levels session. Because of this, you should start with the Gray Point Eyedropper if you plan to use it. Then do other Levels adjustments to finish fine-tuning the tones in the image.

3. Click the Options button, and be sure that Enhance Per Channel Contrast is checked on the Auto Color Correction Options, as shown in Figure 2.14.

4. Click the Gray Point Eyedropper to activate it. Now, anywhere you click in the image becomes neutral. Click sample point number 1 in the image. Notice that the readout in the Info palette shows that the numbers have been nudged into alignment.

 If they aren't exactly the same, it's probably because you didn't click in exactly the same spot as where the sample is placed. Not a problem — they don't have to be absolutely perfect.

5. Every time you click the image, the gray point is reset. Click sample point 2. Notice that the whole image gets cooler.

 This is because that part of the white fence was reflecting all the red flowers. When we force the color to white, it removes the color being cast by the reflection, but the new color is unacceptable. The lesson to be learned here is that not all neutrals are created the same. When you use this tool, you must be sure that the color you're clicking is actually supposed to be neutral.

FIGURE 2.14

When you click the Options button in Levels or Curves, you get the Auto Color Correction Options dialog box. For neutralizing color, be sure to check Per Channel Contrast.

6. Click sample point 1 to get the color back into alignment.

7. Now do your other Levels adjustments.

8. Click OK when you're finished.

> **TIP** Curves has this same set of eyedroppers, which are used in the same way to set black point, white point, and neutral gray.

Sometimes, the image may not have anything that is supposed to be a neutral gray. Or maybe you use the Gray Point Eyedropper, but you still want to do some further adjustment to get the colors to look just right. When that's the case, you're ready to move on to the main color adjustment tools in Photoshop CS3.

Using the Variations command

The real trick to color correction is this: Identify the color that you don't like, and add its opposite until you don't see the offending color anymore. In order to pull this off, you must be able to see and identify the colors in an image. As we've seen, color is a science, but the perception of it is very personal.

I learned color theory when I began working in professional labs several years ago. Over the years, I color-corrected thousands of prints at those labs, so color correction became second nature to me. I sometimes have to remind myself just how difficult it was to learn color correction. With that in mind, I want to show you one of the best color-correction learning tools: the Variations command. Follow these steps to do some color-correcting with the Variations command:

1. Open the file titled Oregon_vineyard.tif from the enclosed CD.

 This image was captured late in the day. As you can see, the auto white balance on the camera over-compensated for the warm tones in the sky, which resulted in too cool of a white balance. Let's warm it up.

> **NOTE** The Variations command does not work on 16-bit files; you can learn more about 16-bit files in Chapter 3.

2. Open the Variations command — Image ➪ Adjustments ➪ Variations; it's at the bottom. When the dialog box opens, you get what we call a color ring-around. The uncorrected image is in the center, and it's ringed by equal amounts of the individual six colors, as shown in Figure 2.15.

3. To warm up this image, we need to add some red and possibly some yellow. Click the thumbnail just above where it says More Red. Notice that the current pick at the top of the screen has changed to reflect the addition of red. Also notice that the whole ring-around has been updated too.

 A big chunk of red was added, but it may have been too much. We need better control of this tool so we can be more discriminating with our color adjustment.

FIGURE 2.15

The Variations command displays a color ring-around of each of the six colors we use when making color adjustments. Click a color's thumbnail to add it. Use the Fine/Coarse slider to adjust the amount of color that will be used when color is added.

4. Click the Original thumbnail at the top left to reset the Current Pick thumbnail to its original setting.

5. Go to the Fine/Coarse slider at the top right of the window. Move the slider to the left so that it lines up with the first vertical mark on the left. Notice that the color value difference in the thumbnails is much lower now.

 Lowering the amount of color correction makes the Variations tool usable for color correction. Now we can make minor adjustments and build them up until we've added the appropriate amount of color.

6. Click the More Red thumbnail again. A small amount of red is added to the Current Pick preview. Continue to click the red thumbnail until you feel that you've added enough red. To back up and remove some red, click the More Cyan thumbnail. If you want to add some yellow, do it now.

> **TIP** You can adjust the shadows, midtones, and highlights in variations by clicking the appropriate buttons at the top right of the dialog box. If you're having trouble with a color cast that's only in the shadows, for example, you can try to address it without shifting the highlights as much.

7. When you're happy with the new color, click the OK button.

 This is the moment of truth. It can be hard to see your adjustments in the Variations window because everything is small. After you click the OK button, you really get a look at it. If you don't like it, press Command/Ctrl+Z on your keyboard to undo the Variations adjustment. Go back to Variations and try again with a different adjustment.

I encourage people who are new to color adjustment to begin with the Variations command because it can be a great tool for learning the differences among the six colors we use. Try sliding the Fine/Coarse slider all the way to the right. When you do, you'll see the color ring-around in its purest form with all the individual correction thumbnails completely saturated.

By looking at the color ring-around, you can train your eye to see the subtle differences in the colors; for example, you can learn to see the difference between red and magenta or between green and cyan. As I mentioned earlier, seeing these subtle differences is the trick to correcting color. After you can do that, your color-correcting experience will become much more powerful.

Using the Color Balance command

After you're comfortable with color and you've mastered the Variations command, you're ready to move up to a more flexible tool, the Color Balance command, as shown in Figure 2.16. The Color Balance command has most of the same adjustments as the Variations command, but it has some differences. One of the main differences is that you don't get thumbnails for visual comparison, but you do get a better preview because you see real-time adjustments in the image as you move the sliders.

The other big difference is that you can make color adjustments one color unit at a time by moving these sliders. With Variations, you don't really know how many units of color you're adding when you adjust the Fine/Coarse slider. Let's try adjusting a file with the Color Balance command:

FIGURE 2.16

The Color Balance command has most of the same controls as the Variations command, including the ability to target shadows, midtones, and highlights separately.

1. Open the practice file titled Oregon_vineyard.tif again.

2. Open the Color Balance command — Image ➪ Adjustments ➪ Color Balance (Command/Ctrl+B).

 Make sure the Preserve Luminosity box is checked. This prevents any color adjustment from affecting the tonal values in the image.

3. This time, instead of clicking the More Red thumbnail, move the Red/Cyan slider to the red side. As you do, notice that your image responds by getting redder.

 If the Color Balance dialog box is blocking the image, grab the window where it says Color Balance and drag it to the side.

4. Adjust the red until it's almost where you want it, but stop short. Click the Highlights button to switch to highlight correction, and add more red to finish off your correction.

 I use this technique of splitting my correction between midtones and highlights often, especially in portraits. I add about 75 percent of the color to the midtones and the remaining 25 percent to the highlights.

5. Add some yellow to the midtones and highlights. When you like the color, click the Preview button in the Color Balance window to turn off the preview function. This shows you what the image looks like without the correction. Turn Preview on and off a few times to evaluate your correction.

> **TIP** Our brains are really good at adapting to what's in front of our eyes, so we may lose track of what our adjustments are doing to the image. That's why the Preview function is so valuable. It's in almost every Photoshop CS3 dialog box. Use Preview to toggle any adjustment you're doing so that you'll know if you're on the right track.

6. When you like what you've got, click the OK button. Figure 2.17 shows image after color correcting with the Color Balance command. Now the colors in the sky look more like what I'd expect in late afternoon light.

The color of an evening sky can be quite arbitrary. I prefer the warmer version. Your adjustments may look different.

Photo by John McAnulty

The Color Balance tool gives us incredible control over the overall color of our images. When you understand color theory, you'll realize that it's the perfect tool for making global color adjustments to an image. I use it on just about everything.

Using the Hue/Saturation command

Even though the Color Balance command is my faithful companion, my favorite color adjustment tool is the Hue/Saturation command. With this amazing tool, you can work with color in a variety of ways that aren't possible with the Variations and Color Balance commands.

Figure 2.18 shows the dialog box for the Hue/Saturation command. This command allows you to modify three different aspects of a color: hue, saturation, and lightness:

FIGURE 2.18

The Hue/Saturation command allows you to control three different aspects of the color in an image: hue, saturation, and lightness.

- **Hue** is the color of a color — the difference in the red of an apple and the red of a strawberry is the hue. Use this slider to change the base color of a color.

- **Saturation** is the purity of a color — the difference between a black and white print and a color print. Use this slider to increase the saturation of a color with positive values or lower it with negative values.

- **Lightness** is just what it sounds like — it's the lightness of a color. Positive values add white to the color, and negative values add black to the color. With these three sliders, we are able to have amazing control over the colors in an image. Let's look at some of the standard uses of the Hue/Saturation tool with these steps:

NOTE The Colorize box is used to colorize an image with an overall color cast. This is one easy way to create sepia-toned photos, as we see in Chapter 11.

1. Open the practice file titled high_desert_flower.tif from the downloadable practice files on the Web site.

2. Open the Hue/Saturation command — Image ⇨ Adjustments ⇨ Hue/Saturation (Command/Ctrl+U).

3. Move the Hue slider way to the left and right. Notice as you do that the bottom color bar shifts as you move the slider.

 The bottom color bar is giving you a preview of how the relationships in the color spectrum are changing as you adjust. Look at a color on the upper color bar, and then look directly below it to see what the new color will be on the bottom color bar. Your image should be reflecting these changes.

4. Reset the Hue slider to 0.

5. Now adjust the Saturation slider all the way to the left. When you do this, all color is removed from the image, and it takes on a black and white appearance. Adjust the slider all of the way to the right, and notice how all the colors become too saturated. Move the slider back to the left, and stop at +15. Click the Preview check box a couple of times to look at the before and after versions.

6. We're going to skip the Lightness slider for the moment. It's more useful when specific colors are being targeted.

7. Leave the image open so you can use it in the next example.

This tool also can be used on all colors, or it can be used on specifically targeted colors. This amazing tool really shines when used this way. Let's see how:

1. Open the file titled high_desert_flower.tif again (if you didn't keep it open after the preceding steps). Adjust the Saturation slider to +15, and leave the Hue/Saturation dialog box open.

2. Our goal here is to change the color of the flower without changing the color of the rest of the image. To do that, we need to inform the Hue/Saturation command about the color range we want to adjust.

 Go to the top of the Hue/Saturation window, and click the pull-down menu next to where it says Edit: Master. The interactive menu allows you to select the color range you want to work with: Reds, Yellows, Greens, Cyans, Blues, or Magentas.

3. The purple color of the flower is mostly magenta, but it also has some blue in it. Select Magentas, and move the Hue slider to +56. When you do this, you shift the magentas to more of a red hue.

 The problem is that the colors in the flower that shifted were the magenta tones. The other tones weren't affected much. There's a better way to isolate the colors we want to adjust. Return the Magentas slider to 0.

4. You may have noticed that when you selected the Magentas to edit, some eyedroppers lit up on the Hue/Saturation dialog box, as shown in Figure 2.19. These eyedroppers are not available until you select a particular color to edit.

TIP **When you use the eyedropper, it isn't important which color you choose from the Edit box. After you click a color, Photoshop makes its own decision as to the color range and names it appropriately.**

The eyedroppers have the following functions:

- The first eyedropper allows you to click a specific color.
- The middle eyedropper allows you to add to the selection that was made with the first eyedropper. Doing so increases the range of colors being affected.
- The third eyedropper allows you to subtract colors from your selection. Doing so decreases the range of colors being affected.

FIGURE 2.19

The Hue/Saturation dialog box shows the hue on only the Magentas after it has been changed. The eyedroppers allow you to fine-tune your selection of specific colors for adjustment by clicking them in the image. They are not available for use until you select a color in the Edit box.

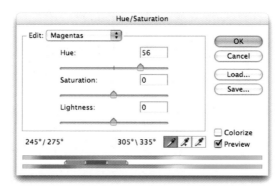

5. At this point, the first eyedropper should be active. Move your cursor over the image, and click the flower.

 You also can drag your cursor across the image while holding down the mouse button to sample different areas. Watch the two color bars at the bottom of the window to get an idea of the most representative area of the image to click.

6. Now move the Hue slider back to 56. Notice how much cleaner the adjustment is around the outside fringes of the flower now that the affected color range is defined more accurately, as shown in Figure 2.20.

CAUTION Be aware that when you target specific colors with the eyedropper tools, all similar tones in the image are affected.

7. If you're still seeing some unevenness in the edges of the flower, try clicking and dragging across the flower to see if you can fine-tune your selection of colors that are being affected. If that doesn't work, try using the middle eyedropper to selectively add colors to be affected by your adjustment. Zoom in (Command/Ctrl++), and click colors to be added. If too many colors are being affected, use the third eyedropper to remove colors from the selection by clicking them.

8. Use the Lightness slider to tone down or lighten up the brightness of the colors you're adjusting. I didn't make any changes to Lightness, but you might like to.

 When you use the Lightness slider, you may notice that the colors become desaturated. That's because white is added when you lighten and black is added when you darken. To compensate for this, increase the saturation.

9. When you're happy with the color, click the OK button. Use Command/Ctrl+Z repeatedly to undo the correction and reapply it so that you can compare before and after versions.

FIGURE 2.20

The top image was adjusted by selecting Magentas from the Edit box in Hue/Saturation. The bottom image was adjusted by clicking the colors in the image to be adjusted after selecting Magentas.

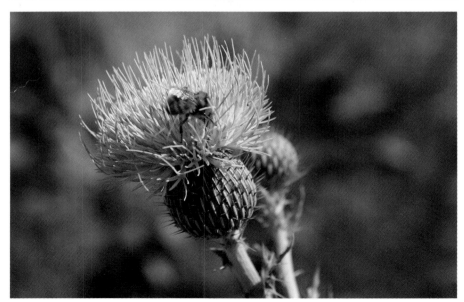

> **TIP** Using the Undo/Redo (Command/Ctrl+Z) command in Photoshop is a great way to check your work after you've done something. Consecutive typing of Command/Ctrl+Z cycles back and forth between Undo and Redo, allowing you to cycle the preview of your image between before and after states.

Summary

Color can be a tricky issue due to the dichotomy between its subjective and objective natures. Color is a science, but our experience of it can be quite personal. Before we can even address color in Photoshop CS3, we need to level the playing field by calibrating our monitors and setting up preferences in Photoshop to handle color the way we want it handled.

Color correction can be challenging to learn at first. That's why the Photoshop Variations command is very useful for the color correction novice. It provides an interactive color ring-around to help the beginner learn the differences between colors.

After you understand color correction better, you can use the Color Balance and Hue/Saturation commands to take control of the color in your digital images. Other tools in Photoshop also are available for working with color, but if you learn the tools in this chapter and become comfortable with them, you can handle 99 percent of your color correction needs.

Chapter 3

Understanding Raw and High-Bit Files

In the world of digital imaging, not all files are created the same. Some files have more information than others. This extra information can be handy when you're called upon to do "heavy lifting"—to make extreme tonal adjustments or do heavy retouching. We call these files high-bit because they have more bits of information per pixel than a regular image file. The most common way to get a high-bit file these days is by shooting in the Raw format in your digital camera and then using Photoshop CS3 to convert that Raw data into a high-bit file. You also can get high-bit files from most print and film scanners. In this chapter, we look at all these issues and more so you'll know when to use them and be prepared to take advantage of them when the need presents itself.

What Is Raw?

When I point my DSLR at a scene and click the shutter, the camera's chip captures a huge amount of information. If I have the camera set to capture JPG files, the camera's onboard processor processes all that information into a JPG file. The processor looks at all the settings I have dialed into my camera—sharpness, white balance, color space, contrast, and so on. Then it applies all these settings and creates the JPG file from a small sliver of the data that the chip recorded. The rest of the information—most of what was captured—is ignored and deleted.

The JPG process seems easy because it allows the camera to make lots of decisions very quickly. If I am working in a very controlled environment, or under extreme deadlines, this can be a fast way to work.

The problem is that I don't get to look at all the information before it gets thrown away. What if I want to give the image a different interpretation and use some of the missing data? When we shoot JPG, we have to live with the data the camera used to create the JPG files. A great analogy is that shooting JPG is just like shooting film and then taking the film to the lab and telling them to process a set of proofs and throw the film away.

Raw is the solution to this problem. It allows us to save most of the information that a camera's chip is capable of capturing. After we have this information in a file, we can selectively choose which information becomes part of the file by converting the data from the Raw file into a working file that Photoshop can use. We talk about how that conversion is carried out later in this chapter. Right now, I want to dig a little deeper into the mechanics of Raw files because you should be aware of some important things when deciding whether to shoot Raw with your DSLR.

> **NOTE** Raw files can be created only in digital cameras. That's why it's often referred to as Camera Raw.

So back to my opening question: What is Raw? A Raw file is a grayscale image. This means that qualities like color attributes and color space have not been assigned to the file. In fact, the only camera settings that are permanently part of a Raw file are ISO, aperture, and shutter speed. Everything else is up for grabs. Decisions like color space or exposure settings can be made after the fact during the process of converting the Raw file. This is why you often hear Raw files described as being "digital negatives." They are open to a great deal of interpretation that can be done during conversion — just like the process a film photographer printing in a darkroom goes through to best interpret a negative.

Calling a Raw file a digital negative makes sense because it shares another important trait of a film negative. Altering a Raw file permanently in Photoshop CS3 is virtually impossible. The file can be interpreted in many ways, but none of the conversions alters the underlying file. Instead, a set of *metadata* instructions is written to describe the way the Raw file is meant to look.

> **NOTE** The word *metadata* means data about data. Each digital camera file contains metadata about the file and the camera that created it. The metadata we're referring to here is called XMP metadata.

This means that no matter what you make a Raw file look like when you convert it, you can always back up to what the file looked like the day you created it. Any adjustments you make are simply written to a file that can be overwritten at any time. In fact, when I convert a Raw file and open it in Photoshop, it becomes something different than a Raw file. Here's what I mean. My Canon shoots with the Raw file format of .CR2. When I save an open file in Photoshop, the Save As dialog box doesn't include a format called CR2. Photoshop Raw is one of the choices, but it's something completely different. It's used for transferring images between different computer platforms and applications.

I imagine that you're starting to see lots of advantages to shooting Raw. I'd be remiss if I didn't take a moment to warn you about some of the disadvantages.

Disadvantages of shooting Raw

Raw allows us to make all sorts of interesting adjustments to an image post-capture, but that means that we have to take time to do something that the camera often does a pretty decent job of doing when it's creating a JPG for us. We have to convert every Raw image into some other format such as JPG, TIF, or PSD. (We take a closer look at file types in Chapter 5.) This extra time has frightened away many a would-be Raw shooter. However, if you consider the control that comes with that extra time, the trade-off is worth it.

Raw files are much bigger than JPG files. They can run two to four times larger because lots more information is being saved. This means that Raw files consume media cards and hard drives much faster than their JPG cousins. I've spoken to many wedding shooters who shoot their first Raw wedding without being aware of this size issue. In a panic, halfway through the wedding, they had to switch the camera back to JPG because they had already consumed most of their media cards with large Raw files. This problem can be solved with a little preparation. Media cards are cheap now. If you are shooting Raw, buy some extras.

The biggest problem regarding the Raw format is that there are many varieties of Raw. Each camera company creates its own "flavor" of the Raw format. In fact, these companies can have several slightly different flavors that all have the same name. For example, my Canon camera shoots Raw files with the extension of CR2. Other Canon DSLRs also share this file format, yet they are different; different algorithms are used to convert the files. Adobe estimates that at least 200 different versions of the Raw file format exist.

When a camera manufacturer comes out with a new camera, even though the Raw file's format still has the same name, Photoshop CS3's Raw converter can't open the file. Adobe must update the Raw converter and issue the update to Photoshop CS3 users. If you run into this problem when you buy a new camera, go to the Photoshop CS3 menus and click Help ➪ Updates... to see if any updates to the Adobe Camera Raw converter are available.

NOTE Adobe is attempting to address this issue with the creation of a standardized Raw format called DNG (digital negative). Adobe's goal is to get everyone using the same standard so that all these problems caused by different flavors of Raw go away.

Now you know some of the main disadvantages to shooting Raw. I hope you see that the advantages far outweigh the disadvantages. Yes, Raw files take more time to deal with and they consume more space, but these are minor problems compared to what you can do with a Raw file.

The mechanics of a Raw file

One of the big things to understand about Raw is that digital capture is linear in nature. Without getting too technical, this means that it devotes more bits to capturing highlights than it does to capturing shadows. This is the opposite of the way humans see things. We're really good at distinguishing detail in the shadows but not very good at seeing detail in the highlights. Film was designed to mimic human vision, so it works in much the same way.

A typical Raw file captures 4,098 distinct tonal levels within a six-stop range. Because this is a linear capture, a full 50 percent (2,048 levels) of the file's tonal information is devoted to the brightest stop of information. Only 1.6 percent (64 levels) of the file's tonal information is devoted to capturing the shadow detail, as shown in Figure 3.1.

FIGURE 3.1

A typical 12-bit Raw file covers about six stops of exposure with 4,096 tonal levels recorded. Because Raw files are linear, they devote a large amount of their capturing ability to recording highlights and a small amount to recording shadows.

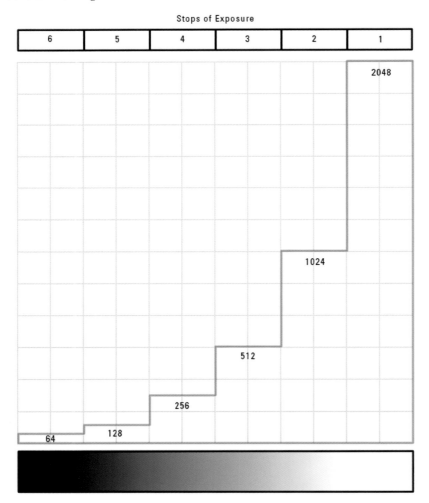

When an image is underexposed, as shown in the first diagram of Figure 3.2, half of the levels in the file are wasted on information that wasn't captured in the brightest stop. If the camera is adjusted to move the histogram to the right by increasing exposure, then the brightest stop of information is used. Now it describes the highlights in the image, as shown in the second diagram of Figure 3.2. Because so much information describes these highlights, detail that seems lost at first can be recaptured. (Also notice that twice as many levels are being used to describe the shadows.)

I know this flies in the face of conventional wisdom for a JPG shooter. When you shoot JPG, a highlight that gets overexposed is gone forever. When you shoot Raw, this isn't always the case. I shot the barn in Figure 3.3 when I was photographing flowers at a local tulip field. When I shot this picture, I forgot that I had a +2-stop bias dialed into my camera's exposure meter. When I got home and looked at the image, I realized that I had overexposed it by two stops, as shown in the first image in Figure 3.3. Fortunately, this was a Raw file with 50 percent of its capturing band-width devoted to capturing highlights. I was able to open the file in Photoshop CS3's Adobe Camera Raw converter and recover all highlight detail, as shown in the second image in Figure 3.3. If this had been shot in JPG, the file would have been useless.

So here's the thing to remember. If you're shooting Raw, be sure to fully expose for the highlights. Needing to darken an image and compress shadow detail is better than needing to lighten an image and spread out the shadow levels, revealing the image's noise. Naturally, nailing your exposures right the first time is always best. But if you're going to err on one side or the other of a perfect exposure, make sure that you err in the overexposed direction when shooting Raw.

FIGURE 3.2

When we underexpose a Raw file, we waste half of the file's bandwidth on information that isn't recorded, as shown in the first diagram. When the brightest part of a scene is exposed correctly, we take advantage of the ability of a Raw file to capture highlight detail. The correct exposure moves the rest of the image's tonal levels to the right, so that each gets twice as much information dedicated to describing it, as shown in the second diagram.

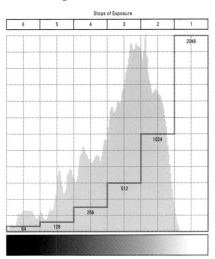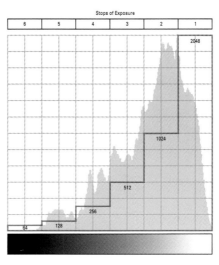

FIGURE 3.3

This barn photo was exposed two stops too bright. The first image shows what the image would have looked like with no conversion. The second image shows the amount of highlight detail that was hidden, ready to be revealed during the Raw conversion.

Converting Raw files in Photoshop CS3

Due to space limitations, I can't give you a comprehensive tour of Photoshop CS3's Raw converter, Adobe Camera Raw (ACR). But I am going to show you how to make the same kinds of adjustments we already learned about — brightness, contrast, and color — to a Raw file with ACR. We want to make the adjustments in ACR because we want to do so while working with the massive amount of Raw data.

When you open a file in ACR, you get a window like the one shown in Figure 3.4. Across the top left is a toolbar with a small set of tools similar to the toolbar in Photoshop CS3. At the top right is a histogram. Below it is a set of panels that allow you to access various controls such as Curves and Sharpening. The first panel, the Basic panel, is the only panel we discuss here. It has everything we need to adjust the brightness, contrast, and color of a file. If you know how to use the controls on the Basic panel correctly, you are well on your way to making quality Raw conversions in ACR.

FIGURE 3.4

The Adobe Camera Raw converter allows you to process a Raw file before you open it in Photoshop CS3. The Basic panel, on the right, has all the adjustment sliders needed for making basic color and tonal adjustments. The clipping preview is active, showing clipped shadows in blue and clipped highlights in red on the image. This preview is activated by clicking the two small triangles above the histogram.

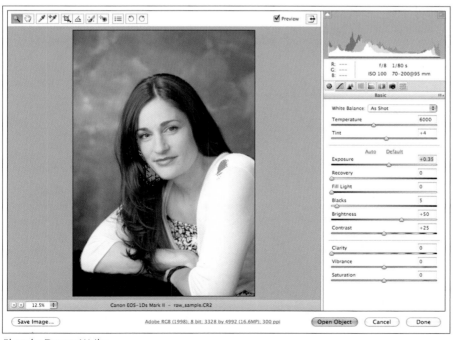

Photo by Denyce Weiler

NEW FEATURE Photoshop CS3 introduced a new version of Adobe Camera Raw, version 4. This new version has several new adjustment tools as well as an improved interface. If you're shooting Raw but you haven't moved to CS3, the new ACR should be reason enough.

There are five main sliders in the Basic panel, and they work quite similarly to some of the tonal adjustment tools you've already learned about. In fact, these five sliders work like a combination of the Levels and the Shadow/Highlight commands sliders in Photoshop. You can even get a clipping preview with Exposure, Blacks, and Recovery by holding down the Alt key just like Levels.

TIP ACR allows you to turn on a clipping preview that is visible while you're working on an image. To do this, click the two triangles that appear above each end of the histogram; one is black, and the other is white. With this preview active, black clipping is indicated by blue in the image preview, and white clipping is indicated by red.

Here's how the sliders in the Basic panel of ACR relate to their cousins in Photoshop CS3:

- **Exposure** is like the White Input slider in Levels. It sets the white point of the image.
- **Recovery** is like the Highlights portion of the Shadows/Highlights command. It recovers difficult highlight detail.
- **Fill Light** is like the Shadows portion of the Shadows/Highlights command. It opens hard-to-handle shadows.
- **Blacks** is like the Black Input slider in Levels. It sets the black point of the image.
- **Brightness** is like the middle Input slider in Levels. It adjusts the overall brightness.

I don't use the Recovery and Fill Light sliders much. I use them only when I'm having trouble with difficult highlight or shadow details.

Let's look at how all this works by converting a Raw file with the Adobe Camera Raw converter in Photoshop CS3. Follow these steps:

1. Open the practice file titled raw_sample.CR2 from the downloadable practice files on the Web site.

2. Locate the file in Bridge, and double-click it to open it in ACR. You should see something similar to Figure 3.4 when ACR opens.

3. I prefer to take care of brightness and contrast before adjusting color, but because we're working on a Raw file, we're going to deviate from that for a moment. Look at the toolbar at the top left of the ACR window. Notice that an eyedropper tool is available. This White Balance tool performs a similar function to the middle eyedropper in Levels and Curves: It neutralizes color cast.

 Click it to activate it, or use its shortcut (I).

4. Now look for an area in the image that's supposed to be black, white, or gray, and click it with the White Balance tool. Try clicking a few areas until you like the color you're seeing.

If you want to monitor the differences in color between these areas, use the Color Sampler Tool (S) to add some sample points much like the Eyedropper tool on Photoshop CS3's toolbar. It's located at the top right next to the White Balance tool.

Try a few areas: The white shoulder of the model's sweater, the black bracelet, the black fabric in the foreground, the black and white print in her blouse. Notice that each of these gives you a slightly different color because not all neutral colors are created the same, especially when we're talking about clothing. Fabric often has optical brighteners added to make colors reflect ultraviolet light more brightly. In fact, many laundry detergents have optical brighteners too.

Decide which area gives you the best color, and go back to click it. I like the color I get when I click the upper shoulder, so I'll use that spot. We can fine-tune it after the file is open in Photoshop.

5. Now let's address the brightness and contrast of the image. Be sure to check the two clipping preview buttons above the histogram to turn the previews on. Click the white triangle (U) and the black triangle (O). You know they're active when a small white box appears around them.

6. Start with the Exposure Slider. Drag it to the right until you begin to see clipping (red). Back up until all clipping is gone from the preview, and stop.

7. Now move down to the Blacks slider. Drag it to the right until you see clipping (blue). Back up until the clipping disappears.

 If you prefer to see richer shadows, letting some of the shadows clip is okay. Just be sure that it's not happening in areas with important detail.

8. The basic contrast is set. Now it's time to deal with the overall brightness. Go to the Brightness slider, and move it back and forth until you like the image's brightness.

You'll notice a Contrast slider below Brightness. I rarely, if ever, use this crude slider. If I feel that contrast needs to be further addressed, I do it with the Curves panel in ACR or later with the Curves command in Photoshop.

The basic color and tonal adjustments are now finished. Figure 3.5 shows the settings I used. Click Open Image to open the image in Photoshop. After the image is in Photoshop, you won't have to deal with brightness and contrast unless you want to do some fine-tuning with Curves. The same is true for color; fine-tune it if you need to.

We've only scratched the surface of what's possible with Adobe Camera Raw. If you plan to shoot Raw, I encourage you to learn more about the adjustments that can be done in the other panels like the Curves and HSL/Grayscale panels. After you've experienced the power of Raw, going back to shooting JPG will be hard.

This image looks much better after the Basic panel's adjustment sliders have been modified. Notice that I am allowing a little clipping in the deepest tones of the woman's hair, near her face.

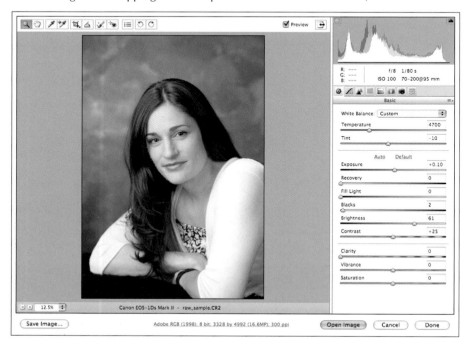

This is a book about Photoshop CS3 retouching and restoration, so you may be wondering why I've spent so much time discussing Raw files. I have two reasons:

- The first is that if you're interested enough in Photoshop to be reading this book, then you've likely started working with Raw files already. I want to be sure that you know how to optimize those files in ACR so that you have the very best file to work with later.

- The second reason I want you to be familiar with Raw is that you can do something important when converting a Raw file. You can open it as a 16-bit file in Photoshop. Creating a 16-bit file gives you the advantage of having more data to work with. Let's see how this works.

Working with 16-bit files

When we worked with Levels in Chapter 1, you may have noticed something funny going on in the Histogram palette. When you adjusted the Levels in snow_dog.tif, some gaps appeared in the data area of the histogram. The first image in Figure 3.6 shows what mine looks like after I adjusted the file.

FIGURE 3.6

The first image indicates combing — data loss — in the histogram after adjusting Levels. To update the histogram after making a Levels adjustment, click the yellow exclamation icon shown in the second image.

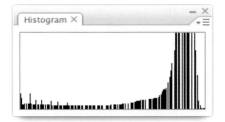 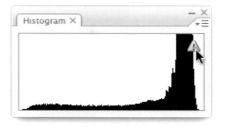

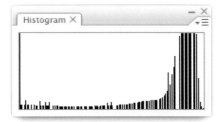

These gaps are called *combing* because they make the histogram look like a comb. Combing is caused by data that is thrown away when we make a Levels adjustment. If you think about it, this makes sense. When I adjusted Levels on snow_dog.tif, I moved the Black Input slider to 23 and the White Input slider to 226. When I clicked OK, I told Photoshop to make level 23 the new 0 (pure black) and level 226 the new 255 (pure white). When that happens, the histogram is stretched from end to end. When we stretch the histogram, we pull the various tonal levels apart, creating gaps.

> **TIP** If you don't see combing after making a Levels adjustment, click the Exclamation icon in the Histogram palette, as shown in the second image in Figure 3.6.

To the left of the first histogram in Figure 3.6 are some spikes in the shadow area. This is called just that — *spiking*. It's the result of tonal ranges being compressed during a Levels adjustment. It's happening here because I moved the Gray Input slider to the left a bit to lighten the midtones. That compressed the shadow levels a bit.

Suppose I decide to do another Levels adjustment on this image later. When I do, I will lose more data. Every time I make a Levels adjustment, I lose data. So cumulative adjustments result in increased data loss. The first image in Figure 3.7 shows what happens to the snow_dog.tif histogram after a few Levels adjustments. When you look at this histogram, you can see that the image is losing integrity in the highlights.

FIGURE 3.7

Cumulative adjustments result in severe data loss in 8-bit files, as shown in on the left. When the same adjustments are done to a 16-bit version of the same file, data loss — combing and spiking — is non-existent, as shown on the right.

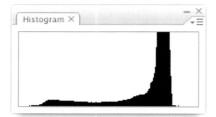
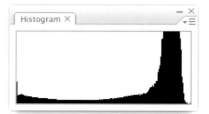

The second image in Figure 3.7 shows the histogram for a 16-bit version of the same snow_dog.tif image after the same set of Levels adjustments. Notice that the combing and spiking we saw in the 8-bit version is non-existent.

The reason for this striking difference is that 16-bit files contain much more information than 8-bit files. That's because they devote more bits of information to describe each pixel. The difference between 8 and 16 may not seem like much, but consider this:

- An 8-bit file has 256 tonal values per channel. A 16-bit file contains over 65,000 tonal values per channel.

- An 8-bit file contains a possible 16.7 million colors. A 16-bit file contains over 281 trillion colors.

NOTE High-bit files usually are only 12-bit or 14-bit when they come out of a DSLR or a scanner. Photoshop treats any file larger than 8-bit as a 16-bit file. With this as a reality, the 16-bit files we bring into Photoshop don't actually have the full range of a true 16-bit file. However, as Figure 3.7 demonstrates, they contain lots more information than an 8-bit file.

This may seem like overkill — and quite often it is. Humans can't even see 281 trillion individual colors. But if we're going to be making cumulative or massive adjustments in Photoshop, or if we're working with marginal original files, then having lots of extra editing headroom is good.

One more thing is worth mentioning before we move on. Not all file formats support 16-bit. For example, saving a 16-bit file in the JPG file format is impossible. If you try to do it, you won't see a JPG option under Format in the Save As dialog box. If you need a JPG, you can convert the file to 8-bit. Choose Image ⇨ Mode ⇨ 8 Bits/Channel. Now you can save it as JPG, as well as all other common file formats.

CAUTION Sixteen-bit files contain much more information than 8-bit files, so they are larger. In fact, they're twice as big as 8-bit files. Because they're bigger, they consume more hard drive space and other computer resources like RAM. Also be aware that some commands in Photoshop CS3 don't work with 16-bit files. For example, the Variations command is grayed out when working with 16-bit files.

You can create 16-bit files in two ways: One is done during the Raw conversion, and the other is done when scanning prints or film. Let's look at the Raw conversion method first.

Creating 16-bit files with Adobe Camera Raw

Earlier when we used Adobe Camera Raw to convert a Raw file, you may have noticed a blue hyperlink at the bottom of the ACR window. When you click this hyperlink, a Workflow Options window appears. This dialog box allows you to choose the type of file that opens in Photoshop. With it, you can choose color space, bit depth, image size, and resolution, as shown in Figure 3.8. Attributes like this are up for grabs in a Raw file, so we can change them to whatever we want during the conversion process.

FIGURE 3.8

When you click the Workflow Options hyperlink in ACR, a dialog box opens that allows you to determine the type of file that opens in Photoshop.

NEW FEATURE In previous versions of ACR, the Workflow Options buttons were displayed separately on the dialog box. Photoshop CS3 combines them into a single dialog box that is accessed by clicking the hyperlink.

The Workflow Options dialog box is where you choose to create a 16-bit file. To do so, select 16 bits/Channel from the drop-down box next to Depth. When you open the image in Photoshop, it is a 16-bit file.

Creating 16-bit files with a scanner

Another way of getting a 16-bit file is with a scanner. Scanners, like cameras, are capable of capturing a large range of data. The main difference is that you can't create a Raw file with a scanner. However, you can open a scan into Photoshop as a 16-bit file.

We talk more about scanning in Chapter 9. For the sake of this discussion, let's focus on how to ask for a high-bit file when scanning. Naturally, this varies with the scanner being used. With that said, the settings tend to come in two varieties:

- Some scanner software has an image setting that allows the user to select 24-bit color or 48-bit color. This is how it works with the Epson Scan software that I use with my Epson flatbed scanner. The difference in terminology stems from a different way of counting bits. Instead of 8 bits per channel, the bits in each channel are added together and the total number is used. Three channels x 8 bits = 24 bits. Three channels x 16 bits = 48 bits.

- Other scanner software may ask for you to specify bit depth. In the case of my Nikon film scanner, the options are 8-bit and 14-bit. When I scan at 14-bit, the file is converted into 16-bit when it comes into Photoshop.

Most scanner settings for high-bit are one of these two varieties. Whichever way you get there, 16 bits can be useful when working on a scan in Photoshop. This is especially the case when the scan is from an original print or negative of marginal quality and you have to do some heavy lifting.

Using ACR to Edit 16-bit Scans

Here's my favorite part of this whole discussion. Photoshop CS3 has a new feature that allows you to open JPG and TIF files in the Adobe Camera Raw Converter. This is a preference that can be turned on in Bridge or Photoshop.

NEW FEATURE You can now edit JPG and TIF files in Adobe Camera Raw by turning on a preference. This gives you the opportunity to take advantage of the advanced editing tools in ACR with 16-bit files.

- In the File Handling section in Photoshop CS3's Preferences, check the box labeled Prefer Adobe Camera Raw for JPEG Files.

 Mac = Photoshop ⇨ Preferences ⇨ File Handling

 PC = Edit ⇨ Preferences ⇨ File Handling

- Check the same box in the Bridge Preferences under the Thumbnails section in the Performance and Handling section.

 Mac = Bridge CS3 ⇨ Preferences ⇨ Thumbnails

 PC = Edit ⇨ Preferences ⇨ Thumbnails

When I first saw this new feature in Photoshop CS3, I didn't really see any use for it. After a file is a JPG, bringing it into ACR doesn't offer much because there's not much data to work with. However, when someone is scanning into 16-bit and saving the file as a TIF and then opening that file in ACR, lots of benefits appear. It becomes possible to use the sophisticated tools inside ACR to take advantage of all the data that a 16-bit file contains. This shows that you don't have to be a DSLR user to gain advantage from learning how to use the Adobe Camera Raw converter.

Summary

The advantages of shooting in the Raw file format far outweigh the disadvantages, especially when considering the new features in Photoshop CS3's Adobe Camera Raw converter. ACR gives us the ability to choose which data we want to work with when converting from Raw. We can then go one step further and create a 16-bit file to use in Photoshop that gives us much more editing headroom.

High-bit files also can be created when scanning prints and film. When opened in Photoshop, these files become 16-bit. With a new feature in Photoshop CS3, you can take advantage of the controls in ACR when editing these large files. This is especially useful when working with low-quality originals.

The choice of working in 16-bit or 8-bit should be determined by the amount of work you plan to do in Photoshop. If you're doing a quick project, working in 8-bit is probably a better choice. However, if you're doing some heavy lifting in Photoshop, the extra data in a 16-bit file can make a big difference.

Chapter 4

Working with Layers

The use of layers is one of the most powerful concepts in Photoshop. Layers are so important that a comprehensive main menu and a full palette are dedicated to working with them. Even with all these controls, you must remember that working with layers is more than a set of commands and options: Using layers is a workflow methodology.

Layers in Photoshop allow you to build flexibility into your editing workflow so that you're able to keep your future options open. You do this by placing important image information on separate layers. Understanding how layers work in Photoshop will change the way you work with important images forever.

In this chapter, I get you up to speed with the whole concept of layers and how to work with them in Photoshop. I cover everything from creating layers in a variety of ways to different ways of merging multiple layers and flattening all layers. By the end of this chapter, you'll be ready to take advantage of some of the techniques I share in later chapters.

Because the use of layers is central to much of what we do later, this is one of the more important chapters in this book. Even if you already feel comfortable with layers in Photoshop, I suggest you review this chapter as a refresher. You may even pick up a new trick or two.

IN THIS CHAPTER

Understanding layers

Using adjustment layers

Working with the Layers palette

Understanding the Background layer

Managing layers

Layer opacity and blending

What Are Layers?

Let's think about music for a moment. When a band is in a recording studio putting together songs for a new CD, a sound engineer records each singer

and instrument individually on separate sound tracks. In fact, vocals and instruments often are recorded at different times with different musicians in attendance. Sometimes, multiple recordings of the same vocalist or instrument are overlaid to create the sound the CD's producer wants. No one really knows what the song sounds like until all the pieces are blended together on a mixing board and played back as a single musical piece.

All these separate tracks give the producer a tremendous amount of creative control. If she doesn't like the way a particular instrument sounds, she can modify it — or even toss it out and recreate it — without affecting all the other pieces. If she had to work with a single track of all vocals and instruments recorded at the same time, massaging the sound would be very difficult. This is very similar to the concept of layers in Photoshop.

Photoshop has used layers since version 3.0. They allow us to isolate various elements of an image so one element can be managed separately from other elements. Just like the sound engineer in a recording studio, we control all the separate elements of an image. If we don't like the way all these pieces fit together, we can modify some of them or throw them away without compromising the whole image. This ability creates a huge amount of flexibility when editing an image. When you can potentially invest hours of work on an image in Photoshop, you don't want to have to go back to the beginning to fix something that should be a minor adjustment.

Layers, in their most basic sense, are layers of image information that sit on top of each other. The best way to see this is to do a little experimenting with these steps:

1. Create a new file by choosing File ➪ New (Command/Ctrl+N), and give it the following properties: width = 6, height = 4, resolution = 300, Color Mode = RGB Color, and Background Contents = White. These settings are shown in Figure 4.1. Be sure to choose "inches" from the pull-down menu next to the Width and Height input boxes.

FIGURE 4.1

To get the New file dialog box with the settings we're using in this exercise, choose File ➪ New (Command/Ctrl+N).

2. Select the Rectangular Marquee tool (M) from the toolbar. It's the second tool from the top on the single-column toolbar.

 If you don't see the Rectangular Marquee tool, it's hidden beneath another tool. Click and hold your mouse button on the tool that you see there to reveal other choices, as shown in Figure 4.2.

FIGURE 4.2

To save room on the toolbar, many tools are stacked on top of each other. If you see a small black triangle at the bottom right of a tool's icon, you know that the tools are stacked below.

3. Use the Rectangular Marquee tool to draw a selection in the middle of the new file you created. Make it any size you like. You should see the "marching ants" that indicate something is selected.

 NOTE **I talk at length about selections in Chapter 7. For now, just be aware that a selection isolates part of an image so that you can affect it by itself.**

4. Press the D key on your keyboard to set your color swatches to their default colors — black as the foreground color and white as the background color.

5. Select the Paint Bucket tool (G) from the toolbar. It's the twelfth tool from the top on the single-column toolbar. Click inside the selection to fill it with black paint.

 If you don't see the Paint Bucket on the toolbar, it's hidden under the Gradient tool.

6. Deselect the rectangular selection by choosing Select ➪ Deselect (Command/Ctrl+D).

You just created a black box in the middle of your white image. Cool, huh! But what if you now decide to move the black box to a different part of the image? Or maybe you'd like to change the rotation of the black box so that it's tilted a little. (I cover how to do this with the Transform command in Chapters 9 and 15.) In order to do either of these, you must go back to the preceding section and repeat Steps 3 through 6. If the file has been closed and reopened, which deletes the history states for the steps you just did, you need to go back to Step 1 and begin again with a new file. In this case, that's easy to do. But that isn't always true in Photoshop.

Let's try again. This time, we'll use a separate layer for our black box:

1. Repeat Steps 1 through 4 above.

2. Go to the Layer menu, and select New ⇨ New Layer. Click OK when the New Layer dialog box appears.

 Take a look at the Layers palette, and notice that a new layer called Layer 1 appears above the Background layer.

3. Select the Paint Bucket tool from the toolbar, and click inside the selection to fill it with black paint.

4. Click the Select menu at the top of the screen, and choose Deselect (Command/Ctrl+D) to deactivate the selection around the black box you just created. Your Layers palette should look something like Figure 4.3. We get into the details of this palette in a moment.

FIGURE 4.3

The Layers palette for our example has two layers. Creating the black box on a separate layer allows it to be moved independently of the Background layer. To hide a layer's visibility, click the eyeball to the left of it.

5. Select the Move tool at the top of the toolbar (V). Click the black box, and drag it to a new position while holding down the mouse button. The Move tool allows you to move a layer, other than the Background layer, to any position you desire.

NOTE You don't have to actually click the box itself to move it. You can click anywhere and drag because the entire layer is active.

By creating the black box on its own layer, you can isolate it to work with it independently. This is a very powerful concept to understand.

6. Go to the Layers palette, and click the eyeball next to the thumbnail on Layer 1 to hide the layer. Click the eyeball again to make Layer 1 reappear.

7. Click the eyeball icon on the Background layer. Now the Background layer is hidden, so none of the white is visible. Click the eyeball again to make the Background layer visible again.

> **NOTE** **What's up with the checkerboard? When Layer 1 is the only layer visible, a gray and white checkerboard surrounds the black box. Photoshop uses this checkerboard to indicate *transparency*; in other words, the area has no image information. When part of a layer has no information, you can see right through it to the layer below.**

As we move through this book together, you'll see me use layers to create lots of flexibility in my editing workflow. The goal with layers is to create a bulletproof workflow that keeps all my options open so I can make future adjustments if I change my mind — or if I learn a new and improved technique.

Using Adjustment Layers

The first place to begin harnessing the power of layers is with adjustment layers. In Chapter 3, I mentioned that data is lost every time we make tonal adjustments to an image. This data loss shows up as combing and spiking in an image's histogram (refer to Figure 3.6). The solution in the exercise in Chapter 3 was to work with a 16-bit file so we had plenty of extra data. Sometimes though, we don't have a 16-bit file to work with. Even if we do, we still may want to do tonal and color adjustments in a *non-destructive* way. Photoshop solves this problem by allowing us to isolate tonal adjustments to individual layers. Those layers are called adjustment layers.

Let's revisit one of our projects from Chapter 1 and adjust its tonality again with an adjustment layer:

1. Open the practice file titled snow_dog.tif.

2. Go to Layer ⇨ New Adjustment Layer ⇨ Levels. Before you let go of the mouse button, look at the different kinds of adjustment layers that you can create, as shown in Figure 4.4.

3. Click OK in the New Layer dialog box. When you do, the Levels dialog box opens in the usual way. Adjust the image, checking for shadow and highlight clipping with the Alt key. When you're finished, click OK.

> **TIP** **I don't usually bother naming adjustment layers unless I have more than one of the same kind of layer, such as Levels, Curves, Color Balance, and so on.**

4. Now look at the Layers palette. A new layer named Levels 1 is above the Background layer, as shown in Figure 4.5. Click the eyeball icon next to it. Now the image looks the way it did without the adjustment. Turn the layer's visibility back on.

FIGURE 4.4

Adjustment layers can be created from most tonal and color adjustment commands. The most notable exception is the Variations command. To work with the color adjustment commands we explored in Chapter 2 on an adjustment layer, you must use the Color Balance command or the Hue/Saturation command.

FIGURE 4.5

An adjustment layer allows you to place a tonal and color adjustments on their own layers.

5. Double-click the thumbnail that's directly to the right of the eyeball on Levels 1 to open the Levels dialog box. (On a Mac the thumbnail looks like a histogram. On a Windows machine it looks like a yin-yang symbol.) The settings you entered last time still appear: It picks up where you left off.

 If you make a straight Levels adjustment without an adjustment layer, the Levels dialog box opens with its default settings of 0, 1.00, and 255, without taking into consideration any changes that were made previously.

6. Try adjusting the color of the image with a Color Balance adjustment layer; choose Layer ⇨ New Adjustment Layer ⇨ Color Balance. Notice that it adds a third layer to the stack in the Layers palette.

An adjustment layer allows you to repeatedly change the settings of a particular tonal adjustment. Some loss of information occurs, but it happens only once when the layer is flattened.

TIP **You can test this out by making cumulative adjustments to the Levels 1 layer while monitoring the Histogram palette. Notice that data loss in the histogram stays about the same every time you make a new adjustment.**

I don't use adjustment layers if I'm working quickly with an image, spending only a few minutes or even seconds with it. In those cases, I don't need the flexibility of an adjustment layer. However, when I spend lots of time editing an image, I'm sure to use adjustment layers to do all tonal and color adjustment.

I want to tell you one more thing about adjustment layers: You can have more than one of a particular type. It's quite common to have one Levels adjustment layer for overall image adjustment and a second Levels adjustment layer that is used only for a particular printer. This way, the second Levels layer is used only to compensate for any variations with that printer. It's turned on just when you're ready to print. This is very common with Levels, Curves, and Color Balance adjustment layers.

This kind of flexibility is only the beginning of what we can do with adjustment layers. We revisit these special layers in Chapter 8 when I discuss masking.

Working with the Layers Palette

In Photoshop, you can always find more than one way to do things. Often, one way is as good as another: It just depends on how you like to work. This is especially true with layers.

We've worked with Layers in two different places — the Layer menu at the top of the screen and the Layers palette. For the most part, we've used these two areas to do different things with the layers we were working on. We went to the Layer menu to create adjustment layers, and we used the

Layers palette to work with them after they were in place. What if I told you that you can access almost every command in the Layer menu from somewhere on the Layers Palette? Follow these steps to find out how:

1. Open snow_dog.tif again.

2. Click the small yin-yang icon at the bottom of the Layers palette, near the center, shown in Figure 4.6. This icon is a shortcut for creating a new adjustment layer. Select Levels.

FIGURE 4.6

Click the Create a New Fill or Adjustment Layer icon at the bottom of the Layers palette to quickly create a new adjustment layer. Compare the options here to the options under New Adjustment Layer in the Layers command in Figure 4.4.

78

3. Notice that the New Layer dialog box doesn't open. Instead, the Levels adjustment dialog box opens immediately, and an often unnecessary step is skipped.

Using this icon saves time, especially if you don't care about naming an adjustment layer. In fact, the whole process of using the icon instead of digging through the Layer menu saves considerable time. Every time you reduce the amount of clicking you do in an editing session, you save time.

Another icon at the bottom of the Layers palette that's useful is the Create a New Layer icon, just to the left of the Delete Layer icon (trashcan). In the second exercise of this chapter, you created a new layer by choosing Layer ⇨ New ⇨ Layer. You then had to click through a New Layer dialog box. You can do this with a single click by using the Create a New Layer icon. Much more efficient, don't you think?

The Delete Layer icon is used to do just that. Either click a layer to make it active and then click the Delete Layer icon, or drag any layer — other than the Background layer — onto the icon to delete it. Try both, and you'll discover that dragging saves a step because you don't have to confirm the deletion. You can delete a layer in several other ways, but this is the fastest and the most elegant.

Several other commands and options that are quite useful are hidden from view in the Layers palette menu. This menu is revealed by clicking the palette menu icon with three horizontal lines in it, just below the *X* at the top right of the palette. Figure 4.7 shows the list of commands and options that is revealed when clicking this icon. The command I use here the most often is the Flatten Image command. I can get to it faster here than by using the Layer menu.

TIP Every palette is loaded with options. Hover your cursor over the icons to learn what they are and investigate the Palette options in the palette menu. Working with palettes like this saves time and makes your editing more efficient.

FIGURE 4.7

The Layers palette menu is accessed by clicking the icon just below the *X* at the top right of the Layers palette. It gives you quick access to many of the same commands that are in the Layer menu.

Understanding the Background Layer

Earlier I said that you can't do certain things with a Background layer. You can't move a Background layer or change its stacking order; it must always be on the bottom of the layer stack. That's because a Background layer has special properties. This special nature is indicated by a small lock icon that appears on the right side of the layer circled in Figure 4.8. This locking property is designed to keep you from making inadvertent changes to the Background layer. But what if you want to do something to a Background layer that's prohibited, such as move it?

FIGURE 4.8

When a layer has the name "Background," it is locked, as indicated by a lock icon on the layer (circled in this figure). When a layer is locked, a number of things can't be done to it, such as moving it or changing its stacking order.

Follow these steps to recreate the first section of the second exercise in this chapter and then make changes to the Background layer:

1. Create a new file by choosing File ➪ New (Command/Ctrl+N); give it the following properties: width = 6, height = 4, resolution = 300, Color Mode = RGB Color, and Background Contents = White.

2. Select the Rectangular Marquee tool (M) from the toolbar.

3. Use the Rectangular Marquee tool to draw a selection in the middle of the new file you created. Make it any size you like. You should see the "marching ants" that indicate something is selected.

4. Press the D key on your keyboard to set your color swatches to their default colors — black as the foreground color and white as the background color.

5. Go to the Layer menu, and select New ➪ New Layer. When the New Layer dialog box appears, click OK. (Or click the Create a new layer icon on the bottom of the Layers palette.)

6. Select the Paint Bucket tool from the toolbar, and click inside the selection to fill it with black paint.

7. Click the Select menu at the top of the screen, and choose Delelect (Command/Ctrl+D) to deactivate the selection.

8. Choose the Move tool (V) and use it to drag Layer 1 to the right or left. This is the same thing we did in an earlier exercise.

9. Click the Background layer and try to move it with the Move tool. Notice that when you do, the error message shown in Figure 4.9 appears.

81

FIGURE 4.9

If you try to move the Background layer, you get this message. To move it, you have to rename it by double-clicking its name. Anything other than Background will do for the name.

10. If you want to move the Background layer, you have to unlock it. To do so, simply double-click the layer's name. The New Layer dialog box opens, and Layer 0 is suggested as a new name. You can type in a different name or just click OK. As soon as you do, the lock icon disappears. Now you can reposition the layer with the Move tool. Give it a try by dragging it to the right or left.

NOTE A image can only have one official Background layer. You can rename a second layer Background, but it won't automatically be locked like a true Background layer. If you want to convert an ordinary layer to a Background layer, select the layer and choose **Layer** ⇨ **New** ⇨ **Background From Layer.**

11. Undo the move of Layer 0 so that the bottom layer is back in position.

12. Let's try something different. Click the thumbnail in Layer 1, and drag it so that it's below Layer 0. The two layers swap positions, and Layer 1 becomes hidden below Layer 0 because the white in Layer 0 fills the entire layer.

13. Go back to Step 9 before the Background layer was renamed, and try dragging Layer 1 below the Background layer. Now it won't work because a layer named "Background" has to be the bottom layer.

You need to be aware of the special nature of the Background layer only when you want to do something "illegal" to a Background layer, such as move it, transform it, or change its stacking order. When that need arises, just remember to rename the layer and you'll be in business.

Managing Layers

As I mentioned earlier, you'll use layers extensively in later chapters. To take advantage of the flexibility that using layers provides, you must be comfortable working with the Layers palette. You need to know how to move layers up and down in the Layers palette's layer stack, individually and together; how to create a new layer by cutting something from an existing layer; how to merge two layers; and how to flatten all layers. Let's explore each of these ideas one at a time.

Moving layers

Follow these steps to get some practice moving layers in the layer stack:

1. Open the practice file titled layers_fun.psd from the downloadable practice files on the Web site. You should see something similar to Figure 4.10.

2. Select the Move tool (V) from the toolbar. Make sure that the green triangle layer is active.

FIGURE 4.10

The layers_fun.psd file contains four separate layers: the white Background layer, the red square layer, the yellow circle layer, and the green triangle layer. The layer highlighted in blue — the green triangle layer — is the active layer.

3. Click anywhere in the image, and drag while holding down the mouse button. As you do, the green layer begins moving in the direction it's being dragged. Notice that only the green layer is moving.

4. Click the yellow circle layer in the Layers palette to make it active. Move it to a new position with the Move tool.

5. Click the red square layer in the Layers palette to make it active. Move it to a new position with the Move tool.

6. Click the yellow circle layer. Go to Image ⇨ Adjustment ⇨ Hue/Saturation (Command/Ctrl+U), and adjust the Hue on the Master channel to +143. Notice that only the yellow layer is affected by this change.

Something to take away from this exercise is that only the layer that's currently active is affected by a tool or command. That's almost always the case when you work with layers. When a layered image is being edited, adjustments usually must be performed on a layer-by-layer basis.

NOTE **Adjustment layers are an exception to this rule. When you place an adjustment layer into an image, it affects all the layers that are below it. If you need to make the same color adjustment to all layers, do it with a Color Balance adjustment layer at the top of the stack; don't try to adjust every layer individually.**

You can do some things to multiple layers at the same time. Repositioning with the Move tool is one of them. Here's how:

1. Open the layer_fun.psd file. If you already have it open from the preceding exercise, return it to its opening state by clicking the image's icon at the top of the History palette.

2. This time, we want to move all layers — except the Background layer — at the same time. The green triangle layer should already be active. Hold down the Shift key, and click the red square layer so that all three layers are active, as shown in Figure 4.11.

TIP **To select *contiguous* layers — layers that are next to each other — click the first layer, and then Shift-click the last layer. To select non-contiguous layers, use the Command/Ctrl key while clicking them individually. You also can use the Command/Ctrl key to deselect a selected layer.**

FIGURE 4.11

You can select multiple layers by using the Shift or Command/Ctrl keys as modifiers when clicking the layers. When multiple layers are selected, they can be moved with the Move tool as a group.

3. Use the Move tool to move all three layers at the same time. Experiment with different combinations of layers and the Move tool.

All the moving we've done here has been on an x,y-axis — up and down or side to side. As we saw in an earlier exercise, you can move layers forward and backward by changing their position in the layer stack in the Layers palette. Try this little exercise:

1. Open the layer_fun.psd file. If you already have it open from the preceding exercise, return it to its opening state by clicking the image's icon at the top of the Layers palette.

2. Click the red square layer in the Layers palette, and drag it upward while holding down the mouse button. Drag the layer up until it is between the green triangle layer and the yellow circle layer. When you see a black line appear between them, release the mouse button.

 Now the red square layer is above the yellow circle layer, as shown in Figure 4.12.

FIGUER 4.12

The red square layer was moved above the yellow circle layer by dragging it upward in the Layers palette. When a layer is moved up in the layer stack, it hides information on layers that are below it.

3. Select two contiguous layers with the Shift key, and move them up or down together in the Layers stack.

You can move layers together or by themselves. You can move them on an x,y-axis and on a z-axis — forward or backward in space — by moving them up and down in the layer stack. Sometimes, though, you may want to move only part of a layer rather than the whole layer. To do this, you need to cut or copy sections of information from a layer before you can move it.

Creating a new layer by copying

Earlier we created new layers by using the New Layer command in the Layer menu and by using the Create a New Layer icon at the bottom of the Layers palette. In both cases, the new layers we

created were completely empty. Sometimes though, we want to create a new layer with information in it by copying all or part of an existing layer.

Duplicating an entire layer works very much like creating a new empty layer. You can do it in two ways:

- You can duplicate a layer using the Layer menu. To use this method, follow these steps:

 1. Make sure that the layer to be duplicated is currently active.

 2. Go to the Layer menu, and select Duplicate Layer.

 3. When the New Layer dialog box opens, click OK.

- You can duplicate a layer using the Layers palette. To use this method, click the layer to be duplicated and drag it to the Create a New Layer icon on the Layers palette.

The second method is faster because it's more direct and you don't have to go through the New Layer dialog box. Either way works just fine, so choose the method you prefer.

Creating a layer from part of another layer works a little differently. To do this, a selection tool is used to isolate the part of the image to be copied to the new layer. I haven't discussed selection tools in detail yet, so I'll help you out on this one by supplying the selection. Follow these steps:

1. Open the practice file girls_vette.tif from the downloadable practice files on the Web site.

 The goal here is to copy this young woman and place the new layer beside her so that you get the effect of twins.

2. Go to Select ➪ Load Selection to load the selection that I provided. The Load Selection dialog box opens with the selection already selected, so just click OK.

 After the selection is loaded, the marching ants start moving around the girl. This indicates that a selection is active, as shown in Figure 4.13. Only this area is affected in the next step.

3. Go to Layer ➪ New ➪ Layer via Copy (Command/Ctrl+J).

 The marching ants go away, and the image looks the same as it did before. The clue that something has changed is in the Layer menu. A new layer called Layer 1 has been created above the Background layer.

4. Go to the Layers palette, and turn off the visibility of the Background layer by clicking the eyeball. Now the new layer is more obvious because you can see all the transparency around it, as shown in Figure 4.14.

FIGURE 4.13

The marching ants surrounding the girl show that a selection has been created in the shape of her outline. When part of an image is selected, only that part of the image is affected by changes.

Photo by Jerry Auker

FIGURE 4.14

The girl has been copied to a new layer. When the visibility of the Background layer is turned off, you can see the new layer by itself. The checkerboard surrounding the girl indicates that no image information is available in that area.

5. Turn the visibility of Layer 1 back on. Select the Move tool (V). Click anywhere in the image, and drag the girl's "twin" to her new spot. I moved her to the front, as shown in Figure 4.15.

TIP **Here's a great shortcut. When you need the Move tool, you can hold down the Command/Ctrl key to temporarily access it. This saves switching tools just to move something.**

FIGURE 4.15

The girl's "twin" has been positioned next to her. For this effect to look realistic, more work must be done to blend her into the background. However, this is a good start.

6. If you're up for more fun, duplicate Layer 1 to create another copy of the girl and move it somewhere else.

In reality, you probably won't be creating many images like this. However, copying information from one layer to another is a very common technique in restoration and retouching. Often, you may need to copy information from a layer and move it into another image — for instance, when you're doing a head-swap, as we do in Chapter 14.

Merging and flattening layers

One of the main reasons for creating layers is to have flexibility in the future. Consider the exercise above with the girl. As long as we keep Layer 1 around, we can continue to reposition the copy of the girl. When we go through the effort to create layers in an image, we usually intend to keep them around.

Sometimes though, it is desirable to merge layers together. For example, when reconstructing someone's eye in a restoration job, you may need to copy information from a couple of different eyes and merge them together onto a single layer so that they can be worked on as one unit.

Also, not everyone is prepared to deal with layered files. Often, when sharing files with someone else, like a graphic designer, you should supply a flattened file — all layers merged into a single layer — to avoid confusion. If any modifications need to be made, they can be done on a copy of the layered file. Then a new flattened file can be sent to the designer.

When you take a file to a photo lab, it almost always has to be flattened. Very few labs will accept layered files because the file size is much larger. That's right; every layer adds to the overall file size. If a Background layer is duplicated, the file size instantly doubles. Smaller pieces copied to a layer add smaller amounts to the overall file size.

NOTE To save layers when saving a file, choose PSD or TIF as the file format. A JPG file doesn't save individual layers. When you save a JPG, all layers are automatically flattened in the JPG file.

Let's take a quick look at how merging and flattening is done:

1. Open the layer_fun.psd file again. Make sure that the green triangle layer is active. Go to Layer ➪ Merge Down (Command/Ctrl+E).

CAUTION If you do something to a layered file and you don't get the expected result, you're probably on the wrong layer. Whenever things don't go the way you expect them to, check the Layers palette first to see which layer is active.

 Notice that the green triangle layer and the yellow circle layer are now combined into one layer called yellow circle. The green triangle was merged with the yellow circle; they are no longer independent, as shown in Figure 4.16.

2. Select the Move tool (V), and move the new combination. Notice that they move together now.

3. Merge the newly combined layer with the red square layer below using Layer ➪ Merge Down (Command/Ctrl+E).

 Now all three of the colored layers are combined into one layer called red square. Any movement with the Move tool affects all of the colored shapes because they are all part of the same layer.

FIGURE 4.16

When the green triangle layer is merged with the yellow circle layer, they become one layer called yellow circle. Any changes you make with the Move tool affect them both.

4. Let's do it one more time. Merge the red square layer with the Background layer. Now try the Move tool. It won't work because all layers have been merged down to the Background layer, and by its very nature, the Background layer is locked.

5. If the goal is to merge all layers into one, there's a faster way. Go back to the opening state of the image by clicking the thumbnail at the top of the History palette. This time, instead of merging one layer at a time, go to Layer ⇨ Flatten Image. (You also can access Flatten Image from the Layers palette options menu.)

6. Here's one more wrinkle that's quite useful. Suppose we want to merge all the layers except the Background layer. The fastest way to do this is to turn off the visibility of the Background layer and select Layer ⇨ Merge Visible. Only the layers that are currently visible get merged. (Naturally, this command also can be accessed from the Layers palette options menu.)

So that's the scoop on merging and flattening layers. When you use layers to separate image elements, you have to know how to bring them back together when it's appropriate. You'll see some of those instances in better context later as we move through this book together.

Layer Opacity and Blending Modes

A big feature of layers is that we can control the way one layer blends with the layers below it. The most basic way to affect the interaction between two layers is to adjust the opacity of the upper layer. Here's how to do that:

1. Open the layer_fun.psd file again. If it's still open from the preceding exercise, return it to its opening state by clicking the thumbnail at the top to the History palette.

2. Select the yellow circle layer, and adjust its opacity to 50 percent by typing a value of **50** into the box, by clicking the arrow next to the input box and using the slider as shown in Figure 4.17, or by using a *scrubby slider*.

FIGURE 4.17

When the opacity of the yellow circle layer is lowered to 50 percent, it's only 50 percent visible. Opacity can be changed by using the Opacity slider or by using a scrubby slider (circled), next to the opacity input area.

TIP

Wherever a slider is available in Photoshop CS3, a scrubby slider also is available. A scrubby slider is a cool little shortcut that allows you to adjust a slider without clicking the arrow to activate it. To use a scrubby slider, move the cursor to the left of the input window. When a hand with double arrows appears, circled in Figure 4.17, click and drag to the right or left to raise or lower the value.

Another way to change how layers interact with one another is to change the *blending mode* of a layer. A layer's blending mode affects the way it interacts with the layer directly below it. In Chapter 12 when I discuss burning and dodging, you'll see me use a layer's blending mode to create a flexible burn and dodge layer. For now, I want to introduce the idea by showing you a cool way to deal with overexposed and underexposed images using a method called *self-blending*. A self-blend is when a layer is duplicated and blended with itself using a particular blending mode.

Sometimes, an overexposed image can be hard to deal with in Levels or Curves. If you're working quickly and you don't feel like spending lots of time fixing an overexposure, you can use a fast two-step process to make a huge improvement on the image:

1. Duplicate the layer.
2. Click where it says "Normal" to see the Blending Mode pull-down menu. Change the duplicate layer's blending mode to Multiply. The Multiply blending mode is easy to remember because it's right below Darken, which is what you want to do.

Figure 4.18 shows an original image and the result of doing a self-blend with the Multiply blending mode. This adjustment took about 5 seconds.

FIGURE 4.18

In the original photo on the left, it's hard to see that this dog is in trouble for digging a hole. After a self-blend is done with the Multiply blending mode, the evidence is hard to deny.

TIP Sometimes, doing one self-blend isn't enough. When that happens, duplicate the new layer so you create a third layer. Because this is a duplicate of a blended layer, it already has the correct blending mode selected. If a self-blend is a bit too strong, simply reduce the layer's opacity until you like it.

To get a look under the hood of what's going on here, look at the histogram after doing a self-blend. Figure 4.19 shows the histogram I got when I blended the image in Figure 4.18.

Fixing an underexposed image works in exactly the same way with one minor change. The blending mode on the self-blend is set to Screen instead of Multiply. Screen is easy to remember because it's just below Lighten, which is the end result you're looking for.

TIP If you want to know more about the various blending modes and how they work, take a look at Photoshop CS3's help. Go to Help ⇨ Photoshop Help, and type list of blending modes into the search field. Number 1 in the search returns should be "list of blending modes"; click it to see a complete list with explanations.

FIGURE 4.19

Notice that when we use the Multiply blending mode, most of the adjustment is happening in the middle and lighter tones. The darker tones show a bit of spiking, but it's fairly minimal. The result is very similar to moving the gray slider in Levels to the right.

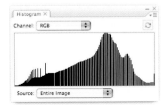

Summary

Working with layers in Photoshop opens the door to greater workflow flexibility and editing power. We use layers extensively in the later projects in this book, so you want to develop an understanding of how to work with layers now.

An adjustment layer is one of the most basic types of layers. With these layers, you can make repeated non-destructive tonal adjustments to an image. Adjustment layers can be created from most of the options under the Image ➪ Adjustments menu with the notable exception of Variations.

As with most things in Photoshop, you can work with layers in many ways. You can reach commands by going to the Layer menu at the top of the screen or by accessing the hidden commands on the Layers palette. Use whichever system is more comfortable for you.

Layers can be moved, duplicated, and copied. The stacking order also can be changed by dragging individual layers up and down in the Layers palette. Just remember that certain things can't be done to the Background layer because it's automatically locked. To unlock it, just change its name to something other than Background.

Layer blending modes provide another way of working with layers. By using blending modes, we can quickly fix overexposed and underexposed images. This is just the beginning of the usefulness of blending modes. We run into them again later in this book.

Chapter 5

Getting Organized

When we first get interested in digital imaging, few of us realize just how quickly the digital dream can become an organizational nightmare. In the days of shooting film, organization was just as important, though much more intuitive. After film was developed, it — and its associated proofs or contact sheets — was placed in a box or file cabinet. When a negative was needed for printing, we had a clear idea of where to find it.

With digital photography, organization gets more complicated. For one thing, the place where image files are stored isn't quite so intuitive. Sometimes, files end up in cryptic places requiring three software engineers to find them. Second, when working with digital images, we tend to create lots and lots of derivative files from some original files. When we begin creating so many similar yet different files, organization takes on a whole new meaning. Finding a particular picture is important, but finding a particular interpretation of that particular picture is even more important. Add the fact that you can easily create huge quantities of digital files, and you'll soon be lost in a sea of image files.

My goal in this chapter is to help you get a handle on organization right now. I begin by explaining the primary file formats we use when working with digital photography and when they're appropriate in the workflow. Then I describe different ways of getting organized, focusing primarily on Adobe Bridge CS3. I also talk about different ways of protecting all your work by backing up and archiving digital files. By the end of this chapter, you'll be ready to create your own intuitive organizational system that helps you quickly locate your files when you want them.

IN THIS CHAPTER

Understanding file formats

Creating an organizational system

Managing your organizational system with Adobe Bridge CS3

Backing up and archiving

Understanding File Formats

Adobe Photoshop CS3 works with a variety of file formats. Most are created when edited files are saved with the Save As command. Figure 5.1 shows the various options available in the File Format pop-up menu. Choices here determine the kind of file that is created during saving. Be aware that this set of options is available only when saving an 8-bit file.

FIGURE 5.1

The File Format pop-up menu in the Save As dialog box gives us the option of saving a file in various formats. Notice that several types of Photoshop documents are available. The top choice, highlighted in blue, is the one to choose to create a Photoshop PSD file.

NOTE Only certain file formats accommodate a 16-bit file. For example, you cannot save a 16-bit file in the JPG format, so you won't see JPEG as an option in the File Format pop-up if you're working with a 16-bit file.

TIP Sometimes, I work with 16-bit files, but I convert them to 8-bit TIF's when I save them because I'm sending them to someone who doesn't use 16-bit. If I go to Save As and don't notice JPEG as an option, then I know the file is still 16-bit and I have to convert it to 8-bit before saving.

These file formats are not all needed by people who deal with digital photography. I work with lots of professional photographers and imaging professionals. These people use files from four file formats 99 percent of the time: Raw, PSD, TIF, or JPG.

I discussed the Raw file format in detail in Chapter 3, so I don't need to say much more here. I will reiterate, though, that each camera has its own flavor of Camera Raw. Because these formats are so individualized, Photoshop can't save back into the original file format. For example, my Canon camera shoots in the CR2 Camera Raw file format that is Canon's proprietary format. Take a close look at Figure 5.1, and you'll notice that there is no CR2 option for saving. After a Raw file is open in Photoshop, it must be saved as a different file format — usually PSD, TIF, or JPG. This prevents us from inadvertently overwriting an original Raw file. Cool, huh?

> **CAUTION** You may notice an option in the pop-up called Photoshop Raw. This isn't a Camera Raw file format. Photoshop Raw is used as a flexible file format for transferring files from one computer platform to another (Mac, PC, Unix, and so on) or between exotic applications.

PSD

PSD is Photoshop's proprietary default file format. It supports more Photoshop features than JPG or TIF. In fact, the only other file format that supports as many features — like layers — is the Large Document Format (PSB), but that's a file format I've never needed. One of the big advantages of working with PSD is that other Adobe products like Illustrator can open PSD files and access all the saved features. This makes life easier for people who move back and forth between those Adobe software applications.

A special option can be set in Photoshop's preferences that maximizes PSD file compatibility when saving. With this option turned on, a composite version of all the layers in the image is embedded in the file. This composite can be read by other non-Adobe applications as well as earlier versions of Photoshop. The downside to doing this is that the PSD file is larger because of the imbedded composite. If you open your files only in Photoshop CS3, then you don't need this option. You should just set it to Never.

Let's look at how this is done:

1. Go to Photoshop's Preferences:
 - Mac: Photoshop ➪ Preferences ➪ General
 - PC: Edit ➪ Preferences ➪ General
2. Choose File Handling from the menu on the left. The Preferences dialog box opens.
3. Under Maximize PSD and PSB File Compatibility, click the pop-up as shown in Figure 5.2. Make your choice, and click OK.

 If you choose Ask, Photoshop asks you before saving a PSD file. This is a good way to make the compatibility choice on a case-by-case basis.

FIGURE 5.2

The File Handling preference in Photoshop CS3 allows you to choose how Photoshop handles PSD file compatibility. The Ask option allows you to make the choice each time you create a new PSD file using the Save or Save As commands.

One of the big advantages of using PSD is that all layer information is preserved and stored. When the image is opened, it goes to the state that it was in when it was last saved. All the layers are there, and the last active layer is still active. When you work extensively with layers, as we do in this book, saving them becomes important.

NOTE Layers also can be saved in the TIF file format.

TIFF

TIFF (or TIF, as it's abbreviated) stands for Tagged Image File Format. TIF is a flexible format that's supported by virtually all image-editing and graphics software. Layers can be saved in TIF, and the format supports a number of color models like CMYK and LAB.

Normally, a TIF file is larger than a PSD file that's saved from the same image. That's because PSD files are *compressed* a bit to make them smaller when they're saved. File compression is a system of analyzing a file and looking for common strings of data. When several identical stings are located, they are replaced by a single representative string with references to all the places where it appears in the image. Compression can substantially reduce file size when images contain lots of the same tones, such as solid backgrounds. Images with lots of details and colors won't compress as much.

Many file formats support file compression. With PSD, it's a transparent part of the process that happens automatically when a PSD file is saved. With a TIF file, compression is an option. It must be selected in the TIF Options dialog box when the file is first saved, as shown in Figure 5.3. Photoshop offers three different types of TIF file compression: LZW, ZIP, and JPEG. The main difference among these three compression methods is that LZW and ZIP are *lossless* compression methods and JPEG is a *lossy* method of compression.

FIGURE 5.3

When a TIF file is saved for the first time, four compression options are available: None, LZW, ZIP, and JPEG. LZW and ZIP are lossless compression methods; JPEG is a lossy method. When layers are present, options for compressing them are presented under Layer Compression.

When an image is compressed, the data is generally handled in one of two ways:

- **Lossless compression:** All information is retained during the compression. This means that an image can be resaved and recompressed without compromising image quality.

- **Lossy compression:** During compression, data is permanently removed. Higher levels of compression result in greater data loss. Every time a file is resaved with lossy compression, more data is lost. This cumulative data loss can greatly affect the quality of an image.

When compressing a TIF file, stick with lossless compression by selecting LZW or ZIP. They're fairly equal in performance, and Photoshop opens either of them. However, be aware that ZIP is not supported in older software. I compress a TIF file only when I'm planning to e-mail or FTP it to someone and I want to save space. Many people compress all TIF files to save room on their hard drives.

Another option with TIF files in Photoshop is the ability to save layers. You can even compress the layer data without compressing the *composite* data. This seems pretty cool, except that few image-editing applications can open a layered TIF file. I don't use layered TIF files often. If I'm saving a layered file and planning to use Photoshop to edit it, then I save it into Photoshop's native file format: PSD. If you're worried about hard drive space, save your files in the compressed TIF format.

NOTE A layered TIF file contains individual layers and a composite of the flattened file. If the file is opened in software that can't see the individual layers, the composite data is all that can be seen.

I have Photoshop warn me when I'm about to save a layered TIF file. I check the box for Ask Before Saving Layered TIFF Files in the Photoshop File Handling preferences, as shown in Figure 5.2. When this box is checked, a warning pops up to remind you that you're about to save a layered TIF file, as shown in Figure 5.4.

FIGURE 5.4

When "Ask Before Saving Layered TIFF Files" is checked in the File Handling preferences, Photoshop reminds you that the TIF file you're about to save contains multiple layers.

JPG

JPEG (usually shortened to JPG) files are always compressed. JPG was designed to be a space-saving file format. This format was created in 1992 by a committee called the Joint Photographic Experts Group. That's where the acronym JPEG comes from. The committee's goal was to establish a portable standard for compressing photographic files that would be universal.

JPG is one of the most widely used file formats for digital imaging. Virtually any software that can open an image file can open a JPG. What's more, nearly all the photographs you see on the Internet are JPG files — at least the ones that look good. JPGs can be compressed to very small sizes, which is perfect for online delivery or e-mail.

JPG files are usually created by digital cameras when they are not set to capture Raw files. Again, this goes back to the ability of JPGs to be compressed. In the early days of digital cameras, memory cards were small and expensive, so the files had to be small so that more would fit onto the card.

JPG compression is a double-edged sword. Very small files can be created with high compression, but JPG compression is lossy, so image quality can be affected. Additionally, whenever a file is resaved, more data is lost. The amount of loss depends on the amount of compression.

You select the amount of JPG compression in Photoshop when a JPG file is saved. Figure 5.5 shows the JPEG Options dialog box. In this case, an image that is 24.8MB as an uncompressed TIF file becomes a 3.2MB JPG with a compression quality of 12. If the compression on this file is lowered by two, to 10 instead of 12, the file size is reduced by two-thirds to 1.0MB without adversely affecting the image quality. The key is to try to compress a JPG file only once by not resaving (and further compressing), the file later on.

FIGURE 5.5

The JPEG Options dialog box lets you compress the size of your image. The lower the Quality number is, the smaller the file will be, as shown by the file size preview just below the Preview checkbox. The file in this case is 3.5MB with a Quality setting of 12. Don't worry about the Format Options. The default, Baseline ("Standard"), is fine.

NOTE Some photo labs are beginning to require that all JPGs submitted be saved at a level of 10 instead of 12. This saves space on their servers, which, as you can see from the example above, can add up quickly.

As you can see, the higher the Quality number in the JPEG Options dialog, the lower the amount of compression will be. (Lower amounts of compression equal higher quality files.) When saving at a quality of 12, you can make a few multiple resaves to JPG files without noticeable image degradation, (it's happening, you just can't see it yet). If you think you'll be reopening a JPG and resaving it, choose the highest quality when saving.

With that in mind, JPG files can be quite useful. As I mentioned, they're perfect for the Web and e-mail. PSDs and TIFs are mostly useless for those two purposes because of their relative size. Also, most photo labs want only JPG files because they take up less room on their servers and move through the workflow faster. Many labs won't accept TIFs, and I've never heard of one that will accept PSDs, though I'm sure you could find one. The real trick to working with JPG is picking the right time in your workflow to save a file as a JPG, which is usually at the end of the process when you're ready to create a file for output.

Creating an Organizational System

The tools and techniques used in this book are built around a non-destructive workflow. The idea is to use layers to isolate all the important elements in an image so that they can be managed individually. Image editing remains flexible as long as the layers are intact. After the image is flattened into a single layer, choices are very limited.

NOTE No one wants to start all over again with an image just because he made a bad decision while editing. A non-destructive workflow is a methodology of editing an image in ways that minimize permanent changes so that more options are available later.

Considering the non-destructive workflow

One of the other ways to limit the destructiveness of image editing is to avoid cropping and image-size adjustments whenever possible. After these changes are made and the file is closed, they become permanent. What if I decide tomorrow that I don't like the cropping I did, or what if I cropped to a 5×7 but the client has decided she wants a 16×20? These things happen all the time. You can protect yourself by always saving a master file before doing anything—like cropping—that will permanently change the image.

The problem is that we need to flatten and crop files at some point. You usually do this when you're giving someone else a copy of the file or taking it to a lab to be printed. To solve this problem, you need to save two separate files. You need to keep a master file (PSD) that retains all the flexibility possible in a PSD and a final file (JPG) that has been sized and prepared for sharing or printing. Often, you'll prepare multiple JPG files from the same original image for different uses. These files begin to add up, creating a level of complexity that was never a problem when everyone was shooting film.

If you are doing your own printing on an inkjet printer, you don't need to flatten an image file or to save it as a JPG. You can print straight from a layered PSD file. However, if you're going to crop and/or size the file before printing, save a master copy first.

Three kinds of files

With the workflow in this book, we are working with three kinds of files: originals files from the camera or scanner, master files that contain as much information as possible, (usually in layers), and final files for printing or display. Both a master file and any related final files are derivatives of the same original file. Let's look at these three kinds of files:

- **Original files:** These files should never be overwritten. When you make changes to an original file, always save it with a new name. Period. Original files need to remain pristine so you can go back to them when necessary — for example, when you learn a new technique. These files should remain in their original file format, which usually is Raw or JPG for DSLR captures and TIF or PSD for scans.

- **Master files:** These files contain all the flexibility and options that are built into the file as it is edited with a non-destructive workflow. Layers are used extensively, and permanent changes are avoided at all costs. These files are almost always saved as PSD files, though they can be saved as layered TIF files.

- **Final files:** These files have been prepared for some final usage like print, Web, or e-mail. They have been cropped and sized to a final size and sharpened for output. In some cases, you may have quite a few of these originating from a single original.

When all these different files from the same image are stored in the same place, they become difficult to manage. They all look similar in a file browser like Adobe Bridge, so you spend time sorting through them. In my own personal workflow, I can't stand to see a bunch of similar images together. I waste too much time trying to figure out which file I want.

To minimize confusion, these three file types need to be organized in two ways: They need to have unique names based on the original file's name, and they need to be in special folders. Let's look at naming first as we build an organizational system.

Building the system

One of the worst things to do when dealing with these three types of images is to use filenames that don't have the same base name. For example, suppose the original file is named scan223.tif, the master file is named family_scan4.psd, and the final file is named mom1967.jpg. This causes problems in two ways. First, if the files are all in the same browser and they are being sorted alphabetically, they are scattered all over the place. Second, if I learn some new tricks next year and decide to redo the mom1967 image, I may have trouble remembering which original file I started with last time. This isn't as big as a problem with scans as it is with original files from a digital camera. When using a camera, you can have lots of originals with cryptic names that all look alike.

I solve this problem by naming the original file early in the process. Then any new file uses that name as a base. In my example above, the original scan file becomes mom1967.tif, the master file becomes mom1967_edited.psd, and the final file becomes mom_1967_8x10.jpg. This way, I know exactly what kind of file I'm looking at just by looking at the name.

After you've established a naming methodology, you must address the second level of file organization: filing different kinds of files in the appropriate folders. Figure 5.6 shows how I organize my file folders. When I begin a new project, I create a folder for it. In this case, the *parent* folder is titled "Family Scans." I place it inside of a folder called "Photos" that's used to store all my photo projects. I then create three subfolders:

- **Originals:** For all original files.
- **Masters:** For all master files.
- **Finals:** For all final files. Sometimes, I break this folder into two subfolders titled "Printing" and "Email" so I can stay organized when I'm sending e-mail versions to someone.

FIGURE 5.6

This shows how I organized the folder titled Family Scans into subfolders. This intuitive organizational system allows me to always know where to find a file.

My goal with this organizational system is to make it so intuitive that I know where everything is without looking. Even though I never do it, I want to be able to call my assistant back at my office and ask her to send a particular file to me. I can do that because I know exactly where the file should be, and so does she.

Your system doesn't have to look exactly like mine. If necessary, create something that makes more intuitive sense to you. The thing that's important is to get a system in place and begin using it now.

Managing Your Organizational System with Adobe Bridge CS3

Early versions of Photoshop had no file browser. If users wanted the ability to visually browse through files to find a particular image, they had to purchase a separate file browser. When Adobe released Photoshop 7, they finally included a very useful file browser that came as part of Photoshop. When Photoshop CS2 was released, the file browser was retooled and separated from Photoshop. The file browser became Adobe Bridge, a standalone software that could be used even if Photoshop wasn't running.

Compared to the File Browser in version 7, Bridge was like a file browser on steroids. With Bridge, you can view and organize images in a very flexible and intuitive environment. You can rate images and sort them with colored labels and stars, and you can attach a variety of metadata so they can be quickly located later.

NOTE Bridge is named Bridge because it's more than a Photoshop file browser. It's a file browser for a number of Adobe titles like InDesign and Illustrator. It acts as a bridge between these applications.

Understanding the usefulness of Bridge

When Photoshop CS3 was launched, an updated version of Bridge was launched too — Adobe Bridge CS3. With the new version of Bridge, Adobe took a great piece of software and made it even better. Because Bridge CS3 is such a powerful piece of software in its own right, an entire book easily could be devoted to it. Here, I touch on some of the highlights as they apply to our task at hand.

NOTE Bridge comes with Photoshop CS3. When you install Photoshop, Bridge also is installed. You can launch it independently of Photoshop by clicking its icon in your Applications folder (Mac) or from the All Programs button in the Start menu (Windows).

I talk to lots of professional photographers, and I'm continually amazed at how many use Photoshop CS2 or CS3 but aren't using Bridge. Many don't even know how to launch it from Photoshop. It isn't because they don't like Bridge; they just don't know how to use it. After they learn to use Bridge, they seldom go back to their old system.

This section is designed to help people new to Bridge get up to speed so they can begin using it to manage their digital files. If you're already working with Bridge and feel comfortable using it, you still may want to review at this section to see some of the new features in Bridge CS3.

So let's jump in and look at Bridge CS3. Please feel free to follow along with your own image files when possible.

 To open Bridge from Photoshop, go to File ⇨ Browse. You also can launch Bridge by clicking the Go to Bridge button at the top right of the Photoshop CS3 workspace. When Bridge is already running, this is a quick way to jump to it from Photoshop.

When Bridge opens your screen will look something like Figure 5.7, with a couple of small exceptions. I have the Favorites panel on the upper left hidden so I can easily see the Folders panel. I also selected a different color as an accent color.

If your screen looks different from the one shown in Figure 5.7, it's because your *workspace* is different. You can use different layouts of the Bridge workspace for different tasks, which is a great asset. We look at that in a moment. First, set Bridge back to its default view by choosing Window ➪ Workspace ➪ Default (Command/Ctrl+F1), shown in Figure 5.8.

FIGURE 5.7

I modified the default view of the new Adobe Bridge CS3 interface to hide the Favorites panel and have amber as the accent color by making some changes in the Bridge preferences. Four panels surround the Content area: the Folders panel, the Filter panel, the Preview panel, and the Metadata panel.

Folders panel Content panel Preview panel

Filter panel Thumbnail size slider Metadata panel

FIGURE 5.8

Bridge CS3 comes with six different workspaces installed. To create a custom workspace, organize the workspace the way you like it and click Save Workspace. As you can see, I have two custom workspaces saved: Mark's Default and Large Previews.

Bridge CS3 Default workspace view has five areas of information:

- **Folders panel:** This displays the folder tree of the folders on the hard drive. Notice the folder structure in Figure 5.7. The main folder, "Robby & Karyn," is divided into subfolders for different content as discussed above. The folder currently being viewed is the Originals folder.

- **Filter panel:** This is a new feature in Bridge CS3. In the first version of Bridge, filtering wasn't very intuitive. Now in Bridge CS3, it's easy. Whenever the content of a folder is displayed in the Content area, the Filter panel looks at the content and dynamically displays all the different ways that the particular folder can be filtered. If you are viewing a new folder where few changes have been made in Bridge, then the options are limited. In Figure 5.7, you can see that the Filter panel is aware of the different color labels, rating stars, and metadata tags that are relevant to the files in the "Originals" folder. Sorting for one of these criteria is easy. You just click it in the Filter panel. You can even sort for more than one criterion by checking multiple criteria. For example, if I want to see only the files that have a red label and three stars, I would check both criteria to select them. To turn filtering off, uncheck the filter criteria by clicking them.

- **Content panel:** This is the main viewing window. Thumbnails of the selected folder in the Folders panel are displayed here. Use the thumbnail size slider at the bottom right of the workspace to change the size of these thumbnails.

- **Preview panel:** This shows a preview of the selected thumbnail(s). I usually don't find this panel very useful because it's so small. However, I'll show you how to make use of it in a moment when we set up custom workspaces.

NEW FEATURE In Bridge CS3, you can display multiple images in the Preview area by selecting them in the Content area. This can be useful when using the Large Preview workspace, which we look at in a moment.

- **Metadata/Keywords panel:** This panel contains two subpanels. Both display information about the currently selected thumbnail(s). The Metadata panel displays information about the file, such as when it was created and what kind of file it is. The Keywords panel displays currently assigned keywords and allows you to apply additional keywords or remove current keywords. Changes here are reflected in the Filter panel.

Creating custom workspaces

Workspaces have been part of Bridge from the very beginning. One of my favorites is the Light Table workspace (Command/Ctrl+F2). When you activate it, all side panels are instantly hidden and the Content area is maximized, allowing you to focus on only the thumbnails.

What makes these workspaces even cooler is that you can create your own custom workspaces. I like to create a workspace that gives me large previews. I show you how to do that in just a moment. First, I want to show you how to modify the default layout so you can save your own default layout too:

1. I don't use the Favorites panel, so I just turn it off. To turn yours off, go to the Window menu and click Favorites Panel to uncheck it, as in Figure 5.8.

 If you don't want to see other panels, now is the time to uncheck them.

NEW FEATURE Bridge CS3 takes panel management to a new level by allowing all panels to be dragged and dropped to different locations. To change location of a panel, click its title and drag it to the new location. A blue box, or in some cases a blue line, shows you a preview of where the panel will be placed if you release the mouse button. This flexibility allows you to lay out Bridge CS3 just the way you like it.

2. I also changed the accent color in the Bridge preferences. Here's how:
 - Mac: Bridge CS3 ➪ Preferences
 - PC: Edit ➪ Preferences

3. Make sure that the General preferences are highlighted in the menu on the left. Select Appearance ➪ Accent Color, and choose a different color. I chose Amber, which you can see in Figure 5.9. I also checked High Quality Thumbnails from the Thumbnails menu

on the left, as shown in Figure 5.10, so the thumbnails in the Content area are generated from their source files instead of low-resolution Quick thumbnails that aren't color managed.

You also can change the User Interface and Image Backdrop brightness settings here.

4. Click OK. Now your view of Bridge should be very close to Figure 5.7.

FIGURE 5.9

The General panel in the Bridge Preferences dialog box allows you to personalize the Accent Color you use and the brightness of the User Interface and Image Backdrop. You can customize the Favorites panel, if you're using it, by selecting the items that you want to have displayed there.

NOTE Due to space limitations, I can't really go into the rest of Bridge's preferences. However, I want to point out one setting in the Preferences ⇨ Thumbnails menu, shown in Figure 5.10. Under the Details heading, you can select the kind of information that's displayed under Bridge's thumbnails. Click the pop-up beside Show to change the information to what you want to see. (You may notice that even though I have Color Profile selected, it isn't showing up on the thumbnails in Figure 5.7 because these are Raw files, so no particular Color Profile is attached to the files.)

5. Make other adjustments to panel positions until you have a workspace that you like and can use every day. When you're ready to save it, go to Window ⇨ Workspace ⇨ Save Workspace. The Save Workspace dialog box appears. Figure 5.11 shows how I filled it out for my default workspace.

FIGURE 5.10

The Thumbnails panel allows you to customize information that's displayed below the thumbnail in the Content Panel.

FIGURE 5.11

The Save Workspace dialog box allows you to save custom workspaces. You can give the workspace a meaningful name and even assign a keyboard shortcut to it. I choose Command/Ctrl+F7. I usually check Save Window Location as Part of Workspace, but I leave Save Sort Order as Part of Workspace unchecked because if I manually sort my files in a particular way in one workspace, I don't want them resorted when I switch workspaces.

Okay, now that you have a default workspace saved, let's create another one that's designed for seeing larger previews. The upper image in Figure 5.12 shows after the first step. All panels have been hidden except for the Content panel (which can't be hidden) and the Preview panel. The Preview panel is then resized so it becomes very useful.

FIGURE 5.12

(Top) A custom large preview workspace is created by hiding all side panels except for Preview. (Bottom) The preview area is enlarged by clicking and dragging the vertical dividing line.

To create a workspace like Figure 5.12, follow these steps:

1. Go to Window and uncheck all the panels except Preview. You'll have to uncheck them one at a time. When you're finished, your screen should look like the top image in Figure 5.12.

2. Move your cursor over the line that divides the Preview panel and the Content area. When you see the cursor change to a double-sided arrow, circled in the bottom image in Figure 5.12, click and drag to the left until a single column of thumbnails is visible on the left.

3. The only thing left to do is to save the workspace. Go to Window ➪ Workspace ➪ Save Workspace. I named mine Large Previews and assigned Command/Ctrl+F8 as the shortcut key.

Now you can instantly jump back and forth between these two workspaces by using the assigned shortcut keys. When I'm working in Bridge, I use these two custom workspaces, along with the Light Table workspace, exclusively.

> **TIP** If you decide later to modify one of these workspaces, delete the old one before saving the new one. That way, you can reuse your shortcut key for the new version of the workspace.

Now that you have Bridge looking the way you like it, it's time to put it to work.

Naming, labeling, and sorting

Creating a system where all images are always placed in the appropriate folder is just the beginning of getting organized. The image files still need to be organized within those folders. Often, the Originals folder is the most crowded. In order to create a smooth-running workflow, this folder should be sorted out as early as possible.

I mentioned earlier that naming should happen to an original file early on so that any derivative images use the original name as the root of their own name; in other words, master file123_edit.psd becomes file123_8x10.jpg when the file is prepared for the lab. For this to be truly effective, you must apply meaningful names to the original images as early as possible. Instead of filenames like DSC0721.tif, we use names like Alaska_2008-123.jpg.

To rename a file in Bridge, simply click its name below the thumbnail in the Content window. Sometimes, it takes a moment for the name to highlight. Be patient. If you're in a hurry and click twice, the file opens.

> **TIP** If a file begins to open when you don't want it to, try pressing the Esc key on your keyboard. If you get to it soon enough, the file opening is aborted.

Being able to rename a file is useful, but for this to really work we have to be able to rename all files at once. This is called *batch renaming*. Batch renaming is extremely useful for dealing with digital camera files because there are usually quite a few of them. Fortunately, batch renaming is quite simple and straightforward in Bridge. Let's see how it works:

1. Select the files that need to be renamed. If renaming happens early enough in the process, you usually rename all files. If that's the case, select all files by choosing Edit ➪ Select All (Command/Ctrl+A).

2. Choose Tools ➪ Batch Rename. The look of this dialog box varies depending on whether the Batch Rename function has been used before. These settings are "sticky"; they stay where you last left them.

3. The first thing to check is that the files being renamed are in the same folder under Destination Folder.

 One of my clients inadvertently checked "Move to other folder" when renaming a wedding she photographed. When she did, all the files disappeared from her folder and she thought they had been deleted. If this happens to you, just do a search for the new name to find the folder to which your images were moved.

4. Go to the first box directly below "New Filenames"; Current Filename may already be selected. Click the pull-down menu to open the menu, and select Text. A text box appears to its right. Type the new filename as you want it to appear. In my case, I typed Europe_2007-.

5. Now we need to add a sequence number to the filename so that all files are named sequentially. If no other boxes are below the Text boxes, click the plus button (+) to the right to add an additional naming element.

 When you click this button, a new row of boxes appears below the Text boxes. Use the pop-up menu on the first new box to change it to Sequence Number. Use the pop-up on the right box to set the number of digits to what you want. I selected Four Digits. In the middle box, enter the starting number of your sequence. Usually, you will choose "1." Figure 5.13 shows what my Batch Rename dialog box looks like.

6. Click OK to rename you files.

> **TIP** At the bottom left of the Batch Rename dialog box is a section called Preview. It allows you to preview what the new filename will look like. This can be very useful. For example, in the case of Figure 5.13, I am using a date at the end of the filename. By looking at the preview, I can see that the date's last number is right next to the sequence number, making it hard to read. By adding a hyphen to the end of the date, I can separate the two numbers.

FIGURE 5.13

The Batch Rename dialog box is filled out for the preceding exercise. Text is selected as the first naming criterion with Sequence Number selected next. To add or subtract naming fields, click the plus (+) and minus (-) buttons to the right. Use the Preview area at the bottom left to monitor what your new filenames will look like.

After the files are renamed, it's time to sort through them and identify the winners and losers. The best way to do that is to use colored labels and rating stars.

- You can add colored labels to an individual image or to a group of selected images by choosing the Label menu and selecting the color you want.

 You know I don't like digging through menus when there's an easy shortcut. Notice that all the colored labels under the Labels menu have a shortcut next to them, except for Purple (they ran out of numbers). So instead of choosing Label ⇨ Red, I can just select the image to be labeled and press Command/Ctrl+6 on my keyboard to add a red label.

- Rating stars work pretty much the same way. Go to the Labels menu and select the number of stars that you want to place on the thumbnail, or use the shortcut key.

 Another way to quickly add stars to a file is to use the shortcut that's built into the thumbnail. Just below the image on each selected thumbnail are five little dots. You can see them on the selected image in Figure 5.7. These dots represent the five rating stars.

Just click the dot number that represents the number of stars that you want; in other words, click the second dot from the left to add two stars. To remove stars, click the Cancel icon that appears just to the left of the first star when you move your cursor there.

> **TIP** If the thumbnails are scaled too small, the dots (and labels for that matter) may not be visible. Use the Thumbnail size slider at the bottom right of the Bridge interface to increase their size until you can see the labels.

You can use labels and stars to identify and sort image files in a variety of ways. I use a fairly simple system: Green labels mark images I like, and red labels mark images I want to delete. I do this very quickly, usually in the large preview workspace so I get a good look at each image. (We look at the large preview workspace in a moment.) Here's how this procedure works:

1. When I see an image I like, I add a green label (Command/Ctrl+8). When I see one I want to delete, I add a red label (Command/Ctrl+6).

2. After all images of the losers are labeled, I go to the Filter panel and click the Red label to display only the red labels.

3. I select all the red labeled images, and press the Delete key. Then I click the Red label in the Filter panel to turn the filter off so I can see all the remaining images again.

 When I do this, I delete only the obvious rejects. I never know when I may want to use a piece of an image for something, so I'm fairly conservative when deleting images.

 In Bridge CS3, a new dialog box opens when a file is selected to delete, as shown in Figure 5.14. This dialog box allows you to Reject an image or Delete it. The difference is that Reject hides the image without deleting, while Delete does just that. If you aren't using the Reject feature, then this would be a good opportunity to check the "Don't show again" box so you don't have to see this dialog box again.

> **NEW FEATURE** This dialog box is a feature of CS3. I'm sure it'll come in handy for you.

4. Now I can click the green label in the Filter panel so I can focus on my favorites. As I go through these, I look for the best of my favorites and use stars to make them stand out even more. One star = mild interest; two stars = more interest; three stars = very interested.

5. After that's finished, I go to the Filter panel and select three stars under Ratings. Now the only images I'm viewing are the most important images in the folder.

> **TIP** Stars also are a great way to let clients rate their images after you've done a rough sort with colored labels. Show them the green ones, and let them use stars to indicate their favorites.

FIGURE 5.14

Bridge wants to make sure you really want to delete the files you've selected. If you do, click Delete. If you get tired of seeing this dialog, check "Don't show again."

You don't have to use colored labels and rating stars exactly the same way I do here. Just develop a system with them that means something to you. After you have that system, try to use it all the time. When you see a particular colored label or a certain number of stars on an image, you'll know how important it is instantly.

Applying and using metadata

The last piece of the organizational puzzle is *metadata*. Metadata literally means data about data. In the case of digital photos and scans, it refers to standardized information that's imbedded in the image file that describes various aspects about it.

The first type of metadata provides information on the most basic level. This information relates to conditions at the time of the creation of the file like time, date, bit depth, and color space. In the case of digital cameras, exposure settings also are included. Basic metadata information is visible in the image on the left in Figure 5.15. This information cannot be altered in Bridge's Metadata panel.

A second type of metadata includes information about the creator of the file, copyrights, and other information called *keywords*. Keywords are words that describe various things about an image, such as places, people, and events.

Some of this information is visible in the lower section of the image on the right in Figure 5.15 in the IPTC Core section. When you click one of these headings, data input boxes appear. To add or change information, just type in the box.

The first type of metadata, shown on the left in Figure 5.15, is important when you need to know something about a file — when it was created, what the color space is, how big the file is, or what camera settings were used to capture it. This metadata can't be removed from the original file in Bridge, so it is always there when you need to know something. It can be very useful when you're trying to track down a technical problem with a camera. Say, for example, that you think you're having problems with your flash. By checking the Camera Data (EXIF) section, you know whether the flash fired on specific exposures.

FIGURE 5.15

(Left) This image shows the File Properties and Camera Data sections of the Metadata panel in Bridge CS3. This metadata provides information describing file properties and basic camera settings. Other metadata fields such as IPTC Core and Camera Raw are collapsed. To open them, click the triangular *twirly* to their left. (Right) Here, the IPTC Core section has been un-collapsed. This editable section allows the image's creator to add personal and copyright information.

TIP **EXIF information is visible only on files that originate in digital cameras.**

The second type of metadata, the editable metadata in the IPTC Core section, is what interests us here. You can input and create this information in a couple of ways. You can click a single thumbnail in Bridge and type the metadata for it, or you can select groups of images in Bridge and add metadata to all of them at once.

> **TIP** If you see a pencil icon to the right of a metadata field, that field is editable. Click next to the name and start typing.

A third way to add IPTC metadata to files is available in Bridge. You can create a metadata template so that every time new images are brought into Bridge, the metadata template can be used to attach basic IPTC metadata to every file. Let's give it a try:

1. In Bridge CS3, choose Tools ➪ Create Metadata Template. The Create Metadata Template dialog box opens as shown in Figure 5.16.

FIGURE 5.16

The Create Metadata Template dialog box allows you to set up a metadata template that can be used for all files. Simply name the template, and fill in all appropriate information fields.

2. Type a name for the template at the top, and begin adding the information you want to add to your files by filling in the appropriate fields.

 This template will be used on all images, so make the information general. For example, this is not the place to add keywords or descriptions.

3. When you have all the information input that you want, click Save.

4. To apply the template to files, select the files in Bridge and choose Tools ➪ Append Metadata or choose Tools ➪ Replace Metadata.

 ▪ Append Metadata adds the information from the template to any IPTC metadata contained in the selected files.

 ▪ Replace Metadata replaces the IPTC metadata with the metadata from the template.

 When you hover your cursor over either of these options, any available metadata templates pop up on the right, as shown in Figure 5.17. Select the one you want to apply.

TIP If metadata has not been previously added to the file, then select Replace Metadata. This way, if a metadata field says "Unknown," it will be overwritten with the correct information. If you use Append Metadata on a file like that, the word "Unknown" stays with the file.

FIGURE 5.17

After a template is created, it can be used to Append or Replace current metadata by going to the Tools menu in Bridge.

NEW FEATURE Bridge CS3 has a new Photo Downloader feature: File ➪ Get Photos from Camera. When a camera or a media card is attached to the computer, this downloader can import images into the computer. The cool part is that you can specify a metadata template during download so that basic metadata is added to your files as they are brought into your computer.

Using keywords

I've discussed basic IPTC metadata that's used on large groups of images. Another kind of metadata that's image-specific is keywords. This information can be incredibly powerful because Bridge can perform a search of your hard drive based on specific keywords, or any other metadata for that matter.

The most basic way to add keywords to image files is through the IPTC section of the Metadata panel. Select an image in Bridge (or select multiple images), and then click in the Keywords section of the metadata and begin typing information about the people, places, or things in the image(s). Try to enter information that you might want to use later if you need to do a search.

> **TIP** **Adding keywords is a real balancing act. You want to have enough information to be usable, but you don't want to get crazy with small details. When I'm adding keywords, I always try to think about words that I might use in future searches.**

Another way to add keywords is with the Keywords panel. This panel is stacked behind the Metadata panel. When you select an image in Bridge, all assigned keywords are shown in the Keywords panel with a checkmark beside them as shown in Figure 5.18. To add more keywords to an image, just click the box beside them to check them.

Keywords are organized by dragging and dropping them into the appropriate categories like Places or People. You can add new keyword categories or subcategories, or you can delete keywords using the icons at the lower right of the panel.

Using metadata for searches

The real power of metadata is revealed when it's time to find something. Let's say that I'm looking for images of my dog Ruby, but I don't remember where they are. To do a search for all photos of Ruby, I can use the Find command in Bridge via Edit ➪ Find (Command/Ctrl+F).

Figure 5.19 shows what the Find dialog box looks like after I fill it in. Notice that I'm choosing to search the entire hard drive under Look in. Using the area under Criteria is similar to the data boxes in the Batch Rename dialog box. Click the pull-down menu to change the search criteria to any search parameters you like; it's a pretty big list. In this case, I chose Keywords as my search criteria. You also can add additional criteria, such as dates, by clicking the plus (+) button to the right. Because I'm searching the entire hard drive, I also checked Include All Subfolders. When I click Find, the Content area of Bridge is repopulated with the search returns.

The powerful search feature in the Find command makes it worth the effort of adding the most relevant metadata to your files. The ability to search thousands of images to find the one you need cannot be overrated. This feature has saved me many times when I knew I had a file, but I didn't know where it was located.

FIGURE 5.18

The Keywords panel is stacked behind the Metadata panel. You access it by clicking the Keywords tab. The Keywords panel shows all keywords that are associated with the selected image. You can add more keywords by clicking them. And you can add and delete keywords using the icons on the lower right of the Keywords panel.

FIGURE 5.19

Bridge features a power search function in the Find Command. The Find dialog box can be customized to do all sorts of searches by clicking the pull-down menus under Criteria.

Backing Up and Archiving

Why organize all your photos if you don't take the time to back it all up? Digital offers all kinds of creative opportunities that have changed the way we work with images. Unlike film, though, digital files can disappear in an instant when a hard drive has a hard crash. If proper archiving measures aren't used, a bad hard drive crash can be catastrophic.

Hard drives

One of the easiest ways to create a backup is with a separate hard drive that backs up all image files. In its more sophisticated form, this is often an array of hard drives that are set up to act as one. This kind of array is called a *RAID* — Redundant Array of Independent Drives (or Disks). Several different schemes are used to protect file integrity on a RAID. Let's look at the two main ones:

- **Mirroring:** Identical data is written to more than one disk. If a disk in this array crashes, identical data is recovered from the mirrored disk.

- **Striping:** Information is spread out across multiple disks. This greatly enhances performance because several disks are doing the job of one disk when reading and writing. However, unless some form of *redundancy* is built into the system, there is no data protection as in mirroring. Setting up some form of redundancy allows for striped data to be recovered after a crash. One method of doing this is to reconstruct missing data by analyzing data that wasn't lost.

All the workings inside a RAID, mirroring and striping, happen in the background. The best part is that it happens automatically. The RAID just looks like a big hard drive to the computer's operating system. After a RAID is set up, it does its job whether you think about it or not. With the low cost of hard drives today, a RAID is a great option.

A less sophisticated hard drive solution is to have a secondary hard drive that's used for storing backup copies. These backups can be created automatically with specially designed software, or they can be created manually by dragging and dropping files. Of these two schemes, the automatic solution is by far the best. With backup software like ChronoSync by Econ Technologies (for Mac), you can even back up to another computer on your network.

Hard drive storage is a great solution for storing backup files, but this also can lead to a false sense of security. A few years ago, shortly after relocating my office, I had three hard drives crash within months of each other. They were all from different manufactures, and they weren't in a RAID. One of those drives was my main drive that had lots of data files on it. One of the other drives was a backup drive of that same data. Unfortunately, I hadn't taken the time to restore all the backed up data, so when the second drive crashed, it was gone.

TIP I solved my crashing hard drive problem by purchasing a universal power supply (UPS). A UPS is little more than big battery that you plug your computer into. If the power goes out unexpectedly, the battery kicks in, giving you time to close important files and shut down your computer. UPS units also do something else. They "clean up" the incoming power so it's more stable. That's what solved my crashing problem.

A more extreme nightmare scenario with hard drives is fire and theft. Either of these events can wipe out years of work. We have to think about all these possibilities as we consider the storage of our image files. I know several photographers who locate a backup drive or RAID in a hidden portion of their home or office, in case of theft. With some of the wireless hard drive solutions appearing today, this is an even more viable option. In the case of fire, the best protection is to have a backup of important data that's stored offsite. This is something we couldn't do back in the days of film, because there was usually only one copy of the original.

TIP Many photographers are beginning to use online storage options for backing up image files. This can be a great solution too. But if you use online storage, make sure it's not your only backup. We all know what happened to many Internet companies a few years ago when the economy took a dive.

CD/DVD

Another system for backing up and archiving images is our old friend the plastic disc: CD or DVD. CDs and DVDs are cheap, and almost any computer can read them. If handled properly, they will preserve data for many years.

NOTE Currently a debate is raging concerning the longevity of CDs and DVDs. Some people say that they can't be trusted, while others say they'll last 100 years. In my own experience, I've seen more hard drives fail than CDs or DVDs. Some people re-copy their CD/DVD archives every few years to ensure longevity.

CDs and DVDs are not as easy and seamless as using a RAID, and they don't offer quick access to data. In my mind, they are best used as an adjunct to a hard drive backup — more of an archive that can be pulled out anytime a file needs to be resurrected. In a well-designed workflow, they should be used at two different times. Here's what I recommend to my clients:

■ As soon as you finish sorting and renaming a new job or project in Bridge, burn a CD (or DVD if necessary) of all original files and store it in a safe place. In the case of a professional photographer, that would be in the client's folder.

■ After all work has been done with the job or project, burn a DVD of all related folders — originals, masters, and finals folders. File this DVD with the first CD/DVD backup you created. If the job or project is important, burn a second copy and store it offsite. Now everything is completely covered. You will probably never need these disks, but it is comforting to know that they are there in case you need them. If the job or project is a big one that takes lots of time, then intermediate DVD backups are a good idea. You can use re-recordable media for this.

When working with plastic discs, you need to observe some basic ground rules regarding handling. They scratch easily when dragged across rough surfaces, so they should be in some sort of acid-free sleeve at all times. Keep these additional things in mind when working with CDs and DVDs:

■ Try to avoid writing on the top surface with ink pens. These discs are read by a laser beam that shines up from the bottom through the lower layers of plastic, reflects off the shiny layer on top, and bounces back down. If anything is done to degrade the reflective surface on the top of the disc, the laser won't be able to read it. Sometimes the acid in a pen's ink can destroy the shinny layer on top.

If you have to write on a disc, try to do it on the inner circle where the plastic is clear. Another option is to purchase printable CDs and DVDs. These are designed to be printed with an inkjet printer. They have more durable surfaces.

■ Only use labels that are approved for CDs and DVDs. These use adhesive that's acid-free.

You really don't know what kind of adhesive is used on a standard mailing label. Besides the adhesive issue, mailing labels can cause a different set of problems. A couple of years ago, a client of mine dropped off a CD with files he wanted me to work on. He labeled them with three small, rectangular labels. Each label had a different set of information. I was unable to read this disc on any of my systems because when it was spinning at 10,000 RPM in the disc drive, the labels threw it out of balance.

■ As I mentioned, store disks in proper, acid-free sleeves or envelopes. Keep them out of the sun, preferably in the dark. Store them lying flat, rather than standing on end.

In a perfect world, hard drives and CDs/DVDs are used together with the hard drive acting as an up-to-date backup that can be easily accessed and the plastic discs acting as long-term storage. You don't need a sophisticated backup and archiving system, but you do need a system. Working without one is like a trapeze artist working without a net. When things come crashing down, it can be a real showstopper.

Summary

We covered lots of ground in this chapter. First, we looked at the different kinds of files that typically are used for images in Photoshop and when they're most appropriate. We then explored the ways these files are used in the workflow and how to organize them so they can be accessed quickly when needed.

Much of this chapter dealt with Adobe Bridge CS3, the file browser that ships with Photoshop CS3. With Bridge, you can organize and sort image files in very intuitive ways. You can use Bridge to rename, label, and add metadata to image files. Because we only scratched the surface of this powerful piece of software, I encourage you to dig deeper into the many features that I didn't cover. You'll be amazed at some of the things you'll find when you get in there and start poking around.

In the last section of this chapter, we covered backing up and archiving. What's the point of getting organized if all that effort is left to the whim of a random electrical surge that takes out a hard drive? Losing once-in-a-lifetime photos can be heartbreaking. Take the time to implement some kind of backup system now. Start small with plastic discs if you need to and grow into a RAID when you can. When things turn ugly, you'll be glad you did.

Part II

Photoshop Tools and Techniques

In a sense, restoration and retouching are completely different disciplines because they have different sets of goals. In restoration, the objective is to return a damaged "original" to its former glory by scanning it, digitally repairing any damage, and then making a new print. On occasion something creative is done, like colorizing a black-and-white original. However, these techniques are almost always in keeping with the styles that prevailed at the time the original was created.

Retouching, on the other hand, is more concerned with fine-tuning an original image and making improvements to it so that it rises to a higher level of quality. Retouching is often used to fix problems, but its true power is revealed when it's used to turn good images into great images.

Even though these two disciplines have different sets of goals, the tools and techniques used to achieve those goals are the same. In this part we survey many of these tools and techniques When we get to Parts III and IV you'll be ready to see how to put these tools and techniques to use solving common restoration and retouching problems.

Chapter 6

Using Photoshop's Main Retouching Tools

In this chapter, we focus on the three main retouching tools in Photoshop: the Clone Stamp, the Healing brush, and the Patch tool. Along the way, we take a couple of side trips to visit some other tools called the Spot Healing brush and the Liquify filter.

You may have noticed that I'm calling these tools retouching tools, yet this book is titled *Photoshop CS3 Restoration and Retouching Bible*. That's because these tools and many techniques associated with them are often used in the same ways to solve restoration and retouching problems. For example, the procedure for repairing a hole in an old print in a restoration job is the same as removing something distracting in a retouching job. The tools are generically called retouching tools, because that's what they're most known for.

This is much like the relationship between a carpenter and his tools. After he's mastered them, he can use them to achieve all sorts of goals. The carpenter can use his tools to restore a historical home, or he can build a new home from scratch.

Just like the carpenter's tools, the concepts in this chapter are core to the restoration and retouching processes. Any serious restorer or retoucher uses most of them on a daily basis. I encourage you to spend some time exploring them as you move through this chapter because everything you learn here will serve you well in the future.

Working with Brushes

Some of the tools we explore here use what are called *brushes*. A brush is the virtual equivalent of a real paintbrush. It's used to apply colors, tones, and

pixel information in a variety of ways for a various number of reasons. Their properties — such as size, hardness, and opacity — can be modified in countless ways to produce just the results that are needed. We begin our exploration of the brush concept in Photoshop with its most basic form: the Brush tool.

Changing brush settings with the Tool Options bar

One basic way of making adjustments to a brush is with the tools options on the Tool Options bar near the top of the screen. Here's how:

1. Open the New Document dialog box using File ➪ New (Command/Ctrl+N), and set the following properties: Width = 6 inches, Height = 4 inches, Resolution = 300, Color Mode = RGB Color/8-bit, and Background Contents = White.

2. This isn't the first time we've needed a new file with these properties. So before clicking OK, click the Save Preset button. When the New Document Preset dialog box opens, enter **4x6 @ 300 white** into the Preset Name text box. Click OK twice as seen in Figure 6.1.

FIGURE 6.1

After the New file dialog box is completed, a preset is saved when you click the Save Preset button. When the New Document Preset dialog box opens, give the preset a unique name and click OK.

Now that you've saved these properties as a preset, you can quickly create a file with the same properties in the future by selecting the preset from the Preset pop-up menu in the New file dialog box.

TIP You can save presets in a variety of places in Photoshop. You can use them for all kinds of things, from creating new files to saving a set of special properties for a tool. Using presets helps to save time and guarantees that when a particular preset is loaded, the settings are exactly the same every time.

3. Select the Brush tool (B) from the toolbar. If you don't see the Brush tool on the toolbar, you'll find it stacked with either the Pencil tool or the Color Replacement tool, eighth from the top on the single-column toolbar.

4. Set your foreground color to black by pressing the D key (for default foreground and background colors) on your keyboard.

5. Before you begin to paint, we need to make sure that we're all using the same paintbrush. Go to the Tool Options bar at the top of the screen, and click the pop-up menu next to Brush, as shown in FIgure 6.2. Set the Master Diameter to 100px, and set the Hardness to 100%.

TIP A moment ago, you saved a preset for creating new files. Tool presets work in much the same way. You can save a preset for this tool by clicking the Create New Preset button on the pop-up menu, as shown in Figure 6.2. However, with this brush, you don't need to do this. It's already one of the default presets.

FIGURE 6.2

The pop-up menu next to Brush on the Tool Options bar provides a quick way to change brush diameter and hardness. The Brush Preset picker is part of this menu. To select a preset, click it. To save a new preset, click the Create New Preset button.

6. Click one side of the new file you opened, and drag across the upper part of the white background while holding down the mouse button. You should see a heavy, black line appear on the white background.

TIP If you want the line to be perfectly straight, hold down the Shift key while drawing.

7. Go back to the Tool Options bar, change the hardness to 0%, and draw a new line just below the first line.

 Notice is that the edges of the line are much softer. Notice also that the line isn't as thick as the first line. The softness of the edge fades in toward the middle of the stroke.

8. Go back to the Tool Options bar, change the Opacity to 50%, and draw a third line below the second line. The new line is just like the previous line except that it's much lighter.

9. Now, draw another line just like the last one except from top to bottom, as shown in Figure 6.3. Notice that when this line crosses the bottom line, the two strokes combine to create a darker tone that's twice as dark.

 If you want to verify this, use the Eyedropper tool to measure the bottom line where the lines cross and where they don't cross. When I did, the values were 64 and 128 respectively. Recall that we have 256 tones at our disposal (black = 0, and white = 255). The vertical stroke darkened the horizontal stroke by 50%.

FIGURE 6.3

Brushes have variable settings like size, hardness, and opacity. Different effects can be achieved by modifying these variables.

You may have noticed that when two 50% opacity strokes cross each other, they don't combine to create 100% opacity. That's because each of the 50% strokes is simply making the current darkness of the stroke 50% darker. Even ten strokes on top of each other don't combine to equal 0 (black). Instead, they equal 1 because no matter how many times we reduce the brightness of the strokes by 50%, we can never halve the density to 0.

Here's another useful experiment:

1. Go back to the opening state of the file above by clicking its thumbnail at the top of the History palette.
2. Go to the Brush Tool Options bar, and set the Master Size to 100 px, the Hardness to 100%, and the Opacity to 100%.
3. This time, set Flow to 50%, and draw a curvy line across the upper part of the white background.
4. Change the Flow to 25%, and draw a second line below.

 Flow adjusts the rate at which a color is applied as a stroke is drawn. The lower the value, the more spread out the color's application is. With a hard brush, this manifests as overlapping circles, as shown the two top lines in Figure 6.4.

FIGURE 6.4

The Flow setting on a brush affects the rate at which the color is applied. With a hard brush, a stroke looks like overlapping circles. When the brush is soft, the overlapping isn't noticeable.

5. Change the brush's hardness to 0% and the flow to 50%, and draw a third line below the first two.

6. Change the flow to 25%, and draw a fourth line.

7. Change the flow to 100%, and draw a fifth line at the bottom of the white background.

 Your image should look something like Figure 6.4. Notice that when Flow is lowered with a hard brush, the result is very noticeable. However, when a soft brush is used, the different Flow settings look more like variations in opacity and hardness.

Now that you know all about Flow, I have to tell you that I rarely change it from 100% when I'm working on a restoration or retouching project, or anything else for that matter. This section is the last time we change Flow. I included it because I am often asked by students what the Flow setting does.

One more thing to look at on the brush's Tool Options bar is the Airbrush setting. This is enabled by clicking the small airbrush icon to the right of the Flow setting (refer to Figure 6.2). When this setting is enabled, paint is continually applied while the mouse button is held down, much like holding a can of spray paint in one place while spraying. Here's how to use the Airbrush setting:

1. Go back to the opening state of the file above by clicking its thumbnail at the top of the History palette.

2. Set the brush size to 200 px, Hardness to 50%, Flow to 100%, and Opacity to 50%.

3. Click and hold in one location to paint a soft circle. Notice that no matter how long you hold down the mouse button, the circle doesn't change.

4. Activate the Airbrush feature by clicking the Airbrush icon. Now click and hold just as you did above, but in another spot.

 This time, the longer you hold down the mouse button, the more paint is applied, just like an airbrush.

5. Try experimenting with different settings to see what kinds of changes you get. Also try drawing some lines with and without the Airbrush feature turned on.

The results of painting with the Airbrush vary depending on the other settings on the brush. It's a cool feature to know about when painting with the brush. This feature is available only on the Brush tool and the Clone Stamp tool. We won't use it on the Clone tool when we explore it. However, we will return to the Brush tool in Chapter 12 when we cover burning and dodging. That will be a good time to remember the Airbrush feature.

Before we move on to the actual retouching tools, I want to tell you about some great shortcuts you can use when working with brushes. Remember that other tools besides the Brush tool use brushes, so these shortcuts are useful for many of them.

- To change the brush size, use the bracket [] keys on your keyboard. The right bracket makes the brush larger, and the left bracket makes it smaller.

- To change the hardness in 25 percent increments, press the Shift key and the right or left bracket. The left bracket reduces the hardness, and the right bracket increases it. If you are set at 100%, pressing Shift+[four times reduces the hardness to 0%.

- To change opacity, use the numbers on the keyboard. Press 3 to set it to 30% or 5 to set it to 50%. If you want 55%, press 5 twice quickly.

- To change the brush's flow, press Shift plus the number; Shift+5 equals 50% flow.

- When the Airbrush feature is active, some of these shortcuts work a little differently. Pressing numbers on the keyboard changes Flow instead of Opacity. To change the brush's opacity when using the Airbrush, use Shift plus the number. (This is the opposite of when the Airbrush isn't activated.)

Another shortcut I use all the time in Photoshop and other programs is the right-click on the mouse. When you right-click in Photoshop, a context-sensitive menu pops up. For tools that use the brush, right-clicking opens the tool's Brush Presets pop-up menu dialog box, shown on the left in Figure 6.5. The only variation is when using the Healing Brush tool or the Spot Healing Brush tool. Because those tools have slightly different brush controls, the context-sensitive pop-up is a little different, as shown on the right in Figure 6.5.

FIGURE 6.5

Right-clicking in Photoshop opens a context-sensitive pop-up menu that varies with the tool that's currently in use. This is a great way to quickly gain access to tool settings and options. Take the time to explore right-clicking in Photoshop, as well as other programs you use.

TIP I know that some Mac users may be a little confused right now. For many years, Macs didn't have a right-click option. Even the latest laptops don't have a right-click button by the trackpad. Instead, Mac users use the Control key when clicking to achieve the equivalent of a right-click.

This has changed with newer Macs running current versions of OS X. Apple's newer mice have a right-click button, even though it may not be obvious. Many users don't realize that they have this capability. It may not even be activated in the Mouse Preferences. If you're a Mac user, find out if your mouse has a right button and see if it works.

If you use a newer Mac laptop, you can still set up the trackpad to right-click by tapping with two fingers at the same time. The setting is found in System Preferences under Keyboard & Mouse ⇨ Trackpad.

The Brushes palette

With the Tool Options bar and a handful of shortcuts, you can quickly change the main settings on a brush. Sometimes, though, those quick settings aren't enough. When this happens, it's time to go to the Brushes palette.

The Brushes palette, shown in Figure 6.6, is activated by choosing Window ⇨ Brushes, if it's not already on your desktop. This is where serious brush users go to create all sorts of custom brushes. Each setting in the left Brush Presets menu activates different options on the right. The preview window at the bottom shows how the current selection of settings is affecting the brush.

FIGURE 6.6

The Brushes palette contains a powerful brush engine that allows you to customize every conceivable aspect of a brush. The preview at the bottom of the dialog box shows what a stroke looks like with the current settings.

This is where brush power-users come to create their special tools. These people usually are illustrators and painters who use Photoshop in very creative ways. Even though I use Photoshop tools that use brushes, I don't really consider myself one of these power-users. In fact, I rarely go to the Brushes palette, because I don't need such sophisticated brushes. I pointed out the Brushes palette here because I want you to know it exists in case you decide to explore some of the custom settings — and maybe become a brush power-user yourself.

Working with a graphics tablet

I don't know about you, but I can't draw very well with a mouse. Mice are great for moving around and clicking things quickly, but they don't do well when it's time to work on the details. Try using the Brush tool to write your name with your mouse. That's really hard for most people. Mice just aren't built for fine detail and articulation — things that are important when working in the restoration and retouching fields.

This raises another point. Because mice aren't built to be used in the way they're often used, they aren't ergonomic. (I know there are ergonomic mice out there, but they still don't give us the mobility we need.) This can lead to repetitive stress injuries. When we use mice in a very controlling way, we tend to tense the muscles in our hand, sometimes all the way up our arms and our necks.

When I really got serious about Photoshop several years ago, I began developing pain in my wrist and neck because I was spending so much time editing. The pain began to diminish the pleasure I was getting from Photoshop. I tried a trackball, but that wasn't any better. After I bought a graphics tablet, my Photoshop life changed. I can now work long hours with much less stress to my body.

> **TIP** When we spend so much time in front of a computer, we have to be conscious of our working environment. I've met many digital photographers who pour lots of money into their equipment, but never consider the health consequences of working in a non-ergonomic environment. To learn more about ergonomics, see the U.S. Department of Labor's Safety and Health Topics Web site at `www.osha.gov/SLTC/ergonomics/`.

A graphics tablet consists of a special pen called a stylus and a sensitive tablet that can sense when the pen touches the tablet. Because the action of holding a pen and drawing with it is more natural than using a mouse, the tablet requires much less strain. This natural motion also lends itself to fine articulation and detail work. I often work with mine in my lap to give my arm a rest.

Wacom tablets, as shown in Figure 6.7, are the industry standard for graphics tablets. Wacom makes a variety of tablets with different features and sizes under two main lines: Graphire and Intuos. They come in sizes from 4×6 inches to 12×19 inches. Keep in mind, though, that this is one case where bigger isn't necessarily better. For one thing, a large tablet takes up lots of room on your desk. When moving around the tablet, you have to cover more distance on a large tablet, requiring more hand and arm movement. I have used the 6×8 tablet for many years, and I'm completely satisfied with that form-factor.

FIGURE 6.7

Wacom tablets come in a variety of sizes. This one is one of the newer models, the Intuos 3 6×11-inch tablet. The standard size in this range used to be 6×8 inches. This one is 3 inches wider to make the form factor match more closely to the wide displays that are being used by so many people today. The 6×11 also is very useful for people working with two monitors.

The pen that comes with a Wacom tablet has two buttons that can be used for right- and left-clicking. In essence, it's like a pen-shaped mouse. You also can "click" by tapping the tablet; one tap equals one click, and two quick taps are a double-click. Some of these tablets also come with mice. Personally, I don't care for these mice, so I use a different one instead.

Be aware that beginning to use a graphics tablet can be a little disorienting. For one thing, the tablet is mapped to the screen. That is, if the pen is touching the tablet in the lower-left corner, the cursor is in the lower left of the screen. To move the cursor to the top right of the screen, move the pen to the top right of the tablet. This learning curve can take a little time, but it's well worth the effort.

NOTE You may have noticed that some of the settings in the Brushes palette have a Control setting that allows various features — such as the Shape Dynamics Size Jitter control — to be controlled by pen pressure. These settings are designed to work in conjunction with a graphics tablet. They're more useful for people doing creative painting than for the tasks we do here. I tend to turn these settings to the Off position.

Using the Clone Stamp Tool

The Clone Stamp tool has been with Photoshop since the earliest days. In essence, the Clone Stamp is used to clone information in an image so that it can be painted into another part of the image. For example, clean skin is *sampled* and painted on top of blemished skin. This simple, yet powerful, ability of the Clone Stamp tool in early versions of Photoshop opened the door to retouching as we know it.

Let's get familiar with this tool and then look at some of the more advanced techniques that are used with it:

1. Open the practice file, bird_1.tif, from the downloadable practice files on the Web site.

2. Select the Clone Stamp tool (S) from the toolbar. It's ninth from the top on the single-column toolbar. Make sure that you're not selecting the Pattern Stamp tool that's stacked with the Clone Stamp.

3. Click the bird's head while holding down the Alt key on your keyboard.

 When you press the Alt key, notice that the cursor changes to a target-like cursor. This is a clue that you are about to sample something.

4. Set your brush size to 100px and the Hardness to 0. Make sure Aligned is checked in the tool options. Also make sure your opacity and flow are set to 100%.

 I tend to work with a soft brush at a setting of 0 until I'm forced to use a harder brush around hard edges.

5. Release the Alt key, and move you cursor to the right side of the image where the sky is mostly empty. Click and begin painting in a second bird.

 Notice that two cursors appear as you paint, shown in Figure 6.8. One cursor is in the area where you're painting, and the other is on the content that's being sampled. As you move the cursor to paint, the sampling cursor follows in alignment, continually updating the information that's being sampled.

NOTE When the Aligned box is checked, the two Clone Stamp cursors stay in alignment each time you stop and resume painting. When the box is not checked, the sampled pixels from the initial sample area are used for every stroke.

6. After you have painted the bird duplicate, it should look something like Figure 6.9.

FIGURE 6.8

When painting with the Clone Stamp tool, you see two cursors. The cursor on the left indicates where information is being sampled and the cursor on the right shows where the sampled information is being applied. As you paint, the source cursor follows the painting cursor in perfect alignment.

FIGURE 6.9

The cloning job is complete, but in a few areas I picked up some of the sky around the bird I was sampling, causing some haloing around the new bird.

This image is somewhat forgiving because of the sky and clouds in the background. These soft details lend themselves to blending together. If the background had lots of complicated details, we would have to be more careful about the edges of the duplicate bird blending in.

With that said, I still see a few problems with the duplicate bird in Figure 6.9. A white halo has formed around the bird's tail, beak, and far wingtip caused by clouds around the original bird that I picked up when sampling. I can deal with this in two ways. I could undo the new bird and then repaint it with a smaller brush, especially around the beak and wing. This way works fine, though it can take some trial and error to get just the right size for the job. A faster way to handle this would be to fix the duplicate bird instead of taking the trial-and-error route.

Undoing with the History brush

Right next to the Clone Stamp tool is another brush tool called the History brush tool. The History brush is perfect for solving the problem at hand. The way the History brush works is that you pick a previous history state from the timeline on the History palette by clicking in the box to the left. After a history state is selected, it can be used to paint that state back into the image. In this case, we want to pick any history state that is previous to the cloning of the bird. By default, the History brush is set to the opening thumbnail at the top of the History palette, as shown in Figure 6.10, which is exactly what we want.

Let's play with the History brush for a minute:

1. Go back to Step 6 in the preceding set of steps. Select the History brush (Y) from the toolbar. It's tenth from the top on the single-column toolbar. Make sure you aren't selecting the Art History brush that's stacked with the History brush.

2. Select a small, soft brush and paint away the halos around the bird by replacing them with the blue that was there before the cloning. Zoom in to make it easier to see what you're doing.

 If your brush is too soft, you'll have a hard time getting a nice edge along the wing because the softness of the brush bleeds over to the wing. Try a harder brush with an opacity of 50 to 75%. If you're still having problems with the edge of the wing, try reducing the opacity of the History brush to 50% to get a better blend along the edge.

3. If you need to paint some of the wing or beak back in, use the History brush. Select the last Clone Stamp history state in the timeline on the History palette by clicking in the box next to it. Don't close the image yet, because we use it again in just a moment.

NOTE Be aware that this tool is tied to the History palette. That means that when the file is closed, all history states are lost. So be sure to use this tool, if necessary, before closing and saving.

FIGURE 6.10

Any history state in the History palette can be used for sampling with the History brush by clicking the box to the left of the history state you want to sample. By default, the History brush is set to sample the opening state of the image: the thumbnail at the top. You can tell because the History brush icon is in the box to the left of the thumbnail.

Cloning from one image to another

We could continue cloning the original bird until the image is full of birds. The problem with this is that each bird would be identical to the first bird so the image wouldn't look very convincing. We can solve that problem by opening another image and cloning a different bird into the first image:

1. Go back to the bird_1.tif image that we worked on earlier. If the image is not currently open, open it again.

2. Open the bird_2.tif practice file from the downloadable practice files from the Web site. You should now have two images open. Position them so you can see both images.

3. Select the Clone Stamp (S), and use the Alt key to sample the bird in bird_2.tif.

4. Go back to bird_1.tif, and begin painting the new bird in between the two existing birds. When you're finished, your image should look something like Figure 6.11.

As you can see, the Clone Stamp is a versatile tool. You can handle all sorts of restoration and retouching issues with it by sampling (copying) part of an image and painting (pasting) the new information into another part of the image — or an entirely different image. Now, with a new feature in Photoshop CS3 that's called the Clone Source palette, the Clone Stamp is even more powerful.

FIGURE 6.11

The Clone Stamp tool can be used to duplicate information from one file into another. To do this, sample the content of one file by Alt-clicking, and then paint the new information into the second file.

Using the new Clone Source palette in Photoshop CS3

One of the cool new features in Photoshop CS3 is the Clone Source palette, shown in Figure 6.12. This new palette provides a number of features that enhance the performance of the Clone Stamp and the Healing brush tool:

- You can save up to five different sample sources by selecting the Clone Source icons at the top before sampling with the Alt key.
- You can transform — rotate or scale — the source material as it's being painted in.
- An overlay can be displayed to help with positioning cloned data as it's applied.

143

Let's try out some of these new features on our bird photos. Saving multiple Clone Source points is pretty straightforward, so we focus here on the other two features — rotate/scale and the overlay:

1. Open the bird_1.tif file from the enclosed CD. If the file currently is open from the preceding exercise, close it and reopen it by choosing File ➪ Open Recent ➪ bird_1.tif. Also make sure that bird_2.tif is closed.

> **TIP** The Open Recent menu gives you access to the last ten files that were opened or saved. You can change the number of files that appear in this menu in the File Handling preferences in Photoshop's Preferences.

2. Select the Clone Stamp tool, and make the Clone Source palette is visible by choosing Window ➪ Clone Source. Check the box beside Show Overlay.

3. Sample the bird using the Alt key, just as you did in the first exercise with this file. After the sample has been made, the clone overlay appears, as shown in Figure 6.12.

FIGURE 6.12

The new Clone Source palette provides a number of enhanced controls for the Clone Stamp and Healing brush tools. You can designate up to five clone sources, indicated by the five icons across the top of the palette. Cloned data can be rotated and scaled using the Offset controls in the middle area. Also, a new overlay can be turned on so that it's easier to see where cloned data will appear, as shown on the right.

4. When the overlay is positioned where you want it, click and begin painting. If you don't want to see the overlay while you paint, check the box beside Auto Hide on the Clone Source palette.

This overlay feature is really nice. It allows you to see what you're cloning before you paint it. The overlay really shines when combined with the rotate/scale feature.

5. Now, undo any cloning you just did. The image should look like it did when it was opened. The sample point you selected previously should still be active.

6. Go to the Clone Source palette, and change the scale of the width to 50 percent. Now the sampled data should be half the size in the overlay. Begin painting again. This time the bird is smaller, so it looks like it's farther away — a much more convincing effect than cloning at 100 percent.

TIP A great way to work with the scale and rotation boxes is to use scrubby sliders to change the values. When the Overlay is active, any settings changes are previewed as soon as they're made, which provides an interactive way of finding the best setting for what you need.

7. Enter a value of **180** into the Rotation box just below the W and H boxes. Notice that the preview in the Overlay is upside down, which is not such a convincing effect!

8. Let's try one more setting. Reset all transform settings by clicking the Reset transform button to the right of the Rotation box, the one with a circular arrow on it. This time, change the width setting to **-100%**. Now the preview is a mirror image of the bird.

Making either the width or height a negative value flips the cloned content on its vertical axis, causing it display a mirror image, as shown in Figure 6.13.

This new palette adds a huge amount of flexibility to the Clone Stamp tool. Spend some time familiarizing yourself with it now, so that you'll be comfortable with it when the right opportunity presents itself.

FIGURE 6.13

To get a mirror of the cloned source data, change either the width or height value to a negative number.

Working with Tool Blending Modes

As you can see, the Clone Stamp tool is quite useful for sampling information and painting it back into the image in a different spot. In the preceding exercises, we used it to add new visual content to the image. When using this tool on restoration and retouching jobs, the thinking is a little different, even though the process is quite similar. With restoration and retouching, the objective is usually to hide something in the image by copying information on top of it. For example, when retouching a blemish on someone's face, clean skin is sampled and painted on top of the blemish to hide it. New content is being added to the image, but in a way that it doesn't draw attention to itself.

This sample-and-paint method works quite well when retouching blemished skin in a portrait as long as the skin being sampled is the same color as the area into which it's being painted. If the sampled skin is darker or lighter — even by a small amount — the retouching is noticeable.

When you run into this scenario, you can modify the Clone Stamp tool so that those differences in tone are easier to manage. The main way of gaining control over the Clone Stamp is to change the tool's blending mode.

In Chapter 4, we used layer blending modes to change the way one layer blended with the layer below it. You've probably noticed that the Brush and Clone Stamp tools also have a blending mode drop-down menu on the Tool Options bar. It's located just to the left of the Opacity setting. (You can see it back in Figure 6.2.)

These tool blending modes work in the same way as layer blending modes do, except that they only affect strokes that are painted with the tool, rather than the entire layer. This is extremely useful when working with the Clone Stamp. The two blending modes we're interested in here are the Lighten and Darken modes. Here's what these modes do:

- The Lighten mode affects tones that are darker than the sampled tone. Any tones that are lighter than the sampled tone are unaffected.

- The Darken mode works in the same way, but with the opposite effect. Tones lighter than the sampled tone are lightened. Tones darker than the sampled tones are unaffected.

Figure 6.14 compares the difference between using the Clone Stamp with the blending mode set to normal and lighten. In this example, I'm attempting to tone down the dark blemish in the center of this young woman's forehead; you can see it in the first, unretouched image. In the second image, I sampled the skin just to the left of the blemish and painted it on top of the blemish. I did this in a slightly exaggerated way so that you can see the effect. In the third image, I did everything exactly the same, except that I changed the blending mode on the Clone Stamp to lighten. Now you can see that only the dark tones of the blemish have been replaced, while the surrounding lighter tones are unaffected.

FIGURE 6.14

In this demonstration, the goal is to lighten the dark blemish in the center of this young woman's forehead (first image). First, I use the Clone Stamp with the blend mode set to normal. The slightly darker skin that is sampled is too obvious (second image). I undid that cloning and changed the blending mode to Lighten. Now only the darker areas are being affected by the cloning and the retouching is barely noticeable (third image).

TIP Another way to gain control over the Clone Stamp tool is to lower its opacity so that you're not painting with 100 percent of the sampled tones.

I find this technique to be most useful when working with flyaway hair. If I'm dealing with light-colored hair against a dark background, I select the Darken mode. If I'm dealing with dark-colored hair against a light background, I select the Lighten mode. This technique also can be used in a variety of other scenarios — like wrinkles and folds in skin. However, in most of those cases, I prefer to use two more powerful retouching tools called the Healing brush and the Patch tool.

Using the Healing Brush

The Healing brush tool (J) appeared in Photoshop 7, and it completely changed the way digital retouchers work. The Healing brush is similar to the Clone Stamp in that information is sampled by Alt-clicking and then painted into other parts of the image. The big difference is that the Healing brush attempts to make the sampled data match the lighting and shading of the area to which it's being applied. In other words, it looks at the area where the sampled data is being applied and tries to make the sampled information match the target area. This is huge! Before the Healing brush, we had to futz around with the Clone Stamp's blending modes and opacity to get it to work just right. With the Healing brush, all that trial-and-error is eliminated.

 Before we get into the nuts and bolts of the Healing brush, I want to show you just how powerful it is. Let's go back to the image of the young woman. This time, instead of sampling her skin, I'm going to sample the black background to the right and apply it to the blemish, as shown in the first image in Figure 6.15. At first, this might look like I've lost my marbles. However, when I let go of the mouse button, the transparency, lighting, and shading of the black sample is changed to match the skin tones where it's being applied, as shown in the second image in Figure 6.15. If I had sampled the light-colored sweater to the left instead of the black background on the right, the tones would have still blended, but the texture of the sweater would be noticeable.

> **NOTE** Because of this blending capability, the Healing brush doesn't always do a good job of making a literal copy, like what we were doing with the bird photos earlier.

This young woman has plenty of clear skin that I could have sampled instead of the dark background. Sometimes, though, that's not the case. By using any area in the image that doesn't have a strong texture — like the background here — you can build an area of smooth skin that can be used as a sample area for further retouching.

Even though the Healing brush is a brush tool, the options for setting it up are a little different than the Clone Stamp or the Brush tool. The first thing you'll notice is that it doesn't have an Opacity setting. This can be a bit disconcerting at times. (I'll show you how to deal with it in a moment.) Another big difference is that the Brush pop-up menu on the Tool Options bar isn't the same. Figure 6.16 shows what it looks like.

FIGURE 6.15

The Healing brush tool does such a good job of blending that it's able to blend the sample of the dark background to the right of the woman into the skin tones nearly seamlessly.

FIGURE 6.16

The Brush pop-up menu for the Healing brush is different than the Clone Stamp's pop-up menu. The main thing that's missing is an opacity slider.

Something else you might have noticed is that when the Healing brush is selected, all the options on the Brushes palette are grayed out. That means that you can't use the Brush palette with this tool. The few features that are available have been moved to the pop-up Brushes menu in Figure 6.16. You already know about the Diameter and Hardness settings, so let's look at the other options on this menu:

- Spacing controls the distance between the marks that are laid down when a brush stroke is made. The value is a percentage of the size of the brush. When higher values are used, the brush stroke skips along, laying down a series of dots rather than a solid line. I seldom raise this any higher than 1 percent, which is the lowest value.

- Angle controls the rotation of the long axis from horizontal. This setting can be used to create a chiseled effect.

- Roundness controls the ratio between the long axis and the short axis of the brush. The lower the value, the more linear (rather than round) the brush is.

- The Size pop-up allows you to use pen pressure on a graphics tablet to vary the size of the stroke. The harder you press, the bigger the stroke. In Figure 6.16, you'll notice a warning icon just to the left of this setting, which indicates that a graphics tablet is not currently connected to the system.

- The Brush Preview allows you to see changes to the shape of the brush when values for Angle and Roundness are modified. You also can click and grab sections of this display to interactively change settings.

Now that I've explained these settings, I want to tell you that it's pretty rare for me to change them. I find that I can accomplish what I need to do by working mostly with Diameter and Hardness. In fact, I always retouch with a graphics tablet, yet I turn off pen pressure because I want to control brush diameter with a fixed setting, rather than the pressure of my pen.

The Healing brush also has a Blending Mode pop-up, though the options are more limited than with the other brush tools. These additional settings on the toolbar are worthy of note:

- Source determines where source data comes from. When set to Sampled, the Alt key is used to sample image information. When set to Pattern, a pattern from the Pattern pop-up menu (which is activated when this is selected) is used. I always leave this set at Sampled.

- Aligned is the same as the Aligned setting in the Clone Stamp options. When this is checked, sample points are aligned with the brush as it moves. When it is deselected, the original selection is used for every new stroke.

I'll cover the Sample settings when I talk about retouching multiple layers.

The new Clone Source palette, which we explored when I discussed the Clone Stamp, also can be used with the Healing brush. I find the overlay settings to be quite useful here too.

As I demonstrated earlier, the Healing brush is a powerful tool. However, the blending features that make this tool so powerful also can cause it to fail miserably in certain circumstances. Whenever this tool is used in an area where there's a big difference between light and dark tones, it gets confused. This confusion manifests itself as a smear in the image.

Let's go back to the image of the young woman. Imagine that I want to retouch something on the edge of the white hood she's wearing. I sample the white area to the left and paint a stroke along the edge of the hood. When I do this, the tool wants to blend my stroke with the underlying tones. But it gets confused because it doesn't know if I'm interested in the light tones or the dark tones, so it gives me a little of each — a dark smear as shown in Figure 6.17.

FIGURE 6.17

The powerful Healing brush tool can be fooled easily when it's used along an edge with strong contrast. This confusion shows up as a smear in the image.

There are two ways to deal with this scenario. The first is to switch to our old friend, the Clone Stamp tool. The other is to use a selection to isolate the area so that tones outside of the selection are not used in the Healing brush's calculations. (I cover selections in detail in Chapter 7.)

Busting Dust with the Spot Healing Brush

The Spot Healing brush is a close cousin to the Healing brush. They're both stacked together, along with the Patch tool and the Red Eye tool. The Spot Healing brush has the same blending abilities as the Healing brush. The main difference is that sampling isn't done with the Alt key. This tool automatically creates a sample from around the area that's being retouched. This can save lots of time,

but it also can cause some problems when detail you don't want to sample is being sampled. It works best in areas that are low in detail, such as backgrounds. This tool is most useful when cleaning up dust on scans, removing DSLR sensor dirt from a background, or getting rid of dirt and mold spots from scans of old photos.

 The first image in Figure 6.18 shows a photo of my mother that was taken many years ago. It has a number of dirt and mold spots in the sky and on her dress. The Spot Healing brush is the perfect tool for handling these spots because of the lack of detail in these areas.

FIGURE 6.18

This old photo has several dirt and mold spots in the sky and on her dress. These can be removed in a number of ways with the retouching tools in Photoshop, but the Spot Healing brush is the fastest. With only a couple of minutes' work, the spots are removed.

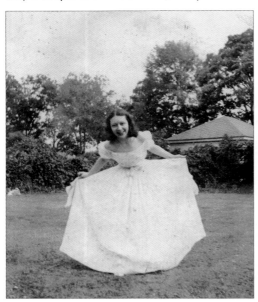 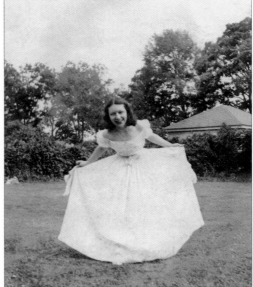

To quickly remove these spots, I select the Spot Healing brush, adjust the brush size so that it's a little bigger than the spots I'm removing, and simply click them to remove them. The second image shows what the image looks like after about two minutes of work with the Spot Healing brush. Retouching doesn't get much faster than this!

Two of the tool options for the Spot Healing brush to note are Proximity and Create Texture:

- **Proximity Match** uses pixels around the selection to generate the sampled data.
- **Create Texture** uses the pixels in the selection to create a texture that is used to fill the area being painted.

For the example in Figure 6.18, each of these settings worked equally well. However, if you don't like the results of one setting, try the other.

Using the Patch Tool

As useful as the Healing brush is, I prefer to use the Patch tool for a large percentage of my retouching. The Patch tool is stacked with the Healing brush and the Spot Healing brush, and it works in a very similar way. The main difference is in the way image information is sampled and applied. This tool uses a selection instead of a brush. A selection is drawn and then dragged to the area to be sampled. When the mouse button is released, the sampled information fills the original selection and blends it in the same way as the Healing brush does. Let's see how this tool works:

1. Open the practice file, portrait_1.tif , from the downloadable practice files from the Web site.

2. Select the Patch tool (J) from the toolbar. It's stacked with the Healing brush, seventh from the top on the single-column toolbar. Make sure that Source is selected in the Tool Options bar next to Patch.

TIP **To quickly select a tool that's stacked underneath another tool, use the Shift key along with the tool's shortcut key to cycle through the stacked tools. In this case, use Shift+J. (To make this work, be sure to select Use Shift for Tool Switch in Photoshop's General preferences; it is already selected by default.)**

3. In this example, we want to tone down the lines under the woman's eyes. Click and draw a selection around the lines under the right eye, as shown in the first image in Figure 6.19. Keep the selection a little loose around the outside so it's not too close to the detail that's being removed.

TIP **Selections can be created using any of the selection tools covered in Chapter 7.**

4. Move the cursor so it's inside of the selection. Notice that a small box appears next to the cursor as in the first image of Figure 6.19.

 When the cursor is inside of the selection, you can click and drag the selection to the area you want to sample. If the cursor is outside of the selection, a click erases the selection and begins a new one.

5. Click inside the selection and hold down the mouse button while dragging it to the top of her forehead where the skin has the least amount of texture, as shown in the second image in Figure 6.19. Don't get too close to the hairline.

 As you move the cursor, you'll notice that the original selection under the eye is constantly being updated with the information that's inside the second cursor. This preview is extremely useful when patching an area that contains detail such as lines or patterns. Using the preview, you can line up these patterns before releasing the mouse button.

FIGURE 6.19

Fixing the lines under this young woman's eyes is a perfect job for the Patch tool. A selection is drawn around the area with the Patch tool (first image). The selection is moved to an area with clean skin (second image). When the mouse button is released, the pixels from the clean skin are pasted and blended into the original selection (third image). Because the blend is a little too strong, the Fade command (fourth image) is used to reduce the Patch tool's effect to 60 percent.

6. When the selection is in place, release the mouse button. When you do, the information in the original selection is replaced with the information from the second selection. Choose Select ➪ Deselect (Command/Ctrl+D) to deactivate the selection. Now you can see that the lines under the eye have been eliminated, as shown in the third image in Figure 6.19.

The only problem with what we just did it that the effect is too strong. Even though this woman is young, she should still have some definition under her eye to give it shape. Because the Patch tool — like the Clone Stamp — doesn't have an opacity setting as an option, we'll have to try something else to reduce the effect of the tool.

7. Go back two steps in the History palette's timeline. You should now be at the point where the selection was first created with the lines showing under her eye. Drag the selection to the skin at the top of her head, and release the mouse button — just as you did in Steps 5 and 6 above.

8. Before you do anything else, choose Edit ➪ Fade Patch Selection (Shift Command/Ctrl+F) to open the Fade dialog box. Move the slider to the left until you see just enough of the lines reappear to give the eye socket some shape, as shown in the fourth image in Figure 6.19.

The Fade command allows you to fade the last thing that you did so that you can select the opacity you like. This is also how we adjust the opacity of strokes painted by the Healing brush. When retouching portraits, I use the Fade command constantly, as you see in Chapter 16.

TIP The Fade command can be used after just about anything you do in Photoshop. I find this extremely useful. It allows me to overdo something and then fade it back to the point where I like it. The key to using Fade is that it must be the very next thing you do. For example, if you had deselected the selection first, the Fade command under the Edit menu would have been grayed out.

NOTE Instead of using Fade, you could do all retouching on a separate layer and then lower the opacity of the layer. However, the Fade command allows you to adjust the opacity of individual actions instead of everything on the layer at once.

9. I want you to see how powerful this tool is. Back up again to Step 3 using the History palette. This time, drag the selection to the dark background in the top right of the image and release the mouse button. When you do, notice that the background tones are blended in to match the skin tones — very much like the Healing brush. The effect is even softer than when you sampled the skin on her forehead because the background doesn't have as much texture as the skin you sampled earlier. Use the Fade command to tone it down.

10. Follow the same procedures to retouch the lines under the left eye.

The tool options for the fade command on the Tool Options bar are fairly simple. On the left, just to the right of the Tool Presets box are four small icons. These allow you to modify your selection by adding or subtracting to it. I explain how this is done in Chapter 7.

To the right of these icons are two radio buttons that control what area is being patched. There are two settings: Source and Destination. When Destination is selected, the information from the selection you first draw is dragged and dropped when you move the selection — sort of the opposite of the effect of having the Source button checked. This can be quite useful when working quickly to clean up a background. When you check the box next to Transparent, only the texture of the sample area is used as a sample. None of the color and tone information is sampled.

You should be aware of a couple of things when using the Patch tool. Quite often, you need to do a little clean up around the edges of the patched area with the Healing brush, or the Patch tool itself, so that the edges blend a little better, especially when patching large areas. Another issue with the Patch tool is that it suffers from the same smudging problem as the Spot Healing brush when patching areas that are near edges of high contrast or the edge of the image frame.

Fixing Red Eye

The Red Eye tool first showed up in Photoshop Elements, Photoshop's little brother. The tool was brought into the full version of Photoshop with the release of Photoshop CS2. The Red Eye tool, which is stacked with the Healing brush, offers a quick and efficient way for dealing with red eye.

Red eye is caused by light reflecting off the retina and bouncing back into the lens of the camera. It usually shows up when a camera's flash is on the same plane as the lens. The effect is more pronounced in subjects who have gray or blue eyes, as well as children.

Figure 6.20 shows a photo of my two dogs, Hazel and Ruby. Whenever I point a camera with an on-camera flash at Ruby, the Husky on the right, I get red eye. (I've noticed this with other blue-eyed dogs as well.)

To fix this, I draw a selection with the Red Eye tool that encompasses the eye, as shown in the second image. Because this tool works only on red, I don't have to be very careful with the selection. After the selection is in place, I release the mouse button and the red eye is instantly eliminated, as shown in the third image in Figure 6.20. Something that would have taken a bit of doing with other techniques a few years ago now takes way less than a minute with the Red Eye tool.

NOTE **Because this tool works with the color red, I was able to use it to remove a piece of Ruby's red collar that was poking out through her fur.**

The Red Eye tool has only two options: Pupil Size and Darken Amount. By default, both of these are set to 50 percent. Try adjusting these values if you're not getting the results you want.

FIGURE 6.20

Photoshop's Red Eye tool makes fixing red eye a snap. With the Red Eye tool, a selection is drawn around the eye. When the mouse button is released, the red disappears. This tool works only on red, so you don't have to be too careful about drawing the selection.

Retouching with Layers

In Chapter 4, we discussed using layers to create flexibility in the workflow by isolating permanent changes to individual layers. The main reason for doing this is to minimize the destructive nature of some of the things we do in Photoshop. "Destructive" may seem like a harsh term when we are, in fact, making the image better. What the term really refers to is the fact that original pixel data is being replaced by something else. After that happens, it may not be possible to undo the change.

This may come as a surprise, but any retouching tool that samples pixel data from one part of the image and paints/drops it into another part of the image is destructive by its very nature because pixels are being permanently altered. After those tools have been used and the image has been closed, those changes can't be undone. Therefore, you must learn various retouching strategies that protect the original properties of the underlying image.

The most fundamental way of accomplishing this is to duplicate the layer that's being retouched — quite often the Background layer — and doing all retouching on it instead of the original layer. That way, if you don't like something, you can remove it — or the whole layer — and begin again by duplicating all or part of the original layer.

Sampling multiple layers

In recent versions of Photoshop, Adobe has addressed this issue by adding limited multi-layer retouching. This feature has been taken to a whole new level with the release of Photoshop CS3. In the tool options for the Clone Stamp, the Healing brush, and the Spot Healing brush, you may have noticed the Sample pull-down menu, which I haven't discussed yet. This pop-up menu allows you to choose which layers are being sampled. You have these three options, as shown in Figure 6.21:

- **Current Layer:** Only pixels from the current layer are sampled.
- **Current & Below:** Only pixels from the current layer and below are sampled.
- **All Layers:** All layers are sampled.

FIGURE 6.21

Now you can have more control over layers when sampling for cloning or healing by selecting which layers are being sampled. Adjustment layers can be specifically ignored by clicking the button just to the right of the Source pop-up.

NEW FEATURE The Clone Stamp, the Healing brush, and Spot Healing brush have a new setting in their tool options that allows for much greater flexibility when using retouching tools with multi-layered images. When Current & Below is selected in the Source pop-up, any layers above the current layer are ignored. Additionally, a new button on the right allows you to ignore Adjustment Layers when sampling.

In Photoshop CS2, the options were limited to all layers or the current layer. The choice was made in CS2 by clicking in a check box next to Sample All Layers. The extra option of Current & Below allows you to arrange the layers you're working with so you sample only the layers you're interested in. After the retouching is done, the layers can be rearranged if needed.

One of the most popular ways of using this multi-layer sampling ability is to create an empty layer above the layer to be retouched so that all new retouching is added to the empty layer. Let's try it:

1. Open the bird_1.tif practice file.

2. Create an empty layer above it using Layer ➪ New ➪ Layer and then click OK. The new layer, Layer 1, is added to the top of the layer stack and becomesthe active layer.

3. Select the Clone brush from the toolbar, and change Sample to All Layers. Also, make sure that the blending mode is set to Normal.

4. Let's clone the bird onto a separate layer. Set the brush's diameter and hardness to the settings of your choice. Alt-click to sample the bird, and then begin painting it into a new place in the sky.

 When you're finished, the image should look like one of the preceding exercises, with two birds in the sky. The difference is that the cloned bird is on Layer 1. Let's verify it.

5. Click the eyeball icon next to the Background layer to hide the layer. Now the cloned bird should look something like Figure 6.22.

The important thing here is that the Background layer is undisturbed, which can be verified by turning its visibility back on and turning off the visibility of Layer 1. This is an effective way of quickly isolating retouching done with the Clone Stamp, the Healing brush, or the Spot Healing brush.

Ignoring adjustment layers

Another setting in this new feature is a button just to the right of the Source pop-up that allows you to ignore adjustment layers when cloning or healing. When all layers are being sampled and adjustment layers are present, the effect of the adjustment layers is duplicated. This is really easy to see by doing a simple experiment:

FIGURE 6.22

When you check Sample All Layers in the Source pop-up menu, you can place cloned data on its own layer using the Clone Stamp. This can be verified by turning off the visibility of the Background layer.

1. Open a new file using File ➪ New, and give it the following properties: Width = 6 inches, Height = 4 inches, Resolution = 300, Color Mode = RGB Color / 8-bit, and Background = White. If you created the "4x6 @ 300 white" preset in the New File dialog box earlier in this chapter, use it to quickly create this file.

2. Choose Edit ➪ Fill, and select 50% Gray from the Contents pop-up. At this point, you should be looking at a gray background layer.

3. Create a Levels adjustment layer using Layer ➪ New Adjustment Layer ➪ Levels, and change the middle, gray slider to 1.48. Don't change the white-point slider or the black-point slider. When you click OK, the gray of the image gets lighter.

4. Make the Background layer active again by clicking it.

5. Select the Clone Stamp (S) from the toolbar, and change the brush diameter to 200px. You can use the Hardness setting of your choice. Make sure that the Blending Mode is set to Normal and Opacity is 100 percent.

6. Choose All Layers from the Sample pop-up on the Options toolbar, and make sure the Ignore Adjustment Layers icon is not clicked.

7. Choose any spot you like, and Alt-click to sample it. Scoot the cursor over a bit, and paint a small circle. When you do this, notice that the circle you just painted is lighter than the gray you sampled. That's because the lightening effect of the Levels adjustment layer was doubled when it was sampled.

8. The way we used to deal with this was to turn off the visibility of any adjustment layers when sampling all layers. Let's try it. Click the eyeball icon next to the Levels layer. You don't even need to resample because you already have a sample loaded. Just paint another circle. This time, you can't see your painting because it's the same color as the sample.

9. Turn the Levels layer visibility back on. In the Tool Options bar, click the Ignore Adjustment Layers button and paint again. The painted gray is the same tone as the sampled gray. The effect is the same as turning the layer's visibility off.

The inadvertent sampling of adjustment layers when all layers are selected for sampling has thrown many a novice retoucher for a loop because they didn't realize that the adjustment layer's effects were being multiplied. Now that you know what this problem looks like, you can take appropriate action, like clicking the Ignore Adjustment Layers icon in the Tool Options bar.

I imagine you've already guessed what my biggest problem is with this technique for retouching on a separate, empty layer. These options aren't available with my favorite portrait retouching tool, the Patch tool. I use the Patch tool extensively when retouching a portrait, so I duplicate the main layer and do most of the retouching on that layer.

Body Sculpting with the Liquify Command

Photoshop has a highly specialized retouching tool called the Liquify filter. This tool is so specialized that I rarely use it. However, when conditions are right, few retouching tools can match the Liquify filter's abilities.

The Liquify filter works by distorting the image with tools like Warp, Pucker, and Bloat. The Liquify filter is located in the top section of the Filters menu, accessed by choosing Filter ➪ Liquify. Figure 6.23 shows the Liquify dialog box. As you can see, the Liquify filter is complex. On the left is a set of tools that affect the filter's distortion in different ways. On the right side are a number of options for fine-tuning the effects of those tools.

I could write an entire chapter about the Liquify tool. My goal here is to introduce it so that you're aware of it. I don't use Liquify often, but when I need it, other techniques can't match the speed of its results. I hope you'll be inspired to explore this filter further after you see what you can quickly accomplish with it.

In this example, the model in Figure 6.23 doesn't like the way the lower part of her dress looks. This is the sort of problem that the Liquify tool is well suited for solving. The goal here is to distort the image so that the protruding fabric is minimized.

FIGURE 6.23

On the left of the Liquify filter's dialog box is a set of tools with names like Warp, Pucker, and Bloat. On the right are various tool options that are used to fine-tune the way the tools on the left affect the image.

For this job, I selected the Push Left tool from the toolbar on the left, sixth from the top. The Push Left tool moves pixels to the left when you click and drag straight up. When the cursor is dragged downward, the tool moves pixels to the right. Here, I want to move the pixels around her dress to the right, so I drag the tool downward while holding down the mouse button. The first image in Figure 6.24 shows the effect of dragging and moving pixels to the right. The second image shows what the image looks like after the stroke is completed. This was all done with a single stroke.

This filter works so well here because the background is simple. The image lends itself to being liquefied. If the background contained lots of detail — like an outdoor portrait in a garden — adjustments like this would require more work. As it is, the only area that needs to be cleaned up with the Clone Stamp or Healing brush is where the bottom tips of her hair were also distorted to the right. This kind of cleanup is quite common when using the Liquify filter.

NOTE The Liquify filter is a resource hog. If you're working on a large file, it can take quite a while to load and execute. When working with a large file, use a selection to isolate the area being worked on. That way, only the selected area is loaded into the Liquify filter's dialog box, which speeds up the process quite a bit.

FIGURE 6.24

As the Push Left tool is dragged downward, pixels under the brush are moved to the right. Using only a single downward stroke, this problem is solved.

Again, we're barely scratching the surface of what this filter is capable of. I encourage you to spend time exploring it in more depth. When you get playful with it, you can create some really interesting and creative visual effects.

Summary

This chapter introduced a number of retouching tools and some of the ways in which they're used. Even though these tools are commonly referred to as retouching tools, they also are used for photo restoration in much the same way.

At the heart of some of these tools are brushes that can be modified almost endlessly. We started off by looking at brushes in general to get the concept of how brushes are modified and fine-tuned using the brush pop-up on the Tool Options bar and the Brushes palette. Learn to use the most basic setting for these brushes before becoming dazzled by the cool, custom brushes that can be created with the Brushes palette.

Then we looked at some of the tools that use brushes, like the Clone Stamp, the Healing brush, and the Spot Healing brush. We found that the Clone Stamp is useful when literal duplicates need to be created and that the Healing brush is most useful when you need to blend retouching strokes. The Spot Healing brush is best suited for quickly removing spots.

We then explored my favorite retouching tool, the Patch tool, which is a close cousin to the Healing brush. This tool uses selections for sampling and pasting pixel information from one part of an image to another. You should learn to use the Fade command with this tool to get the most from it.

We saw how easy it is to use the Clone Stamp and the Healing brush/Spot Healing brush on a separate layer by selecting which layers are sampled in the Source setting on the Tool Options bar. This allows you to isolate retouching strokes to their own layer. The only drawback to this technique is that it isn't available with the Patch tool.

Lastly, we took a quick look at the powerful Liquify filter. In the right scenario, this tool can be hard to beat when compared with other retouching tools and techniques. Remember, if you're working with a large file, you can speed up the process by using a selection to isolate the area you want to work on before invoking the Liquify filter.

Chapter 7

Working with Selections

W e've touched on selections a few times in this book. I don't really like to mention something without explaining it. But I don't want to confuse you by trying to explain everything at once. That's sort of the nature of Photoshop or any other complicated system. Many different concepts depend on and interact with each other in an almost circular manner.

Of all the concepts we've discussed so far, this one seems to be the most familiar to new users. Most people have seen the "marching ants" that define a selection, and they understand that selections are usually created around objects in an image.

If that doesn't apply to you, fear not. By the end of this chapter, you'll know when to use one selection tool rather than another and how to combine selection tools to create complex selections. You'll also know how to modify the edge of a selection with the new Refine Edge command and how to use the new Smart Filters feature in Photoshop CS3 that everyone is so excited about.

What is a Selection?

In Photoshop, selections provide a system for isolating pixel information in an image so that adjustments are applied only to the selected area. This is very useful when it's necessary to darken something or adjust its color independently of the rest of the images. Selections also are useful for isolating part of an image that is duplicated and moved to another layer or image. You saw this in Chapter 4 when we copied the young lady in front of the Corvette to a different layer. In that example, I provided the selection for you. (In a little bit, I show you how that selection was created.)

Let's begin this exploration into selections by looking at one of the most basic selection toolsets, the Marquee tools.

Using Photoshop CS3's Main Selection Tools

As with just about everything else in Photoshop, there's more than one way to create a selection in Photoshop. The primary selection tools are located on the toolbar. They are: the Lasso tools, the Marquee tools, the Magic Wand tool, and the Quick Selection tool. As we look at these tools, notice how each is best suited to creating a particular type of selection.

The Marquee tools

You'll find the Marquee tools under the second icon from the top on the single-column toolbar. The toolset consists of four tools that are stacked together, as shown in Figure 7.1:

The Marquee tools

- The **Rectangular Marquee** is used for making rectangular selections.
- The **Elliptical Marquee** is used for making elliptical selections.
- The **Single Row Marquee** is used for selecting a row that's only one pixel high.
- The **Single Column Marquee** is used for selecting a column that's only one pixel wide.

I don't think I've ever used the Single Row Marquee or Single Column Marquee. However, I use the Rectangular Marquee and Elliptical Marquee all the time. They both work in pretty much the same way, so we'll look at the Rectangular marquee here:

1. Create a new file using File ➪ New, and give it the following properties: Width = 6 inches, Height = 4 inches, Resolution = 300, Color Mode = RGB Color / 8-bit, and Background = White. If you created the "4×6 @ 300 white" preset in Chapter 6, use it to quickly create this file.

2. Choose the Rectangular Marquee tool (M) from the toolbar. Go to the top-left area of the new file. Click and drag downward to the lower right. As you do, you'll see a rectangular

shape outlined by the marching ants and anchored at the spot where you first clicked. When you let go of the mouse button, the selection floats on the image.

3. Let's try something else. Remove the selection by going to the Select menu and choosing Deselect (Command/Ctrl+D).

> **TIP** **You also can deselect by clicking outside the selected area with any of the other Marquee tools.**

4. Being able to draw a rectangle is cool, but what if you really need a square? You can get a square in two ways. The first way is to hold down the Shift key while you draw the selection. Give it a try. Draw a new selection while holding down the Shift key. This time it's a square because the Shift key locks the aspect ratio to a square ratio.

> **NOTE** **When you use the Elliptical Marquee tool, the Shift key modifier creates a perfect circle.**

5. Deselect again. Now go to the Tool Options bar, click the pull-down menu next to Style, and choose Fixed Aspect Ratio. Enter a value of **1** in the Width and Height boxes. Draw another square selection.

 This feature is very useful when you need to draw a rectangular selection that has a fixed aspect ratio other than one-to-one. Using the Shift key is faster if you need a square.

> **NOTE** **The Fixed Size option in the Style pop-up allows you to draw a rectangular selection that is an exact size.**

6. Select the Brush tool (B) from the toolbar. Set the brush's properties to any settings you like. Now use the paintbrush to draw a stroke across the entire image that begins and ends outside the boundaries of the selection. Notice that the stroke appears only within the selection, as shown in Figure 7.2.

FIGURE 7.2

When a selection is active, changes to the image occur only within the selection. When this brushstroke was drawn, only the pixels inside the selection were affected. The pixels outside the selection were protected from change.

This is what a selection is all about. When a selection is active, any action taken affects only pixels within the boundaries of the selection. All the pixels outside the selection are protected from any changes.

TIP To change the color you're painting with, go to the two color swatches at the bottom of the single-column toolbar. The top swatch — the one on the left — is the foreground color. The swatch on the right is the background color. When you're using a tool like the Brush that paints with color, the foreground color is the one being used. Click the color to change it. When the Color Picker dialog box opens, select the color you want and click OK.

7. While we're here, let's try one more thing. Undo the paint stroke you just made, and then choose Select ➪ Inverse (Shift+Command/Ctrl+I). This inverts the selection so that pixels outside the original box are now selected and the pixels inside the box are protected (unselected).

 The only change you'll notice is that the marching ants begin to march around the perimeter of the image. (If you can't see the edges of your image, zoom out.)

8. Draw another stroke across the image. This time the paint gets applied only outside the box, as shown in Figure 7.3.

 The ability to invert any selection is very useful. It allows you to alternately isolate opposite areas of an image. It also allows you to make a difficult selection by selecting something easier and then inverting it.

FIGURE 7.3

You can invert a selection with the Select menu's Inverse command. This "flips" the selection so that pixels that were unselected become selected, and vice versa. When a selection is inverted, changes occur only outside the original selection. Pixels inside it become protected.

In the exercise above, we visited the Select menu twice. That's because the Select menu is the main place to go to modify the properties of a selection after it's been created. Another way to access some of the commands in the Select menu is to right-click with your mouse anytime a selection is active and the selection tool is chosen, as shown in Figure 7.4. Notice that this context-sensitive menu has some options that aren't in the Select menu in Figure 7.3. Also, be aware that if you right-click when no selection is active, you get a different context-sensitive menu.

The Elliptical Marquee tool works the same way. I use this tool often when I want to darken the corners of an image, as you see later. The Shift modifier-key restricts the tool to drawing perfect circles.

The Marquee tools are wonderful when you need to select an ellipse or a rectangle. But quite often we need to make selections that are more organic, freeform shapes. There are a few tools in Photoshop that are perfect for those kinds of selections. We'll look at the Lasso tools first.

FIGURE 7.4

Selection properties and other useful shortcuts can be accessed quickly by right-clicking when a selection is active. If you right-click when a selection isn't active, you get a different menu because the right-click option is sensitive to the context in which it's being used.

The Lasso tools

I've always liked the name "Lasso" for the set of tools we're about to discuss. It implies that the tool is used to throw a selection around something to gain control of it. In this case, instead of a rope, we throw a line of marching ants.

NOTE The term *marching ants* describes the moving, dashed line that surrounds a selected area because the moving line looks like ants marching in unison.

The Lasso toolset is the third icon from the top on the single-column toolbar. There are three Lasso tools stacked together, as shown in Figure 7.5:

FIGURE 7.5

The Lasso toolset

- The Lasso tool is a true freeform tool. You can create a selection with just about any type of organic shape. This tool is not very well suited to creating selections with hard lines — selecting the side of a building, for example.

- The Polygonal Lasso tool is used to create selections with straight lines. Every time you click with this tool, a straight line is drawn between your current click and the most pervious click. It works quite well for selecting areas with hard edges.

- The Magnetic Lasso tool is a "smart" selection tool. It's designed to see the lines that divide regions of differing tonal contrast — the boundary around a silhouette against a bright sky, for example.

The Polygonal Lasso tool is useful when straight lines are needed, but I rarely use it. Most of the time, I need a selection that follows the contours unique to a specific situation in a specific image. For that reason, we focus here on the two other Lasso tools: the Lasso and Magnetic Lasso tools.

Let's do some exercises to compare and contrast these two tools:

1. Open the snow_dog.tif practice file from the downloadable practice files on the Web site. Make a Levels adjustment (Command/Ctrl+L) similar to the one we did in Chapter 1. I used 23, 1.08, 226.

2. To be effective here, we need to see the entire dog all at once, so zoom out until the entire dog is visible.

3. In this exercise, we want to enhance Ruby's colors — as neutral as they are — so that they're richer against the neutrality of the snow. However, we don't want to intensify the cyan/blue tint of the snow; we want it to be as neutral as possible. Select the Lasso tool (L), and draw a selection around the dog. Stay as close to the edges of the dog as you can. Go all the way around until you get back to the place where you started drawing. When you connect the beginning and end points, the selection is complete.

 As you can see, this is easier said than done. Making an accurate selection like this is difficult with the Lasso tool, even if you're using a graphics tablet. (Good luck if you're using a mouse.) The Lasso tool does have good uses. It's great for creating freeform selections that are loose, as you see in later chapters. It just isn't the right selection tool for this job.

4. Remove the selection you just created by choosing Select ⇨ Deselect (Command/Ctrl+D), or just click somewhere outside the selection with the Lasso tool.

5. Switch to the Magnetic Lasso tool. It's stacked under the Lasso tool. In the Tool Options Bar, set the tools options to the following settings: Feather = 0px, Anti-alias = checked, Width = 5px, Contrast = 40, and Frequency = 40. (We look closer at these settings in a moment.)

6. Click near the tip of one of the ears to get the tool started. After you've clicked, release the mouse button. Begin outlining the dog again, staying as close to her edges as possible. Notice how much easier you can follow the edge of the contrast between the dog's dark fur and the snow with the Magnetic Lasso. Continue tracing her entire outline until you get back to where you started.

TIP If you have your cursor preferences set to Standard under Preferences ⇨ Cursors ⇨ Other Cursors, your cursor will look like the icon of the Magnetic Lasso tool. If you want to see the actual width of the tool, press the Caps Lock key. Just remember to press the key again when you're finished, because it modifies the way many cursors look. An easier way to accomplish this is to change your cursor preference from Standard to Precise, which allows you to always see the brush size (unless the Caps Lock key is active).

 As you trace, notice that fastening points are being laid down by the Magnetic Lasso. These points anchor the selection to the lines and points that separate areas of contrast. If the tool won't place a point where you want one — maybe near the tip of the Ruby's white tail or paw or along her back, click to manually insert a fastening point. If a point is placed in a place where you don't want one, use the Delete key to remove it. Successive points are removed every time you press the Delete key, so you can back up several points in a row if you need to. If you want to bail and start all over, press the Esc key.

7. When you complete the selection and get back to the starting point, a small circle appears next to the cursor. This indicates that a click will connect the beginning point with the end point, completing the selection. If you have problems closing the selection, try a gentle double-click. Your selection should now look something like Figure 7.6.

NOTE If your gentle double-click is too strong, or not in the right place, the tool thinks you want to start a new selection. If this happens and the selection you just drew disappears, press the Esc key to make your selection reappear.

FIGURE 7.6

The Magnetic Lasso tool is well suited for selecting a shape that contrasts with its surroundings. Click once to get the tool started, and then let the tool do the rest as you draw. Click to add more fastening points, and use the Delete key to remove unwanted points. A small circle appears next to the cursor when the outline is complete. (If you're using the precise cursor, the tool's icon reappears when the selection is complete.) Click to create the selection.

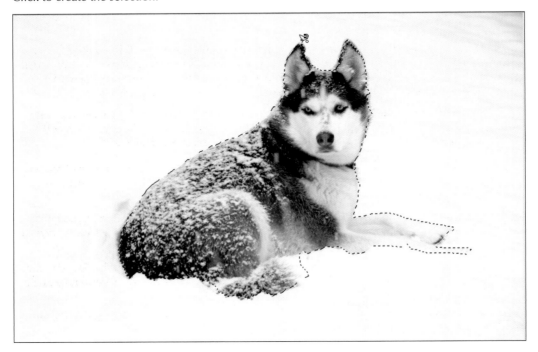

NOTE I saved a selection for you in case you're having problems getting the kind of selection you want right now. You can load it by choosing Select ➪ Load Selection and then clicking OK.

Notice that the selection in Figure 7.6 isn't perfect. I missed the tip of one of her ears, as well as the edge of her fur in a couple of places. I'll show you how to fine-tune selections in a moment. For now, let's work with what we've got.

8. Now that the dog is selected, we can adjust her color independently of the color of the snow. Choose Image ➪ Adjustments ➪ Hue/Saturation (Command/Ctrl+U). (Don't use an adjustment layer just yet.) Change the Master Saturation value to 55. Notice that the dog's colors intensify, especially her blue eyes. The white fur begins to look more yellow, which is accurate to true life. (I always realize that Ruby's white really isn't white when I see her in fresh snow.) Make any other adjustment you want to make, and click OK.

9. Now Ruby stands out from the background because her colors are so much richer. Because most of the snow was outside the selection, the color of the snow is still cool. Let's warm up the color a bit. Invert the selection by choosing Select ⇨ Inverse. Now the marching ants are moving around the outside perimeter of the image.

10. I want to desaturate some of the cool colors in the snow. Choose Image ⇨ Adjustments ⇨ Hue/Saturation. Select Cyans in the Edit pop-up menu, and use the eyedropper to sample the colors in the top-right corner of the image. Lower the Saturation value to -100, and click OK.

TIP To temporarily hide a selection, use the Command/Ctrl+H keys. This is a good way to see what the changes look like without deselecting the selection. However, don't forget to unhide it when you're finished. Otherwise, you may forget it's there and you won't know why weird things are happening later. To unhide it, press the Command/Ctrl+H keys again.

CAUTION Anytime you're adjusting an image and unpredictable things are happening, check to see if you have something selected. Even if you don't think you do, choose Select ⇨ Deselect to be sure. Sometimes, something can get selected without your realizing it.

The change is very subtle, but I like snow more without the cyan cast. If we had made this adjustment to the entire image — without any selections — Ruby's eyes would have lost their blue color.

Those of you who are following along with the sample file probably see something that doesn't look right. The snow on Ruby's back still has a cyan cast to it. We look at ways to quickly fix that in Chapter 8 when we look at masking.

11. Let's do one more thing. Choose Filter ⇨ Blur ⇨ Gaussian Blur. When the Gaussian Blur dialog box opens, enter a value of **5** and click OK. This blurs the snow around the dog a bit, making her pop out of the background a bit more.

Using selections (or masks) to isolate areas for selective blurring or sharpening is a very common technique that we'll revisit later.

As you can see, the Magnetic Lasso tool is powerful, especially in a scenario with edges between regions of contrasting tones like this one. When edges aren't so well defined, it becomes necessary to modify the tool's properties in the Tool Options bar so that it accurately follows the edge. Let's look at some of these settings:

NOTE In order to have an effect, all the settings on the Tool Options Bar — except Refine Edge — are applied before the tool is used.

- **Feather** is used to blur the edge of the selection, creating softer selections. We talk about it in detail in a moment.

- **Anti-alias** is used to smooth jagged edge transitions. This should be turned on. It's available for the Lasso tools, the Elliptical Marquee, and the Magic Wand.

- **Width** specifies the size of the area where edge detection occurs. It specifies the maximum distance from the pointer where an edge will be seen by the Magnetic Lasso tool.

- **Contrast** is used to modify the Lasso's sensitivity to edge contrast. Higher settings cause the tool to see edges with higher contrast only.

- **Frequency** specifies the rate at which fastening points are attached to the edge. Higher settings tend to anchor the selection more quickly.

- The **"Use tablet pressure to change pen width" button** is used to quickly turn the pen pressure setting on and off.

- **Refine Edge** is an exciting new feature in Photoshop CS3. I discuss it in detail in a moment.

Experiment with each of these settings individually on the snow_dog.tif file. Get a feel for how each affects the Magnetic Lasso's selection process. When used properly, this tool creates a selection that's 90 percent complete in just a few moments. Areas that are missed can quickly be added to the selection with more appropriate selection tools.

The Magic Wand tool

The Magic Wand tool — as I'm sure you can tell by its name — is another automated selection tool. It's best suited for selecting colors that are similar to one another. In fact, in the right scenario, few selection tools can match its speed. Let's play with the Magic Wand a bit:

1. Open the bird_2.tif practice file. The goal here is to select the bird as quickly as possible. You could probably select it with the Magnetic Lasso in under a minute.

2. Choose the Magic Wand tool (W) from the toolbar. It's fourth from the top on the single column toolbar. It might be stacked under the Quick Selection tool. Set the tool options to the following values: Tolerance = 30, Anti-alias = on, Contiguous = on, and Sample All Layers = off.

 - Tolerance affects the range of similar colors that the tool selects. Low settings restrict the selection to colors that are very similar. High values allow the tool to select a broader range of colors that are less similar. Settings range on a scale of 0 to 255.

 - When Contiguous is checked, only similar pixels that are touching are selected. (Contiguous means that two things are touching, or sharing a common border.) This is a great way to control the Magnetic Lasso's power. Using Contiguous allows you to do things like select a single flower out of a field of similarly colored flowers, as long as their borders aren't touching one another.

3. Click the sky. When you do, everything but the bird is selected. Invert the selection by choosing Select ➪ Inverse, and the job's done. The bird was selected with two clicks.

It's pretty rare for an automated tool to work this flawlessly. As I mentioned, it's quite common to combine multiple selections to create the right selection. Let's look at how we can do this with a single tool:

1. Go back to the bird_2.tif file. If any selections are active, deselect them.

2. Try selecting the bird directly with the Magic Wand using the same tool options that you started with before. Click in a couple of darker tones on its chest. As you do, you can see that you can select only small areas at one time. No matter where you click on the bird's chest, you end up with a selection that looks something like the first image in Figure 7.7.

> **TIP** When you're using the Magic Wand tool, you can deselect a current selection by moving the cursor inside the selection and clicking once.

3. Go to the tool options, and uncheck Contiguous to turn it off. Click the bird's chest again in the same spot. Now more tones are being selected because they no longer need to be touching one another, as shown in the second image in Figure 7.7.

4. Try increasing the Tolerance setting. Move it up in increments of 20, and experiment by clicking the bird's chest. The third image in Figure 7.7 shows what I got with a Tolerance of 100. Close, but no cigar.

 We can continue experimenting with increasing Tolerance settings until we eventually stumble across the magic number. Or we can do it much more quickly by building a selection with multiple selections.

5. Reset the Tolerance value to 30, and deselect any selections. Click the bird's chest. This time, while the selection is active, hold down the Shift key. A small plus sign (+) appears next to the cursor, indicating that another click will add a new selection to the current selection. Click somewhere else on the bird. Notice that more pixels have been added to the first selection.

6. If you continue Shift-clicking different areas of the bird, you'll eventually get all of it selected. Let's speed up the process. Increase the Tolerance value to **60**, and continue Shift-clicking. Now it can be done with three of four clicks.

 It's easy to accidentally select pixels you don't want to select when the tolerance is set this high. If that happens, use the Alt key to Alt-click the areas you want to remove from the selection. When you hold down the Alt key, you see a small minus sign (-) next to the icon, indicating that you're about to remove something from the selection.

FIGURE 7.7

A narrow range of tones is selected because only contiguous tones are being selected (first image). When Contiguous is turned off in the tool options, more tones are selected from the same range (second image). Increasing the Tolerance value allows the Magic Wand to select a greater range of tones. This is what I get with a setting of 100 with Contiguous unchecked in the tool options (third image).

You also can use the icons on the left side of the Tool Options bar, circled in Figure 7.8, with any of the selection tools we've discussed so far. The advantage to using the keyboard modifier keys is that they're faster. The advantage to using the tool options icons is that you can turn on a setting and leave it turned on. Just remember to turn it off when you're finished so you don't get confused later.

FIGURE 7.8

Four icons appear on the left side of the Tool Options bar when the Marquee tools, the Lasso tools, or the Magic Wand is being used. The first button is the normal selection mode, the second button adds to the selection, the third button subtracts from the selection, and the fourth button selects only the area of two intersecting selections.

You can learn a couple of important lessons from the previous set of exercises. First, you can always do things in more than one way in Photoshop. Second, one way is often much more efficient than another. In the previous example, the difference was in the selection strategy, rather than the choice of tools. So remember, using the right tool for the job is important, but using that tool in the most efficient way is equally important.

When you're starting out, these distinctions may not be so clear. Being able to simply get the job done, in some cases, is cause for celebration. That's okay. As you've already seen, you can get to the same place in more than one way. Just allow yourself to continue learning about the main tools you use so you become familiar with their various nuances. Eventually, you'll learn to quickly recognize situations that lend themselves to one particular tool or technique.

The new Quick Selection tool

The Quick Selection tool, introduced in Photoshop CS3, is the latest smart selection tool from Photoshop. This new tool combines the smart technology behind the Magic Wand with the flexibility of a brush tool, allowing smart selections to be painted into the image. The Quick Selection tool also does a nice job of creating boundaries around the selected area, providing more defined selection boundaries than selections with the Magic Wand.

NEW FEATURE The new Quick Selection tool in Photoshop CS3 allows you to create smart selections by painting them in with a paintbrush styled tool.

1. Open the practice file, spring_tulips.tif, from the downloadable practice files on the Web site.

2. Choose the Quick Selection tool from the toolbar. (It's fourth from the top in the single column toolbar.) It's stacked with the Magic Wand. Make sure that Auto-Enhance is selected in the tool options.

TIP If you check Auto-Enhance on the Tool Options bar, the boundary of the selection is smoother. It adds some of the selection edge fine-tuning that can be found in the Refine Edge dialog box, which is discussed shortly. This setting also allows the selection to flow more easily toward the edges of the content being selected.

3. Let's try to select the orange and yellow flowers in the foreground so we can do something to them. Adjust the size of the Quick Selection tool to 100px, and begin painting in the lower-right section of the image. As you paint, notice how the tool seeks similar colors, as shown in the first image in Figure 7.9.

NOTE By default, the Add to Selection button on the Tool Options bar is selected, which means that every stroke adds to the last.

4. Continue painting until all of the flowers in front of the fence are selected. Decrease the size of your brush when you get to the edges where the flowers and the fence overlap. If some of the fence is accidentally selected, press the Alt key while you paint to subtract it. Soon, your selection should look like the second image in Figure 7.9.

FIGURE 7.9

The Quick Selection tool seeks similar colors as it's brushed across the lower-right corner of the photo (first image). You can see how the Quick Selection tool creates defined boundaries as it seeks similar colors. With only a few more strokes, all of the foreground flowers are quickly painted in (second image).

As you can see, this tool is quite smart. It can be used to quickly create a base selection that can be fine-tuned with other selection tools.

Strategies for selection success

Each of the selection tools we've looked at so far has strengths and weaknesses. Some tools are smart: One might be good at selecting similar colors, while another is good at finding edges. Other "dumb" tools, like the Lasso, are great when you want complete control over the tool: If I have to quickly draw a loose selection around something, I may not want to use the smarter Magnetic Lasso.

Knowing about these differences — and choosing selection tools based on them — is the foundation of successful selection strategies. After you're comfortable with these differences, you can take your selections to the next level by combining selection tools, based on their strengths, to quickly create perfect selections.

In the example above, we still have a problem. You can see it in the second image in Figure 7.9. Background areas, showing between and behind the foreground flowers, were also selected when the flowers were selected. We could use the Subtract selection button on the tool options of the Quick Selection tool (or hold down the Alt key) so that we could go back and remove each of these areas from the selection. However, I want to show you a much faster approach that takes only one or two clicks on the image with the Magic Wand tool:

1. Return to Step 4 in the exercise above. Choose the Magic Wand tool, and set its Tolerance value to **28**. Make sure that Contiguous is unchecked so that all similar tones are selected.

2. Alt-click in the large dark area that's just left of the middle of the image. When you do, all the dark areas in the foreground are deselected, as shown in Figure 7.10. If too much is deselected, back up and try again with a slightly lower Tolerance value.

3. If by chance a couple of "floating pixels" are not deselected when they should have been, Alt-click them, or switch to the Lasso tool and remove them by holding down the Alt key and drawing a loose shape around them.

This is the key to selection success. You can mix and match tools to quickly piece together a great selection. Begin by using one tool that's suited to quickly building 90 percent of the image. Then use other selection tools to add and remove the bits and pieces they're most suited for working with. This strategy is much more efficient than fiddling with a particular tool's settings, trying to set its preferences so it creates the perfect selection all by itself. Creating a "superstar" selection tool might be fun, but teamwork is much more efficient.

FIGURE 7.10

The dark areas between and behind the flowers were selected by the Quick Selection tool, along with the flowers. That's okay because they are quickly removed with the Magic Wand tool. One click removed all but a one small group of floating pixels below and to the left of the cursor.

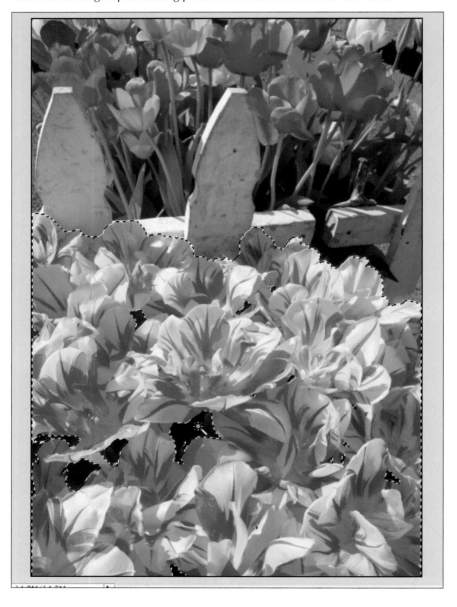

Fine-tuning Selections

Selecting the right information is the first part of creating a great selection. The second part is adjusting the edge of the selection so that adjustments made to selected pixels blend with the surrounding, non-selected pixels.

Feathering a selection's edge transition

One of the most used methods of modifying a selection's edge boundary is the Feather command. We feather some selections in later chapters, so let's look at the Feather command here:

1. Open a new file using File ⇨ New, and give it the following properties: Width = 6 inches, Height = 4 inches, Resolution = 300, Color Mode = RGB Color / 8-bit, and Background = White. If you created the "4×6 @ 300 white" preset in the New File dialog box earlier, use it to quickly create this file.

2. Use the Rectangular Marquee tool to create a selection on the left side of the image. (Make sure that the feather value on the Tool Options bar is 0px before you draw.)

> **NOTE** The Marquee tools and the Lasso tools have a Feather setting in their tool options. When this is checked, feathering is applied as the selection is being created. I rarely check this box because I often don't know how much feathering I want until the selection is in place. I'd rather leave this setting at 0px and apply feathering later so I can try a couple of different settings, if needed.

3. Choose the Paint Bucket tool (G) from the toolbar. It's stacked with the Gradient tool, twelfth from the top. Click inside the rectangular selection to fill it with the foreground color. (I used black, the default foreground color.)

4. Move to the right side of the image, and draw another selection with the Rectangular Marquee similar in size to the selection on the left.

5. Choose Select ⇨ Modify ⇨ Feather, and enter a value of **30** when the Feather Selection dialog box opens. Click OK. Use the Paint Bucket to fill the new selection with the foreground color. Your image should look something like Figure 7.11.

 I want to point out a couple of things here. First, when the selection is feathered, the angular corners are rounded off. This shows that feathering tends to smooth edges around sharp detail. Second, the feathering takes place on both sides of the marching ants. That means the feathering effect is feathering outward and inward, with respect to the selection boundary.

FIGURE 7.11

The box on the left was created by filling a non-feathered selection with the Paint Bucket. The box on the right was created by filling a selection that has a Feather Radius of 30 pixels. Notice how much smoother the edge transition is on the box on the right and that the transition is on both sides of the selection.

Feathering a selection allows changes in a selected area to transition into unselected areas. This is extremely useful. We could have used it earlier when we were working on the photo of Ruby in the snow (snow_dog.tif). If we had taken the time to zoom in to the edges of the selection, we would have noticed abrupt changes where the focus goes from sharp to blurred. You can see this in a close up of the area along the edge of her head in Figure 7.12. This abruptness is always a sign that something digital has taken place. A feather of about 20 pixels would have helped to minimize the abruptness of the change from blur to non-blur, shown in the second image. Go back and give it a try, experimenting with various amounts of feathering.

The amount of feathering for a particular job depends on the size of the file. Thirty pixels is a lot for a small file like the 4×6 @ 300 ppi file we just used. On a larger file, like a 16×20 or 20×30, a feather of 30 pixels would have much less of an effect. Sometimes it takes a little trial-and-error to find the right amount of feathering. You try one setting and follow through with whatever adjustments you want to make in the selected area. If you don't like the selection boundary transition after your changes, back up and try a different amount of feathering and redo the effect until you find the right formula.

FIGURE 7.12

When we adjusted this image earlier, we didn't feather the selection before blurring the background. The hard transition between the blurred background and the non-blurred dog is easy to see in the first image. When the selection is feathered before blurring, the transition becomes much softer and less noticeable.

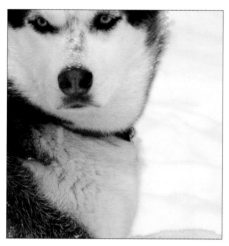 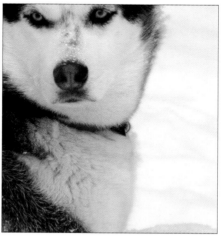

You know I'm all about being efficient, so I'm happy to tell you that much of the trial-and-error I just described became history the moment Photoshop CS3 was released. Now there's a new feature that takes the guesswork out of feathering, as well as other selection edge adjustments. That new command is called Refine Edge.

Using the Refine Edge command

You may have noticed that I carefully avoided mentioning the Refine Edge button in the tool options of the tools I discussed above. You can see it back in Figure 7.8. And you may have noticed the Refine Edge command in the Select menu, right above Modify. Now that you understand how to create selections, let's talk about this new feature, which in my opinion is one of the coolest new things in Photoshop CS3.

When you look at the Refine Edge dialog box, as shown in Figure 7.13, the first thing you'll notice is that some of the same options that are available in the Select ➪ Modify menu also are in the Refine Edge dialog box. Commands like Smooth, Feather, Contract, and Expand have been in Photoshop's Select menu for years. The breakthrough here is that these adjustments can be previewed in a variety of ways before any adjustments are applied. Let's break this complex command down and look at it piece by piece.

NEW FEATURE The new Refine Edge command takes the refinement of selections to a new level by providing a preview of a selection's modifications while they're being applied.

FIGURE 7.13

Some of the options that are available in the Select ➪ Modify menu are also in the Refine Edge dialog box.

The Refine Edge dialog box features five tools for modifying the edges of a selection. These tools can be used individually or together:

- **Radius** is used to designate the size of the area around the selection's boundary in which changes will occur. This can be increased to create more precise selections around soft detail like hair and fur. (This would have been useful on the snow_dog project you did earlier.)

- **Contrast** removes any "fuzziness" in a selection's edge. It's often used to remove any *noise* that's picked up by increasing the Radius setting. (Noise is caused by random fluctuations in pixel values. In it's purest sense, it usually looks like film grain.)

- **Smooth** is used to remove the hills and valleys in a selection's boundary. Higher settings create a smoother edge.

- **Feather**, as we've already seen, is used to soften edge transitions on either side of a selection.

- **Contract/Expand** is used to make a selection larger or smaller.

NOTE There's a very useful area at the bottom of the dialog box, called Description. It gives you a description of the various sliders and viewing options when you hover the cursor over them. If you don't see any descriptions, click the arrow button to show them.

In the past, we had Smooth, Feather, Expand, and Contract as options in the Select menu. Using them was anything but intuitive because the effects of changes to these settings couldn't be seen until after the selection process, which resulted in lots of trial and error. When these settings were combined, the results would become even harder to predict. The new Refine Edge command provides an elegant solution to that problem by giving us five different ways to preview any modifications to the command's settings.

At the bottom of the Refine Edge dialog box are five preview thumbnails. When one of these buttons is clicked, it changes the way the selection is being previewed. Figure 7.14 shows each of those previews:

TIP Press the F key while the Refine Edge dialog box is open to cycle through the five preview modes. While in those modes, press the X key to temporarily hide the preview. Press the X again to reinstate it.

- **Standard** shows the selection in the usual way with our friends the marching ants.
- **Quick Mask** previews the selection as a Quick Mask. We don't talk about Quick Masks much in this book. But if you like to use them, you might find this preview setting handy.
- **On Black** places the selected area on a black background to isolate it from the rest of the image content.
- **On White** places the selected area on a white background to isolate it from the rest of the image content.
- **Mask** previews the type of mask that will be created by the selection. This is extremely handy when creating masks from selections. (We cover masking extensively in Chapter 8.)

This preview feature is huge. It allows you to create the selection you need without lots of trial and error. It also lets you see how one setting can be used to tweak the modifications of other settings. The biggest drawback I see is that I end up "playing" with this tool more than I need to because it's so much fun to compare and contrast different edge refinement scenarios.

TIP When you get down to business with this tool, zoom in to take a closer look at the selection's edge. You can use the Zoom tool in the dialog box to click the image or use the standard keyboard shortcuts for zooming. If you use the Zoom tool and you need to zoom back out, press and hold the Alt key and click the image. This changes the Zoom tool to zoom-out mode.

FIGURE 7.14

Selections can be previewed in five ways with the Refine Edge command.

Standard

Quick Mask

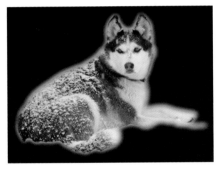

On Black

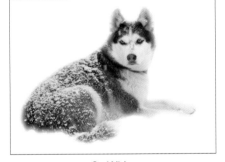

On White

Mask

Saving and Loading Selections

Sometimes, it takes lots of work to build a complex selection. Several selection tools and techniques might have to be combined to get it just right. You usually don't want to have to redo one of these selections after all that work is done. If you are about to make permanent changes to a complex selection with the tools in Refine Edge, or if you are going to deselect a complex selection, then save the selection in case you want to go back and try a different editing direction. If you're building a quick selection that can easily be repeated — like the Magic Wand selection of the sky in the bird photo in the earlier exercise — then you can easily recreate it again if you need it. My rule is that I save a selection if it takes longer than 5 minutes to create. That way, if I need the selection again, I don't have to re-create it or try to remember how I created it in the first place.

To save a selection, choose Select ⇨ Save Selection. When you do this, the Save Selection dialog box opens, as shown in Figure 7.15. You have three options in the Document pop-up as to the location of where the selection will be saved:

- Choosing the current filename allows you to save the selection as part of the current file so you can access the selection later. This is the usual place to save a selection.

- Choosing New allows you to create a new file that contains only the selection. This is a good way to store a selection by itself. I rarely do this, but it's nice to know it's possible.

- If there are other files open and they have the same *pixel dimensions* of the current file, their names appear in the list. You can save the selection to one of those files to transfer it. This is useful when the second document contains the same area that needs to be selected.

TIP To see a file's pixel dimensions, choose Image ⇨ Image Size. The pixel dimensions are the first set of numbers.

NOTE When a selection is saved, it's saved as a channel. This isn't highly important right now, but I discussed channels in Chapter 2, so I thought I'd mention it. If you want to see what a saved selection looks like, go to the Channels palette. It will be sitting at the bottom of the stack.

Loading a selection works pretty much the same way, except in reverse. The dialog box is shown in Figure 7.16. The Document pop-up allows you to choose which image you want to work with. The same rule applies. Only images with the same pixel dimensions as the current document appear in the pop-up. You can invert the selection as it's loaded by checking the Invert check box.

Saving a selection allows you to make a copy of any detailed selection so you'll have it in the future in case you need it. It also allows you to share a selection with another, similar file. You can retrieve these selections later with the Load Selection command. I tend to work with masks often, so I don't save lots of selections. However, when the need arises, the ability to save and load selections is very handy.

FIGUER 7.15

The Save Selection dialog box allows you to save complex selections for future use. You can even save a selection from one image to another image by selecting another open file (with the same pixel dimensions) in the Document pop-up, or you can save it to a new document by selecting New in the Document pop-up.

FIGURE 7.16

The Load Selection dialog box allows you to load a selection from the current image or from another open image with the same pixel dimensions. If there are multiple saved selections, they appear in the Channel pop-up. The selection can be inverted on-the-fly by checking the Invert check box.

Cutting and Pasting with Selections

You've seen how useful selections are for isolating parts of an image so that local changes can be made to them — tonally or with filters. Selections also are used to isolate something and then copy it somewhere else or remove it altogether. In Chapter 4, we used a selection to copy the girl by the car to a new layer. Then we positioned this "twin" elsewhere in the image.

Let's revisit that technique with the bird photos we were using earlier:

1. Open the bird_2.tif practice file.

2. Choose the Magic Wand from the toolbar. Set the Tolerance to **30**, and check Contiguous. Click the sky.

3. When the entire sky is selected, invert the selection using Select ⇨ Inverse (Shift Command/Ctrl+I). Now only the bird is selected.

4. We have two options here for creating a duplicate of the bird. We can copy the original information, or we can cut it. The difference is that cutting leaves a hole behind in the original layer. Copying doesn't affect the original layer. You can see the difference in Figure 7.17.

 Let's try cutting first. Choose Layer ⇨ New ⇨ Layer via Cut. The first clue that a new layer has been created is that the marching ants disappear. The second clue it that a new layer, called Layer 1, appears in the Layers palette.

5. Choose the Move tool (V) from the toolbar, and move the bird to the right. When the duplicate bird on Layer 1 is moved, the hole it left behind is revealed. Your image should look like the first image in Figure 7.17.

> **TIP** Here's a shortcut I use all the time. When you temporarily need the Move tool, use the Command/Ctrl key instead. This key makes the Move tool appear as long as the key is held down. When you release the key, your cursor goes back to the previous tool. This saves lots of time because you don't have to visit the toolbar as often. (This shortcut to the Move tool doesn't work with all tools. For example, if you're using the Hand tool and you press the Command/Ctrl key, the Hand temporarily becomes the Zoom tool. It also doesn't work when a selection is active.)

> **TIP** If you want to move the duplicate bird straight to the right, hold down the Shift key as you click and drag. The Shift modifier key restricts the movement of the Move tool to straight lines: up, down, and sideways.

6. Go back to the end of Step 3. Choose Layer ⇨ New ⇨ Layer via Copy (Command/Ctrl+J). Move the duplicate bird to the right. This time, your image should look like the second image in Figure 7.17, with two birds visible.

> **NOTE** Because cutting is destructive, I rarely use it. Instead, I rely on Layer via Copy, or more usually, the keyboard shortcut Command/Ctrl+J.

7. Now let's move the duplicate bird to another image. Open the bird_1.tif practice file. You should now have two files open. Position the images so you can see both of them at the same time, as shown in Figure 7.18. One way to do this is to go to the Window menu and select Arrange ⇨ Tile Horizontally.

FIGURE 7.17

In the first image, a new layer is created by cutting a selection from the original layer (Shift Command/Ctrl+J). This technique leaves a hole in the original layer. In the second image, a new layer was created by copying the selection to a new layer (Command/Ctrl+J).

> **TIP** When you use the Arrange command, you also can match all files to the current file's zoom and location by selecting Match Zoom and Location from the Arrange submenu.

8. Click the header of the bird_2 file to make it active. (The header is the top of the image that displays the name of the file.) When the bird_2 file is active, you can see both layers in the Layers palette. To transfer the duplicate bird to the bird_1 file, just click and drag the duplicate bird's thumbnail in the Layers palette from its original file into the new file; simply drop it on top of the main image, as shown in Figure 7.18. It's that easy. (You don't have to use any particular tool when doing this.) Go ahead and give it a try. By the way, when you drag a layer from one image into another, the first layer stays behind and a duplicate is created in the second image's Layers palette.

NOTE If these two documents had different color profiles, (Adobe RGB1998 and sRGB), and your color management policies were set up as I recommended in Chapter 2, a Paste Profile Mismatch dialog box would open when information was being copied and pasted between them. This is similar to the Profile Mismatch and Missing Profile dialog boxes I discussed in Chapter 2. It's more of a reminder than a warning. If it happens to you, click OK.

FIGURE 7.18

It's easy to move a layer from one file to another. Open both files, and position them so you can see both images. Go to the Layers palette of the image with the layer you want. Click and hold on its thumbnail while dragging it into the second image.

TIP If you hold down the Shift key as you drag and drop a layer, the new layer is dropped into the center of the image. Otherwise, it is placed wherever you drop it.

I use this technique when I need the same adjustment layer on two files. Suppose I have two photos that were shot of the same subject at the same time. If I create a Color Balance adjustment layer for one, I can drag it onto the other image instead of building one from scratch for the second image.

NOTE You also can use the Move tool to copy layer content from one image to another without using the Layers palette. I prefer the method I just showed you because it saves having to switch tools. Also, by using the Layer palette to select the layer I want to drag and drop, I can confirm that I'm working with the right layer. This is important when an image has lots of layers.

9. After the duplicate bird is in the new image, you can use the Move tool to fine-tune its positioning.

The two images in this example happen to have the same pixel dimensions. In practice, they don't have to be the same. However, be aware that if the dimensions are different, the incoming layer will change size relative to the difference in sizes between the two files. If I'm dragging a layer from an image with pixel dimensions of 1200×800 into an image with pixel dimensions of 2400×1600, the incoming layer — the bird in the example above — will look much smaller in the new image than it did in its original image.

NOTE This size differential isn't the case when dragging and dropping adjustment layers. They resize themselves to fit the entire image's pixel dimensions when dragged into an image with different dimensions.

The results of the exercise above may seem similar to an exercise we did in Chapter 6 when we were experimenting with retouching from one layer to another. This similarity is another example of the fact that you can always find more than one way to do things in Photoshop.

The general idea when using the technique we used above is to add a visual element to an image. However, the same technique also can be used to hide a visual element by copying information and placing it on top of the thing you want to hide. For example, you may want to hide an annoying light switch on a wall in the background of an image. Yes, you can do a job like that with a retouching tool like the Clone Stamp, but sometimes it's faster to copy a section of nearby wall and drop it on top of the light switch.

Here's an example of using this method to hide something. In the image in Figure 7.19, I want to remove the long drawstring that's hanging down on the right side of the sweater:

1. First, using the Lasso tool, I draw a loose selection around the area I want to cover, as shown in the second frame of Figure 7.19. This selection is used to get the shape I need when I create a copy. The area where the selection touches the edge of the sweater is the most critical part of this selection.

2. Next, I drag the selection to the side so that none of the white drawstring is inside of it, as shown in the next frame of Figure 7.19. Now that the selection has been repositioned, I can use its shape to select material to be pasted over the area I originally selected.

3. I want the information I copy to blend with the sweater's edge, so I need to soften the edge of the selection. I use the Feather Command (Alt-Command/Ctrl+D) with a value of 1.

NOTE I almost always feather a selection by 1 or 2 pixels when copying and pasting like this. Otherwise, the hard edge of the selection will show on the edges of the copied information.

4. Now, I copy the selection to a new layer (Command/Ctrl+J). A new layer, Layer 1, is created with the exact shape of the selection, shown in the fourth frame of Figure 7.19. You can see that the 1px feather softened the edges just a bit.

5. Next, I reposition Layer 1 so that it's back in the spot where the original selection was created, as shown in the final frame of Figure 7.19. If you look closely, you can still see the shape of Layer 1 along the right edge and the bottom. This is because the area of background that was copied is slightly darker than the area next to the girl. Ideally, it would blend perfectly with the background.

FIGURE 7.19

In this example, I want to remove the long drawstring on the right side of the image. The fastest way to accomplish that is to use a selection to define the area to be covered (second image). Then use the selection to copy a piece of background to a new layer (third and fourth images). Once that's done, the new layer is positioned over the drawstring and merged back into the Background layer (final image).

Photo by Dan Christopher

6. I usually use the Patch tool to clean up something like this. Because the Patch tool works with only one layer, I need to flatten the duplicate layer back into the Background layer first. After that's done, it takes only two applications of the Patch tool to blend these edges and complete this procedure.

> **TIP** If you're working with an image that has several layers, you may not want to flatten the entire image just to do a bit of retouching. In these cases, you can use the Merge Layers command (Command/Ctrl+E) under the Layer menu. The Merge Layers command flattens the current layer with the layer directly below it, while leaving other layers intact.

The entire process took less than a minute and is much cleaner than trying to do this with one of the standard retouching tools because of the large area being covered. This technique won't always work, but when it does, it's hard to beat for speed.

Combining Selections and Filters

I've mentioned filters a couple of times in this book. In fact we used one, Gaussian Blur, earlier in this chapter. But I never stopped to define exactly what a filter is. Let's take care of that right now.

Filters get their name from their counterpart in the film world. Film photographers have always used glass and other materials in front of their lenses to change the way images are captured by film. For example, photographers used to do things like smear petroleum jelly around the edges of a clear filter to blur the background around someone. With digital capture, most filtering takes place after the image is photographed or scanned. Thank goodness petroleum jelly never has to come near our cameras again!

Photoshop has a large array of filters available under the Filters menu. Some of them are fun and can be used to create cool, creative effects. Those aren't the kind of filters we're concerned with here. We're mostly interested in the more utilitarian filters such as Blur and Sharpen, though these techniques can be used with most other filters.

Earlier, in the exercise with my husky Ruby in the snow, I used a filter to blur a selected area of the image. I blurred the snow around her so she'd stand out from it. This is a common technique, especially in the digital age because digital SLRs tend to have a greater depth of field than their film counterparts. When everything's in focus, the viewer may not know what to look at. By selectively adjusting areas of sharpness (or blurriness), we can guide the viewer through the image.

> **NOTE** This blurring technique also can be used to fix an image where the subject isn't as sharp as you'd like it to be. You just select everything around the subject and blur it a bit, causing the subject to look sharper in relation to it.

Figure 7.20 shows a nice portrait of a couple with their dog. I really like the portrait, but all the sharp detail in the garden behind them is distracting, especially because their skin was smoothed during retouching to give them a softer look. (I show you a couple of techniques for smoothing skin in Chapter 15.)

FIGURE 7.20

The only thing that bothers me about this portrait is the sharp background that competes with the main subjects.

This problem is solved in three main steps:

1. The layer must be copied because blurring will permanently affect the pixels. That way, all blurring is isolated to its own layer. If I change my mind later, I can toss it and try something different. (If I think that's a real possibility, I'll save the selection before moving on.)

2. Select the area to be blurred. In this case, I draw a close selection around the people with the Magnetic Lasso tool and then invert it to select everything around them. (I had to remember to come back and subtract the background area between the man and the dog.) Before moving on, I feather the selection by 1 or 2 pixels and adjust the Radius setting in the Refine Edge to soften the boundary of the selection. The first image in Figure 7.21 shows the selection.

FIGURE 7.21

The problem can be fixed easily by creating a selection around the subjects, inverting it, and then blurring the pixels inside that selection. The final image with the blurred background is much more appealing.

NOTE It doesn't make much difference if you feather a selection before or after inverting it.

TIP Major changes like those in Figure 7.21 should always be done on a duplicate layer to maintain flexibility.

3. Use a blur filter to blur the selected information on the duplicate layer. I use the Gaussian Blur filter with a setting of 2.4 and then deselect the selection. The result, the bottom image in Figure 7.21, looks much better because it brings the focus back to the main subjects.

When enhancing eyes in a portrait, similar methods are used to sharpen only the eyes with one of the sharpening filters: Smart Sharpen or Unsharp Mask.

Using Smart Filters in Photoshop CS3

Something that Photoshop users have begged for over the years is a way to use filters non-destructively. When you use a filter on an image layer, the pixels are changed permanently — unless, of course, you're able to go backward in the history timeline. You already know how I feel about making permanent changes like this.

In the previous example, I got around this limitation by duplicating the layer before I applied any filters. This way, if I later decide I don't like the effect, all I have to do is delete the layer. This technique works, but it's less than elegant. The first problem is that when you duplicate layers, you increase the size of the file. When I duplicated the Background layer, I doubled the size of the file. The second issue is that if I do decide later that I don't like the effect of the filter and I want to redo it, I don't always know what the previous filter settings were. I have to start all over and experiment with various settings. When Adobe released Photoshop CS3, they solved both of these problems with a new filter feature named Smart Filters.

NEW FEATURE Smart Filters is a new feature in Photoshop CS3. Smart Filters allow for the creation editable filter adjustments that are non-destructive to the image. The filter's settings can be change at a later date or be removed completely.

When a Smart Filter is used, it becomes part of the layer stack in the Layers palette. Figure 7.22 shows what this looks like when I use a Smart Filter instead of duplicating the layer in the exercise above. A mask in the shape of my selection appears on the filter's thumbnail because a selection was in place before the filter was used. (I explain selections and masks in Chapter 8.) Clicking the eyeball next to the name hides the filter's effects. Double-clicking the name itself opens the filter dialog box with the settings that were used when the Smart Filter was created. This allows you to make further adjustments if needed. All this flexibility is achieved without a noticeable change to the file's size.

NOTE Smart Filters support all of Photoshop's filters except for Extract, Liquify, Pattern Maker, and Vanishing Point.

FIGURE 7.22

When a Smart Filter is created, it shows up just below the layer to which it is applied. In this case, because a selection was used, a mask appears in the thumbnail. To edit the filter, click the filter's name. To edit the way the filter blends, click the blending options icon to the right of the name.

Before we go any further with Smart Filters, I need to explain what it is that makes them so smart.

Understanding Smart Objects

Smart Filters work only on Smart Objects. If you have a normal image open and you look in the Filters menu, you won't see a command for Smart Filters. Instead, you see Convert for Smart Filter. If you click that command, the layer that's currently active is converted to a Smart Object.

Smart Objects first appeared in Photoshop CS2. They offer a way to open a file — usually a Raw file — as a reference to the original file, rather than a file full of pixels. When you edit a Smart Object, pixels aren't changed because there aren't any pixels to change. The Smart Object acts like a proxy of the original file. In other words, transformation adjustments like scaling and rotating are not destructive to the file.

One of the issues with using Smart Objects — especially when considering the objectives of this book — is that Smart Objects don't consist of actual pixels, so retouching tools can't be used on them. If you try to use the Clone Stamp on a Smart Object, you'll get the message dialog box shown in Figure 7.23 telling you that you have to *rasterize* the smart object. The Smart Object must be converted back to pixels — losing its smart capabilities — before the Clone Stamp can be used on it. When the Smart Object is rasterized, all Smart Filter effects become permanent and non-editable.

Naturally, you could use the Clone Stamp to clone to another layer by selecting All Layers in the Sample pop-up in the Clone Stamp's tool options. But you can't use the Patch tool. Because of that limitation, I don't use Smart Objects/Filters much when I'm working on restoration or retouching projects. However, they do offer us a different way of approaching a non-destructive workflow mentality, so I want to take a closer look at them.

FIGURE 7.23

Retouching tools can't be used on a Smart Object because they don't contain actual pixels. In order to retouch a Smart Object, it must be rasterized first.

Using Smart Filters

Let's revisit the portrait of the couple with their dog. This time, I'll use Smart Filters to blur around them:

1. Create a Smart Object from this file in one of two ways:
 - Open it as a Smart Object by going to File ⇨ Open As Smart Object.
 - Open the file, and choose Filter ⇨ Convert for Smart Filters. When this option is selected, a dialog box opens, reminding you that the layer is being converted into a Smart Object, as shown in Figure 7.24. If the layer is named Background, it will be renamed because that name is a special name with special properties.

 FIGURE 7.24

 This dialog box reminds you that you're creating a Smart Object when you choose the Convert for Smart Filters option under the Filter menu.

NOTE A Raw file can be opened as a Smart Object by selecting the box that says "Open in Photoshop as Smart Objects" in the Adobe Raw Converter's Workflow Options dialog box.

You can tell that a layer is a Smart Object by looking at the layer's thumbnail in the Layers palette. If it's a Smart Object, it has a small icon on its lower-left corner, shown in Figure 7.22. When you hover the cursor over this icon, the tooltip shows "Smart Object thumbnail."

2. Create a selection around the subjects and invert it, as I did earlier.

3. Choose Filter ➪ Blur ➪ Gaussian Blur. After you like the setting, click OK. The effect is the same as what I got without using a Smart Object. The only difference is in the Layers palette, as shown earlier in Figure 7.22. The Smart Filter appears just below the layer it is affecting.

4. If you want to change the filter's effects, simply double-click the name of the filter, Gaussian Blur. The Gaussian Blur dialog box reopens with the settings used last time still in effect, as shown on the left in Figure 7.25. This gives you the same kind of flexibility you get with adjustment layers, allowing you to go back and readjust your original setting at any time, as long as the image remains unflattened.

 If you double-click the icon to the right of the filter's name, a Blending Options dialog box opens that gives you control over how the filter blends with the layer's content, shown in the image on the right of Figure 7.25.

FIGURE 7.25

Double-clicking on the name of a Smart Filter reopens the filter's dialog with the previous settings still in place (first image). The Smart Filter's Filter Blending Options dialog box allows you to change the filter's blending mode and the opacity of the effect (second image). This dialog box is accessed by clicking on the icon to the right of the Smart Filter's name. (You can see the icon in Figure 7.21; it consists of two small black triangles and lines.)

The Blending Options dialog box allows you to lower the opacity of the filter, just like lowering the opacity of a layer. It also allows you to select a different blending mode so you can affect the way the filter's effects blend with the layer's image content. (One of the ways this is used is to select the Luminosity blending mode when sharpening so that any color noise caused by sharpening is eliminated.)

Here's another interesting thing that can be done with Smart Objects. In Chapter 4, I said that adjustment layers can't be made with the color Variations adjustment command. Well, with a Smart Object, you can create a non-destructive, re-editable Variations layer, but you can do the same thing with the Shadow/Highlight command.

Here's how it works. After a Smart Object has been created, choose Image ⇨ Adjustments. Notice that all of the adjustment commands are grayed out, except for the Shadow/Highlight and Variations commands. If you use one of these commands, it appears below the layer it was applied to, just like a Smart Filter, as shown in Figure 7.26.

FIGURE 7.26

Smart Objects allow you to use the Variations and Shadow/Highlights commands in a non-destructive way. When used with a Smart Object, these two commands appear in the Layers palette just below the layer to which they are applied. Their settings can be readjusted by clicking on their names, just like an adjustment layer.

Smart Objects coupled with Smart Filters offer a new way of addressing the age-old problem of making filters non-destructive. Our main problem with them here is that when additional retouching needs to be done, the method leaves something to be desired. However, Smart Filters are very powerful if used after all retouching is completed, or in cases where retouching needs are minimal.

Summary

In this chapter, we took a detailed look at selections, one of the most important tools for restoration and retouching. Selections are used to isolate regions of an image so they can be manipulated independently of the rest of the image. This way the final image can be constructed and fine-tuned piece by piece.

Selections are created with a variety of tools, including the Marquee, Lasso, Magic Wand, and Quick Selection tools. Each of these tools can be fine-tuned through its settings in the Tool Options Bar. Complex selections are created using a new selection to add to or subtract from an existing selection. Even more complex selections are created by combining multiple selection tools and techniques. Each tool is used on the parts of the selection that are most suitable for it.

After a complex selection is in place, its edge can be modified with the new Refine Edge tool. Refinements include Radius, Contrast, Smooth, Contract/Expand, and Feather — the most common refinement we do in this book. The Refine Edge dialog box also allows you to select the way the refinements are previewed. This new preview ability enables us to intuitively mix and match settings, creating the perfect selection edge.

After you've invested lots of time in creating a complex selection, you don't want to risk losing it. You can save a selection as part of an image, or as part of any other open image with identical pixel dimensions. This ability allows you to share a selection with a similar file that has the same selection needs. You also can create a new file that contains only the selection for long-term storage.

We looked at how selections are used to copy or remove selected areas from an image. This is one way to duplicate pixels so they can be used to add detail to an image or to hide it. New layers created by copying or cutting also can be shared with other images, no matter what their relative pixel dimensions are.

Finally, we looked at how the filters in Photoshop's Filter menu are used with selections. For the techniques in this book, we mostly work with blurring and sharpening filters, though we use a couple of others on rare occasions. The most exciting thing about filters in Photoshop CS3 is the new ability to use Smart Objects combined with Smart Filters to create non-destructive filters. Because Smart Objects don't contain actual pixel data, retouching tools can't be used directly on them. There are ways to deal with this, but to get the most use from a Smart Filter, you want to take care of all major retouching before turning your image into a Smart Object.

Chapter 8

Creating Flexibility with Layer Masks

S o far in this book, we've covered several important Photoshop concepts. Some of them are more important to us than others because they're encountered more often in a non-destructive workflow. With that in mind, most of these concepts pale in comparison to the concept you learn about in this chapter: layer masking.

When I first began using Photoshop many years ago, I heard and read about masks and masking, but I never really understood what they were or how they're supposed to be used. The concept just seemed so abstract. A couple of years later, when I finally understood masking, it completely changed the way I did things from then on.

My goal in this chapter is to help you learn about masking so you can begin using this powerful technique now. I explain exactly what layer masks are, show you how to create them, and then show you how to leverage them by combining masks with some of the things you've already learned in this book. When you're through with this chapter, you'll be ready to take your Photoshop workflow to a higher level.

Understanding Layer Masks

My neighbors recently had their house painted. Before the painter began spraying the house with paint, he used masking tape and paper to cover all the windows so they wouldn't be sprayed with paint. This is very much the way selections work in Photoshop. We select only the things we want to

paint before we start painting. Everything outside the selection is covered with virtual tape and paper. Masking in Photoshop works in a similar way, except that the "tape and paper" don't have to be applied before the painting begins; they can be applied after the fact, after the painting is done.

Layer masking is just what it sounds like — masking on a layer. When one layer sits on top of another, part of it can be hidden selectively, and temporarily, with a mask. When the information is hidden, that part of the layer becomes transparent. It would be the same as using the Eraser tool, except that the Eraser is a destructive tool; when something is erased, it's gone. When image information is masked, it can be unmasked if it needs to be revealed again.

The old cliché goes like this: A picture is worth a thousand words. Let's look at how masking works and then come back and dig into the details.

Figure 8.1 shows two completely different images: a girl by a car and a Japanese garden. My goal here is to combine them into a single image with the girl in front of the garden instead of the car.

From what you've learned so far, you might think that the best course of action is to use the Magic Wand to select the girl, copy her to a new layer, and then drag her into the garden image. That would work okay, if the selection were perfect. If I had problems with the original selection and didn't notice them until later, I'd have to back up and start all over again. As I'm sure you can imagine, this kind of technique goes against my philosophy of using a non-destructive restoration/retouching workflow.

Here's what I decide to do instead: I combine the two images into a single file with the girl as the top layer, as shown in the first image in Figure 8.2. I then create a mask and use the Brush tool with black paint to hide everything I don't want to see on the girl's layer. When I'm through painting the mask, the layers and image look like the second image in Figure 8.2.

Look at the layer stack in the second image in Figure 8.2. Notice that a new black and white thumbnail is now beside the thumbnail of the girl on Layer 1. This black and white thumbnail is the layer mask I created with the Brush tool. Everywhere I painted around the girl with black is now hidden from view, which leads to the basic rule of layer masks: Black hides, and white reveals. The beauty of this is that anytime I want to unhide something, I just come back with the Brush tool and apply some white paint to the area I want to reveal.

This concept is simple and powerful. With a layer mask, you can hide and reveal layer information at will. This is the ultimate in workflow flexibility because layer masks are completely non-destructive. Any application of paint on a layer mask can always be undone, as long as the layer is never merged or flattened with other layers.

FIGURE 8.1

I want to combine these two images so it looks like the girl is sitting in front of the garden. I could do it by selecting the girl and copying her to a new layer, but that technique isn't as flexible as using a layer mask.

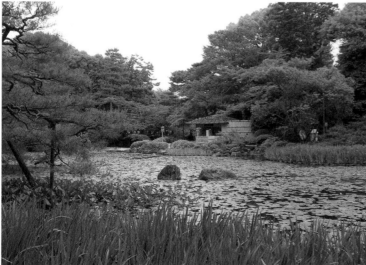

Photo by Jerry Auker

FIGURE 8.2

After both images are combined into a single file as individual layers, a mask is created on the top layer. Black on the mask hides information on the layer, and white reveals the layer's information.

Creating Layer Masks

Now that you understand the general idea, let's do the masking project together so you can get a real feel for layer masking:

1. Open the 78_vette.tif and the garden.tif practice files from the downloadable practice files on the Web site. Position them on the screen so that you can see some of both images at once.

2. Click the 78_vette file to make it active. Then go to the Layers palette, and drag the background layer into the garden file. Hold down the Shift key as you drag so the layer is dropped into the center of the image.

3. Now that both images are in the same file, you don't need the 78_vette file, so close it. The garden.tif image and its associated Layers palette should now look like Figure 8.3.

FIGURE 8.3

Both images are stacked together in the same file. The layer with the girl (Layer 1) is on top, so we can't see the garden image below her. The icon that looks like a target at the bottom of the Layers palette can be used as a shortcut for creating a layer mask.

4. You're almost ready to start masking. All you need is a mask, which you can create in two different ways:

 ▪ Go to Layer ⇨ Layer Mask ⇨ Reveal All. (I'll discuss the difference between Reveal All and Hide All in a bit.)

 ▪ Simply click the Add Layer Mask icon, the target-like icon at the bottom of the Layers palette, circled in Figure 8.3.

CAUTION If you accidentally click the Add Layer Mask icon a second time, a vector mask is created. A vector mask is also created if you click this icon after creating an adjustment layer. A vector mask appears as a second mask thumbnail, next to the layer mask thumbnail on the Layers palette. We don't use vector masks here, so if you create one by mistake, you can delete it by dragging it to the trashcan icon at the bottom right of the Layers palette.

Now your Layers palette should look like Figure 8.4 with a white box beside the image thumbnail. This white box, as you saw in Figure 8.2, is a representation of the mask you'll be creating. It isn't the mask itself, just as the image icon in the Layers palette isn't the image itself. It's only a representation of it. The link icon that appears between the two thumbnails signifies that the mask is *linked* with the layer's image content. If I use the Move tool to move the layer's image content, the mask moves too, staying in alignment with the image.

FIGURE 8.4

When a Reveal All mask is created, it appears as a white thumbnail beside the image thumbnail in the Layers palette. (We know that white reveals, so it makes sense that a Reveal All mask is white.)

5. Select the Brush tool, and set its Master Diameter to 300px, Hardness to 0%, and Opacity to 100%. Make sure that black is the foreground color. It should be because when you create a layer mask using the two methods shown above, the color swatches are reset to their defaults — black as the foreground color and white as the background color.

> **NOTE** When a layer mask is active, you can't select any colors other than black, white, or gray in the Color Picker. Even if you click red in the Color Picker, the swatch on the toolbar is gray. That's because only black, white, and shades of gray can be used on a mask.

6. Start painting around the outer edges of the image. Don't go too close to the girl just yet. Notice that as you paint, you begin to see the garden layer below. Keep painting until most of the detail around the girl is hidden, as in the first image in Figure 8.5.

> **TIP** When painting a mask with the Brush tool, all painting is done on the image itself, not on the little mask thumbnail.

7. Reduce the size of your brush, and move in closer to the girl. When you get right next to her, you'll find that the soft brush doesn't work very well. You can't get right next to her without affecting her too. (Remember, in an earlier chapter, I said that I like to work with a soft brush until I'm forced to go to a harder brush? Well, this is one of those times.) Raise the Brush tool's Hardness value to 80 or 90. Try to avoid going to 100 so you still get a soft edge along the outline of the girl.

8. If you accidentally hide part of the girl instead of the background, switch your foreground color to white (using the X key or the curved arrow by the swatches) and paint the detail back in. It's that easy.

FIGURE 8.5

Information on Layer 1 is hidden as you begin painting with black on the image. This painting is reflected in the layer mask thumbnail on Layer 1 in the Layers palette.

9. Your image should now look very close to what I got earlier in Figure 8.2. Press the back-slash key (\) to take the image into *Quick Mask mode.*

 This viewing mode allows you to see all your masking strokes as a red overlay, as shown in Figure 8.6. This is a great way to see exactly where your brushstrokes are. In Figure 8.6, you can see where I missed a spot below her elbow on the left. It wasn't noticeable in the image preview until Quick Mask mode was turned on. You can continue painting while in Quick Mask mode if you want to.

NOTE The red color of the Quick Mask goes back to the days when masks were hand-cut, with a razor blade, on orange or red plastic sheets called Amber-lith and Ruby-lith. If you want to use a different color or change its opacity, double-click the mask thumbnail in the Layers palette.

10. When your mask is fine-tuned to your liking, press the \ key again to go back to normal viewing mode.

TIP If this were a real job, I'd take another few moments to remove some of the distractions in the background, like the two lavender shapes on the right. Remember, if you're going to do this, you have to click the Background layer first to make it active before you can use any retouching tools on it.

FIGURE 8.6

Press the \ key to see your masking on the image while you're using the Brush tool. To hide the mask, press the \ key again. This is a good way to see exactly where your brushstrokes are on the image as you paint them.

To temporarily hide a mask so you can see the image without the effects of the mask, press the Shift key and click the layer mask thumbnail in the Layers palette. When you do this, a big red X appears on the thumbnail, signifying that the mask is hidden. Click the thumbnail again to unhide the mask.

Another useful viewing option with a mask is to Alt-click the mask. This makes the actual mask appear in the image preview, as shown in Figure 8.7. This mask viewing mode is extremely revealing. Now I can see other areas I missed when painting my mask. I didn't notice them in Quick Mask mode. After I have those areas taken care of, I Alt-click again to go back to the normal view.

You need to be aware of one more thing when working with masks. When you're painting, or retouching for that matter, you can choose to work on the mask or on the image. This makes sense. Sometimes you want to paint the mask, and other times you may want to paint on the image itself. You can tell which area will be painted on by looking at the thumbnails in the Layers palette.

FIGURE 8.7

Alt-click the layer mask thumbnail in the Layers palette to see the actual mask in the image preview. You can paint on it like this to fix any problems it reveals. When you're finished, Alt-click the thumbnail again to go back to the normal view.

Click the image thumbnail for Layer 1 in the previous example. When you do this, notice that a small black box appears around the thumbnail. (You can see this in the Layers palette Layer 1 mask thumbnail in Figure 8.5.) Now you can paint on the image itself, or you can use a retouching tool on it. Click the mask thumbnail, and watch the box move back to the mask. (You can see this on the Layers palette thumbnail in Figure 8.4.) Now any painting or retouching that you do is applied to the mask. When a mask is first created, the black box is always around the mask thumbnail, indicating that you can start masking right away.

CAUTION If you're using a retouching tool on a layer that has a mask and nothing is happening, it probably means that you're retouching the mask instead of the image. To solve this, click the image thumbnail in the Layers palette to make it active instead of the mask.

Now that you see how easy and powerful layer masking is, let's tie this concept in with some of the other things you've learned so you can see how they all work together.

Using Masks with Selections

At the beginning of the preceding exercise, I suggested an alternate way of handling the project. I could have selected the girl and then copied her to a new layer. (Or I could have selected her, inverted the selection, and then pressed the Delete key to delete everything around her, as long as her layer was not named Background.) After that was done, I could have moved her layer into the garden image. If you recall, the main drawback to this strategy is the fact that a move like this is permanent (destructive to pixels). If I did it that way, I'd have to live with that original selection after the girl was separated from her original background. I'd rather have some options in case I want to make changes later.

Painting a mask with the Brush tool is non-destructive, but it can be time consuming. Also, it isn't always as exact as a selection (as you can see by my sloppy masking job in Figure 8.7). The good news is that the speed and accuracy of a selection can be combined with the non-destructive nature of a mask, giving you the best of both worlds:

1. If you still have the file from the previous exercise open, click and drag the mask thumbnail to the trashcan icon at the bottom of the Layers palette. When a dialog box opens asking if you want to Apply or Delete the mask, click Delete.

 Be sure that you don't accidentally grab the image thumbnail. If you do, you'll delete the entire layer instead of just the mask. (If you don't have the image still open, open it and complete Steps 1 through 3 from the preceding steps.) Your Layers palette should look like the Layers palette in Figure 8.3 again.

2. Use the Magnetic Lasso to draw a quick selection around the girl. Use the Lasso tool to fine-tune the selection by adding and subtracting. It isn't necessary to make this selection absolutely perfect. Just get it close to perfect as quickly as you can. When you're finished, feather the selection one or two pixels to soften its edge.

3. After your selection is in place, it can be used to create a mask. Click the Add Layer Mask icon at the bottom of the Layers palette (the icon that looks like a target). A mask is created as soon as you click it, hiding everything on Layer 1 that was outside of the mask.

 This is a much better technique than cutting and pasting for removing the girl from her background because all the background information is still there. It can be masked back in anytime.

4. Use the Brush to touch up the mask in any of the spots where the selection wasn't perfect.

CAUTION **Creating a mask from a selection doesn't work if you create the mask the other way by choosing Layer ➪ Layer Mask ➪ Reveal All. You have to use the icon on the Layers palette or choose Reveal Selection from the Layer Mask submenu. (I discuss this command in a moment.)**

Using a selection is much faster than manually masking out everything around the girl with the Brush tool. It's not only faster in this case; it's also quite accurate along the edges of the girl. Keep in mind, though, that you don't have to be this accurate with the initial selection. A loose selection

can be used to quickly hide most of the layer, and then the Brush tool can be used to fine-tune the mask. It really depends on the kind of image you're working with. In this example, the crisp outline of the girl in the original image lends itself to the Magnetic Lasso.

This ability to convert a selection into a mask works both ways: A mask can be loaded as a selection. You may remember back in Chapter 7 that I discussed saving and loading selections, and I pointed out that a saved selection is saved as a channel in the Channels palette. Well, look at your Channels palette from the preceding exercise. It should look much like the Channels palette in Figure 8.8. This is the same channel that would be created if the selection were saved, rather than converted to a mask.

I'm sure you've already figured this out by now, but to load a mask as a selection, choose Select ⇨ Load Selection. When the Load Selection dialog box opens, click OK to load a selection from the channel. You can do this at any time as long as the mask channel is in place.

NOTE If you modify the mask, the associated channel changes also.

FIGURE 8.8

When a mask is created, it becomes its own channel in the Channels palette. This is very similar to what happens when a selection is saved. To load this mask as a selection from the Channels palette, click the indicated icon. (You also can load a mask as a selection by Command/Ctrl-clicking on the mask in the Layers palette.)

You can load a selection from a mask in two faster ways:

- In the Channels palette, click the Load Channel as Selection icon, shown in Figure 8.8.
- Command/Ctrl-click the mask thumbnail in the Layers palette.

TIP **Command/Ctrl-clicking any layer content loads it as a selection. In the preceding chapters, we selected a bird and copied it to a new layer. After the bird was isolated on its own layer, it could have been reselected by Command/Ctrl-clicking on its thumbnail in the Layers palette.**

As you can see here, selections and masks have a special relationship. This is a great thing to be aware of as you begin to use masks in your restoration and retouching workflows.

Comparing Reveal All and Hide All Masks

When you create a new layer mask using the Layer menu (Layer ⇨ Layer Mask), your two options are Reveal All and Hide All, as shown in Figure 8.9. The only difference between these two options is the color that's used to fill the mask when it's created:

- A Reveal All layer mask is filled with white. It's used when a small amount of information is going to be masked out and hidden.
- A Hide All layer mask is filled with black. It's used when a large amount of information needs to be hidden so that a small amount of information can be revealed by using the Brush tool with white paint.

We know that white reveals and black hides information on the layer the mask is applied to. So it makes complete sense that a layer that reveals all is white and a layer that hides all is black.

CAUTION **When you're thinking about masks and the information they reveal and hide, always remember that we're talking about information on the layer that the mask is on, not information that is being seen on layers that are below the masked layer.**

Most of the time, we want a mask that reveals all. However, sometimes, hiding everything and revealing a small amount of information is faster. For example, I often whiten teeth in a portrait by creating a Hue/Saturation adjustment layer that desaturates the yellows. Then I use the Paint Bucket to fill the mask with black paint to hide the effect of the adjustment layer. This is the same thing as a Hide All mask. Then I quickly come back and paint the mask white in only the places where the teeth show. This way, the adjustment layer is applied only to the teeth. (You'll see this technique in Chapter 15.)

FIGURE 8.9

You have two options when a layer mask is created via the Layer menu. You can create a Reveal All mask that's white or a Hide All mask that's black. If a selection is active, two more choices appear. You have the choice of revealing or hiding the information in the selection as the mask is created.

TIP To convert a Reveal All mask into a Hide All mask, or vice versa, use the Paint Bucket tool. Fill a mask with white to reveal all, and fill it with black to hide all. You also can fill a selection with paint to affect its area on the mask.

When you're creating a mask from a selection you have the choice of revealing or hiding the information in the selection by choosing Reveal Selection or Hide Selection from the Layer Mask submenu under the Layer palette, as shown in Figure 8.9. Figure 8.10 shows the difference between these two options when used with a selection.

I'll bet you have a question right now. How does the Add Layer Mask icon (the target-shaped icon), at the bottom center of the Layers palette fit into all of this? Good question. As we saw earlier, when this icon is clicked, a Reveal All mask is created. However, you can make it create a Hide All mask instead; simply hold down the Alt key when you click the icon to create a Hide All mask. It works the same way with a selection too. If a selection is active, when you hold the Alt key while clicking the icon, the information in the selection is hidden. (I'd hate to tell you how long I used Photoshop before discovering this shortcut!)

FIGURE 8.10

In the first example, Reveal Selection is chosen from the Layer Mask submenu. Everything outside the selection is hidden by the mask. In the second example, when Hide Selection is chosen, everything inside the selection is hidden by the mask. The only difference in these images is that the whites and blacks on the mask have swapped positions.

Using Masks with Adjustment Layers

Adjustment layers also have a special relationship with layer masks. You may have already noticed it. Whenever you create an adjustment layer, a layer mask is automatically created at the same time. The mask is ready to go; you just have to choose the Brush tool and start painting. Masks are created with adjustment layers because the two are used together extensively.

The image in Figure 8.11 is a portrait of a young man and his musical instrument. A technique that's popular with a portrait like this is to convert everything in the image to black and white, except for the musical instrument. It's reminiscent of a hand-toning effect that film photographers have used since the earliest days of photography. Fortunately, creating this effect with Photoshop is much easier than hand-toning a black-and-white print.

You can use several techniques to create this effect in Photoshop. Some of the solutions are less than elegant because they make permanent changes to the pixels in the image. None of them compares to the ease and flexibility of using an adjustment layer coupled with a layer mask.

Here's how I handle this project:

1. Create a Black & White adjustment layer. (We cover the Black & White command in Chapter 11.) This makes the image look like a black-and-white photo. Because it's an adjustment layer, a mask is automatically created.

2. Paint the saxophone with black paint to hide the black-and-white effect of the adjustment layer, allowing the full color of the saxophone to show. (If the musical instrument were a bright color, I could save time by using the Magic Wand to select it before creating the mask instead of painting it in afterward.)

NOTE Because there is no image thumbnail on an adjustment layer, you don't need to make sure you're on the mask when painting. If the adjustment layer is the active layer, then you're on the mask.

The whole process took about two minutes to create, and it can be removed in a moment by turning off the visibility of the Black & White adjustment layer. Figure 8.12 shows the mask I painted and the Layer palette with the Black & White adjustment layer.

This hand-toning effect is popular in wedding photography. You see it most often in portraits of the bride with her bouquet. Everything in the image is black and white, except for the flowers. The effect causes the flowers to almost jump out of the image.

FIGURE 8.11

A popular technique with a portrait like this is to convert everything except for the instrument to black and white. This is a simple two-step process when using an adjustment layer.

Photo by Denyce Weiler

FIGURE 8.12

After the adjustment layer is created, you can paint this mask in a couple of minutes. The color of the musical instrument can be returned to black and white by deleting the mask. Or the image can be returned to full color by turning off the adjustment layer's visibility or completely deleting it.

Combining Selections, Adjustment Layers, and Masks

Now that you have a clear idea of how all of these elements work together, I want to show you one of the ways I most commonly combine the three of them. I always like to have the corners of an image darkened a bit to draw the eye away from its edges. This is something that custom printers have been doing for years in color and black-and-white darkrooms. In Chapter 12, we explore *burning and dodging*, a technique to locally darken or lighten selected areas of an image.

Right now, I want to show you how to use the techniques you've learned so far to darken all the corners of the image at the same time. I'm going to do it with a Levels adjustment layer and a mask to keep my workflow flexible:

1. Open the snow_dog.tif practice file. Adjust the Levels, and make any other adjustments to tone and color that you feel like doing.

2. Choose the Elliptical Marquee tool from the toolbar. Make sure the Feather value is 0px, Anti-alias is checked, and Style is Normal. Create an elliptical selection that covers most of the central area of the image, as shown in Figure 8.13.

 Remember that you can reposition the selection after it's drawn by placing the cursor inside the selection and then clicking and dragging into position. This way, you don't have to draw it perfectly the first time.

FIGURE 8.13

The first step to darkening all the corners with an adjustment layer is to create a large elliptical selection. This selection is then inverted so that the image surrounding the main subject is selected.

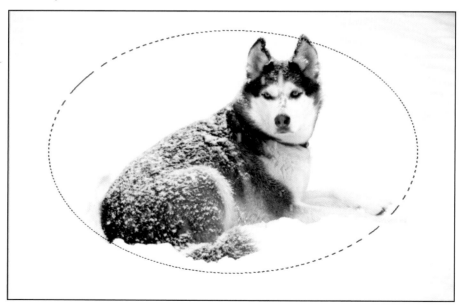

3. After the selection is in place, choose Select ➪ Inverse (Alt+Command/Ctrl+I) to invert it so that the area around the dog is selected.

4. Create a Levels adjustment layer. Change only the middle gray slider. Set it to a value of .50, and click OK. Your image, as well as the mask you created, should now look like the first set of images in Figure 8.14.

There's a problem here because we skipped a step. I'll bet you know which one. We should have feathered the selection before creating the adjustment layer. I skipped it on purpose because I want you to see the difference.

5. Undo the last step and go back to the end of Step 3 (Command/Ctrl+Z).

6. This time, let's feather the selection before creating the adjustment layer. Click the Refine Edge button (Alt+Command/Ctrl+R) in the Elliptical Marquee tool options. Click the Mask preview button at the bottom right so your selection looks like a mask. Set all Refine Edge values to 0. The hard-edged mask in the preview looks just like the mask for the first image in Figure 8.14.

FIGURE 8.14

In the first set of images, the selection was not feathered before the layer mask was created. You can easily see the effects that a hard-edged mask has on its layer. In the second set of images, the selection was feathered 100px. The feathering creates a soft-edged mask that gradually changes tone.

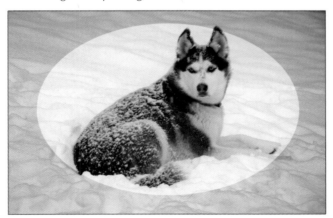

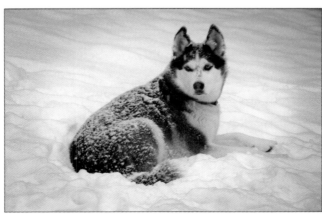

7. Change the Feather value to 100, and click OK. The view goes back to the normal selection view. It's hard to tell that anything has changed.

TIP
This is a good time to adjust the size of your selection, if needed, with the Contract/Expand slider before clicking OK.

8. Recreate the Levels adjustment layer, changing only the gray slider value to .50. This time the darkening effect fades as it moves toward the center of the image, as shown in the second set of images in Figure 8.14.

This simple effect combines three of the main concepts we've covered in the first half of this book: selections, adjustment layers, and masks. This is a good exercise to review whenever you need to refresh your memory about how these three important concepts interact.

Applying a Gradient to a Mask

As you know, black on a mask hides and white reveals. But what about gray? If you look at the mask in the second set of images in Figure 8.14, you can see that the mask fades from black in the center to white around the edges. The transitional area, created by the feathering, has lots of tones that aren't white or black; they're varying shades of gray. If you compare the mask to the image, you'll notice that as the gray gets lighter toward the edges of the mask, the effect of the adjustment layer on the image is more revealed.

The first point to make here is that you can paint on a mask with any shade of gray. The darker the shade, the more hidden the layer's information is. This is useful for toning down something without completely hiding it. If I were to create a white Reveal All mask and paint it with 50-percent gray — or better yet, use the Paint Bucket to fill it with 50% gray (128, 128, 128) — the layer would be 50-percent hidden. The result is the same as reducing the opacity of a layer filled with 100 percent black to 50 percent.

The second point is that a gradient can be used on a mask to fade it from white to black. The effect is similar to feathering a selection, but it gives you a different kind of control over the mask you create. Here's how that works:

1. Open the snow_dog.tif practice file one last time. (This is the last time we'll see Ruby.) Make any levels or color adjustments you want to make. (If you still have the file open from the preceding exercise, back up to the end of Step 1 above.)

2. Create a Levels adjustment layer like the one we used above, changing only the gray slider to a value of .50.

3. Select the Gradient tool (G). It's stacked with the Paint Bucket tool, twelfth from the top on the single-column toolbar. You'll use this tool to draw a gradient on your mask that goes from black to white.

4. Press the D key to set your color swatches to their default colors of white over black. (When you're on a mask, the default is the opposite of when you are working with the image itself.) Press X to exchange these colors so that the color swatch on top is black (the foreground color) and white is on the bottom (the background color).

5. Go to the Tool Options bar to set up the Gradient tool. Click the Gradient Picker pop-up, as shown in Figure 8.15, and select the first gradient option: Foreground to Background. Also make sure that the Radial Gradient style is selected, as circled in Figure 8.15.

 Now the Gradient tool will draw a gradient that begins with the foreground color and ends with the background color. As the stroke you draw gets longer, the gradient becomes more gradual. The Radial Gradient mode creates a gradient that radiates in a circular pattern from the center of wherever the gradient is started.

FIGURE 8.15

The Gradient Picker is located on the Tool Options bar. Choose the first option, Foreground to Background, to make the tool create a gradient that goes from your foreground color to your background color. For this exercise, we use the Radial Gradient style (circled).

6. This time, instead of darkening only the corners of the image — something we can do with this tool — we want to draw attention to the dog's face by lightening around it. Click a spot between the dog's eyes, and drag outward a short distance, as shown in Figure 8.16. When you let go of the mouse, a black-to-white radial gradient is drawn on the mask. You can see this mask in Figure 8.16.

 The size of the gradient on the mask is equal to the length of the line drawn with the Gradient tool, shown in the first image. A short gradient like this lightens a small circular area around the dog's face. Because a gradient is used to create the mask, the transitional boundary from hidden information to revealed information is barely noticeable.

 Experiment with shorter and longer strokes so you can see how they affect the image and the mask. Also try adjusting the gray slider value on the Levels adjustment layer to vary the amount of darkening.

> **TIP** When you're using the Gradient tool on a mask, you don't need to undo one gradient before trying another. When a new gradient is created, it replaces the previous one.

FIGURE 8.16

After an adjustment layer is created to darken the entire image, the Gradient tool is used to create a mask with a gradient from black to white.

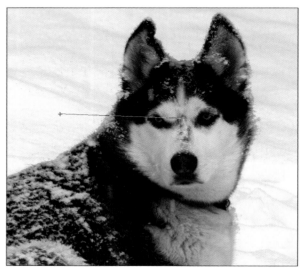

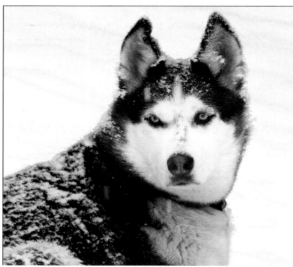

As you can see, a mask can be created very quickly with the gradient tool. We've barely scratched the surface of what can be done with this technique. When the tool is in the Linear Gradient mode — the first mode icon in the tool options — it can be used for things like masking the top part of one image with the bottom of another. For example, you can combine an image that has a nice sky with another similar image that has a nice foreground.

Summary

In this chapter, you learned about layer masking in Photoshop. First, you learned that a mask is used to reveal or hide information on its layer. The main thing to remember here is the basic rule of masking: White on the mask reveals the layer's information, and black on the mask hides the layer's information. You saw how to create masks that reveal all or hide all, and what those two different masks look like.

You also learned that the exactness of a selection can be combined with a mask to create a flexible way to use selections. When a selection is active, you can choose to hide or reveal its contents as you create a mask. You learned that selections and masks have an interesting reciprocal relationship: You can create a mask from a selection as easily as you can create a selection from a mask. You also learned that a saved selection is virtually the same thing as a mask because both become independent channels in the Channels palette.

Next, you saw another way to use adjustment layers by combining them with masks so you can choose which parts of the image are affected by the adjustment layer. Adjustment layers and masks become even more useful when combined with selections. This is a powerful concept that is used often in restoration and retouching. You will see it again in this book.

Finally, you learned that black and white aren't the only colors used on a mask. Shades of gray are used to control how intense the masking is. A 50-percent gray hides and reveals at the same time by applying masking with a 50-percent opacity — much like adjusting a layer's master opacity. This was demonstrated by using the Gradient tool with a black-to-white gradient to create a localized mask — another useful technique for working with adjustment layers and masks.

When creating a non-destructive restoration/retouching workflow, all of these concepts are very important. Make sure that you're comfortable with them before moving on to Part III of this book. A clear knowledge of them will serve you well as you learn specific techniques for restoring and retouching photos with Photoshop CS3.

Part III

Restoration— Rescuing Damaged Photos

The first two parts of this book explain the nuts and bolts behind a number of Photoshop CS3's tools and techniques. Now it's time to put those nuts and bolts into context by showing how to use them to solve real-world problems.

Photoshop and digital imaging have completely changed the way photo restoration is done. The process used to be cumbersome and the results were often as questionable as they were expensive. Today, just about anyone can buy a scanner and learn to bring old photos back to life, preserving and sharing them with future generations.

In Part III I take you through the things you need to know to start restoring your own old photos. I begin by showing you how to work with a scanner to turn your old photos into digital files. Then I take you through a two-stage process: making repairs and then preparing files for final presentation. You'll have a chance to put it all together in the last chapter of this part as we go through a hands-on restoration project together.

Please take the time to read this section even if you don't plan to do any photo restoration right now. The ideas discussed here not only build on the material we've already covered; they serve as building blocks for tips and techniques I share in Part IV.

Chapter 9

Starting with the Scan

When we talk about photo restoration, we're usually thinking about damaged prints from yesteryear that need some TLC so they can be preserved for future generations. The magic that happens with modern restoration techniques is digital, so these old photos need to be converted to digital files before we can work on them. The good news is that converting paper prints to digital files is easy: All you need is a scanner.

A few years ago scanners were expensive and difficult to master. Today they're everywhere and easy to use. Because of this ubiquity, we sometimes lose track of copyrights and find ourselves on the wrong side of the law. In this chapter, we cover the subject so you'll know what your rights and responsibilities are when it come to copyrighted material.

As I mentioned, scanner technology has come a long way. But it still helps to know something about how a scanner works and how to get the best possible files from it. In this chapter, we cover everything you need to know to maximize your scans.

Considering Copyright

In today's digital world, you can copy just about anything easily: photos, music, software, and so on. Because of this ease, we tend to lose sight of the rights of the person who created the thing we are copying. In recent years, we have seen several high-profile court cases involving the unauthorized copying of music. A number of "regular" people have found themselves in court because they were sharing copyrighted music illegally with other regular people.

Just as musicians and record companies own the rights to music, photographers own the rights to their creations. You may not have known this, but unless it is specifically spelled out, you don't own the photos of your wedding or any portraits if a professional photographer took them. Many people are shocked when they hear this because they think that they own the photos since they paid for their creation. In actuality, the subject of a photograph has nothing to do with who owns it.

> **NOTE** **People sometimes forget that professional photographers depend on future print sales for a portion of their income. That's why the sitting fee for a portrait session might be priced low, but enlargements may not.**

When a professional photographer takes a photograph, she owns the copyright to it from the moment she clicks the shutter. You may buy a tangible copy of the photograph, but she still owns the intangible aspect of the work — as intellectual property — because she is its creator. Ownership can be transferred, but it must be in writing and signed by the owner. When the original owner of the copyright is no longer living, the image may still be covered by copyright if the copyright was passed on in a will or trust.

If you have an image you want to scan, but you think it may be covered by a copyright, try to find the creator of the image and ask for written permission to scan and reproduce it for your own uses. Unless the image is recent, most photographers will gladly comply. The best guideline to follow is this: If in doubt, do the right thing and try to contact the copyright holder.

> **CAUTION** **Copyright litigation is one of the few areas of law in the United States where an accused party can wind up paying both sides' attorney fees. This adds incentive for the copyright holder to prosecute infringement if they have a strong case.**

If you bring a scan from a "professional-looking" photo to a lab or mini-lab for printing, you may need written permission. So many of these small businesses have been sued for printing copyrighted materials that they're quite careful about what they print. In some cases, if it looks like a professional created it, the lab won't touch it without a release — even if you're the one who shot it.

Demystifying Resolution

One of the things that can be the hardest to get your head around when you start down the digital path is resolution. This confusion is compounded by the fact that there are two different kinds of resolution in the digital world. One is *dots per inch,* and the other is *pixels per inch.*

Dots per inch (dpi) refers to the number of dots per inch that an inkjet printer is capable of applying to a sheet of paper. It can range from 720 to 2800 and more. The closer these dots are to each other, the more they blend together forming continuous tones on the print. Naturally, this depends on the paper that is being printed on. If the paper is porous watercolor paper, the dots will soak in and blend just fine at lower dpi settings like 720. On glossy photo papers, a higher setting — such as 1440 — is needed because the ink dries on the surface. About the only time people discuss dpi is when they are talking about a printer.

When we're talking about resolution in digital photography, we're usually thinking about pixels per inch (ppi). This refers to the distance between the pixels that make up our digital images. Pixels per inch is an important setting because it determines what our digital images look like when they're displayed and printed. Sometimes a lower value is desirable, and other times a higher value is preferred.

> **TIP** Keep in mind that people often use the terms dpi and ppi interchangeably, saying dpi when they really mean ppi. If they're not specifically talking about a printer's output, then they probably mean ppi.

We're most aware of a file's ppi when it comes time to print. If we have a file with a low resolution, like 150 ppi, we run the risk of seeing the space between the pixels when we print. This causes edge detail that should be smooth in the print to look jagged. The goal is to get the pixels close enough together so that these single dots form continuous tones and lines. If you are printing on an inkjet printer, the sweet spot for matte and glossy papers is 300 ppi. If you plan to take files to a commercial photo lab for printing, you'll need files that are 250 or 300 ppi; 300 seems to be the most common. It's best to check with the lab ahead of time to see what's best for them.

If I have an image file that is 150 ppi and I need to convert it to 300 ppi for printing, when I convert the image, it will be reduced to half its size. An 8×10 will become a 4×5.

Doing the simple math

I know I just said the dreaded *M* word, but please keep reading because in the next few paragraphs I'll show you how to use simple math to understand what Photoshop is doing when you resize your photo files. Let's start off with getting a better handle on how resolution works:

1. Choose File ➪ New, and create a new file with the following attributes: Width = 2 inches, Height = 2 inches, Resolution = 300, and Color Mode = RGB Color, 8-bit. The New dialog box shown in Figure 9.1 shows these settings.

2. When the file opens in Photoshop, choose Image ➪ Image Size (Alt+Ctrl+I). Notice that the dimensions are the same as what you specified with the New File command.

3. For the first part of our experiment, uncheck the Resample check box.

 Notice that the Pixel Dimensions area at the top of the Image Size window goes gray when Resample is turned off. That means that the number of pixels being used in our image is fixed at 600×600 pixels. We'll come back to this in a moment.

4. Change the resolution setting to **150**. Notice that the size of the image goes from 2"×2" to 4"×4", as shown in Figure 9.2.

 We're changing the distance between pixels as we modify the resolution of the file. We have fixed overall pixel dimensions of 600×600. When we set our resolution to 300 pixels per inch, the math dictates that the image is 2"×2" (2" x 300 ppi = 600 pixels).

 When we set our resolution to 150 ppi, then the image must become 4"×4" in size (4" x 150 ppi = 600 pixels).

231

FIGURE 9.1

Use these settings in the New dialog box to set up a sample file for this exercise.

FIGURE 9.2

When Resample is turned off, Resolution affects Document Size and vice versa. However, no new pixels are added and none are removed because the actual Pixel Dimensions cannot be changed.

Resizing and resampling

In the last example, I asked you to turn off Resample because Resample has a special function that affects the math involved in resizing an image. With Resample turned off, the Pixel Dimensions remained fixed. Any change to Resolution affects Document Size and vice versa. Let's see what happens when Resample is turned on:

1. Create the same sample file again: 2"×2" at 300 ppi.

TIP If you still have the Image Size window open from the preceding example, you can reset it to the settings it had when you opened it by holding down the Option/Alt key and clicking Reset (where the Cancel button used to be). This works with almost every dialog box where you see a Cancel button.

2. This time, leave the Resample box checked. (Click it if it isn't already checked.)

3. Change the Resolution to **150**.

 Notice that the Image Size remains at 2"×2". What did change was the Pixel Dimensions at the top of the window. They went from 600×600 to 300×300.

4. Change the Resolution to **600**. Now the Pixel Dimensions changes to 1200×1200, but the Document Size remains fixed, as shown in Figure 9.3.

FIGURE 9.3

When Resample is turned on, changes to Resolution or Document Size affect Pixel Dimensions only. Pixels are added or removed to accommodate the changes. This can be seen in changes to Pixel Dimensions at the top of the window.

When Resample is turned on, modifications to Resolution or Document Size in the Images Size window affect only the Pixel Dimensions. What's happening is that when we make the document smaller or reduce its resolution, resampling takes pixels from the image to make it smaller. This is called *downsampling*.

If we make the Document Size larger or increase the Resolution, resampling adds pixels to the image. This is called *upsampling*. You can verify that this is taking place by looking at the file size readout next to Pixel Dimensions. In Figure 9.2, the file size was 1.03 megabytes. In Figure 9.3, it becomes 263.7Kb. Fewer megabytes means fewer pixels.

Keep in mind that adding lots of pixels to an image can affect the image's quality. Photoshop is pretty good at upsampling, but only so much can be done. Lots of guesses need to be made on Photoshop's part when deciding what color to make a new pixel. If you push it too far and try to upsample an image beyond Photoshop's capabilities, you can end up with a low-quality file. For projects that require upsampling beyond Photoshop's abilities, look to a plug-in like Genuine Fractals by onOne Software. This plug-in uses fractal math to accomplish some amazing upsampling feats.

NOTE **A plug-in is an additional piece of software that is designed to compliment Photoshop by working within Photoshop's environment. Plug-ins usually can be accessed under the Filters menu.**

So remember, if you only want to change the resolution of the file, uncheck Resample. If you need to make the image smaller or larger, then Resample must be checked.

Sometimes it's necessary to change the document size and resolution at the same time. For example, suppose I have a file that is sized to 8"×10" at 250 ppi, and I need to change it to a 4"×5" at 300. Making this change with the Image Size command requires two steps. Both steps can be carried out in one use of the Image Size command:

1. Create a new file by choosing File ➪ New; make the file measure 8"×10" at 250 ppi.
2. Open the Image Size dialog box by choosing Image ➪ Size (Alt+Ctrl+I).
3. Uncheck Resample Image, and change the resolution to **300**. Notice that the Document size changes to 6.67×8.33 because we're moving the pixels closer together.
4. Check Resample, and change the Document Size Width to 4 inches.
5. Click OK.

 Now you have a file that is 4"×5" at 300 ppi.

Using the correct Image Interpolation method

There's one more wrinkle to throw at you before we move on. In the previous examples, you probably noticed a box next to Resample Image in the Image Size dialog box, as shown in Figure 9.4.

FIGURE 9.4

Image Interpolation gives us different options with the kind of math that's used when we resample an image.

This box allows us to change the *Image Interpolation* that's used when we resample an image. Different interpolation settings affect the way new pixels are assigned color based on the surrounding pixels. You have five choices:

- Nearest Neighbor: Fast, but not very precise; best for illustrations with edges that are not anti-aliased rather than photos
- Bilinear: Medium quality results
- Bicubic: Slower but more precise; produces smoother graduations than the two methods above
- Bicubic Smoother: Based on Bicubic Interpolation, but designed for enlarging images
- Bicubic Sharper: Based on Bicubic Interpolation, but designed for reducing image size

The two interpolation methods that interest us most are Bicubic Smoother and Bicubic Sharper. These are the two we'll use almost exclusively when resampling images in Photoshop. When you're upsampling, increasing the number of pixels in an image, choose Bicubic Smoother. When you're downsampling, decreasing the number of pixels, choose Bicubic Sharper.

NEW FEATURE With earlier versions of Photoshop, we had to remember what these two interpolation methods did. Now in CS3, a short description appears behind Bicubic Smoother and Bicubic Sharper in the Images Size dialog box to remind you when to use them. Thank you, Adobe!

These two resampling interpolations, introduced in Photoshop CS, allow much cleaner resampling of images. Before they were introduced, upsampling was done in a different way. Something known as the Ten Percent Method was common. Ten percent increments were used to increase the size of

a file with the Bicubic interpolation method. The process was repeated, ten percent at a time, until the image was close to the desired size. This process was used as a way of dealing with the limitations of the Bicubic interpolation. Now with Bicubic Smoother, the Ten Percent Method is no longer needed. Jumps of 100 percent and more can be done in one step.

Understanding how resolution relates to scanning

So what does all this have to do with scanning? By understanding how resolution works, we can take advantage of it when scanning. Imagine that we're scanning a frame of 35mm film. A frame of 35mm film measures about 1.5 inches by 1 inch. If we were to scan this frame of film at 300 ppi we would get a file that measures 1.5"×1" at 300 ppi. If we wanted to make an 8"×12" from this scan and plan to print it on a printer that requires a file resolution of 300 ppi, we would have to do some serious upsampling to make a 1.5"×1" file into an 8"×12" file. I'll save you some time and tell you right now that it won't work very well.

There's a much better way to solve this problem. Scan the film at a higher resolution, and then change the resolution to 300 without resampling. Suppose we scan our 35mm slide at 2400 ppi, as shown on the left in Figure 9.8. If we go to the Image Size window and change the resolution to 300 with Resampling turned off, we get an 8"×12" Document Size, as shown on the right in Figure 9.5.

FIGURE 9.5

The first image shows the Image Size of the scan. The second image shows the Image Size after changing the resolution to 300 with Resample Image turned off. Notice that the Pixel Dimensions are the same in both examples.

What this means is that a little bit of planning before you scan can save time later and yield a higher quality file. If you're scanning a 4"×5" print and you need a file that you can use to print an 8"×10" at 300 ppi, then you know that scanning the 4"×5" at 600 ppi and then converting the file to 300 ppi without resampling gives you an 8"×10". It's all simple math.

Scanning Prints and Film

To begin scanning, you need to get a handle on two things: the scanner and the software the scanner uses. The more you know about your scanner and its software, the more fun your scanning will be.

Scanner hardware

The most common style of scanner is the flatbed print scanner. Tabletop scanners have a lid that lifts to reveal the glass-covered copying bed where you place prints for scanning. These flatbed scanners are useful for scanning documents and photos up to legal size. This style of scanner starts at about $100.

More advanced hybrid flatbed scanners are capable of scanning prints and film. These range in capabilities as well as price. Hybrid scanners start at about $200 and rise quickly to $1,000 and more. A decent one will run you about $300 to $400. A hybrid scanner in this price range will do a decent job of scanning film as long as your needs are not too great. If you're on a limited budget, one of these can be a good starting scanner.

If you're serious about scanning film, you'll want a dedicated film scanner. The quality on these is far superior to the film scans from hybrid scanners. These dedicated film scanners start at about $500 for one that will scan only 35mm film. For a scanner that will scan wide format 120/220 film, you're looking at about $2,000 for starters. High-end scanners used by photographers, film labs, and service bureaus can easily cost ten times that. My film scanner is from the $2,000 range. I've used it for scanning a variety of negatives and slides with excellent results.

When you decide to purchase a scanner, think about how you plan to use it. What will your scanning needs be? Will you be scanning prints and film or just prints? If you're scanning film, what formats will you be scanning? What will the final use of your scan be — an Internet image or a wall print? The answers to questions like these will guide you to the type of scanner you require. After you narrow your search to the type of scanner you're interested in, do some research online. A couple of quick searches on the Web will lead you to boundless information on the most common scanners and what users think about them.

Scanner software

Just as scanner hardware varies, so does scanner software. Scanner software usually comes with the scanner and is the software you're expected to use. Aftermarket software solutions are available, but for the average user they're not necessary.

The software that comes with a scanner usually comes in two parts. The first part is the *scanner driver*. The driver software allows the scanner to talk to the computer. This conversation is often referred to as a "digital handshake." Driver software works behind the scenes. If it's doing its job, you won't even be aware of it.

NOTE The technology that was developed to allow the conversation between scanner and computer is called TWAIN. It's my favorite acronym. It stands for Technology Without An Interesting Name.

The other piece of scanner software is the *User Interface* (UI) that pops up when the scanner is activated. This is usually some form of scanning software that the scanner's manufacturer has created. Figure 9.6 shows a typical interface from an Epson scanner. The scanner can be set up to make many of these scanning decisions automatically, or advanced settings can be turned on to activate more advanced options. I recommend that you find the advanced settings on your scanner software and turn them on so that you have more control over your scanner. We'll talk about how to use some of those settings in just a moment.

FIGURE 9.6

The Epson Scan software provides control over the kind of files that are made when scanning. Professional Mode has been selected at the top right to get this particular software to display its advanced options.

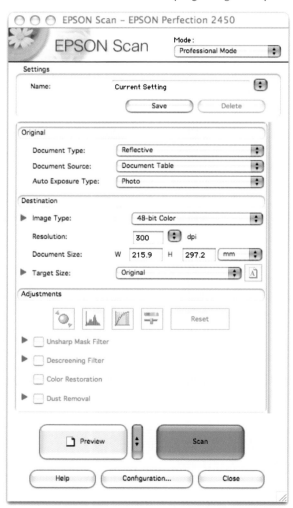

Before we move on, I should mention one other kind of software. Some third-party software works within the scanning software. The most popular of these is Digital ICE, which is a product of Applied Science Fiction Inc. This amazing software goes through the file after the scan and tries to remove dust spots. It's a must when scanning film because it takes care of most dust spotting. This software is activated from within the main scanner window, as shown in Figure 9.7. Applied Science Fiction also makes other scanner add-ons like Digital ROC for automatically correcting and restoring color, and Digital GEM for reducing and managing digital noise and film grain. Sometimes these products come with the scanning software, and sometimes they have to be purchased individually. To learn more about these products, visit `http://asf.com/products/`.

FIGURE 9.7

Here's the toolbar from Nikon Scan software that comes with the Nikon Coolscan series of film scanners. Digital ICE, Digital ROC, and Digital GEM are advanced scanning options that perform post-scan adjustments.

After you purchase a scanner, check the manufacturer's Web site to see if they have updates to the software that came with the scanner. You want to always have the latest and greatest software updates. Look for updates to the driver as well as to the scanning software. Also check for *firmware* updates. Firmware is software that is coded into the hardware. It controls the various programmable chips inside the scanner on a hardware level. When upgrading firmware, be sure to follow the manufacturer's instructions exactly.

TIP Checking for upgrades is a good practice any time you add new hardware or software to your system. Even if you just purchased a brand new copy of Photoshop off the shelf, it may have been sitting there for months. If updates have came out since it was shipped by the manufacturer, they won't be on the disk.

Using your scanner

With some scanners, you can scan directly into Photoshop. Turn on the scanner, choose File ➪ Import, and look for your scanner in the drop-down menu. In this case, we can see an Epson Perfection 2450, as shown in Figure 9.8. When you click it, the scanner wakes up and prepares itself for use. The TWAIN software shakes hands with the computer, and the two agree to do business.

FIGURE 9.8

If you choose File ➪ Import, you will see your scanner. Then you can scan directly into Photoshop. If your scanner isn't listed here, launch its scanning software in the usual way outside of Photoshop.

After that agreement is reached, the conversation begins. With so many scanners and so much associated scanning software available, I can't offer a comprehensive set of scanning instructions here. I'll point out the highlights with the Epson Scan software that came with my Epson Perfection 2450 to help you get a handle on the important settings. Just keep in mind that some of this varies from manufacturer to manufacturer, as well as model to model.

Here are the settings to check:

- Make sure your scanner is set to scan the type of media you're scanning — photos rather than documents, negatives rather than slides, and so on.
- Choose RGB for the color mode.
- Set the color setting to 8-bit/24-bit or 16-bit/48-bit. This is where you choose to create a high-bit file.

 If you recall our discussion on high-bit files in Chapter 3, some software calls 8-bit files 24-bit color, and 16-bit files 48-bit color.
- Choose your resolution.
- Look at any color and tone adjustments to see if you can fine-tune the preview that your scanner is displaying.
- If you're scanning film, look for a "dust removal" setting or Digital ICE.

Also make sure the glass is clean and that any dust has been blown off the print or film with compressed air. If you don't have a compressor, use the canned variety of compressed air. Just remember to hold the can upright when using it to prevent condensation inside the can from being sprayed onto your original.

In the preview window, click and drag a marquee around the area you want to scan. After you're satisfied with your selection, click the Scan button.

Scanning Large Originals

Sometimes, you may need to scan something that's larger than the scanning area of your scanner. The solution to this is to make individual scans of the large original and then combine them in Photoshop.

I recently ran across a large print of a photo I shot several years ago. It's a picture I took of my wife, Julia, the day after we were married in 1980. The film was severely damaged years ago and is unusable. I didn't think I had any copies of the print until I discovered this one in storage. Now that I have the print, I can scan it and add it to my archives. The image area of the print measures 14 inches by 12.25 inches. My scanner can only scan an area of about 8 inches by 11. In order to scan this image, I need to make four different scans to cover the four different corners (top left, top right, bottom left and bottom right) and then combine them in Photoshop. Here's how:

1. The first thing to do is turn off any auto color of tone correction in the scanner software. If it is left on, it can be harder to combine all of the pieces later because they may not all be the same color or tone.

2. Place the first area of the artwork to be scanned into the scanner. Pay special attention to alignment to make it as straight as possible. This helps later when we put all the parts together.

3. After the first scan is done, move the artwork over and scan the next quadrant.

4. When all the quadrants in that row are done, rotate the artwork 180 degrees so you can scan the bottom quadrants. The artwork must be rotated 180 degrees because of the way most scanner lids are hinged.

5. After all the scans are done, open them in Photoshop and rotate any that are upside down by choosing Image ➪ Rotate Canvas ➪ 180°.

6. Use the Crop tool to trim any ragged edges from each file. Make sure that there is plenty of overlap in image content so that the files will line up correctly when combined. They don't have to be exactly the same dimensions. Figure 9.9 shows the four scans I made after they have been cropped.

7. Here's where Photoshop CS3 takes over. With the images open in Photoshop, choose File ➪ Scripts ➪ Load Files into Stack.

8. When the dialog box opens, click the Add Open Files button. Also click where it says Attempt to Automatically Align Source Images.

 If the source files have not been saved, you get a warning that says, "Documents must be saved before the can be merged." If you get this warning, click Cancel, save your documents, and try again.

NEW FEATURE **The script we're using, Load Files into Stack, is new in Photoshop CS3. It makes stacking and aligning layers easier than ever. If you are not using Photoshop CS3, you have to drag all these files together into a single file and manually align them.**

9. After all the layers have been stacked and aligned, check the new file to be sure that you're happy with the alignment. If there are any differences in tone or color on any of the individual layers, this is the time to adjust them.

10. Make any global tone or color changes with an adjustment layer at the top of the layer stack.

 Figure 9.10 shows the stacked and aligned layers for the large print I scanned. It looks pretty good. Now I just need to flatten the layers so I can do a little retouching to blend areas where I can see some overlap. After that's done, I'll use the Crop tool to trim any ragged edges that are caused by differences in the individual file dimensions. (Or I can use the Clone Stamp to fill those empty areas instead of cropping them.)

FIGURE 9.9

When you have to scan something that's too large for your scanner, you need to break it down into pieces. This original had to be divided into four scans to cover four quadrants. There's plenty of overlap to work with as we combine these images.

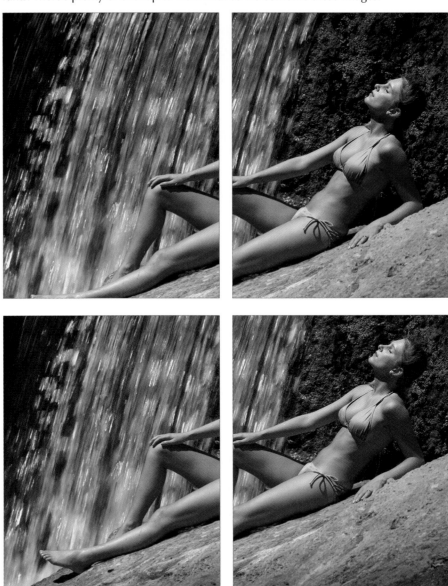

FIGURE 9.10

Now I have a digital file of the only existing honeymoon photo I shot of my wife back in 1980. The ragged edges have to be cropped with the Crop tool to complete the process. Notice that the Load Files into Stack script placed each file on its own layer in the Layers palette.

TIP Sometimes, an original is so large that working with multiple scans is not practical. In a case like this, think about using a digital camera on a tripod to photograph the artwork instead of scanning it.

Using the Crop and Straighten Photos Command

When scanning smaller prints, you can save time by scanning several at the same time. You lay them side-by-side on the scanner glass and do a *gang scan*. After a gang scan is done, you must crop and remove each individual image from the scan. Figure 9.11 shows a scan that includes several images. Instead of cropping each of these images manually, we'll let Photoshop do the work:

FIGURE 9.11

Instead of scanning each of these images separately, we can gang them together and scan them all at the same time, and then let Photoshop crop and straighten them. It's okay to turn some of them sideways to make more images fit onto the scanner.

1. Open a file that contains several images that were scanned at the same time.

2. Choose File ➪ Automate ➪ Crop and Straighten Photos.

 When you do this, Photoshop examines the scan and extracts each image as a separate file. This command saves lots of time by doing most of the work for us.

Be aware that if the command can't distinguish where the edge of the print is, it can have a problem knowing where to crop. You see this most often on old prints that have a white border around them. It's not a big problem; the white border gets cropped off. If you want the border, you'll have to crop the individual image out of the gang scan manually, which is still faster than doing individual scans.

3. Individually save each of the new files that are created.

 To help the Crop and Straighten Photos command do its job, be sure to leave some space between prints and the edges of the frame when gang scanning.

Adjusting Geometry with the Transform Command

Sometimes, the originals we're scanning are not perfect rectangles, meaning that all corners are not perfect right angles. This can be caused by a few different things — maybe the print was trimmed and the person trimming it wasn't paying attention, or the print was printed crooked in the first place. When we're dealing with old prints, all kinds of things can affect the squareness of the corners.

Unless we make some adjustments on a scan like this, we'll have problems when we print it. Figure 9.12 shows a scan that's a little crooked.

FIGURE 9.12

The image on the left shows that this scan has a couple of corners that are not quite square. Cropping closer would result in the loss of detailing in this old-fashioned border. Also, the inner corners would not be square. The Transform command allows us to fix this problem without losing much information.

I could crop in closer to square everything up, but I'd lose some of the intricate border around the image. Suppose I want to keep that border so I can clean it up later. Let's try:

1. Open the file to be transformed, and duplicate the Background Layer by choosing Layer ➪ Duplicate Layer.

NOTE A Background Layer is automatically locked. That means you can't do certain things to it. For example, you can't use the Transform command. One solution is to copy the layer and do all transforming to the copy. Another solution is to double-click the name of the layer and change the name to something other than "Background." As soon as you do that, the layer is no longer locked.

2. Choose Edit ➪ Transform, and click Distort. A thin line appears around the boundary of the image. At the corners of this line are small boxes called *handles*.

 If you can't see these lines, a couple of things could be hiding them. Maybe you're zoomed in too much so you can't see the boundaries of the image. Or maybe the image window is up against the sides of the image so you can't see the handles. One way to solve this is to press the "F" key to go to Full Screen then zoom out (Command/Ctrl+-) until you see the handles.

3. Click the handle of the corner that needs to be adjusted, and carefully drag it to the corner of the image boundary. When it's square, let go of the mouse button and move to the next corner that needs to be adjusted.

 When doing this, I tend to work mostly with the corner handles rather than the middle handles.

4. After everything looks the way you want it to look, press Enter. If you decide that you want to start over in the middle of a Transform operation, press the Esc key and begin again with Step 2.

5. To get out of Full Screen, press Shift+F to go back to the view you had before going into Full Screen. Another alternative is to press the F key by itself three times to cycle through the three other screen modes.

TIP When I'm editing an image in Photoshop, I like to isolate it from the clutter of other images and other applications that are open in the background. So I use the Full Screen mode often.

Sometimes, all four corners are off by the same amount because the whole print was crooked when it was scanned. To solve this problem, use the Rotate option under the Transform command. When using Rotate, move the cursor outside the image area and look for a curved arrow. When you see it, click and drag up or down to rotate the layer.

Later in Chapter 16, we'll look closer at the Transform command. In the meantime, take a peek at the other options under the Transform command and explore some of the things you can do with them.

Summary

Now you're ready to start scanning. Be sure to read the instructions that come with your scanner so you can take advantage of that particular scanner's nuances. Be sure to respect copyrights when they apply and ask for written permission. You'll be surprised at how often it will be granted.

Resolution is simple math. After you understand it, you can use it to be sure your scans are the size you want them to be. Remember the difference between ppi and dpi. When we're talking about resolution in Photoshop, we're usually talking about pixels per inch (ppi).

To scan a large original, break it down into smaller pieces and let Photoshop CS3's new Load Files into Stack script assemble the pieces for you. If the original is really big, consider photographing it with a digital camera instead of doing a bunch of individual scans.

Group your scans together when appropriate, and gang scan them. Then use the Crop and Straighten Photos command to quickly separate the scans into individual files. After that's done, use the Transformation command to correct any geometry issues with your scan.

Chapter 10

Solving Typical Repair Problems

A fter a damaged photo has been scanned, it's time to get to work with Photoshop, repairing the wear and tear caused by poor handling and the passage of time. In this chapter, we're going to survey some different kinds of damage, the problems they present, and typical solutions for those problems. If you understand the handful of techniques I'm about to show you, you'll be prepared to handle a huge array of restoration issues and problems. In Chapter 12, you get a chance to put many of these techniques into action when you work on a hands-on retouching project.

Before we begin, I want to share a personal experience with you. This section of this book is special to me. Several years ago, while visiting my mother, I took the opportunity to go through the family "photo album." At the time, Mom had just moved from San Antonio to Seattle, so the photo album was contained in two large grocery bags and consisted of piles and piles of photos. I dug through those bags for a couple of hours and pulled out the twelve best shots of myself and each of my five siblings. I also set aside all the photos of my parents and any ancestors I could find.

When I got the photos back to Portland, I spent days scanning and repairing about a hundred of them. When they all looked good, I organized them into a presentation that I burned onto several nicely labeled CDs. When the holidays rolled around, I gave a CD to each of my family members. It was one of the most rewarding digital projects I have ever done — not only for everyone who got to see photos they hadn't seen for years, but also for me. Working on the project allowed me to experience and re-experience long past events. When I was finished, I felt closer to my family than I had in years. (Thinking about it now reminds me of those feelings.) My wish for you is that after you learn these techniques, you can use them in ways that are as rewarding for you as they continue to be for me.

IN THIS CHAPTER

Assessing a photo's damage

Working with faded photos

Fixing faded colors

Basic spotting and texture control

Repairing physical damage

Replacing missing photo information

Assessing the Damage

You should always get a bird's-eye view of a restoration project before beginning it. This gives you the opportunity to identify problems and think about how to handle them. Those problems usually consist of light physical damage like rips and mold, as well as faded tones and colors, and extreme physical damage such as major tears and water damage. These issues are often compounded by the fact that old photos tend to be small. This is probably because small photos have always been cheaper, so they are more abundant. Also, smaller photos tend to have a higher survival rate because they were stored in albums and boxes where they were protected for decades. Larger photos that hung on the wall aged much more quickly because they were exposed to elements like the ultraviolet light in sunlight that causes photos to fade.

When working with small originals, print textures become more of a problem and small bits of damage have a greater effect. This is especially the case when the intention is to make the restored photo larger than the original. All those little problems become magnified.

TIP Remember from Chapter 9 that when you scan a small photo, you should scan at a resolution that's at least twice the resolution you plan to print at. (If you're printing at 300 ppi, then scan at 600 ppi, or even 1200 ppi.) That way, you have the option of lowering the resolution and expanding the physical dimensions so that the new print is larger than the original. Just remember that scanning at a higher resolution creates bigger files.

Figure 10.1 shows some typical restoration jobs that range in difficulty. Each of these images has its own set of problems, requiring individual treatment. The first image has some spots and stains, but they'll be easy to remove. Because the man has a beard, the stains won't be as challenging as if they were on his skin.

The second image will be a bit more challenging because the damage is extensive. Luckily, most of it is in neutral areas of the background. The crease across the girl's face and the armrest of the chair will be the most challenging aspects of this particular restoration job because of all the detail in those areas. Both of these images need some tonal work, as well as color adjustment, even though neither of them is a "color" image. Most restoration jobs fall into this realm. They need some basic work, with a few challenges thrown in here and there. For the most part, they're usually handled with similar tools and techniques.

The ante is upped when we look at the third image. It has been heavily damaged by water and neglect. It's amazing that the print still looks as good as it does. Some of the damage is in the neutral background, but at least 50 percent of it is in areas of detail like faces and clothing. This retouching job will require lots of time to repair.

FIGURE 10.1

The three images here represent varying degrees of restoration difficulty. The image of the man won't take long to repair because the damage is light and it's mostly in detail-free areas. The image of the girl is a bit more challenging. A repair job like this requires more time and a higher level of skill. The damage in the image of the couple is extensive. Nearly half of it falls in areas with lots of detail. This photo represents a more extreme challenge, involving a greater skill level and commitment of time.

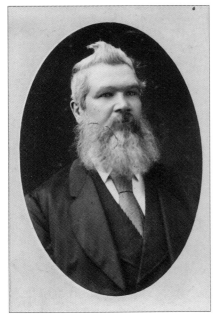

Figure 10.2 is about as bad as it can get. The print was damaged during a fire. The water used to extinguish the fire is what caused the damage. It got the print wet, causing it to stick to the broken glass when it dried. Removing the pieces of glass was impossible because they were "glued" to the emulsion of the print. The original had to be scanned glass and all.

FIGURE 10.2

This example is about as bad as it gets for a restoration project. The project is doable, but it will require lots of time and patience. A project like this must be a labor of love for the retoucher or the person paying for the retouching.

More than 50 percent of this image must be completely reconstructed. The regular pattern of the wall in the background complicates the process because it must be replicated so the background looks convincing. Worst of all, one of the boy's eyes is completely obscured by the damage. This is exacerbated by the fact that the original is a very small print of limited original quality. But you know what? None of this mattered to the photo's owner because this photo is the only photo of this boy.

TIP If you have to scan an original like this one — with glass (or anything abrasive) stuck to it — use a sheet of high-quality clear acetate to protect the glass on your scanner. (If the scanner's glass gets scratched, the scratch will be on every scan you do.) Clear acetate can be purchased at art supply stores. Tape the acetate sheet over the scanner's glass before scanning originals that have the potential for scratching. Remove it when you don't need it.

This project is a major challenge. But it can be done, as you can see in the second image in Figure 10.2. (We look at the process in a moment.) Before making a commitment to a project like this, you have to think about what's involved and how you can handle it with your particular skill set. Don't be afraid to get in over your head; just allow yourself to walk away from the project if it's beyond your current skill set.

When I take on a difficult project like this, I tend to focus on the hardest parts of the job before addressing the small problems, which is kind of backward from my usual process. This way, I get a feel for the problems that need to be solved. This approach saves time if I decide that the project is more than I want to take on because I haven't invested lots of time on the small stuff.

With projects like the first two in Figure 10.1 — where serious damage is limited — I follow a standard type of workflow. We explore that workflow in detail in Chapter 12. For now, I want to focus on dealing with specific restoration problems and solutions. As we explore these examples, notice how the tools and techniques you learned about earlier in this book are combined to solve real problems.

Working with Faded Photos

Photographic prints fade, especially if exposed to lots of ultraviolet light from the sun. When dealing with photos that are 100 years old or older, fading is expected. The best way to deal with it is to use the Levels and/or Curves commands to bring tonal ranges closer to normal. Naturally, if you're dealing with images that have lost all distinguishing tones in the highlights due to fading, this can be a problem.

Figure 10.3 shows a photo that was taken in the mid-1920s. The print this scan came from probably looked great the day it was printed. However, 80 years have taken their toll, especially on the highlights. A quick look at the histogram reveals that this image doesn't have any tones that are close to pure white or pure black.

The first thing I want to do with this image is the same thing I would do to any other image. I want to use Levels or Curves to target the darkest blacks and the lightest whites in the image so I make sure to hold detail in them. Then I want to adjust the midtones so I can pull as much detail as possible from the tones in that region. (Remember, I want to work in a non-destructive way whenever possible, so any tonal adjustments will always be made with adjustment layers.) I'll start with Levels:

FIGURE 10.3

This old photo has faded a lot in the last 80 years. Its histogram reveals that its tonal range is limited to the middle area of the histogram; it has no deep blacks or bright whites.

1. I create a Levels adjustment layer. I use the Alt key while adjusting the black input slider and the white input slider so I make sure not to clip either the highlights or the shadows. I'm especially careful with the highlights because that's where most of the image's tonal problems are. Then I adjust the gray input slider to darken the image overall. My final values are shown in Figure 10.4, along with the image.

TIP I like to work in a non-destructive manner, so when I'm spending lots of time on a project, I use layers and adjustment layers whenever possible to keep my editing workflow flexible.

The massive Levels adjustments worked wonders on the tonal range, but they also oversaturated the sepia tones in the image. Now the color is too yellow. This is a common side effect when making such large tonal adjustments, but I know an easy fix for this problem.

FIGURE 10.4

As you can see from the histogram in the Levels dialog box, this image requires a massive adjustment. This Levels adjustment clips all the unused shadow and highlight tones, expanding the histogram so it covers a broader tonal range, especially in the shadows, as shown in the final histogram.

 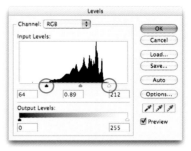

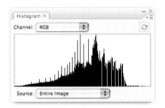

2. All I have to do is change the Levels adjustment layer's blending mode to Luminosity, which instantly solves the color shift problem. Now the color of the improved image is the same as it was without the Levels adjustment layer, as shown in Figure 10.5.

The Luminosity blend mode changes the way the adjustment layer affects color. In essence, what this mode does is tell the adjustment layer to only affect the luminosity (the tonality) of the layer below it, not the color.

TIP There's a way to do this without using an adjustment layer. Make the tonal adjustment with the Levels command from the Image ⇨ Adjustments menu. Then go to Edit ⇨ Fade Levels. When the Fade dialog box opens, change Mode to Luminosity and click OK.

FIGURE 10.5

When the Levels adjustment layer's blending mode is changed to Luminosity, only the tonality of the underlying layer is affected, not the color. This prevents the Levels adjustment from changing the color of the image.

I could have used a Curves adjustment layer here instead of Levels. Doing so would give me a little more control over the midtone contrast. I didn't use Curves in this example because I want you to be comfortable with Levels before you get too deep into Curves.

Fixing Faded Colors with a Single Click

Just as fading is common for old black-and-white photos, color shifts are a common problem when working with old color photos. It's really the same problem; it's just that the different colors are fading at different rates. Some old color emulsions don't stand up well under the test of time, especially when they suffer prolonged exposed to the ultraviolet light in daylight. The range of what's recoverable varies with the amount of color fading. Figure 10.6 shows a color photo from the 1960s. This photo has a magenta/red color cast. However, I see plenty of recoverable color here, and I can get almost all of it back with a single click.

This birthday party photo from the 1960s was quickly color balanced with one click. With the Gray Point eyedropper on the Levels command, I clicked the blade of the saw the boy (me) is holding, neutralizing any colorcasts in the gray blade and the rest of the photo.

If you recall the discussion about the Grey Point eyedropper back in Chapter 2, you'll remember that it's used to neutralize colorcasts. The tool does a pretty decent job as long as something in the image is supposed to be neutral in color, where RGB values are all the same (128, 128, 128, for instance). That's because the Grey Point eyedropper forces all color channels to the same value wherever it's used. I'm going to try it here:

1. I create a Levels adjustment layer. When the dialog box opens, I make the usual adjustments, which is a slight adjustment to the Black Input and the Gray Input sliders to darken the shadows. Then I click the Gray Point eyedropper to activate it. Now it's simply a matter of finding something to click. I try the blade of the saw that the boy's holding because I know it should be silver or gray. When I use the Eyedropper tool to measure the color of the blade, I see that its red, green, and blue values average somewhere around 77, 24, 44. These numbers verify that red is the predominant color in this image.

2. A single click on the saw gives me the second image in Figure 10.6. I try clicking in a few other spots on the saw, giving me a little color variation, but for the most part, all parts of the saw give me similar results. (It's always good to try more than one spot just to see what kinds of variations you can get; one might look a little better than another.) When I re-measure the saw blade with the Eyedropper tool, the average RGB values are now closer to 50, 50, 50.

> **TIP** If I were working on this image quickly, I might forgo the adjustment layer and simply use the Image ⇨ Adjustments ⇨ Levels command. I would just be sure to save it with a different name so I didn't corrupt the original file.

Figure 10.7 shows another example of this one-click technique. In this case, I clicked the turntable of the phonograph in the foreground. (I did try the andirons in the fireplace, but I didn't like the result as much.) This image is older than the image in Figure 10.6, and it's obviously more severely damaged. The result isn't as amazing as the previous example, but the image looks much better. Now you can see the blue stain that needs to be retouched out.

FIGURE 10.7

This image has a severe red colorcast. One click with the Levels command's Gray Point eyedropper reveals that the photo contains some colors I can work with.

After using the Gray Point eyedropper, it's always a good idea to visit the Color Balance and/or Hue/Saturation commands to see if you can improve the Levels command's adjustments. If it's a big project, use adjustment layers. If it's a quickie, go straight to the Image ⇨ Adjustments menu.

Basic Spotting and Texture Control

Large tonal adjustments, like the preceding one, bring out many of the flaws in the image. Any dust spots and damage are enhanced, as well as the original grain and print texture. Figure 10.8 shows a Levels adjustment before and after on another faded image. The tonal adjustment really helped this image, but it also exaggerated many of the image's imperfections. This photo was taken almost 100 years ago. The paper that it was printed on has a soft texture that really pops out when the Levels adjustment is applied.

Almost every scan needs some level of dust spotting to remove dust captured during the scan, as well as minor imperfections like the bigger spots caused by surface damage. That's why it's a good idea to zoom in to 100 percent and work on the image quadrant-by-quadrant. Begin in a top corner of the image. When the first quadrant (everything you see on your screen) has been spotted, move sideways one screen to the second quadrant. When the top row is complete, drop down to the next row and begin working your way across again. It's kind of like mowing the lawn: You go back and forth until the entire image has been spotted.

TIP Zooming in and checking for spotting is a good idea even if you don't notice any dust at first. After you're zoomed in to 100 percent, the dust will reveal itself if it's there. Doing this early prevents surprises later.

FIGURE 10.8

Adjusting the Levels on this image brings it back to life. Unfortunately, it also intensifies the image's many flaws.

Figure 10.9 shows what the first quadrant looks like on this image. As you can see, I have lots of stuff to fix. My strategy is to fix the larger problems with retouching tools and then come back with a filter and a mask to tone down the tiny white spots and the general texture of the paper. Here's my strategy:

FIGURE 10.9

When it's time to remove small dust and damage spots, it's best to zoom into 100% and work in quadrants.

1. Before I break out the retouching tools, I need to duplicate the background layer to hold all my retouching. I double-click its name, and change it to **retouching**.

2. I spend about 5 minutes going over the image with the Spot Healing Brush, which is perfectly suited to this task. In a couple of instances, I switch to the Patch tool to handle larger

areas. When I work on or near the man's face, I take extra precautions because I know that flaws here will be more noticeable. (I'm not going to deal with the stain on his collar and tie right now). Figure 10.10 shows what the image looks like now. Everything is good, except that the texture of the paper is a little strong in the background around him.

A few minutes of spotting goes a long way. Now that all the flaws have been repaired, the original texture of the print is more noticeable and distracting. It can really been seen when zoomed to 100%.

3. I use a filter to tone down the texture in the background. I apply it to the entire image and then mask out the places where I don't want it to show. I copy the retouching layer before I run the filter, so I isolate the filter's effects to their own layer. I name this layer **dust & scratches**. I now have three layers in the Layers palette: the original Background layer, the retouching layer, and the dust & scratches layer.

NOTE When you start creating several layers that look alike, it's a good idea to name them so you know which one is which.

4. Now I use the Dust & Scratches filter to minimize the tiny white specks of dust and the texture of the paper. I choose Filters ➪ Noise ➪ Dust & Scratches. When the Dust & Scratches dialog box opens, I enter 5 for a Radius value and 7 for a Threshold value, as shown in Figure 10.11, and click OK.

The Threshold value controls the range of dissimilar pixels that will be affected. The higher the number, the greater the affected range. The Radius value controls the size of the area that is searched when searching for dissimilar pixels. The greater the value, the stronger the blurring effect. It's best to keep this value fairly low.

5. The filter blurs the entire layer, so I create a mask that can be used to hide any the filter's effects on the man. I paint his face with black and then lower the opacity of my brush to 50 percent as I work my way down his suit. This allows me to partially tone down the speckles in his clothes a bit by partially masking it with gray instead of black. Figure 10.11 shows the finished project.

FIGURE 10.11

The Dust & Scratches filter allows me to tone down all the tiny spots caused by the texture of the paper this image was printed on. The filter is applied to a duplicate layer named dust & scratches. Because this filter tends to blur detail, I use a mask to hide its effects on the man's suit.

As you can see from this demonstration, the Dust & Scratches filter is useful for dealing with many kinds of "noise," from dust to light paper texture. (It would have been useful on the last project with the baseball player.) Just remember that there's a trade-off to using this filter. It blurs detail in the image; that's how it works, after all. Use a mask to contain this filter so that its effects are selectively limited to areas with little important detail.

> **NOTE** Even though we didn't do this exercise together, I'm including this image with the sample files on the Web site. It's named old_photo.tif.

Repairing Physical Damage

Photographs are very fragile items, especially old ones. They can quickly suffer permanent damage or be completely destroyed. Fortunately, in this digital age, most damage can be digitally repaired. In this section, I cover the kinds of problems I see most often and the ways I typically deal with them. Keep in mind that these techniques can be used to solve a variety of problems.

Rips, tears, and folds

Figure 10.12 shows one of the antique photos we saw at the beginning of this chapter. This photo is in remarkable condition, considering its age: It's easily over 100 years old. The main problems with this image are the rip in the side, the folds in the print emulsion at the top, and the fold that runs through her face and down into the couch. You can also see several mold spots to the left of the girl. I want to keep the old border around the image, so it has to be retouched too. The good news is that much of the damage is in areas that contain *neutral detail:* They don't contain lots of important information.

Here's the way I handle this one:

1. The first thing I do is duplicate the Background layer so that all my restoration work is on this duplicate layer.

2. I begin with the easiest big problems first — the two emulsion folds at the top. I use the Patch tool to quickly knock them out. I draw a selection around each of them and drag it to the "clean" area between them to sample it. I'm careful to try not to pick up many of the dark spots so I'm not creating more work for myself later.

> **TIP** Be sure to zoom in when doing this kind of work. However, I rarely find it useful to zoom in any closer than 100 percent.

Figure 10.13 shows these first two moves. Notice in both of them I'm very careful to move the selection straight to the side so that the lines on the border will match up when the sample is taken. For this same reason, I have to break the second fold into two moves with the Patch tool. Otherwise, I would mess up the border section to the right. I also have to be careful around the white outer border. If I get too close to this with my selection, I'll pick up the dreaded smudging that the Patch tool is known for.

FIGURE 10.12

This antique photo has some serious damage in the form of rips, folds, and spots. The most difficult area will be the fold that runs through the girl's face all the way down through the arm of the couch. Most of the areas this line runs through are rich in detail so they'll have to be handled carefully.

FIGURE 10.13

When using the Patch tool around important detail, make sure the sampled detail matches with the area where it will be placed. Here I have to be very careful because I'm working with a hard line around the border of the image.

CAUTION The Patch tool can be a tricky tool to work with. It does a good job with literal copies as long as the boundaries of the sampled and targeted areas are well defined and similar. When they aren't, unacceptable smudging occurs.

3. I finish the second part of the second fold and then move to the left side of the image. When I get to the big tear halfway down, I again have to address this damage in two pieces. If I try to do it all in one piece, some of the details won't line up. The curtains look good, but the border won't work, as shown in Figure 10.14.

So far I've made only six moves with the Patch tool, and most of the severe damage is gone, as shown in Figure 10.15. Now it's time to work on the hardest part of this image — the tear that goes from behind her head, down through her body and the couch, and into her dress. There's no way this will be handled as easily as the other repairs.

If I try to repair this tear in one move, I won't be able to line up all the details. The folds in the curtains look good here, but the border is out of alignment. This tear will need to be repaired with two separate moves of the Patch tool.

FIGURE 10.15

This image is looking pretty good after only six moves with the Patch tool. Now I have to move more slowly and work with smaller areas.

4. When using the Patch tool to work around detail like this, be sure to sample similar detail; otherwise, it just won't look right. The only way I can continue using the Patch tool is to start breaking my moves into smaller pieces, as shown in Figure 10.16. The arm of the couch takes 15 to 20 separate moves with the Patch tool. Within a few minutes, I'm ready to move on to the spots in the background.

CAUTION Again, you must be careful with the Patch tool when doing this kind of restoration work. Because it tends to blend sampled information with the targeted information, you can end up with smeared, blurry retouching. This can be a blessing when working on portraits, but our goal here is to preserve reality.

FIGURE 10.16

I continue using the Patch tool in this area with heavy detail. The secret to using this tool here is to work on small sections because larger areas of detail won't line up when sampled together.

5. I use the Patch tool to quickly take care of the big spots and then switch to the Spot Healing Brush. I work in a grid pattern, starting at the top left and moving across and down. Because this original is only 2×3.75 inches, the dust is really apparent when zoomed in. I don't plan to make a big print, so I keep that in mind as I retouch. No sense working on something I won't be able to see later.

TIP Keep the end use of the image in mind as you work. Even though you can zoom in and see every flaw, you don't need to fix them if they won't show in the final print. Having this awareness can be a big time saver.

6. After the biggest offenders have been removed, I use the Dust & Scratches technique from the last example to blur everything and then mask the important detail back in. I choose to leave the curtains a little blurry so that the girl stands out more. Figure 10.17 shows a before and after view of this process.

FIGURE 10.17

This image is transformed with about 20 minutes of work.

Most of the heavy lifting on this project was done with the Patch tool. Other retouching tools — such as the Clone Stamp and the Healing Brush — could have been used, but the process would have taken much longer. The key to working with the Patch tool in this kind of environment is to be sure that the edges and detail you're sampling lines up with edges and details in areas where the sample will be placed.

Dealing with stains

Stains are usually transparent or translucent areas on a print where the emulsion came into contact with some kind of moisture. Because detail can often be seen through a stain, they're handled a little differently than a spot that completely hides image detail. Sometimes, you can remove stains with the usual retouching techniques, but when lots of detail is involved, that approach is extremely complicated.

The photo in Figure 10.18 is one I was working on earlier. It still has a dark stain right on the man's throat where his collar and tie come together. Even though it's not too dark, I want to remove it because it's distracting. With it there, the restoration job is incomplete. This is a tough area to retouch because of all the detail. Fortunately, I know a much better way to deal with a stain like this one. I can use a technique involving adjustment layers and masking:

1. I first create a Levels adjustment layer at the top of the layer stack. (I want it to be on top so it won't be affected by any of the existing adjustment layers.) I click OK without making any adjustments when the Levels dialog box opens. I'll come back to it in a moment.

> **TIP** Sometimes, an adjustment layer affects another adjustment layer that's below it. For example, a strong Levels or Curves adjustment affects a Color Balance layer below it. For this reason, I make sure that any color adjustment layers, such as Color Balance or Hue/Saturation, are above tonal adjustment layers such as Levels and Curves.

2. Then I choose the Brush tool from the toolbar. I use the tool options to set it up so I'll be painting with black at 100 percent opacity, with a soft brush.

3. I want to paint a mask on the new Levels adjustment layer that covers the stain. Because the Levels adjustment layer isn't affecting the image yet, this is hard to do; I won't see any change to the image as I paint, so I won't know if I am adequately covering the stain. The solution to this dilemma is to press the \ key to change the viewing mode to Quick Mask. Now any painting will be orange on the screen.

4. I paint the area covered by the stain with black. The first image in Figure 10.19 shows what this looks like in Quick Mask mode. When the stain is adequately covered, I press the \ key again to go back to Normal view. Because I'm working with a mask, I can always come back later and tweak it if I need to.

FIGURE 10.18

This image, which was retouched in an earlier example, still has a stain on the man's collar and tie. I'm going to remove it with an adjustment layer and a mask to preserve all the detail under the stain.

5. Even though I can't see it yet, there's a problem with the mask that I just created. I painted black on white, which means that anywhere black appears on the mask is not affected when I adjust the Levels layer; everything except for the stain changes. (Black on the Levels layer mask hides any levels adjustment, and white reveals the adjustment.)

 There's an easy solution to this. I choose Image ⇨ Adjustments ⇨ Invert (Command/Ctrl+I) to invert everything on the layer mask; black becomes white, and white becomes black. Figure 10.19 shows before and after shots.

NOTE **The Invert command is used to switch all tones and colors on a layer to their opposites. If you use this command on a normal photo, it becomes a negative of itself. Since I used it on a mask, it only affected the painting on the mask.**

6. After I have the mask in place, I open the Levels adjustment layer and move the gray slider to the left to lighten the stained area. (Because I know that this Levels adjustment will have an effect on the color, I change the adjustment layer's blending mode to Luminosity before making this adjustment.)

7. The image looks really good, but I can still see a slight color mismatch. The colors inside the masked area look a little duller. It's barely perceptible, but I know it will show in a print. (I don't think it will show here, so I haven't included a figure for this step.) I need to add a tiny bit of warmth back into the masked area. This is easily accomplished with a Hue/Saturation layer. I want to mask the Hue/Saturation layer the same as the Levels layer, so I Command/Ctrl-click the Levels adjustment layer mask to load it as a selection. This way, when the new adjustment layer is created, it uses the selected area to create a mask on the fly.

TIP **Copying a mask when loading another adjustment layer is easy. Just Command/Ctrl-click the existing mask to load it as a selection. That way, when the new adjustment layer is created, it uses the selection to create its own mask.**

8. I create the Hue/Saturation layer and change the Master channel's Saturation to +7. This stain completely disappears. Figure 10.20 shows the final image and its layer stack in the Layers palette. Examine this figure, and make sure that you understand how each of these layers is affecting the overall image. Taking the time to do so will serve you well when we get to Part IV of this book.

FIGURE 10.19

The first image here shows what the mask preview looks like when the \ key is used. This is a great way of knowing exactly where you're painting on a mask. The second image shows what the actual mask looks like. This mask won't help me because it's backward; it's masking the wrong things. This is easily fixed by inverting the mask.

FIGURE 10.20

The stain has been completely removed by using two new adjustment layers with masks.
The Levels 2 and the Hue/Saturation adjustment layers are affecting only the area of their
layers that are white on their respective masks. This technique is fast — and flexible.

Sometimes, a stain like this has a dark ring around the outside where sediment accumulated as the stain dried. When this happens, retouching must take place around the edges of the stain before the preceding procedure is performed.

Notice that everything that's been done to this image has been done on an individual layer. I can't stress the importance of this enough. If I notice any problems with the procedures I performed on this image, I can go back and adjust individual layers to address those problems.

NOTE Even though we didn't do this exercise together, I'm including this image with the sample files on the Web site. It's called old_photo.tif.

Extreme Damage Control: Replacing Missing Information

The image in Figure 10.21 is one of the worst restoration cases I have ever attempted. The print suffered severe water damage during a fire. The print's emulsion had been stuck to the glass for so long that removing the pieces of glass would have completely destroyed the print. You can see where some of the glass was removed from the top of the print. The glass took the print's emulsion layer with it, leaving the paper base behind.

FIGURE 10.21

When a photo has this much damage, knowing where to begin is difficult.

As I mentioned at the beginning of this chapter, I scanned this print glass and all. Because I knew this job was going to require some extreme measures, I scanned it as a 16-bit file to give myself more to work with. I also scanned it at 600ppi resolution because the original print is quite small — 2.5×3 inches. This allowed me to double the size of the new print by converting the resolution to 300ppi with the Image Size command, with Resampling turned off. (See this discussion in Chapter 9.)

CAUTION **Though it can be tempting, be careful when increasing the size of a small original print. Sometimes, small prints have so little information that they don't really look very good when enlarged. Carefully evaluate the image before going more than twice the original size.**

This was a big job, so I can't take you through the entire process. Instead, I show you what my thought process is like on this kind of project and how I use Photoshop's retouching tools in that process:

1. Knowing where to start with a job like this is hard. I know that I'll be copying existing detail, like the boards on the wall to create new boards, so I begin by retouching some of the damage there to prepare them for use. The big scratch on the lower-right side of the boy is a good place to start. (Naturally, I duplicated the Background layer before doing any retouching.)

 This first round of background retouching must be as literal as possible because of the board pattern. I'll primarily use the Clone Stamp. I don't want any of the blending properties of the Healing Brush because they can obscure detail.

2. After the lower boards have been cleaned up, I begin using them to reconstruct the right side of the image. I start sampling the lower boards with the Alt key and painting them on top of the damaged and missing upper boards. The most important thing to be aware of when using the Clone Stamp for something like this is to be sure that the sample point and the spot where you are painting are aligned with each other. The best way to do this is to sample and then paint at corresponding points, as shown in the first image in Figure 10.22.

 After that relationship's in place, I am able to work my way up the wall, copying boards from lower in the photo. The second image in Figure 10.22 shows how the two cursors stay aligned as I move upward. The new boards may not be falling into the exact location of the old damaged and missing boards, but no one will know when I'm finished — except for you, of course.

3. I continue using this strategy — sampling clean boards to reconstruct damaged ones — as I work my way around the outside of the boy. I continually sample and paint in alignment; I sample a straight line and begin painting in a spot where I expect to see a line just like it. I also take care of any spotting as I come across it so my samples stay clean. (I don't want to copy small imperfections and have to remove them twice later.)

 The hardest part of this is matching the tones of the boards. I am careful, but I don't want to get too caught up in this right now. Seeing all the boards fall into place is a big confidence booster. I don't want to get side-tracked. I can address those tonal variations later with additional retouching or burning and dodging. (We cover burning and dodging in Chapter 12.)

FIGURE 10.22

The trick to using the Clone Stamp on a pattern like this is to sample and paint in places where the pattern is the same. For example, here I sampled a corner and then began painting where a corner should be. After that relationship is established, everything falls into place so long as I continue to use the same sample. (I start low so I can copy and paint three boards as I move upward without resampling.)

4. Figure 10.23 shows my progress so far. The wall behind the boy looks great. It needs some more work, but it's much better than it looked when I began. Now the hard work begins. I was able to get away with all kinds of inconsistencies on the wall, but as I begin retouching the main subject, I'll have to be more careful.

I begin by attacking all the cracks in the dark pants and shoes. I don't get carried away with the small white dots because they add some texture to the dark area. I use a combination of the Healing Brush and the Patch tool to work on this area.

FIGURE 10.23

So far, so good. The wall has come together nicely. This is a big confidence booster with a difficult project like this one.

5. After the pants are taken care of, I tackle the jacket. Here I'll have to be more careful about smudging, so I switch back to the Clone Stamp. I also increase the Hardness setting on the brush to 60 percent to facilitate working around the edges of the boy. (I don't want to make the brush too hard just yet because there aren't many hard edges in this image.) Again, I work on small sections until I build up larger, "clean" areas to be used for sampling. The first image in Figure 10.24 shows me sampling one of these clean areas as I reconstruct the main line down the center of his coat. After that relationship is established,

I continue to use it as I move across the coat on the right side, as shown in the second image in Figure 10.24.

If you look closely, you can see that I am picking up a repetitive pattern, seen as short, white diagonal lines. That's because the relationship of the sample and target areas stayed the same as I moved across the coat. (I kept re-copying the pattern every time I moved the brush to the side.) This isn't a problem as long as I remember to come back and do a little cleanup later.

The hardest parts of the jacket are the arms. There's barely enough good detail to use for samples. I have to slow down here and work deliberately.

FIGURE 10.24

After a good relationship is established between the sample and target areas, it can be used for several strokes. This ensures that important details continue to line up with each other. Any repetitive patterns can be quickly removed later.

6. After I'm happy with the jacket, I move to the most difficult part of this project: the face. When I was retouching the wall, and even the clothing, I could get away with some inconsistencies. With someone's face, you can't fake it. The only thing working in my favor is that the quality is so low on the small original that you can hardly tell what the boy looked like.

 I'm forced to clone the eye on the right to create the eye on the left. With very little detail in either eye, I can get away with it. (We look closer at working with eyes in Chapters 14 and 15 — no pun intended.) I also have some trouble working with his cheek. Here I have to raise the hardness of the Clone Stamp's brush to 90 percent so that I get a nice edge.

7. Figure 10.25 shows the efforts of about two hours of work on this project. The image can still use some more work to fine-tune it — mostly spotting — but it's much better than it was.

FIGURE 10.25

Two hours later, the project is mostly finished. It can use a little more polishing, but it's much better than the original scan.

This project is about as extreme as it gets. The whole process is exacerbated by the fact that the original is so small. When the original is this small and this damaged, the process is complex. When you first begin restoring old photos, try to stay away from projects that are this complicated. Cut your teeth on the easier stuff before biting off a project this complex.

Summary

In this chapter, you saw how some of the tools and techniques you've learned about are used to solve typical restoration problems. We started with tonal restoration and then worked our way up to a very complex restoration job. In Chapter 12, you tried most of these techniques with a hands-on restoration project.

For now, the main thing to get from this chapter is that the techniques shown here are used to solve a variety of problems. Use your own files, or the sample restoration file included with the online practice files, to work with these techniques. Take the time to explore these ideas, comparing and contrasting them as you play. A good understanding of these concepts will take you far as you begin your restoration journey with Photoshop.

Repairing the damage to an old photo is the first step in the restoration process. The second step is to apply finishing touches to the image so that it's ready for printing and/or display. We look at this second step in Chapter 11.

Chapter 11

Finishing Touches

In the preceding chapter, we looked at various methods for repairing damaged photos. The results of those types of processes are often beyond amazing. However, repair techniques represent only half of the restoration process. The second half of the process involves finishing the image so it looks its best and is ready to be shared with others.

This chapter explores the second part of this two-stage process. I cover different ways to create black and white images, as well as methods for adding sepia toning. I also show you how to recreate an old-fashioned, hand-tinted color look that was popular long ago before color photography was an option.

We then look at using the Crop tool and the Canvas Size command, and how these tools are used to prepare an image for its final use. Here, we explore ways to crop to a predetermined size and how to create custom crops that preserve everything in the image.

Working with Black and White Photos

Quite often, images that are being restored started out as black-and-white prints. In many cases, they've faded to a yellowish color over the years. Sometimes, this yellowish color is called sepia, but as we'll see shortly, it isn't always a true sepia. The point I'm trying to make is that even though an old photo may have a yellowish color cast now, a true restoration should be black and white because the photos started out as a black and white.

When I first began the outline for this book, I considered covering black and white in two separate places: here in this chapter and again in the portrait-retouching section. That's because Photoshop CS3 offers some very nice features for converting color to black and white. The procedures I show you here are currently used more with new photos like portraits than with old, restored photos. However, because we need to have a serious discussion about black and white here, it just makes sense to cover the entire subject in one place.

> **TIP** I scan all black-and-whites originals as color files (24-bit or 48-bit color) and convert them to black and white in Photoshop. I do this because I feel that my scanner does a better job of capturing information in the full-color mode. Also, if the old photo has a faded tone, I can capture it in the scan in case I want to try to work with it in the future.

You can convert a color image to black and white in Photoshop in numerous ways. A couple of years ago, I researched the subject and found at least a dozen different procedures. Some of those procedures are better than others for reasons of control and flexibility. I show you three different methods here, ranging from the least flexible to the most flexible.

Grayscale mode

The easiest way to change an image from color to black and white is to convert the image's mode to grayscale. You do this by choosing Image ➪ Mode ➪ Grayscale. Figure 11.1 shows an image that's been converted from RGB to grayscale via the Mode command. An image's mode describes how the tones and colors in the image are being interpreted by Photoshop. This is very similar to the idea of color spaces that we discussed in Chapter 5. Changing an image's mode permanently changes the values in the colors.

> **NOTE** The term *grayscale* has multiple meanings here. Generically, it refers to an image that has tones in black and white. In Photoshop, it refers to a particular image mode where the pixels that describe an image only have one value that describes their brightness. These files are not capable of containing color. A true grayscale image, in this sense, only has one channel in the Channels palette. It's called Gray.

When you use the Mode command, a couple of dialog boxes pop up. The first image in Figure 11.2 shows the dialog box you get if the image you're converting has layers. This warning appears because the Grayscale mode doesn't support some adjustment layers. These are primarily adjustment layers that work with color, such as Color Balance, Hue/Saturation, and Black & White. Yes, the Black & White command does use color, as you'll see in a moment. When you see this first warning dialog box, you have the option of flattening the layers so that their adjustments are applied before the conversion. If you don't flatten before clicking OK, the unsupported adjustment layers are deleted, along with their effects on the image.

The second pop-up warning is new to CS3. In previous versions of Photoshop, a warning would pop up to remind you that you were about to discard all color information. The new dialog box suggests that you use the Black & White command instead of the Mode command.

FIGURE 11.1

This photo of my grandfather was taken in 1925 when he was a coffee salesman. The image was converted from RGB color to black and white via the Grayscale option under the Mode command.

CAUTION Some Photoshop commands — such as Hue/Saturation — don't work with images that have been converted to grayscale mode. Any command that isn't available for a grayscale image is grayed out in the menus.

FIGURE 11.2

The first dialog box shown here appears if the image being converted to grayscale mode has layers. Clicking Flatten causes the layers to take effect before the conversion. Clicking OK instead deletes any layers not supported by the grayscale mode. The second dialog box suggests that you try a better option for managing the grayscale conversion.

The reason Photoshop is trying to warn you about the grayscale mode conversion is that some problems are associated with using it. The first one is that the effects of this change are permanent. After all the color has been removed, it's gone forever. Yes, the image can be switched back to RGB mode via the Mode command, but it will still look black and white. The color that was removed from it is gone.

The second problem is that the Mode command isn't very discriminating. It handles all colors the same as it removes them from the image. When working with an image like the one above, this isn't much of an issue because it's a yellowish monotone to begin with. However, when colors are present, the conversion process becomes important.

TIP Some photo labs won't take grayscale image files because they're set up for a RGB color workflow. If you run into this, simply convert the grayscale files back to RGB color with the Mode command. They'll still look black and white, and the lab will be happy.

You may recall from Chapter 2 that RGB color images are composed of three different grayscale channels — one for each color (red, green, and blue). It's hard to believe, but all the colors in an image are created by the interaction of these grayscale channels. Figure 11.3 shows a color image with its channels in the Channels palette. Each of the three channels is enlarged here so you can see how different they are from each other.

FIGURE 11.3

Every RGB color image is composed of three individual grayscale channels. When these channels are combined, they create all the colors we see in a color file. When we look at each of them individually, we can see lots of tonal variation because each channel interprets color differently, depending on its relationship to that color. For example, red is a light tone in the red channel, but it's dark in the blue channel because red doesn't contain any blues.

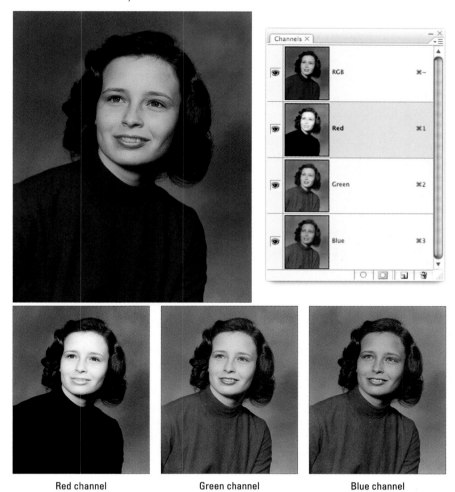

Red channel Green channel Blue channel

Each of these individual channels in Figure 11.3 is its own version of a grayscale interpretation of this color image. The channels look different because each is accenting different parts of the color spectrum. For example, the skin tones are light in the red channel because reds are always light in the red channel, just as greens are light in the green channel and blues are light in the blue channel. The cyan/green sweater is dark in the red channel because those colors are on the opposite end of the spectral scale from red.

I could use one of these channels to create a black-and-white version of this image. All I have to do is turn off the visibility of the two channels I don't want to see and convert the image to grayscale via the Mode command. This ability to select a specific channel helps to address the first problem with using the Mode command by providing some control over the black-and-white conversion process, although that control is still quite limited.

Now that you understand the interaction of these three color channels, I'll show you how you can gain full control over the black-and-white conversion process with the Channel Mixer command.

The Channel Mixer

For many years the Channel Mixer (accessed using Image ⇨ Adjustments ⇨ Channel Mixer) has been one of the most preferred methods for making black-and-white conversions in Photoshop. Its name describes exactly what you can do with it — mix the three color channels to create a special "flavor" of black and white that best suits your image.

The Channel Mixer is also available as an adjustment layer. This is the best way to use it because as an adjustment layer, its effects can be modified at any time. Figure 11.4 shows the Channel Mixer dialog box with the default mix that pops up when the Monochrome check box is checked. The monochrome default settings are as follows:

- Red channel = 40 percent
- Green channel = 40 percent
- Blue channel = 20 percent

These percentages indicate how much of a particular channel is currently in the mix. As you can see, by default, the blue channel is lower than the other two. That's because the blue channel tends to contain the most noise of the three channels. In fact, some noise removal techniques employ a method of blurring only the blue channel.

CAUTION **Remember that this command also is used to create special effects on color images. When it's being used to create black-and-white images, the Monochrome check box must be checked.**

If any one channel is raised to 100 percent while the two other channels are lowered to 0 percent, then the image will look the same as when that channel was viewed in the Channels palette. What I mean is that 100-percent Red, 0-percent Green, and 0-percent Blue would look the same as the first black-and-white image in Figure 11.3.

The objective with this command is to combine the strengths of individual channels while minimizing their weaknesses. When I look at the three channels in Figure 11.4, I like the lightness of the skin in the red channel and the lightness of the sweater in the green channel. I also see that the blue channel doesn't contribute anything to the black-and-white conversion. I go with these settings to create the black and white in Figure 11.4: 50-percent Red, 50-percent Green, and 0-percent Blue. If I go any higher on the red channel, the sweater gets too dark and the lips become too light.

FIGURE 11.4

The Channel Mixer dialog box allows you to mix the three color channels to create custom black-and-white conversion recipes. I combined the red and green channels here because I like the balance of the tonality between the skin and the sweater. Because the blue channel was the worst-looking channel, I didn't use any of it.

NEW FEATURE When using the Channel Mixer, be sure that the three channel values equal 100 percent when added together. Otherwise, the luminance of the image is affected. In past versions of Photoshop, you had to keep track of this total yourself. The upgraded Channel Mixer dialog box in Photoshop CS3 has a new Total field that does the math for you.

As you can see, the Channel Mixer solves both of the problems I have with using the Mode command to convert an image to black and white. The conversion can be controlled, and the change isn't permanent if you use an adjustment layer. However, as useful as the Channel Mixer is, I haven't used it for a black-and-white conversion — other than the one I just did for you — since Photoshop CS3 was released because Adobe added a great, new command to Photoshop's impressive toolset. It's called the Black & White command.

NOTE I just took you through the Channel Mixer command because I want you to understand the idea of mixing channels to create the perfect black and white. This is very similar to the way the Black & White command works. I also wanted you to see the procedure because it's the main way black-and-white conversions in Photoshop have been handled for a long time. You're bound to run across it in other books and study materials as you explore Photoshop.

Photoshop CS3's new Black & White command

When it comes to making black and white, the Channel Mixer has been our trusty friend for many years. It offers the ability to customize the black-and-white conversion process by emphasizing— and de-emphasizing—certain colors as they're converted to grayscale. The only real drawback to the command is that it isn't exactly intuitive for a user who doesn't really get the "channels thing."

The introduction of the new Black & White command in Photoshop CS3 takes the channel-mixing concept to a new level. This new command is easier to understand, and it's much more intuitive to work with. I don't know if I'll ever use the Channel Mixer for black and white again.

NEW FEATURE The new Black & White command in Photoshop CS3 makes the black-and-white conversion process much more intuitive.

Figure 11.5 shows the Black & White command's dialog box. This dialog box has six sliders, one for each of our six main colors: Reds, Greens, Blues, Cyans, Magentas, and Yellows. Dividing the colors like this provides more control than the three sliders in the Channel Mixer dialog box. For example, I can lighten both red and cyan with the Black & White command. In the Channel Mixer, if I lighten one of these colors, I'll darken its opposite.

FIGURE 11.5

With its six color sliders and intuitive interface, the new Black & White command takes the idea of channel mixing to a new level. Moving a slider to the right causes that color's grayscale tone to get lighter. Moving a slider to the left makes the tone darker.

This new command is much more intuitive to use because we no longer have to think in terms of mixing channels. All we have to think about is how light or dark a color will be in the resulting black and white. Let's step through this command together:

1. Open the practice file titled bike_racing.tif from the downloadable practice files from the Web site.

2. Let's do this with an adjustment layer by choosing Layer ⇨ New Adjustment Layer ⇨ Black and White (or use the Create new adjustment layer icon on the bottom of the Layers palette).

3. Your image preview turns black and white when the Black & White dialog box opens with its default settings. Click the Auto button to let the command look at the colors in the image and make its own adjustment.

 As you may have figured out by now, I'm not a big fan of auto adjustments in Photoshop. However, this one does a pretty good job of getting you into the ballpark. It maximizes the distribution of gray values in the image. Because of this, it almost always gets you closer than the dialog box's default settings.

4. Slide the Red slider to 110 percent, and watch how the jerseys of the first and third riders get lighter in tone as you slide. Notice that the skin tones on the Caucasian riders are largely unaffected.

5. Slide the Green slider to 250 percent, and watch the jersey on the last rider. It gets lighter too.

 I think you're getting the point. You can use these six sliders to customize the way each color will be converted to black and white. If you want a certain tone to be lighter, raise the value. If you want it to be darker, lower the value. If you don't remember what a particular color is (because the preview is black and white), click the Preview box to temporarily hide the black-and-white effect.

NOTE You don't have to worry about these settings going over 100 percent like you did with the Channel Mixer.

6. Sometimes, it's hard to tell exactly which slider to use for a particular color. For example, if I look at the blue shoes of the riders in the back, I don't know if they're really blue or if they're actually cyan. One way to find out is to experiment with the sliders until I see which one affects them and then work with it. Fortunately, there's a much better way to know which slider affects the various colors in the image.

 With the Preview check box checked, move the cursor over the image. When you do, you'll notice that the cursor becomes an eyedropper. Click the shoes of the last rider. When you do, you'll notice that the Cyan slider in the Black and White dialog box is activated. Now click the shoes of the other rider, and notice that the Blue slider becomes active instead. This eyedropper allows you to target a color slider, even while previewing the image in black and white. All you have to do is click the tone you want to lighten or darken to see which slider to use. But that's not all. There's something even cooler that you can do when you click and hold the image.

7. Click one of the blue shoes of the rider in third position. This time, click and hold. Notice that the cursor changes to a hand with double arrows pointing sideways, as shown in Figure 11.6. Hold down the mouse button, and drag the cursor to the right. Notice that the tones for the underlying color you clicked starts getting lighter. The Cyans value also begins to increase in the Black & White dialog box. When you click and drag the cursor to the left, the tones darken and the values decrease. It doesn't get much more intuitive than this.

CAUTION Be aware that all the similar tones in the image change together. If I click one person's skin tone, similar skin tones on other people also are affected by any changes.

FIGURE 11.6

When the Black & White command's dialog box is open, you can use the cursor to target and adjust the tonality of the image's underlying color. To lighten a color's corresponding grayscale tone, click and drag to the right. To darken it, click and drag to the left.

8. Experiment with other areas of the image, clicking and dragging until you like the tonality of the black and white. When you're finished, click OK. Figure 11.7 shows my conversion compared to a straight grayscale change with the Mode command.

FIGURE 11.7

This first black-and-white conversion was done by converting to grayscale with the Mode command. In the second version, the Black and White command was used to fine-tune the conversion process, allowing me to create a custom conversion. When you compare the riders' jerseys, you can see that all of them changed except for the second rider, whose jersey was black to begin with. Also notice that the cyan line painted on the track at the top of the background and in the foreground went from being a light tone to a dark tone.

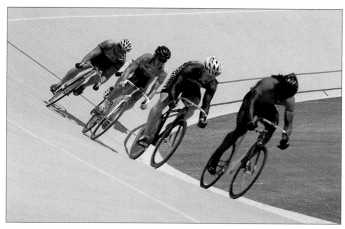

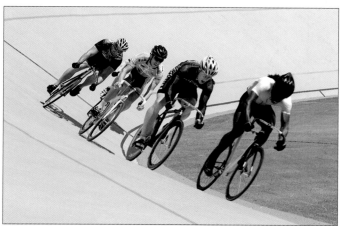

I want to point out one more thing about the Black & White command: It allows you to save presets. Figure 11.8 shows the Preset pop-up menu. As you can see, the command comes with several canned presets. If you find a black-and-white "formula" that you really like, you can save it by clicking the Preset Options button to the right of the Preset pop-up menu.

The Black & White command comes with several canned presets. You also can save your own presets by clicking the Preset Options button.

Let's finish this section by going back to the restoration project we worked on earlier. Figure 11.9 shows what this portrait looks like after I use the Black & White command on it. I like this more than the version I got with the Channel Mixer back in Figure 11.4 because I'm able to lighten the sweater without affecting the skin tones, which wasn't possible with the Channel Mixer.

When working with old black-and-white originals like the one at the beginning of this chapter in Figure 11.1, it's okay to use the Mode ➪ Grayscale method. Just remember to convert the image back to RGB color afterward. This makes life easier because some things in Photoshop don't work with grayscale.

When it's time to convert a color image to black and white, you can't beat the new Black & White command for creating custom conversions. Remember that this command is also available as an adjustment layer. That means that you can convert an image to black and white and then use a mask to go back and reveal some of the color, like the image of the boy with the saxophone in Chapter 8.

FIGURE 11.9

By using the Black & White command to handle this black-and-white conversion I was able to have greater control over the tonality of the sweater. I lightened it without adversely affecting the skin tones.

Applying Sepia Tones

I've mentioned sepia toning a few times in this book, but I've never stopped to precisely define the term. Sepia toning is a chemical process that photographers have been using in the black-and-white darkroom since the early days of photography. The process involves soaking a black-and-white print in bleach to remove all traces of silver. Then the print is soaked in a toning solution, giving it warm brown tones throughout. Though the effect can look very nice, this wet-darkroom chemical process is time consuming and stinky.

When old photos fade, they tend to look sepia toned, even though they may have started out black and white. Figure 11.10 shows two of the old photos we dealt with in Chapter 10. The one on the left is a true sepia-toned print, and the one on the right is a faded black and white. Notice the difference in the tones. The color of the sepia-toned print is more of a chocolate brown, while the print on the right leans more toward yellow.

FIGURE 11.10

The print on the left is a true sepia-toned print, while the print on the right is an old black and white that developed a colored tone as it aged.

When restoring an old photo, you can reinvigorate the old sepia tone or add a sepia tone to an image that was never sepia in the first place. Also, keep in mind that this technique isn't limited to restoring old photos. Sepia toning is still a very popular portrait finishing technique today.

Digitally adding a sepia tone to an image is like converting to black and white; you can do it in more than one way. We cover two different methods here: the Hue/Saturation command, which has been the most popular method for many years, and a brand new method, which is bound to become the most popular method in the near future — the Black & White command.

Using the Hue/Saturation command

When I first discussed the Hue/Saturation command, which you can access using Image ⇨ Adjustments ⇨ Hue/Saturation, way back in Chapter 2, I mentioned that the dialog box has a check box called Colorize. Figure 11.11 shows the Hue/Saturation dialog box with this box checked. If the foreground color (the top swatch at the bottom of the toolbar) is set to either black or white, then the default tone is red (Hue = 0). If the foreground color is any other color, then the hue used for toning is the same as that color.

> **TIP** This is a great way to select a hue for toning that matches an existing image. Use the color sampler tool to sample the existing image. This sets the foreground color to that sample color. Now, when you use the Colorize option, the hue is the same as the sampled image.

FIGURE 11.11

When the Colorize box is checked in the Hue/Saturation dialog box, the image is toned with a single color. The Hue and Saturation sliders are used to create the color that will be used in toning. The stripe along the bottom provides a preview of those settings.

After the Colorize feature is active, the Hue and Saturation sliders are used to specify the color that's being used for toning. As those values are changed, the color preview at the bottom of the dialog box updates to display the color. I prefer chocolaty browns, so the settings I use the most are Hue = 30 and Saturation = 22. (I always leave the Lightness value at 0 when doing this.)

TIP Remember that the Hue/Saturation command also is available as an adjustment layer.

You need to be aware of an important issue when using the Colorize feature on the Hue/Saturation command to create a sepia tone. Because this command adjusts color, it has a different effect on an image that's been converted to grayscale than on one that still has a color tint. Figure 11.12 shows one of the photos from Figure 11.10. The version on the left was colorized with the Hue/Saturation command without converting it to grayscale first. The version on the right was converted to grayscale with the Mode command and then converted back to RGB color before the Hue/Saturation command was used. As you can see, the color of the tone in the outcomes is different. If I were working with several old images, each with slightly different original tones, I'd want to convert them to grayscale before toning so that they would all have the same sepia color when I was through with them.

NOTE Remember that you don't have to use the Mode command to convert to grayscale. You can use the Channel Mixer or the Black and White commands in the Image ⇨ Adjustments menu or as adjustment layers.

The thing to be aware of here is that the same settings will have different effects on images, depending on their existing color or tone. To make the results more consistent and reliable, you must convert images to grayscale before toning them with the Colorize feature in the Hue/Saturation command. Just remember that if you use the Mode command to convert to grayscale, you have to use it again to bring the image back into RGB Color mode before using the Hue/Saturation command. Otherwise, if the image is grayscale, the Hue/Saturation command won't be available because it can't be used in true grayscale mode.

FIGURE 11.12

This original image has a slight color cast to it. When the Colorize feature of the Hue/Saturation command is used, the underlying toning affects the outcome. When the image is converted to grayscale first, the underlying tones have no effect on the toning process, making it more repeatable.

This system for adding sepia to an image is tried and true. I've personally used it countless times. The only problem with it is this: For it to be reliable, it has to be a multi-step process when working with color images because they should be converted to black and white first.

Using the Black & White command for sepia toning

Earlier, you probably noticed that the Black & White command has a Tint option near the bottom of the dialog box. You can see it in Figure 11.6. When this option is checked, a tint is added to the effects of the black-and-white conversion. The Hue and Saturation settings for the tint option are similar to the settings in the Hue/Saturation command. However, I've found that similar values have different affects when used in the Hue/Saturation and Black and White commands. This isn't really a big deal. You just have to find a formula that works for what you like.

NEW FEATURE The new Black & White command allows you to tone an image while converting it to black and white, making the process much more fluid and flexible.

The main advantage here is that the sepia toning is handled during the black-and-white conversion process. This saves time by combining both of these adjustments in the same place. It's also handy that when adjustment layers are used, because both adjustments are on the same layer.

Either of the options discussed here works fine for creating sepia-toned images. Both of these techniques also are useful for creating other types of toned prints, like blue tones, which were very popular a few years ago.

Adding Color to a Black-and-White Photo

I've spent some time talking about the best ways to convert a color image to black and white, so it only seems appropriate that I discuss how to add color to a black-and-white photo. I am often asked to use this technique on old photos to give them a different kind of antique look.

Back in the days before color film was available, hand-coloring black-and-white photos was very popular. Tinted oils were used to add various color washes to different parts of the image. The effects were sometimes uneven, but some color was perceived as better than none. This hand-tinting effect was used so much that it has an antique feel to it when we see it now. Figure 11.13 shows an old photo before and after hand-tinting in Photoshop.

FIGURE 11.13

This hand-colored effect is reminiscent of antique photos that were hand-tinted with colored oils long before color photography was an option. This figure shows the image before and after the process.

Photoshop has two tricks for creating this kind of effect. The first one is to use layers to isolate different colors. The second trick is to use the right layer blending mode when creating those layers. I'm going to step you through the process as we look at an overview of how to create the toned image in Figure 11.13:

1. I open the image and create an empty layer. I'll use this layer to paint the couch and the dress. Before I begin applying color, I change the layer's blending mode to Color.

NOTE The Color blending mode allows the layer to affect the hue and saturation of the underlying layer without affecting its tonal values.

2. I click the foreground color swatch on the toolbar to open the Color Picker. In the dialog box, I choose a cherry red and click OK. I then carefully paint the couch with red.

3. When the couch is fully painted, I repeat the process on a new layer with a nice green for the girl's dress. Figure 11.14 shows the difference between the Normal blending mode and the Color blending mode with the painting I've done so far. In the first image, both of the new layers are using the Normal blending mode. In the second image, the blending modes are set to the Color blending mode.

FIGURE 11.14

Painting with color on layers that are using the Normal blending mode looks like the first figure here. The effect of this painting can be appreciated once the layers' blending modes are changed to Color.

4. I create another new, empty layer and set its blending mode Color. I then select a good color for the girl's skin tone and begin painting all of her skin. The color I use isn't perfect, but I know I can tweak it with the Levels or Hue/Saturation commands because it's on its own layer.

One of the challenges to using this technique is that colors don't look the same when you paint them onto a layer that's using the Color blending mode. That's because this blending mode allows only the painted color to affect hue and saturation. The luminance — or the brightness of the tones — is supplied by the underlying layer. This is one of the reasons I use different layers for different colors. It allows me to modify the colors with the Levels, Curves, or Hue/Saturation commands.

Another advantage to using separate layers is that I can easily use the Eraser tool if I accidentally paint "outside the lines." Because each main color is on its own layer, I can erase bits of it without affecting the other colors.

> **NOTE** This is one of those rare times when it's okay to use the Eraser. Normally, I stay away from this tool because of its destructive nature.

5. After creating all the layers for the girl and the couch, I turn my attention to the background. All the other colors are on separate layers, so I create a new layer with the Color blending mode below them and use the Paint Bucket tool to fill it with a gray-blue. (If I were willing to spend more time on this project, I'd paint each of the background details — curtains, floor, wall — a slightly different color.)

> **TIP** With each of these colors on its own layer, I can control the hardness of their edges by giving the layer a slight blur with the Gaussian Blur filter.

6. I want to preserve the old border of this photo, so I have to create a mask on the blue layer so it doesn't affect the color of the border. I also mask out the girl's legs and shoes because I don't want them to be blue either.

7. The legs and shoes are still a little too yellow, even though they're back to their normal color. I like the yellow on the legs, but not on the shoes. I decide to tone the shoes down with a Hue/Saturation adjustment layer. I create one just above the Background layer, so it won't affect anything else. I lower the Master channel's Saturation value to -100. This removes all color from the image. I then use the Paint Bucket tool to fill the layer with black to hide the effect. After that's done, I paint the shoes with white to reveal the Hue/Saturation adjustment only on them. I also use this mask to whiten the small amount of the girl's shirt at her collar by painting it white too.

8. I'm almost done. All the colors are in place, and all masking is done. The only thing I don't like is the overall intensity of the colors. The hand-tinted effect isn't quite convincing because the colors are too rich. I solve this problem by going to the top of the layer stack and adding another Hue/Saturation adjustment layer. I place it at the top so it affects all colors below it. I lower the Master Saturation to −30, and I'm done. Figure 11.15 shows the layers in my Layers palette. They're numbered in the order in which they were created. Review these steps as you inspect the layer stack in Figure 11.15 and the final result in Figure 11.13.

> **NOTE** I've included this file with the online practice files so you can give this technique a try. The file is called antique_girl.tif.

This overview is somewhat general, but it should give you lots of insight into creating this effect for yourself. I have used this technique in many different ways over the years to solve a variety of problems.

FIGURE 11.15

The final image shown in Figure 11.13 is composed of nine separate layers. Each layer has an effect on the color of the composite image. Layers 1 through 6 all have Color selected for their blending modes.

Final Cropping and Sizing

After all the restoration work is done, it's time to start thinking about preparing the image for its final use. When I did my family restoration project, the goal was to create a Web site of the photos and then burn it onto DVDs so family members could view the Web site locally on any computer. This type of usage required fairly low-quality files because of the limitations of computer screens. However, it didn't make sense to me to go through all that work and then reduce each image to a low-quality file. So every time I finished working on a file, I saved three different versions of it.

- **Master file:** This is the main file on which all the work was done. This file is saved in the PSD file format so that all layers are preserved. These were archived and stored after the project was completed.

- **Print file:** This file is cropped, sized, and prepared for printing. It's flattened and saved as a JPG. I included these on the DVD in a separate folder in case any family member wanted to make prints of any of the files.

- **Screen file:** This file is sized and optimized for Web or screen display. These are what I used to build the Web site.

> **CAUTION** Be sure to save your layered files as master files before cropping or changing size. That way, you can always go back to them if you change your mind about cropping or sizing later on. I can't stress this enough.

In order to make the second two types of files, you must do some cropping and sizing. Often, you also need to increase the size of the image's canvas to accommodate standard print sizes. We looked at image sizing in Chapter 9, so let's look at the other two steps: cropping and adjusting canvas size.

Using the Crop tool

Because cropping is considered destructive — it can't be undone later — I always leave master image files uncropped. However, when it's time to print or display an image, some cropping invariably has to take place. There are two different ways to use the Crop tool. It can be used to crop to a pre-determined size (like 5×7), or it can be used to create a custom crop to suit special needs. Let's investigate this tool:

1. Open the practice file called antique_girl.tif from downloadable practice files on the Web site. Before we do anything, let's look at the document size of this image. Choose Image ⏎ Image Size (Alt+Command/Ctrl+I). Figure 11.16 shows the Image Size dialog box. From it, we can see that the image measures 5. 75×8.6 inches at 300ppi. (I scanned this original at 600ppi and converted it to 300ppi, so it now measures twice the size of the original print.) Click Cancel to dismiss the dialog box.

 This tells us that we can crop this image to 5×7 without having to enlarge the file much. If we decide to make an 8×10 from the image, then it will have to be enlarged substantially through upsampling. Doing so would affect the already marginal quality of the image, so it might not be a good idea in this case.

FIGURE 11.16

Always look at an image's document size and resolution to determine the file's optimal print size. In this case, the image is 5.25×8.48 inches at 300ppi. We can comfortably make a 5×7 print from this file.

NOTE This decision really needs to be made on an image-by-image basis. If this file looked nice and sharp at this size, I wouldn't have a problem resizing it up to a slightly larger size, as discussed in Chapter 9.

2. Select the Crop tool (C) from the toolbar; it's fifth from the top on the single-column toolbar. Go to the Tool Options bar at the top, and click the Clear button to clear any settings from the Crop tool's options. When all settings are cleared, the tool is ready to handle any kind of special cropping.

3. First, we want to even out the white border so that the top, bottom, and sides have the same amount of white border. Click at the top-left corner and drag down to the bottom-right corner, as shown in Figure 11.17.

Here are a couple of different ways to adjust the cropping selection after it's drawn:

 ▪ If the crop box is off by just a bit, you can nudge it right, left, up, or down with the cursor keys on your keyboard.

 ▪ If it needs to be dragged further, click and drag inside the selection to move it.

 ▪ You can use any of the boxes that are at the corners and sides of the selection to resize that corner or side.

 ▪ If you want to bail and start all over, press the Esc key on your keyboard (or right-click and select Cancel).

TIP If a setting called *Snap* is turned on, you may be having trouble with the cropping selection trying to jump to the image boundary instead of where you want it. Snap allows the cursor to move in smart ways so that it lines up with other things in the image. Sometimes, though, it's not smart enough. To solve this problem, choose View and click Snap to uncheck it. (This is one of the few commands you can access while the cropping selection is active.)

FIGURE 11.17

Here the Crop tool is being used without any size or aspect-ratio restrictions. One way a crop can be committed or canceled is by right-clicking and selecting the appropriate choice.

When your cropping selection looks like Figure 11.17, press Enter (or right-click and select Crop, as shown in Figure 11.17). Now the white boundary is about the same all around. We'll come back to it in a moment.

4. Let's try cropping to 5×7 without the border. Go to the Crop tool's options in the Tool Options bar and enter **5 in** for Width and **7 in** for Height. Enter **300** in the Resolution box. This is important. If you don't specify a resolution, Photoshop has a tendency to come up with some pretty crazy values. This isn't a good surprise to find later.

> **TIP** If the reading beside the numbers says something other than "in" (inches), then your ruler preferences are set to something other than inches. This is easy to fix. If the ruler isn't currently visible, choose View ⇨ Ruler (Command/Ctrl+R), right-click the ruler, and select Inches. (I like to leave the Ruler visible because it's useful for other things too.)

5. Click at the top of the image area, inside the original border area, and drag down to the right, stopping just before the border on the right, as shown in the first image in Figure 11.18.

FIGURE 11.18

When the Crop tool's options are set to an aspect ratio of 5×7, we quickly find that some of the image will be cropped. After the cropping selection is drawn in the first image, it's dragged to a lower position in the second image so that all the important information is included in the final crop, shown at the bottom.

It doesn't take long to see that this original image isn't proportional to the *aspect ratio* of a 5×7 print. The aspect ratio is the mathematical relationship between the image's height and width dimensions. For example, a 16×20 and an 8×10 are both a 4×5 aspect ratio. The dimensions of the 16×20 are exactly four times as big as the 4×5, while the 8×10 is twice as big.

One solution to this is to reposition the cropping selection lower so that we include all of the girl and exclude empty space at the top, as shown in the second image in Figure 11.18. When you press Enter, you'll get a 5×7 that looks like the third image in Figure 11.18.

This solution worked here, but sometimes you either can't or don't want to crop any of the original image. When that happens, you can still make a 5×7 print of the entire image by fitting all of it onto a 5×7-inch canvas.

Working with the Canvas Size command

In this exercise, we work with the same image to crop and *float* it so that the entire image fits on a 5×7-inch piece of photo paper:

NOTE *Floating* means an image is allowed to have some border showing around it on all sides. It's as though the image is floating over a neutral field. Fine art photographic prints are often presented this way.

1. Open the antique_girl.tif file. If the file is still open from the preceding exercise, undo any cropping that was done. This time, we use the Crop tool without any predefined sizes. Click the Clear button in the Crop tool's options.

2. Click at the top left of the image again, and drag all the way down to the lower-right corner, just inside of the original border, as shown in the first image in Figure 11.19. When the selection looks good, press Enter to commit the crop.

3. Let's see what we have for a document size now. Choose Image ➪ Image Size (Alt+Command/Ctrl+I). You'll see that the size is approximately 4.25×7.56 inches. That still won't fit on a 5×7 piece of paper, so we have to adjust it.

 We could just change the Height value under Document Size to 7 inches. That would work, but I said that we want to float the image, which means that we want at least a little background to show all the way around the image so it floats on the background.

 Let's give ourselves a quarter of an inch at the top and bottom. Change the Height value to **6.5** inches, and click OK.

4. Now we have approximately a 3.66×6.5-inch image. All we have to do is increase the canvas around the image to 5×7. Be sure you're on the Background layer, and choose Image ➪ Canvas Size (Alt+Command/Ctrl+C). When the Canvas Size dialog box opens, change the Width setting to **5** and the Height setting to **7**, as shown in Figure 11.20. Make sure that Black is selected in the Canvas extension color pop-up. (If I plan to print on an inkjet printer, I choose white instead so I don't consume too much black ink.) When you click OK, your image should look like the finished crop in Figure 11.20.

FIGURE 11.19

This time, we want all of the image. We know it won't fit a 5×7 aspect ratio, so we remove all presets from the Crop tool's options by clicking the Clear button before drawing a cropping selection.

As you can see, there are a couple of options when cropping an image for print. If the original's aspect ratio is different from the intended print size, you can crop part of the original or float the entire image on a larger canvas size. Now that you know how to handle both scenarios, the decision is up to you as you deal with your own images in the future.

All of the above also applies to images destined for the Web or screen preview. The main difference is that you have much more freedom over aspect ratio when working with a screen presentation. You aren't limited to 5×7 or 8×10 sizes. The only thing you're limited to is the number of pixels that will fit on someone's screen. Because the lowest common denominator is 800 pixels wide by 600 pixels high, I make sure everything will fit into this size by going no larger than 450 pixels for width or height. This is easily achieved with our test image by using the Image Size dialog box and setting the Pixel Dimensions Height value to 450 pixels, as shown in Figure 11.21.

FIGURE 11.20

This image can't be cropped to 5×7 inches without losing part of it. This problem is solved by cropping and sizing it so the entire image is floated on a 5×7-inch canvas.

FIGURE 11.21

To size an image for Web or screen uses, go straight to the Pixel Dimensions in the Image Size dialog box. When you do this, you don't have to worry about what the Resolution value is.

NOTE Because we're specifying actual pixel dimensions, the Resolution setting does not have to be changed. It can stay at 300, and the image will display on a computer just fine.

If I wanted to preserve the original decorative border around the image, I would do everything the same, except that I would include the border in the original crop. I would probably also use white for the new canvas color so that it would work better with the white from the scanner lid that shows around the outer edges of the image.

I need to do one more step with this image before printing or displaying it: I need to sharpen it. I cover sharpening in Chapter 12 when we look at the complete restoration workflow.

Summary

Often, an image that's being restored began as a black-and-white print. Over the years, as the tones in the image age and fade, it may develop a yellow tint. You can return an image like this to its black-and-white origins in many ways. We covered three of them here: the Mode command, the Channel Mixer, and the new Black & White command. When working with a monotone print, each of these performs about the same. However, when converting a full-color image to black and white, the Channel Mixer and the Black & White commands are preferred for their flexibility.

You also have several ways to apply a sepia tone to an image. We looked at the Colorize feature of the Hue/Saturation command and the Tint option of the Black & White command. Both of these commands do a good job of creating a sepia tone, though the Black & White command is a bit faster.

Using dyes to hand-tint a black and white print was popular before color photography was available. We can use Photoshop to create a similar effect. The trick to doing this is to isolate different areas of color to their own layers and then use the Color blending mode on each of those layers. After you understand this technique, you can use it to solve a variety of restoration problems.

Finally, we looked at final sizing and cropping. We evaluated different ways of handling an image with an unusual aspect ratio. First, we tried cropping the image to a 5×7 print size. When we did that, we lost lots of original image information. Then we explored ways of sizing the image without losing any original information and floating it on a larger canvas so that it can still be printed as a 5×7.

Now we're ready to put all this learning together into a complete restoration workflow from start to finish.

Chapter 12

Hands-on Restoration Project: The Complete Workflow

Throughout this book I've attempted to present concepts in the order that they're encountered in a typical workflow. Sometimes that wasn't possible because of the way many concepts build on and affect one other: One concept must be explained in order to explain another one. Now it's time to put all those pieces together and see how they fit together into the context of a single restoration project — one that we will do together.

Every restoration project is like a jigsaw puzzle. Some are simple, and others seem impossible. Each is different in its own way. If I wanted to teach you how to assemble jigsaw puzzles, I wouldn't show you how to put together a puzzle and say, "Do this every time." Instead, I'd teach you about puzzle-solving strategies so that you'd be prepared for a variety of jigsaw puzzles. That's what I want to do here as we move through this project together. My goal is to take you through my thought process as I solve this restoration puzzle, so you walk away with an overall strategy rather than just a bunch of cool techniques.

The old photo we're going to restore in this chapter isn't a highly complicated project, which is good. It gives us more time to revisit a few key concepts and explore some new ones along the way — such as burning and dodging, sharpening, and inkjet printing. By the end of this chapter, you'll be completely prepared to tackle your own restoration projects. My hope is that you enjoy doing projects like this as much as I do.

Understanding Workflow

Back before digital — when everyone was shooting film — I almost never heard a photographer utter the word *workflow*. That's because most of their complicated post-production was being done by sophisticated photo labs with well-trained production employees. A photographer just took the picture and told the lab how to process and print it. (You can bet that the photo labs talked about workflow all the time.)

Now, in the world of digital, everything has changed. For better or worse, the tools are available to anyone who wants to use them. Now, people who aren't used to thinking in terms of workflow are having to figure out which Photoshop tools to use and when to use them. Sometimes, the options can seem unlimited. That's why developing a consistent workflow is so important. It spells out the order in which each step is to be carried out. This codification saves time by removing much of the decision-making from the process. However, it also has flexibility built into it to allow for unexpected problems.

Let's look at an analogy here. Imagine that I live in the suburbs and work downtown. Every day I have to be at my job downtown at 8:00. Imagine that instead of looking at a map, I decide to use the streets that I already know to see if I can find my way to work. Sometimes I get there on time, and other times I'm late. This is the way lots of people approach their Photoshop workflow. They don't really have a plan; they just know they'll get there eventually. It's understandable because Photoshop is a complex piece of software. If you dig through the menu commands in Photoshop and explore every submenu, you'll find more than 400 commands and subcommands. And you often have more than one way to do just about anything. The problem is that sometimes one way is better than another, and oftentimes certain steps must be taken in a particular order because of the way they affect one another step.

Another option for driving to work is to use a map to find the quickest route and use it every time. I could perfect that route and learn everything about it. If the road gets blocked by an accident, I go can around it and get back onto my route as soon as possible. After I know my route to work, getting there wouldn't take as much brain power so I could sit back and enjoy the commute instead of wondering when I'll get to work.

A digital workflow is very similar to this. It's a system of mapping out the best route for handling digital projects so that similar situations are handled in similar ways. It's a system of guaranteeing consistent results in the least amount of time, yet it leaves room for handling special circumstances when they show up. As we move through this project together, look for the workflow. At the end of the chapter, I review the major steps.

Evaluating the Project

Figure 12.1 shows the image we'll be working on. It's called antique_man.tif and can be downloaded from the practice files on the Web site. If you've already downloaded it, open it now.

FIGURE 12.1

Here's the image we focus on in this chapter. This file, named antique_man.tif, is available for download from the Web site.

This original photo is in pretty decent shape, especially considering that it's almost 100 years old. The original photo — the only photo of this ancestor — measures about 2.25×3.75 inches, which is smaller than a modern snapshot. (As I mentioned earlier, this is a standard size for photos this

old.) I scanned the original at 600ppi and then converted it to 300ppi with Resample turned off. The image now measures 4.6×7.25 inches at 300ppi. (If you don't remember how this works, review the resolution section of Chapter 9.)

Here's what I see when I look at this image:

- Because this original is so small to begin with, I won't be making any final prints larger than 5×7. This is good to know up front because it affects the amount of work that needs to be done. A large print requires more attention to detail than a small one.

- The image looks flat. The brightness and contrast need to be adjusted.

- It suffers from many of the usual problems like spots, streaks, and smudges, but overall it's in pretty good shape.

- The man's beard has a major scratch, and he has smudges on his cheek.

- His eyes are a tad too dark, and part of his hair is a bit too light. I want to balance these tones better so we can see detail in them.

- The scanner caused a *moiré effect* where the pattern of his tie meets his vest. A moiré is a digital artifact created by digital capture devices like scanners and cameras. It's caused by two different patterns coming together. This sawtooth effect isn't in the original photo.

> **TIP** There are two ways to try to get rid of a moiré when scanning. If the scanner software has a descreening filter, give it a try. If that doesn't work, try scanning the original at an odd angle and then rotating it back into alignment in Photoshop. (I tried both of these techniques with this original, but neither worked because the effect is so strong.)

- The texture of the paper shows through onto the man's skin. It doesn't bother me, so I'm not going to worry about it. If I decide to print larger than 5×7, I'll reevaluate this decision.

- This faded tone doesn't do anything for me. I'll add a sepia tone to it. (Black and white also is an option.)

- I like the oval shape, but I don't like this plain border. I'll replace it, which means I don't have to do any spotting or other restoration work on it.

This list is pretty standard. Fundamentals like brightness and contrast must be addressed, light damage must be repaired, and certain creative decisions need to be made. It shouldn't take more than about an hour to complete this project, including making an inkjet print.

Now that we know what needs to be done, let's get to work.

Putting the Pieces Together

The first thing we need to do is address the tonality of this image. After the brightness and contrast are corrected, we'll get a better view of where we're at:

1. The practice file, titled antique_man.tif, should be open. If it isn't, open it.

2. Create a Levels adjustment layer by choosing Layers ⇨ New Adjustment Layer ⇨ Levels. (If you're comfortable working with a Curves adjustment layer, you can use it instead of Levels.) Use the black input slider to target your darkest tones. Do the same thing with the white input slider to adjust the lightest tones. Now that the whites and blacks are taken care of, slide the gray input slider to the left to darken the image a bit. When you're happy, click OK. My final values are 18, 1.10, 220, as shown in Figure 12.2.

TIP Remember to use the Alt key while dragging the black and white sliders to preview any clipping in the shadows and highlights.

FIGURE 12.2

The first thing we do is adjust the brightness and contrast with a Levels adjustment layer. These are the values I used to fine-tune this image without clipping the shadows or highlights.

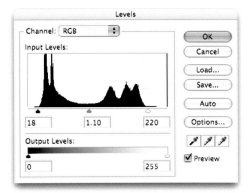

Spotting

Now that the image's tones are looking better, let's start on the repair process. Pick up where you left off after Step 2, and follow these steps:

3. Duplicate the background layer so that all work with the retouching tools will be isolated to this layer.

4. Let's begin with the background area around the man's head. We start with the area just above his shoulder on the left. Our strategy is to clean up a good-sized area so it can be used for sampling when repairing other areas.

 There's so much going on here that the Spot Healing Brush won't perform well. (We would get too much smudging from it.) That means we need to use the Clone Stamp.

Choose the Clone Stamp from the toolbar, and change its blending mode to Darken. Make sure you're working with a soft brush at 100 percent opacity. Also make sure that Sample is set to Current Layer. Begin working on the background, changing your sample point often.

CAUTION It's important that you set the Clone Stamp's blending mode to Darken so it affects only the lighter scratches and spots.

After you get a good-sized area clean, you can increase the size of your brush so you're covering larger areas, as shown in Figure 12.3. If you have to work close to the man, increase the Hardness setting and decrease the size of the Clone Stamp's brush. Don't worry if some of your work spills onto the light border surrounding the photo, because we'll remove it later.

TIP You should zoom in while you work, but don't go over 100 percent. Zooming in to more than 100 percent can be counter-productive because it causes you to work on small things that will never be seen in reality. For example, if I zoom this file to 100 percent, it measures 14 inches wide on my monitor. That's way bigger than the 5×7 I'll make from it later. This size discrepancy is caused by the inability of my monitor to display 300 pixels per inch. It can display only about 90ppi so they get spread out.

5. Continue working with the Clone Stamp until all of the dark background around the man is cleaned up. Keep using the area you cleaned up first as a sample point to keep the tones consistent. The second image in Figure 12.3 shows how I sampled the left side for cloning on the right. After a large enough area is clean on the right, you can begin using it to sample. Use your best judgment in places where it's hard to tell where his hair begins and the dust stops.

FIGURE 12.3

Work with a small brush until a good-sized area is clean. Increase the size of the brush after a large enough clean area is established. When the left side is done, use it as a sample for cloning on the right.

6. After the background is under control, turn off the visibility of the Restoration layer. Notice how much better this image looks already, and give yourself a quick pat on the back. When you're through patting, turn the visibility back on.

7. The background was fairly straightforward because there wasn't much detail to be preserved. Now we want to work on the suit, and we have to be much more careful. Drop down to his shoulder on the right, and keep using the Clone Stamp with the Darken blending mode to eliminate the lighter spots and streaks.

Reduce the size of the brush, and begin sampling close to the area being removed to reduce the possibility of tonal shifts from sampling non-matching tones in his clothing. In Figure 12.4, you can see how I sampled and cloned in line so that areas of detail — like the edge of his coat — line up. Use this technique when removing long scratches, too.

Keep working slowly and deliberately. Don't worry if you notice dark spots that aren't being affected by the Darken blending mode. We'll come back and get them in a minute.

TIP **Remember to try lowering the opacity of the Clone Stamp's brush if you have any problems getting the right tone.**

FIGURE 12.4

Make sure that details stay in alignment by sampling and cloning along a line. After a relationship like this is established, it can be used to repair a few different areas.

8. When you're ready to work on the left side of his clothing, switch to the Spot Healing Brush so you can compare working with it to working with the Clone Stamp. Use it to remove any light or dark spots. Just remember to keep the brush as small as possible so it doesn't leave any smearing behind. (I set it to 20px.) Also keep the Hardness setting low.

This tool works well on small areas. It's especially useful here because we are working around lots of details. If you have problems with this tool smudging, especially around the boundary of the oval, switch the sample type to Create Texture rather than Proximity Match in the tool options. Spot as much of the left side with the Spot Healing Brush as you can.

TIP The Spot Healing Brush has blending modes as part of its tool options, located on the Tool Options bar. The Lighten and Darken blending modes are used in the same way as the Clone Stamp, as discussed earlier. Give them a try to see if these blending modes give you more control.

Figure 12.5 shows what my image looks like at this point. There's still some damage on the suit, and we haven't touched his head or tie yet. Even so, this is a huge improvement in a short time. To compare your work so far, turn the visibility of the Restoration layer off and on a few times.

FIGURE 12.5

This image is already looking better than the original image on the right. Please note: Levels has been applied to the original image here so it's easier to compare the repair work on the two images.

9. Let's take care of the last of the damage on the lower part of his coat. Because it's mostly composed of lots of small, light-colored spots, I want to use a tool that gives me more coverage.

 Choose the Patch tool from the toolbar. Draw a selection similar to the selection in the first image on Figure 12.6. Be sure to keep detail aligned as you drag the selection to a sample point, as shown in the second image. This way, everything lines up when you release the mouse button.

CAUTION Don't get too close to the edge of oval with the Patch tool; otherwise, you'll get some smearing.

 We can use the Patch tool here because we've already done lots of work on the man's coat, giving us large, clean areas to use for sampling. This is one of the tricks to restoration and retouching. Use one tool to build up a clean area that can be used for sampling by another, more powerful tool.

 Continue working on any other damage to the man's coat and vest. Use any of the tools we've used so far to repair them. Stay away from the area where the tie and vest meet. We use a special technique to fix it next.

FIGURE 12.6

Here the Patch tool is used to work on larger areas. When working with details like this, it's all about aligning that detail when using this tool; otherwise the tool doesn't perform well. Finding relationships like the line along the edge of the sleeve allows you to work on larger areas that share that edge.

Repairing damage

At this point, everything should look good except for the man's tie and head. To repair these areas, pick up where you left off after Step 9 and follow these steps:

10. Use the Patch tool to repair the three damage spots on the tie. Keep the pattern lined up in the target and sample areas, as shown in Figure 12.7.

FIGURE 12.7

Here the Patch tool is used to repair these smudges on the man's tie. Normally you might not think of using this tool when such a strong pattern is involved. However, when those patterns line up between the sample selection and the target selection, this tool works beautifully.

11. Now we can use some of the area of the tie we just cleaned up to repair the jagged moiré pattern where the tie and the vest meet. We can fix this with one of my favorite techniques. We can copy part of the tie and paste it on top of the jagged lines. This technique is fast and effective.

 Choose the Polygonal Lasso tool from the toolbar. (You may recall from Chapter 7 that this tool is used for drawing selections with straight lines between two points. It's stacked with the Lasso tool.) Click to the top-right of where the tie and vest meet. Release the mouse button, move the cursor down to the "V" at the bottom of the vest where the two sides of it meet, and click a second time. When you do, a selection line is drawn between the two clicks. Move up and click a third time, move up and to the left and click a fourth time, and then move back down to the first click to complete the selection. Make the selection just large enough to enclose the jagged edges. It should look like the first image in Figure 12.8.

TIP If you don't like the placement of the selection when you click, you can undo it by pressing the Delete key on your keyboard.

FIGURE 12.8

A quick way to deal with this moiré effect is to create a selection around the area being repaired as in the first frame here. This selection is used to map the shape of the area. It's then moved to the area to be copied, as in the second frame. The important thing here is to copy a section of pattern that will match with the original area. After the selected pattern is copied to its own layer, it can be moved into place and merged down with the Restoration layer, as shown in the third frame.

12. Choose Select ➪ Modify ➪ Feather, and feather the selection 1 pixel to soften the edge just a bit so the edge won't be obvious when we're finished.

13. Move your cursor inside the selection, and drag it upward to reposition it, as shown in the second image in Figure 12.8. The idea is to find an area where the pattern matches the pattern inside of the original selection.

TIP Use the arrow keys on your keyboard to nudge the selection 1 pixel at a time for fine positioning.

14. Now that the selection's in place, we need to copy the area inside it to a new layer. Choose Layer ➪ New ➪ Layer via Copy (Command/Ctrl+J). The selection disappears as the pixels inside it are copied to a new layer.

15. Now it's just a matter of using the Move tool to drag the new layer downward until it covers the jagged lines, making sure that the pattern of the tie matches, as shown in the third image in Figure 12.8. After it's in place, merge it back down to the Retouch layer by choosing Layer ➪ Marge Down (Command/Ctrl+E).

Here's a recap of what we just did with the tie. We used a selection to define the area we needed to cover, used that selection to copy pixels to a new layer, moved the new layer into position, and merged it back down with its original layer in a new position.

That may seem familiar because it's almost exactly the same thing that the Patch tool does. The only difference is that the Patch tool is automated and attempts to blend the new layer as it's merged, which wouldn't have worked here. If we had tried to use the Patch tool to fix this problem, the area would be smeared.

319

Everything looks great now, except for the face and beard. Continue with these steps:

16. Use the Patch tool to remove the dark scratch on the beard. Break it down into pieces, being careful to match the beard's texture when sampling.

 When the main scratch is gone, use any tool you like to remove the rest of the spots and blemishes on the beard.

17. After you finish with the beard, continue using the same tools to remove the spots and damage from his face. Be sure to get that bad spot just above his eye on the right. Notice the bit of texture to his skin caused by the texture of the original print's paper. I'm going to leave it, because I think it will help to define his face on a small print like a 5×7. If you want to tone it down with one of the tools we've used so far, go ahead. When you're finished, make one more pass over the entire image, quadrant-by-quadrant, to see if you missed anything.

All the repair work is done. Your version of antique_man.tif should look something like the second image in Figure 12.9. Now we just need to lighten the area around his eyes and darken some other areas locally.

FIGURE 12.9

Half an hour of work with Photoshop's retouching tools has undone the damages of nearly 100 years.

Adjusting Tones Locally with Burning and Dodging

The terms *burning* and *dodging* refer to techniques that have been used in chemical darkrooms since the earliest days of photography. When printing a negative onto a piece of light-sensitive paper with an enlarger, the longer the light hits the paper, the darker the tones on the paper become. When an area of a print needs to be darker than the rest of the print, the printer makes a second exposure onto the paper. During that second exposure, he holds a sheet of cardboard with a small hole between the enlarger and the printing paper, allowing the light to hit only the area to be darkened. This way, he controls where the additional light strikes the paper. This process is called *burning in* or *burning*.

Dodging is the opposite. If something needs to be lighter than the rest of the print, the printer uses a tool to block some of the light passing from the enlarger to the printing paper. This way, he holds back some of the light from hitting the sensitive paper; less light means lighter tones on the print.

In the days of the traditional darkroom, burning and dodging was hit and miss. You never really knew how well you did until the photo paper was developed. (In the world of professional photo labs during those days, that was often the next day.) Fortunately, the process is much easier and more controllable in the world of digital imaging and Photoshop.

The ability to control the darkness and brightness of specific areas of an image helps to balance the tones in an image. When restoring an old photo, the objective is to return the image to the way it used to look, or at least to a reasonable facsimile of it. Therefore, burning and dodging are used to undo damage to a print or to enhance areas that have faded.

This is a little different from what we do in the retouching section of this book. There we use burning and dodging to not only solve problems with an initial exposure, we also use it creatively to guide the viewer's eye through the print by controlling the tonality of important — and less important — areas of the image.

Burning and dodging without the Burn and Dodge tools

Photoshop CS3 has two tools on the toolbar called the Burn and Dodge tools. These two tools have been part of Photoshop for a long time. However, I don't discuss them because I rarely use them. In fact, I don't know many people who do. I don't like to use these tools for two reasons. The first is that these tools can be difficult to control, especially for someone new to photo manipulation. I know a couple of people who have spent time mastering the tools, but I don't think it's worth the time because of the second problem with these tools: They're destructive to the image.

When Photoshop's Burn and Dodge tools are used, they permanently change pixels in the image. If you change your mind tomorrow, you can't undo their effects. The only way to isolate the effects of these tools is to duplicate a layer and use them exclusively on that duplicate. This is one of the least flexible ways of isolating burning and dodging to an independent layer because it still isn't easy to make modifications. Also, duplicating a full image layer adds to the size of a file.

Let's go back to our image so I can show you a way to do some quick burning and dodging on our practice file in a way that's very flexible. Let's pick up where we left off after Step 17, and follow these steps:

18. Click the Levels 1 layer in the Layers palette to make it active. We need to create a layer for our burning and dodging, and we want it above this layer so the Levels adjustment layer does not affect its tones.

Add a new layer by choosing Layer ⇨ New ⇨ Layer (or use the New Layer icon on the bottom of the Layers palette.) Name the new layer **Burn & Dodge**.

19. Change the blending mode of the Burn & Dodge layer to Soft Light.

20. Select the Brush tool from the toolbar. Lower the Hardness value to 0 percent, set the Opacity to 15 percent, and make sure Flow is 100 percent. We're going to be painting with black and white, so make sure the color swatches on the toolbar are set to their defaults by pressing the D key on your keyboard. (Remember that you can use the X key to swap the colors of the foreground and background swatches.)

21. Here's how it works: Paint with white where you want to lighten parts of the image, and paint with black to darken. Adjust the size of the brush to about 30px so it's small enough to work on the eyes. Now use white paint to lighten each eye. Be sure to also lighten the eye socket area between the eye and the eyebrow.

The effect should be barely noticeable. Use a couple of strokes to get the lightness to where you like it. This is the reason we're working with such a low opacity on the Brush tool. It's much better to reach the desired tonality by building up a couple of strokes than it is to try to nail it with one stroke at a special opacity. Occasionally turn the Burn & Dodge layer's visibility off and on to check your work.

> **TIP** Feel free to experiment with higher Opacity settings on the Brush tool. Just be advised that lower settings are often the best place to start.

22. When you like the eyes, move down to his mouth and lighten the right side of his moustache with a couple of light strokes. You may want to work with a larger brush here.

23. When that's done, switch the foreground color to black (X) and paint the top part of his hair where it's a little light to bring some darker tones back into it. I'd like to darken some of the light areas on his face, like his cheek, but doing so magnifies the texture there, so I don't.

> **TIP** If you don't like some of your burning and dodging, use the Eraser to remove any painting from the Burn & Dodge layer and try again with the Brush tool. (Yes, this is one of those rare times when using the destructive Eraser tool is okay.)

24. One last thing while you're working with black paint. Lower the size of the brush, and go back to the eyes. Darken only the pupils, which were lightened during the eye lightening.

Figure 12.10 shows our image before and after burning and dodging. The effects are subtle because our goal here is modest. We're just trying to make the image look a little better — more like it looked almost 100 years ago. The third frame of Figure 12.10 shows what our Burn & Dodge

layer looks like when its blending mode is set to Normal. This shows you why the Soft Light blending mode is important and what will happen if you forget to set the layer's blending mode to Soft Light.

When working with burning and dodging, be aware that if the detail is gone from a blown out highlight, no amount of burning will bring it back. The same goes for detail lost to a shadow. If you try to recover it, you'll end up with a ghostly gray area.

FIGURE 12.10

The changes from burning and dodging in the second frame are subtle, but they do help the image. The third image here shows what the Burn & Dodge layer looks like when its blending mode is set to Normal; it's kind of scary.

Because our burning and dodging is on its own layer, we have lots of control over it. We can go back and make modifications to the painting on the layer. We also can lower the layer's opacity if we want to tone down the overall effect. And, of course, we can delete the layer and begin again, all without permanently changing the underlying image.

Before we move on, here's a quick review of this easy, non-destructive burning and dodging technique:

- Create an empty layer.
- Change its blending mode to Soft Light.
- Use the Brush tool at a low opacity (I usually begin with 15 percent) to paint with black to darken and white to lighten.

As I mentioned earlier, we use burning and dodging when we work on the two retouching projects together in Chapters 15 and 16, so you'll see this technique again.

Adding the Finishing Touches

All of the hard work on this image is done. Now we get to make a couple of creative decisions as we prepare it for printing.

Toning

We still haven't done anything about the tone of this image. We have to decide if we want it to be black and white or tinted with a sepia tone. We could have made this decision early in the process since the change will be on an adjustment layer. I chose to leave it until now because the issue didn't need to be addressed earlier. Pick up where you left off after Step 24, and follow this step:

25. You should still be on the Burn & Dodge layer. If not, click it to make it active. Now add a Black & White adjustment layer by choosing Layer ⇨ New Adjustment Layer ⇨ Black & White (or use the New adjustment layer icon on the Layers palette). When the dialog box opens, click the Auto button to let it make its own adjustment to the image' tones. Because we're dealing with a mono-toned original, we don't need to do much tweaking here. If you want to make any changes to the auto setting, do it now.

 The image looks okay in black and white, but I prefer the sepia look for an old image like this. Click the Tint box in the Black & White dialog box to add a tint. Set the Hue to **32** and the Saturation to **18**. (Feel free to change these settings if you prefer a different colored tint.) When everything looks good, click the OK button.

> **TIP** Sometimes you need to readjust the tonality of an image after converting it to black and white. In this case, that's easy to do. Simply go back to the Levels 1 adjustment layer and make any modifications that are necessary.

This image is looking really great. We just need to get rid of the old, light-colored area that surrounds the photo.

Background replacement

Because this image will be printed on rectangular paper, it must remain in a rectangular aspect ratio. The oval must be surrounded by something. As I mentioned earlier, I'm not wild about this beat-up, light-colored area around the oval. So let's replace it with something cleaner. Continue where you left off, and follow these steps:

26. Click the Burn & Dodge layer to make it active. Create a new, empty Layer just like you did in Step 18. Name the layer New Background. This layer will become the new light-colored field that surrounds the oval image.

27. Here comes the tricky part. We need to use the Elliptical Marquee tool to draw an oval-shaped selection around the photo. This is tricky because the Elliptical Marquee takes a little getting used to. Select the Elliptical Marquee tool, and make sure that Feather is set to 0px and Anti-alias is checked. (Remember, this tool is stacked with the Rectangular Marquee tool.)

28. Start your selection at the top-left corner, and drag down to the lower-right corner, as shown in Figure 12.11. Don't worry if the selection isn't perfectly centered over the image. Just try to get the shape right. When it looks good, drag it into final position by clicking inside it and dragging. (This whole procedure is complicated by the fact that this oval isn't a perfect oval.) Be willing to try this several times before getting the hang of it.

FIGURE 12.11

The cleanest way to create a selection around this oval shape is with the Elliptical Marquee tool. Begin at the top left, circled, and drag downward to the right. Don't worry about placement. Just focus on creating the right shape. When you get it, you can drag it into place.

NOTE **If you have trouble with the elliptical selection, you can use the one I included in the file. Choose Select ⇨ Load Selection, and select Oval in the Channel pop-up menu.**

29. After the oval-shaped selection is in place, choose Select ⇨ Inverse to invert it. Now the area outside the oval photo is selected instead of the oval.

30. Choose the Paint Bucket from the toolbar. Let's make our new background the same color as the old one. Use the Alt key to Alt-click the background. Do it a couple of times while watching the foreground color swatch on the toolbar. Make sure you choose a color that looks like the background. When you like the color, click the image to fill the selected area with the new color.

 Feel free to experiment with different colors. Try Alt-clicking various tones in the image to sample different shades. When you find a color you like and you're finished, deselect the selection. The image should look something like Figure 12.12.

TIP **If you want to change this color later, simply Command/Ctrl-click the layer to reselect the painted area. Then you can use the Paint Bucket to experiment with different colors.**

Cropping and sizing

31. So far, we've been working as non-destructively as possible with this image. Now we're about to begin making changes that are permanent in nature. Before we proceed, this layered master file must be saved. Save it now as a PSD file with File ⇨ Save As. I named mine antique_man_edited.psd.

TIP **You should always intermittently save a file as you work on it. That way, if the computer crashes before you get to this point, most of your work will be saved and you can more easily pick up where you left off.**

32. If you recall, this image measures 4.66×7.36 inches. That's not quite proportional to a 5×7 print. The height already exceeds 7 inches, and the width is short of 5 inches. So the image needs to be cropped to 5×7 or re-sized and floated on a 5×7 canvas.

 Because the oval image already has a border area around it — the painting we did with the Paint Bucket on the New Background layer — we'll keep working with it. First, let's get the overall height down to 7 inches.

 Choose Image ⇨ Image Size. When the dialog box opens, make sure that Resample is checked and that Bicubic Sharper is selected as the resampling method. Under Document Size, change the Height value to **7** and click OK. Now the image's new size is 4.43×7. Now we need to extend the canvas on each side.

33. Choose Image ⇨ Canvas Size. When the dialog box opens, enter a value of **5** in the Width field and click OK. It should look like Figure 12.13.

NOTE **If we were working on the Background layer, we could have selected the Foreground color in the pop-up next to Canvas extension color so the new canvas would be the foreground color. However, because we're working on another layer, the new canvas is transparent.**

FIGURE 12.12

Creating a new background is faster than repairing the old one, and it's much more flexible because it can be changed to a different color at any time.

FIGURE 12.13

The canvas is now resized to 5×7, but the new portion is transparent because the canvas resizing was done on a layer other than the Background layer.

34. Use the Paint Bucket tool to fill the two new transparent strips on each side of the image. Be sure that Contiguous is checked in the tool options; otherwise, you end up filling the entire layer with color.

If you accidentally changed your foreground color since we filled the New Background layer, use the Alt key to Alt-click with the Paint Bucket on the paint you already applied to set the foreground color to match it, like you did in Step 31.

Even though this section is called "Cropping and sizing," you'll notice that we didn't use the Crop tool. That's because we were able to use the Image Size and Canvas Size commands to get this image to its final size with the correct proportions. In a sense, we did crop it; we just did so without the

Crop tool. I put the word cropping into this section title as a reminder that this is where any final cropping usually takes place.

Sharpening Scanned Images

Sharpening in Photoshop isn't about fixing blurry exposures. It's about bringing digitally captured images — captured via scanner or camera — into line. By their very nature, digital image files need to have some sharpening applied.

I've waited this long to talk about sharpening for a reason. Primary sharpening should always be done after the file has been sized and cropped to its final size. This is called *output sharpening* — it's tailored to the size of the output. The reason for this is that different sized files need different amounts of sharpening. For example, a file prepared for a 16×20 print needs more sharpening than a file prepared for an 8×10 print. For that reason, output sharpening should never be applied to a layered master file. It should be applied only after final sizing.

> **TIP** Always save your main sharpening until after final sizing because output sharpening is size-dependent.

Photoshop has a small array of sharpening filters. Some of them are very powerful (like the Unsharp Mask and the Smart Sharpen filter), while others are useless (like Sharpen and Sharpen More). You can also sharpen an image in a number of ways using filters other than Photoshop's standard sharpening filters.

What I decided to do in this book is to show you how to use three different kinds of sharpening. I demonstrate one technique in each of the three hands-on chapters (this chapter and Chapters 15 and 16). In Chapter 16, I cover Photoshop's main sharpening filter, the Unsharp Mask, and in Chapter 15, I cover the much newer Smart Sharpen filter. Each demonstration is appropriate to the sample image in that chapter.

> **NOTE** These image-sharpening methods have one thing in common: They trick us into thinking the image is sharper by enhancing the contrast along any edges that contrast against each other.

The Unsharp Mask and the Smart Sharpen filters work really well with film scans and images that come straight out of a digital camera. However, when scanning prints with some surface texture, especially small ones like the one were working on here, those filters can be a little too much. That's because they sharpen all the little specks of dust and paper texture.

I begin our sharpening journey with an alternative method of sharpening. We use an old technique of duplicating the main layer, running a special filter on the duplicate to find all the important edges, and then blending it back into its parent layer.

To see how it works, pick up where you left off after Step 34 and follow these steps:

35. Zoom to 50 percent for this procedure. (I explain the significance of this when I discuss the Unsharp Mask in Chapter 15.)

36. Click the Retouching layer in the Layers palette to make it active. Duplicate the layer, and rename it Sharpening.

37. Choose Filter ⇨ Other ⇨ High Pass. When the dialog box opens, set the Radius to **5** and click OK. Your image should look like Figure 12.14.

> **NOTE** The High Pass filter is used to enhance edge detail while minimizing the rest of the pixels in an image. It's useful here because it suppresses all the small specks that we don't want to sharpen.

FIGURE 12.14

The High Pass filter targets edges where it sees contrast and minimizes smaller details. When this layer is blended back into the Retouching layer, only these edges will be enhanced.

38. Change the blending mode of the Sharpen layer to Overlay to get the image to look normal again. When you do, the Sharpen layer is blended with the Restoration layer, enhancing only the edges that the High Pass filter found on the Sharpen layer. You can dial the sharpening down a bit by reducing the opacity of the Sharpen layer. (You also can try move the Sharpen layer above the Levels 1 layer in the Layers palette so the Levels adjustment isn't affecting it.)

The texture on the man's face is a little strong. I could use a mask on the Sharpen layer to mask out any of its effects on his face. I'll wait and see if it's a problem when I make a print.

> **TIP** You also can try the Soft Light and Hard Light blending modes to vary the strength of the sharpening effect.

39. Now that the image is sharper, I see a little more dust that needs to be removed. This is quite common, especially with restoration projects that involve scanning old photos. If you notice any dust, drop down to the Restoration layer and clean it up. Figure 12.15 shows the final image along with the layers it's composed of.

FIGURE 12.15

The final restored image is ready for printing. The layer stack in the Layers palette shows each of the layers that make up this image.

Now the image is ready for printing. Because we're going to look at inkjet printing here, it isn't necessary to flatten the file. Save it as antique_man_5x7.psd. If it were being printed at a photo lab, a flattened version would need to be saved. If you're low on hard drive space, flatten it by choosing Layer ➪ Flatten Image.

Inkjet Printing with the New CS3 Print Command

Inkjet printing has come a long way since its early days. The output from modern printers rivals traditional photographic printing in quality and longevity. Additionally, the variety of printing papers is way beyond the narrow range of traditional printing.

Inkjet printing isn't for everyone. The downsides are the cost per print and the amount of time involved, especially when the color doesn't match like it's supposed to. However, for many people, these issues are outweighed by the convenience and control of using an inkjet printer.

NOTE **The goal with printing is to match the way the image displays on the monitor as closely as possible. Naturally, if the monitor isn't calibrated and profiled, it will be hard to determine whether the print is a match to the file. I have seen cases where a photographer's color matching problems disappeared when she calibrated her monitor.**

The other key to determining if the print is a match is to be sure that the print is being viewed under a daylight balanced light source. If the print is being viewed under normal household light (incandescent), it appears warmer than it really is. If it's being viewed under florescent light, it appears cooler.

Understanding the settings

When someone asks me to help solve an inkjet color-matching issue, I usually find that the problem is an incorrect driver setting. That's because three important settings have to be correct for Photoshop and the printer to have an intelligent conversation. If any one of these is set incorrectly, the chances of a good color match become slim. Because these settings are so important, we're going to look at the new Print dialog box and break down its pieces before we continue with our project.

NEW FEATURE **Photoshop CS3 has combined the Print and Print with Preview options from CS2 into one useful Print dialog box. This helps to solve much of the confusion people had with printing in Photoshop CS and Photoshop CS2.**

Figure 12.16 shows the new Print dialog box. Some of these settings are more important than others. Let's go over them from left to right:

- The Preview window allows you to see how the image is positioned on the paper. This preview is very useful because it alerts you to sizing errors. The Preview window has saved me a number of times. Something new about this preview is that it now functions

as color preview when some Color Management settings are changed. (The Match Print Colors box must be checked for this function to be active.) In earlier versions of Photoshop, Print Preview was completely unreliable in regard to color. It was best to ignore it.

■ The information in the middle of the dialog box is mostly self-explanatory. I stay away from using the Scaled Print Size section unless I'm doing a quick print. Normally, I think it's best to have all sizing done before getting to the Print dialog box.

If Bounding Box is selected, a black box outlines the image. The corners of the box can be used to resize the image. Again, I don't recommend using this to resize an image.

FIGURE 12.16

The new Print dialog box in Photoshop CS3 has everything in one user-friendly place. The preview provides a color-managed preview when the Match Print Colors box is checked, and the Color Management settings are laid out more intuitively. The description box on the lower right provides useful descriptions of all the settings in the column above it when the cursor hovers over them.

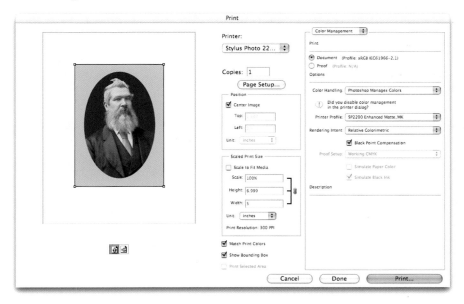

The Color Management settings on the right are where the important settings are. Let's break them down. (If you don't see a heading that says Color Management at the top right of your Print dialog box, click beside Output to open the pop-up menu and select Color Management.) These are your choices:

NOTE Notice that as you hover the cursor over different sections of the Color Management area, a contextual description appears at the bottom of the screen. Use this to learn more about the options here.

- Document informs Photoshop of what the starting color profile is for the document. In this case, it's sRGB color. Be sure this button is checked.

- Color Handling tells Photoshop whether you want it to handle color management or if the printer will be taking care of color. Always let Photoshop manage the color unless you're using *RIP* software with your printer. Photoshop is much smarter than most printers when it comes to color management. (This setting is one of the big three that people often get wrong.)

NOTE **RIP software replaces the driver software that comes with a printer. Its primary function is to make the interface between you and the printer — and the computer and the printer — more flexible and powerful. One of the primary advantages to using a RIP with your printer is that it is very good at handling color. RIP software also does a great job with black and white printing. One of my favorites is ImagePrint by ColorByte (`www.colorbytesoftware.com`). The software isn't cheap, but it pays for itself in no time if you do lots of inkjet printing.**

- Printer Profile is the second important setting. If this one's wrong, all bets are off for consistent color matching. By default, this is set to the color space that the image is currently in — in this case, sRGB. For the most part, that's useless information. Photoshop is already aware of the file's color space. What it needs to know is something about the conditions of the printer where the file is being sent. This is where a profile is selected that describes the printer's paper and the ink that will be used to make the print. (We set it for our project in a moment.)

 Figure 12.17 shows the Printer Profile pop-up. Photoshop comes with a bunch of canned profiles. Also, new printer profiles are installed on your system when a new printer is installed. These printer profiles are the ones we're interested in. All the profiles that begin with SP2200 are profiles that came with my Epson 2200 printer. Each of these profiles describes a particular paper and ink combination used by the printer. Selecting the correct one informs Photoshop about the specific printing environment. In this case, I point to an Epson 2200 profile for Enhanced Matte paper and Matte black ink.

TIP **If you don't see profiles for your printer, or you don't understand what the names of your profiles mean, contact your printer's manufacturer.**

- Rendering Intent tells Photoshop what system to use for mapping colors from the computer to the printer. Photographers tend to work with Relative Colorimetric and Perceptual. Sometimes, changing this setting affects colors, and sometimes, it doesn't. It really depends on the image and the printing environment. If Match Print Colors is checked, any changes in Rendering Intent are reflected in the preview.

- Black Point Compensation helps to map the black from the image in Photoshop to the black that the printer is capable of printing. It's usually best to leave this checked.

The two key settings here are Color Handling and Printer Profile. It is difficult to get a good color match if either of those is not set correctly. Photoshop can't make an intelligent decision unless you give it these two pieces of information.

FIGURE 12.17

The Printer Profile pop-up has a long list of profiles.

The third key setting has to do with the printer's settings. (You won't get to this dialog box until you click the Print button in the Print dialog box.) Now that Photoshop knows what to do with the file, we need to tell the printer to play dumb and don't try to manage the color. If Photoshop and the printer are fighting over color management, there's no predicting what the result will be. This setting is going to vary from printer to printer. Look for a check box in your printer driver settings called No Color Correction or something similar. (You can see what mine looks like in Figure 12.19.)

Getting ready to print

Okay, now that we know what's going on with the Print dialog box, let's see how to use it with our project. Pick up where you left off after Step 39, and follow these steps:

40. The sharpened file of antique_man should still be open. (If not, open the version you saved during the last step — antique_man_5x7.psd.) Open the Print dialog box by choosing File ⇨ Print (Command/Ctrl+P). The new Photoshop CS3 Print dialog box opens, as shown in Figure 12.16. Match the settings in Figure 12.16.

If you have an inkjet printer, choose it from the Printer Profile pop-up menu. Look for a profile for your printer and the paper you're planning to use. If you don't find it, or if you don't have an inkjet printer, choose Working CMYK, which is second from the top. (It simulates sending this print to a printing press, so you may notice the preview changing.)

41. After the Print dialog box is filled out correctly, click the Print button. This opens a second dialog box that gives you access to the settings of your printer. This is where you tell the printer how many copies to make, what kind of paper you're using, and so on. This also is the place to tell the printer not to use any color management. This dialog box looks different on different kinds of printers. It also looks different depending on whether you're using a PC or a Mac. Figures 12.18 and 12.19 show what it looks like for an Epson 2200 on a Mac.

FIGURE 12.18

You can see where I set up the printer driver for the type of paper I'm using. This also is where I set the printer's resolution to 1440dpi. This tells the printer how much ink to apply to the paper.

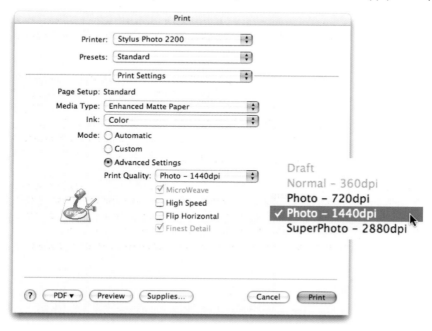

I disabled Color Management by clicking a button.

Figure 12.18 shows how I filled out this basic information for my printer. Notice that I disabled High Speed. That's because faster isn't always better. Also notice that I choose 1440dpi as the printer's resolution even though a higher setting called SuperPhoto is at 2880dpi. This higher setting uses more ink with negligible improvements to overall quality. Figure 12.19 shows how I disabled the printer's color management. Now all I have to do is click the Print button.

Here's a recap of the three important setting when using the Print dialog box. Getting these setting correct is the first step to getting reliable color from your inkjet printer:

- Color Handling: Set to Photoshop Manages Colors.
- Printer Profile: Use a printer profile for your exact printer and paper/ink combination.
- Printer Color Management: Be sure it's turned off in the printer driver.

Be aware that prints don't always match the screen perfectly. The objective is to get as close as possible, with a perfect match being a bonus. In addition to the monitor calibration and viewing light considerations I mentioned earlier, be sure to give the print adequate dry-down time before evaluating its colors. This can range from 10 minutes to an hour or two, depending on the paper. Absorbent papers like watercolor paper dry much faster than hard-surfaced papers like glossy.

Summary

There it is: a restoration workflow from start to finish — including inkjet printing. Here's a summary of the steps we went through:

- We evaluated the project to assess what needed to be done. This is a good time to decide whether the project fits with your skill level.

- We adjusted the contrast and brightness with a Levels adjustment layer. Curves would be a good option here too.

- We repaired the damage. We began by working small to build up clean areas for sampling. After the small stuff was done, we moved to the more difficult areas on the face. I introduced a technique of cutting and pasting with the Lasso tool to repair artifacts caused by the scanner. This work was done on a duplicate of the Background layer.

- I introduced a non-destructive way to do burning and dodging, and we used the technique to adjust local tonal discrepancies within the image.

- We used the Tint option in a Black & White adjustment layer to add a sepia tone to the image.

- We replaced the area surrounding the oval with a more pleasing background. Because the replacement is on its own layer, it will be easy to modify in the future.

- After all this work was done, we saved the file as a master file.

- We then used the Image Size and Canvas Size commands to crop and size the image for printing to a 5×7.

- I introduced sharpening and showed you how to use a special technique involving the High Pass filter.

- Finally, I explained the new Print command in Photoshop CS3 and showed you how to use it to get dependable color.

Remember that everything doesn't have to be done in the exact order that we did it here, unless specified. For example, it would have been fine to work on the spots on the face before working on the clothing. But it isn't okay to do output sharpening until the image is at its final size. The main thing to get about this workflow is that it represents a series of repeatable steps. Using a repeatable workflow saves time and helps to guarantee consistent results.

The other thing to get about this workflow is that it's built on the premise of creating flexibility by incorporating layers whenever possible. If you look back at the layer stack in Figure 12.14, you can see that everything you did to this image can be undone on some level. That way, if you wanted to redo only the retouching, you won't have to start all over again.

Part IV
Retouching—Taking Images to the Next Level

In this section we dive into retouching. You'll take everything you've learned up to this point and apply it to two styles of retouching: hard-edged retouching and soft-edge retouching.

We begin this section by exploring what retouching is and how you can use it to add value to important images. We take a close look at the three-phase retouching workflow and discuss how to use it in different scenarios.

Then we look at some special retouching problems ranging from simple head-swaps to complex glass-glares. In this section you'll see that just about any portrait retouching issue can be solved with a handful of Photoshop's retouching tools.

We complete this part with two hands-on projects. The first one is a portrait retouching project that focuses on soft-edge retouching tools and techniques. In this project we begin with a simple portrait that has a number of typical retouching issues. Once we've addressed those issues, you'll see how easy it is to quickly turn a nice portrait into a very nice portrait.

In the second hands-on project we work on an architectural image. This project focuses on the tools and techniques that are used for retouching around hard edges. You'll also learn how easy it is to correct the perspective on an architectural image and how to retouch within that perspective.

By the end of Part IV you'll be comfortable with Photoshop's main retouching tools and techniques and how they fit into the workflow. When you've completed this part, you'll be ready to handle just about any retouching project that comes along.

Chapter 13

Using Strategies for Success

You may have noticed that some of Photoshop's tools are referred to as "retouching tools." That's because of the way they're used to copy and paste information. But retouching is about more than these tools and techniques. It's also very much about the process. In this chapter, we're going to look closely at that process. However, before we deconstruct the process of retouching and look at its various parts, we should define just what it is we're talking about when we say retouching.

What Is Retouching?

When most people hear the word *retouching,* they usually think about portrait retouching. It's no wonder. In the days before digital, when photographers were shooting film, the things that could be done in post-production were quite limited. A film workflow had two basic types of retouching: film retouching (mostly negatives) and print retouching. Film retouching was done with dyes applied to the negative, and print retouching was done with pencils, dyes, and sprays applied to the print. Print retouching was often necessary after film retouching because of the limited abilities of the film retouching. Any other limited manipulation took place in the darkroom and was considered custom printing, not retouching.

NOTE Naturally, high-end retouching at the time involved film masking and airbrushes, but that kind of work was expensive and usually not available to the average photographer.

Today, the term *retouching* has taken on a whole new meaning. When I looked up the word at Wikipedia.com, the online encyclopedia directed me to a section titled "Photo Manipulation." The definition was "the application of

image editing techniques to modify photographs, through analog or digital means." Clearly, the term has been redefined. The line between film retouching and print retouching has vanished, as has the line between retouching and darkroom work. That's because images can be improved in countless ways during the post-production process using Photoshop and other digital tools. Now it's all part of the same process that takes place with a digital file, before any prints are made, if they're even needed.

> **NOTE** Post-production (or simply known as *post*) refers to anything that's done to an image after its initial creation. This broad term refers to things like cataloging, archiving, and printing as well as retouching.

As these boundary lines disappear, the term retouching has come to broadly refer to just about any image manipulation that can be done to a digital file. Even though the variety of problems solved with retouching may be open-ended, the tools, techniques, and procedures used are very much the same for most of those problems. We'll look at some of those tools and techniques in the remaining chapters. The goal of this chapter is to discuss the path to retouching success, rather than the shoes you should wear when walking the path.

Adding Value with Retouching

Retouching is more about tools and techniques. It's about a process to improve an image beyond what was capable at the time the image was captured by the camera. Sometimes, this consists of fixing problems and mistakes. But in its purest form, retouching is about taking an image to the next level of quality and creativity.

Photographers who understand the retouching process know that their job is only half done when they click the shutter, because they can add so much value to the image during the post-production process. We saw the image in Figure 13.1 back in Chapter 7. This is a portrait I shot of some good friends I've known for a long time. The original photo in the first frame is a nice photo of this couple and their dog. Many people would be happy to have a photo of themselves like this. However, after a little more than an hour of retouching, this image is transformed into something special—completing my vision of what I want from this portrait.

Here's a list of some of the things I did to increase the value of this image:

- I removed a number of distractions from the background and foreground, including dead flowers in the bushes and on the ground. Also, I removed and toned down bright, distracting plants and leaves since they tended to pull the viewer's eye away from the subjects.

- I did a little facial retouching on both of the people. (I didn't have to touch the dog!)

- I burned and dodged to balance out tonal discrepancies.

- I blurred the background to add separation between it and the main subjects.

- I darkened all the corners to keep the viewer's eye focused on the center of the image rather than its edges.

FIGURE 13.1

A little more than an hour's retouching transforms this portrait into what I envisioned when I shot it.

For a professional photographer, the extra hour spent with an image like this means more money. It also means that the final image is beyond what the average photographer produces. It has become a true creative expression. If you're a professional photographer, the ability to take images to the next level with retouching is a way to set yourself apart.

The world of professional photography has changed so much in the last few years. Many photographers now give their clients CDs instead of prints. Those customers think they're getting a good deal because they get a bunch of files that they can print at any photo lab whenever they want. Unfortunately, many of those customers never get around to having prints made. And when they do, they often get disappointing results because the prints aren't produced professionally. The question must be asked: "Is giving a client all of their images on a CD instead of prints really doing them a service?"

NOTE A recent survey by the Professional Photographers of America showed that many photography customers who receive CDs instead of prints never get prints made from the images on the CD.

Whether or not you're a professional photographer, these skills are essential for another reason. They allow you to completely explore your creative vision because you'll know that the click of the shutter is the beginning of a whole process. This is very empowering because when you fully understand the process, you can visualize how it will affect your image before the shutter even clicks. After you have this ability to pre-visualize the retouching process, it changes the way you shoot.

Comparing Soft-edge Retouching and Hard-edge Retouching

Retouching adds value to all kinds of images. Figure 13.2 shows before and after versions of another photo. This photo is the project sample we'll use in Chapter 16. The original images in Figure 13.1 and Figure 13.2 each underwent extensive retouching. Even though the goal with each of these images was to improve it, the retouching process was different.

TIP With a retouching job like the one shown in Figure 13.2, it's important to be faithful to the original image, making the retouching process much more literal rather than creative.

Because we'll be working with this image in Chapter 16, I'll hold off telling you all the changes that were made to it. The main thing I did was to remove everything that was between the viewer and the building. I also corrected the distortion (caused by the wide-angle lens) by straightening the vertical lines.

FIGURE 13.2

Even though the before and after versions of this image are strikingly different, the subject's integrity remains untouched. It looks like someone removed a layer of distractions to reveal the building below.

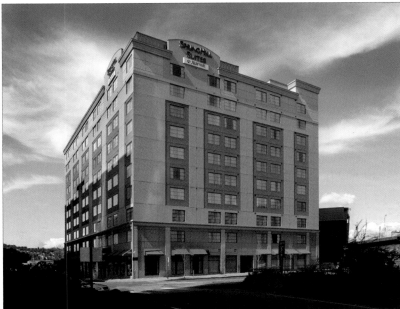

Photo by Seattle Photography, Inc

With the portrait in Figure 13.1, the goal was to tone down distractions and soften a number of elements in the image. Because of the nature of the image, I didn't have to worry about changing the reality of the scene. I had an extreme amount of flexibility, especially when removing dead leaves and bright distractions. It didn't have to be very careful about where I sampled from, as long as everything blended together. When people look at this image, they don't care what the bushes look like — whether this is a depiction of reality. What they want to look at are the people — and the dog, of course.

My goal as a photographer with this project was to capture the personalities of this couple and their dog. My primary goal as a retoucher was to make the image pleasant to look at by removing distractions and creating an environment where the viewer's eye is drawn to the main subjects. I had lots of creative license while doing that, which is one of the attractions of this image and what really makes it a custom portrait.

The goal of the photographer of the building image in Figure 13.2 was to get a good photo of this hotel. He did an excellent job. I've stayed at this hotel is in downtown Seattle a few times. I can tell you that this photo was taken from the one place where the hotel isn't surrounded by other buildings. And the photographer was able to shoot this on a day with a beautiful sky — which can be quite a feat in Seattle!

As a retoucher, my objective with this building image was similar to the portrait Figure 13.1. I wanted to make a nice image even better by removing distractions. However, the process of doing that was very different from my process for Figure 13.1. With this project, not altering the underlying qualities of the building was important; the interpretation had to be a literal interpretation. (Because of this, a project like this is more like a restoration project.) The effect of the retouching needed to appear more like someone peeled off a layer of distractions.

Figures 13.1 and 13.2 are examples of two different retouching styles I call soft-edge retouching and hard-edge retouching. In Figure 13.1, most of the retouching I did has a soft edge to it, causing it to blend more easily with the surrounding pixels. In Figure 13.2, most of the retouching has a hard edge to it. Blending had to be minimized because it would smear important details. All retouching had to be faithful to the original. With the portrait in Figure 13.1, the original was a jumping-off point.

So the terms "soft-edge" and "hard-edge" not only refer to the types of edge detail that's being manipulated in the image, but they also refer to the tools and techniques used with that style. Here's a quick-and-dirty explanation of the differences:

- Soft-edge retouching deals mostly with edge detail that's soft. The retouching tools used with this style are tools that have soft edges or blending capabilities. This style is flexible because you don't need to strictly adhere to the underlying detail. Soft-edge retouching lends itself to creative interpretation.

- Hard-edge retouching is a style of retouching that deals mostly with hard-edged detail. Retouching is done with tools that preserve those hard edges. With this style, you have little room for tools that blend detail because that underlying detail must be preserved. Hard-edge retouching doesn't leave much room for creative interpretation.

A project might require both soft-edge and hard-edged retouching. For example, if the building in Figure 13.2 were in a natural setting with lots of trees and foliage, I would have lots of flexibility while working with the natural setting, but not with the building. In Figure 13.1, if I decided to remove some of the folds in the man's shirt, I would be moving into the realm of hard-edged retouching because I would have to be careful to preserve the underlying structure of the shirt, especially if it had a dominant pattern.

The reason I'm making this distinction between soft-edge and hard-edge retouching is because both of these retouching styles have slightly different thought processes. We explore the differences in these two thought processes in Chapters 15 and 16 when we do a couple of projects together. For the time being, let's focus on the commonalities these two retouching styles share, as we explore the retouching workflow.

The Retouching Workflow

Even though every retouching project has its own idiosyncrasies, they all share a general methodology for approaching the process. When that methodology is refined and documented, it becomes a roadmap that can be trusted to provide repeatable results every time. When we're talking about retouching, we call that roadmap a *workflow*. Let's look at some of the key features of a retouching workflow.

Planning ahead

With any retouching project, you should take some time to evaluate the project and formulate a mental plan of the actions you need to take. Think about where the image is and where you want to take it. Visualize the outcome. After you have that picture in your mind, ask yourself these questions:

- Does that timeframe fit into the time you're willing to allot for the project? How long will it take to move the image from where it is to where you want it to be?

- Does the project fit your skill-set? Will you be able to accomplish what needs to be done with what you currently know? Don't be afraid to take on a challenge or two, but be careful about getting in over your head and making commitments that are hard to fulfill.

- Will you need to learn something new in order to accomplish the project? If so, take the time to seek the resources you need in order to make the project a success. Every time you learn to use a new tool or technique, you can add one more tool to your retouching toolbox.

- What are the intended uses of the image? Will it be an inkjet or photographic print? If so, what size? The retouching process for an image being printed as a 30×40 is much more demanding than the process for an 8×10 because every flaw will be seen at 30×40. If the image is for commercial use, will it be used in a magazine or a Web site? Again, how big will it be?

Knowing the answers to some of these questions will help you to decide how you want to handle the project. After that plan's put together, it's time to do the work.

The three-phase workflow

Most retouching projects differ in many ways, but they all share this basic three-phase workflow:

- **Phase 1 — Adjusting image fundamentals:** This is where the foundation for a successful project begins. Brightness, contrast, and color are adjusted to their optimal settings. Even if these settings were adjusted previously, they're reevaluated at this time. Other things that might fall into Phase 1 are preliminary cropping, size adjustment, and spotting.

- **Phase 2 — Fixing distractions:** This phase is the core of the retouching process. It's where all the hard work is done. As you can see in Figures 13.1 and 13.2, the things done here run the gamut from toning down wrinkles to removing telephone poles.

- **Phase 3 — Controlling the viewer's experience:** After all the hard work is finished, creative techniques are used to create the type of visual experience you want the viewer to have. Some of the techniques used here are non-standard cropping, selective sharpening and blurring, and burning and dodging.

> **NOTE** The three phases in this workflow aren't about the order in which specific tools are used. They're about a systemized approach to looking at a project from different points of view.

Each of these three phases must be considered during the process. For example, when I'm adjusting the brightness and contrast of an image in Phase 1, knowing that it will be cropped to a horizontal panorama in Phase 2 is helpful. That way, if I'm having difficulty with tones at the top of the image, I can ignore them because they'll be cropped out later.

Another thing to remember is that sometimes more than one phase is being addressed at the same time. When I removed the bright plants above and to the right of the woman in Figure 13.1, I was removing something distracting as well as controlling the viewer's experience by removing something bright that was pointing away from the subjects.

Some images require different mixtures of these three phases. The portrait in Figure 13.1 mostly requires Phase 2, with a healthy amount of Phase 3. The building in Figure 13.2 needs plenty of Phase 1 before all the work in Phase 2 can begin. Very little of Phase 3 is needed.

When we get to the hand-on projects in Chapters 15 and 16, you'll see the projects from the viewpoints of each of these three phases.

Knowing when to stop

Knowing when to stop working on an image is just as important as knowing how to begin. I've consulted with lots of professional photographers and digital assistants to teach them these skills. Quite often, they call me in because they've lost control of their retouching workflow. When we begin to deconstruct their workflow, they quickly see that they tend to spend too much time on things no one will see. Don't get me wrong. I'm all about perfecting an image. However, if its final use is going to be an 8×10 inkjet print and you're zoomed in to 200 percent, as shown in Figure 13.3, retouching every pore in someone's skin, you're probably wasting your time. (You may even be wasting your time if the image is going to be a 30×40 photographic print, but will be mounted on canvas hung high where people can't get close to it.)

I know this is a difficult pill for some people to swallow. They take comfort in knowing that every detail is managed. I understand this. If you're working on a labor of love, then by all means go for it. But if you're a professional, or if you have other important images you want to work on, you'll have to learn to use your time efficiently.

One of the things at play here is that with film we were never able to see the image larger than it would be printed. The things we saw were the film and the print itself. It was impossible — or at least prohibitively expensive — to micromanage a retouching project at the level some people do today. With digital, the ability to view the image at extreme magnification has skewed the viewing environment. Remember that as you work. Zoom in when you need to, but avoid the temptation to do unnecessary work.

FIGURE 13.3

It's okay to zoom in close to work on important details like eyes. Just be sure that your time is well spent on details that will show in the final print.

Strategies for Retouching Multiple Images

I want to briefly mention retouching multiple images here because I get asked about it all the time. The conversation usually goes something like this: "I photographed a high-school student for her senior photos. Her mother ordered several different poses, which is great. However, the girl's skin needs retouching. Several of the poses are similar, so can I retouch them all at once, or can I automate the retouching so that after I do it on one image, I can easily apply it to the others?"

It is possible in Photoshop CS3's Adobe Camera Raw to use versions of the Clone Stamp and the Healing Brush on one Raw file and then apply those same changes to other files. It sounds good in theory, but each of the images would have to be identical for this to work. About the only time this feature is useful is when you're dealing with sensor dust that falls in exactly the same place on consecutive images. Even then, the surrounding image content needs to be consistent for this to work on every image — for example, a bunch of product shots with a white background.

You can automate retouching with Photoshop *Actions*, but again the retouching would be happening in exactly the same places. Any variations in image content would have a serious effect on the retouching of different images.

> **NOTE** With Photoshop, you can record just about anything you do so you can play those steps back on another image. These recordings are called Actions. They are very similar to macros in Microsoft Word and other Microsoft Office products.

So what it boils down to is this: If you're faced with a scenario like the high-school senior shoot, you'll have to retouch each one of the images individually. When you work on a project like this, three key things can make the process flow more efficiently:

- Take notes as you retouch the first image, especially if you plan to work on parts of the project in different sittings. I can tell you from experience that it's frustrating to not remember what you did to the first image when it comes time to work on the next one.

- Try to limit the amount of work you do, especially when working on the first image. If you set a high standard, be prepared to stick to it with the rest of the images. As long as you're ready to follow through, it's okay. (Limiting your work makes the recommended note-taking process much easier.)

- Use adjustment layers to share adjustment settings. After an adjustment layer (such as a Color Balance layer) is created, it can be dragged onto another image. Even if the second image's color needs are a little different, you already have a starting place that's consistent with the first image.

If you keep these three tips in mind, the process of retouching multiple images of the same subject will go more smoothly, as shown in Figure 13.4.

FIGURE 13.4

Doing similar retouching on multiple images is made easier if you take notes, limit the amount of work you do on the first image, and share tonal and color changes with adjustment layers.

Photos by Jerry Auker

Summary

In this chapter, we finally sat down and defined retouching. You saw that it's about fine-tuning an image and taking it to a higher level, adding value to it along the way. This value is what separates a custom image from a nice photo.

We also explored two different styles of retouching: soft-edge retouching and hard-edge retouching. Although each of these styles uses some of the same retouching tools and techniques, the subject matter and final goal are different. When evaluating a new retouching project, you should determine which of these two styles the project falls into so you can make intelligent decisions as you formulate your retouching plan.

After the plan is in place, it's time to do the work. That workflow can be broken down into three phases. These phases not only address the retouching needs of the image, but each also provides a different way of looking at the project's needs. Knowing when to stop retouching is just as important as knowing how to begin. Be careful not to spend your valuable retouching time working on details that won't be seen.

Finally, we looked at strategies for retouching multiple, similar images. This may not happen often, but when it does, these strategies will save you time.

Chapter 14

Solving Special Portrait Retouching Problems

Even though the kinds of problems solved by retouching run the gamut, much of the focus in the retouching world today is in portrait retouching. In the next chapter, we'll work together retouching a standard business portrait. During that project, we'll go through the entire portrait retouching workflow from scan to print. However, we won't encounter several special issues while working on that project — issues like swapping heads, replacing missing eyes, and smoothing wrinkled clothing. Photographers and retouchers often ask me about how to handle these special kinds of challenges, so I decided to devote a chapter to the most common ones.

By now, you should be getting a good feel for the tools and techniques used in this book. This chapter shows you how to use some of those familiar tools and techniques to solve some difficult problems. Because the goal of this chapter is to share my overall strategies for dealing with these issues, I don't focus closely on the details of every step. Instead, I show you how a group of similar concepts are used to solve a variety of common retouching problems. We begin with a technique that sounds extreme, but is often one of the easiest — swapping heads.

Swapping Heads

Back in the olden days, when photographers were shooting film, the option of switching someone's head from one image to another was a daunting task, even under the best of circumstances. Because of this, it was rarely an option for the average portrait photographer.

With digital photography and Photoshop, the ease of performing head-swaps has changed modern portraiture. It's no longer necessary to make sure everyone in a group is perfect in a single exposure when photographing a group. The photographer just has to make sure she gets plenty of exposures with at least one good picture of each person. Then each person in the group can pick the exposure where they look best. The retoucher simply brings all the best heads together into a single, perfect group portrait.

NOTE **Swapping heads, and even entire bodies, is a very common technique today. I worked on one family portrait where I completely changed three people's bodies and the heads of two other people.**

Though this technique is most often used to combine individual expressions for group portraits, it's not limited to them. Figure 14.1 shows two images of a young man. He liked the way his hands are positioned in the image on the left, but he wanted a more serious face like the one in the image on the right. With Photoshop, that's no problem.

This procedure is very straightforward. I simply copy the head in the second image to its own layer and then drag it into the first image. The whole process with this particular set of images is facilitated by the fact that his body position and the background are very consistent. The only wrinkle is that the head is larger in the second image.

FIGURE 14.1

Replacing this young man's head in the first frame with the head in the second frame creates the perfect combination of hand position and facial expression.

Let's look how easy this head-swap is:

1. I use the Lasso tool to draw a loose selection around his head in the second image. I always prefer to keep a selection like this fairly loose so I can fine-tune the copied material with a mask after it's in the main image. This means I don't need to feather the selection.

 After the selection is in place, I copy the information inside it to its own layer, as shown in the first frame of Figure 14.2, by pressing Command/Ctrl+J.

 If the man's head were in the exactly same position on both of these images, I would only copy his face from the second image, instead of his entire head.

FIGURE 14.2

After the new head is on its own layer, it's dragged into the main image and placed on top of the original head. When the new layer's opacity is lowered, it's easy to see that the new head is a little bigger than the old head.

2. After the head is on its own layer, I grab its thumbnail in the Layers palette and drag it into the main image, positioning it over the original head. When I lower the new layer's opacity to position the new head, I can see that it's a little too big, as shown in the second frame of Figure 14.2.

3. Remember the Transform command from Chapter 9? I use it here to scale this young man's head so it's the correct size for the image. To do that, I choose Edit ➪ Transform ➪ Scale. An adjustment box appears around the edges of Layer 1. I can scale the layer by clicking and dragging any of the boxes at the corners or the sides of this box. However,

one of the things I need to be careful about here is that I don't change the proportions of the new head when I scale it. So I hold down the Shift key to lock the aspect proportions of the layer as I scale it.

I reposition the layer a couple of times as I scale, to realign the eyes. I use them as a registration point because I know that when the eyes on Layer 1 line up with the eyes on the Background layer, the scale will be correct, as shown in the first frame of Figure 14.3.

FIGURE 14.3

I scale the head with the Transform command until the eyes are the same size in both versions of the head. Then I raise the opacity of the new layer back to 100%. Even though the eyes are aligned with the bottom layer, the shoulder line is out of registration.

4. After the scale is correct, I press the Enter key to accept it and complete the Transform command. Then I return the opacity of Layer 1 to 100 percent, as shown in the second frame of Figure 14.3. I turn the visibility of Layer 1 off and on a couple of times to check my work.

5. The new head looks good, but it's sitting a little too low. The eyes on the layer were aligned with the old head, which was positioned looking downward. I can solve this problem in two ways. I can mask out everything below the chin on the new layer, or I can simply reposition the new layer a little higher. This is a better solution because the eyes will be in the right place because his head isn't tilted downward in Layer 1. It also is faster. I drag

the layer upward until the collar of his jacket matches on both sides. Now I can just barely see the edges of Layer 1 against the Background layer.

6. I create a mask and use a soft brush around the edges of the image to blend the edges of the new layer with the layer below it, as shown in Figure 14.4.

FIGURE 14.4

A bit of quick masking around the outer edges of the new layer blends it with the Background layer in no time. You can see by the mask in the Layers palette that I didn't have to mask the lower section because the collar and shoulders are in perfect alignment.

TIP These two exposures were identical. If there was a tonal or color discrepancy (for example, if the new layer was a little darker and greener), I would have adjusted the new layer before flattening.

If I hadn't stopped to record my steps, this head-swap would have taken about two or three minutes to complete. Even if it took a little longer, it would still have been worth it because it's what made the customer happy.

Replacing Missing Eyes

Human eyes are one of the most complicated things to retouch. They're not only rich with intricate detail; they also are the first things people look at when they view a well-designed portrait. Because they are so important to the viewer, you must always make sure that a portrait subject's eyes look

their best. In the next chapter, we look at ways to enhance the eyes in a portrait. For now, we explore a couple of extreme eye problems and solutions.

Closed eyes: Replacing missing eyes with donor eyes

One of the hardest things a retoucher can be asked to do is to replace a missing eye. Eyes go missing for a variety of reasons; sometimes people blink right when the exposure is being made, and sometimes light reflects off their glasses, causing glass-glares.

When you're faced with having to replace missing eyes, the best-case scenario is to have another set of eyes that can be used as donors. Naturally, it's best if those eyes actually belong to the subject and were photographed similarly with the same kind of lighting and exposure. The direction the head is facing also makes all the difference here.

NOTE I have been known to "borrow" someone else's eyes to fix missing eyes caused by glass-glare in a large group photo (a group of 50 people, for example). You can get away with this only when the heads are so small that seeing detail in the eyes is difficult. Even so, try to match the eye color if you know it because sometimes that's all that can be seen in a group photo.

Figure 14.5 shows two different photos of the same young woman. For the moment, let's imagine that these two photos are the only ones the photographer shot during the session. Because the woman has such a pretty smile, the only way to salvage this job is to combine the eyes from the non-smiling face with the smiling face.

FIGURE 14.5

In this exercise, I use the eyes in the second image as "donor eyes" for the first image. The procedure is much like the head-swap.

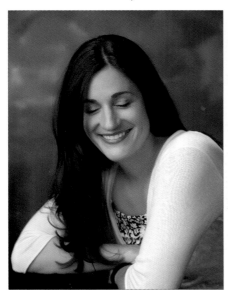 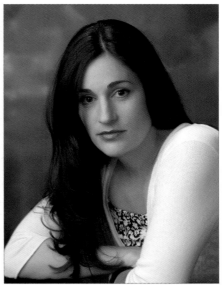

This job looks pretty straightforward. Most things between the two photos are consistent. Both have the same lighting, and the angle of the head is very similar. The only real difference is that the head is a bit larger in the second image. The procedure is much like the head-swap I discussed in the preceding section; you copy the eyes from the donor image and drag them into the target image.

Here's the low-down on how I approach this project:

1. I make a loose selection around both eyes in the second image.

2. I copy both eyes in the second image to a new layer and drag that new layer into the first image.

3. I lower the opacity of the new set of eyes so I can see the underlying layer. I use the eyebrows as a reference point to align both layers.

4. Because the new eyes are bigger, I use the Transform command to scale them down to the correct size.

5. The new eyes are a little dark because the image they came from was a bit darker, so I use Levels to lighten them a tad.

6. Then I finish up by using a layer mask to mask out everything I don't need on the new eye layer, leaving only the eyes and some of the skin around them. You can see what this looks like in the first frame of Figure 14.6.

FIGURE 14.6

The first image shows what the new eyes look like after they're in place. The second image shows what this woman's eyes really look like when she's smiling like this.

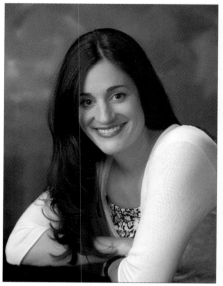

Something still doesn't look right in the new image. The eyes are too wide open for someone who's smiling so much. We intuitively notice it because it just doesn't look right. I included the second image in Figure 14.6 to show you what this woman's eyes really look like when she's smiling. It isn't possible to make the first image in Figure 14.6 look like the second one, but I can improve it.

NOTE When we smile, we tend to tighten our eyes, which completely changes their appearance. Some famous portrait artists only make portraits of unsmiling people. They do this because they want to capture as much of the eyes as possible because they are the central theme of the portrait.

I use the Transform command to scale the new layer containing the eyes. I drag downward, as shown in the first image in Figure 14.7, compressing the height dimension of the eyes. When I'm finished, they look more realistic. (Some might argue that they look better in this portrait than the squinting, natural eyes in the second image in Figure 14.6.)

This project looked like a no-brainer on the surface because the two images are so similar. But after we saw the new eyes in context, something looked funny. The thing to walk away with here is that eyes are very tricky to work with. When you're doing a project like this, try to find donor eyes that match the expression of the main image. Follow your gut instinct when you see them in the context of the new image. If something doesn't look right, try to figure out why.

FIGURE 14.7

The Transform command comes to the rescue again. I use it to squish the eyes a bit so they lose some of their oval shape.

Glass-glares: Rebuilding without donors

Glass-glares are the bane of retouchers everywhere. They represent one of the most common difficult retouching problems that a portrait retoucher is likely to run into. Glass-glares are caused by light — often coming from the photographer's strobes — reflecting off the portrait subject's glasses. When they're severe, they'll completely obliterate the eye, as well as anything else behind the glass like eyebrows and skin.

I've seen glass-glares in studio portraits where the whole surface of the glasses was a blown out reflection of the photographer's umbrella. This shouldn't be happening in the digital world. If you're photographing someone with glasses in the studio, check your exposures often. If you see that the glasses are reflecting light you can use an old studio trick to eliminate them. Tilt glasses downward ever so slightly so that the glass isn't parallel to the camera lens and lights. Be careful, though, because if you tilt too far, it becomes obvious.

> **TIP** If you see glass-glares when you're shooting, take the time to go back and reshoot. It will be much faster — and look much better — than using Photoshop to fix the problem.

Sometimes, tilting still won't do the trick. This is true when you're shooting outside with natural light. If you can't control glass-glares when you're shooting, you can cover yourself by having the model remove her glasses for a couple of frames every time you change poses. That way, you'll have a set of donor images to use if you need to borrow some eyes. Working with donor eyes like this is about the cleanest way of retouching glass-glares.

With that said, severe glass-glares still happen, and they have to be dealt with. Figure 14.8 shows a nice portrait of a high-school senior with some pretty serious glass-glares. The way I'd normally handle a retouching problem like this would be to look at all the other photos from the session to see if I could find an eye or two to act as donors. I've used this strategy many times — in some cases building eyes from different parts of assorted images. It's tedious work, but it can save a portrait.

For this example, imagine that this is the only photo I have so it's all I have to work with. Before I even begin a job like this, I want to know something about how the image will be used. In this case, the client wants a 5×7 print with minimal cropping. This means that her head — from the top of her hair to the bottom of her chin — will only be 1.5 inches in height on paper; the eye itself will be only .05 inches. That small size makes this project doable. If it were going to be printed larger, or if it were being cropped closer, it would be much harder to reconstruct these eyes convincingly.

FIGURE 14.8

These glass-glares were caused by natural light that was reflected in the glasses. This is the only photo I have, so I have to reconstruct the eyes using only information contained within the image. (If you find yourself in a situation like this, have the model remove her glasses for a couple of shots so that you have some clean eyes to drop into the image later.)

Photo by Ted Miller Jr.

This glass-glare removal procedure is complex and detailed. I'll break it down into general steps so you can follow my thinking as I work on this image:

1. First, I need to reconstruct one eye so I can use it to rebuild the other eye. The eye on the left is in the best shape, so I begin with it. I use the Clone Stamp to sample areas of skin that are similar to what I think should be underneath the glare. I don't worry if I'm off in tone a little in this first pass because I'll come back and fine-tune if I need to. The objective is to get some detail into the glare areas. I use parts of the eye on the lower left to rebuild the upper-right area of the eye, as shown in the first frame of Figure 14.9. I work with the image zoomed in close, using short brush strokes with the Clone Stamp.

FIGURE 14.9

A project like this is all about finding good sampling opportunities. In the first image, I use the good parts of the left eye to rebuild the rest of it. In the second image, I duplicate the shadow by the nose by sampling the lower section.

2. I look for opportunities to extend lines like the upper and lower eyelids. If some of these details were showing in the right eye, I'd try to sample them from there. I also pay attention to catch lights. It's hard to tell where they should be, so I have to improvise. After I get most of the area filled in, I do some fine-tuning.

> **TIP** Because all the retouching is on a duplicate layer, I can hide it occasionally to compare my work with the original. This is a good indicator to let me know if I'm on track.

3. Now that the tones are similar, I can use the Patch tool to blend them together better. I also use the Clone Stamp at 50 percent opacity to do some blending around the edges. I then clone the shadow along her nose because there should be one inside the glasses, as shown in the second frame of Figure 14.9.

> **TIP** I often find it useful to look at some real eyes when doing a project like this, even if they're in the mirror.

4. Now that the left eye is looking good, I can copy it and use the copy for the right eye. I draw a loose selection around it and then copy it to a new layer. Before I can move it into place on the right side, I have to flip it horizontally so that it's oriented correctly. To do that, I choose Edit ➪ Transform ➪ Flip Horizontal. Then I use the Move tool to drag it into place on the right side, as shown in the first frame of Figure 14.10.

5. After the new eye is in position, I use a mask to remove everything around it that I don't want, trying to salvage as much a possible from the underlying eye. I use a soft brush with its opacity set to 50 percent to get better blending of my strokes.

6. When you look at the first image in Figure 14.10, you probably notice something strange. The girl looks cross-eyed because the right eye is backward; the catch-light is on wrong side. If her pupils were more visible, it would look even weirder.

 Here's how I solve this problem. Now that the right eye is mostly reconstructed, I go back to the left eye and sample it with the Clone Stamp. (I make sure that Current and Below is chosen next to Sample on the Tool Options bar so that I can sample from the Left Eye layer and paint on the Right Eye layer.) Then I clone the iris area from the left eye onto the right eye, as shown in the second frame of Figure 14.10. Now the eye is looking in the right direction. Essentially, I un-flipped the orientation of just the central part of the eye.

> **CAUTION** Copying and flipping an eye to replace another eye is a risky thing to do. The only way to make it convincing is to go back and re-clone the iris and pupil area so that the eye looks in the right direction.

FIGURE 14.10

After the left eye is complete, I copy it to a new layer. I have to flip it horizontally before I can move it into place. Even though the eye is flipped, it still looks weird because it's looking the wrong way. In the second frame, I'm using the center part of the left eye to re-create the central part of the right eye to un-flip its orientation.

7. The eyes are starting to look pretty good, but the lack of dark pupils bothers me. To solve this, I create a new layer above the new eye layer and name it Pupils. Then I use the Brush tool to paint a small black pupil in the center of each eye. Because these two paint spots are on their own layer, I have lots of control over them. I take advantage of this control by changing the layer blending mode to Soft Light. That way, any catch-lights that are below the paint will show through it.

I use the same technique on another new layer set to Normal blending mode to use white paint to add a couple of very light catch-lights. Because catch-lights aren't always in the same position in both eyes, I'm sure to vary them a bit. I then lower the opacity of the layer so they're very translucent. I also use the Gaussian Blur filter to smear them a bit.

8. Next I add a burn and dodge layer (see Chapter 12) and use it to add some contour to the eye sockets and to darken areas where I think the glasses frame would cast a shadow.

9. I then use the Clone Stamp to tone down some of the reflections on the frames of the glasses. Sometimes these can be as bad as the glass-glares themselves.

NOTE **Sometimes, the glare on the frame is worse than the glare on the glass. It doesn't always have to be completely removed, but it does have to be toned down.**

10. Now it's a matter of fine-tuning. This step can take as long as all the previous steps combined because this is where everything comes together. I repeatedly turn off all new layers so I can compare the new and old images. This is a good way to spot anything that doesn't look right. I'm working at 100 percent zoom, so I occasionally zoom out to 50 percent to see the image closer to its actual size. This always puts things into perspective.

TIP **The most important step in a project like this is to walk away from it and do something else for a while. When you come back, you can see the project from a fresh perspective and know immediately if it isn't working.**

Don't be afraid to back up and try again at this point. Sometimes, you need a couple of tries with a complicated project like this. Just save your layers from the first attempt so you can compare both attempts. You may even find that you can combine parts of your first attempt with parts of your second attempt to get it right.

Figure 14.11 shows the final portrait and the layer stack in its Layers palette. Notice that I used a Curves adjustment layer with a mask on the top layer to darken the edges of the image.

Use this technique only as a last resort. If you do attempt it, be sure to give yourself plenty of time to work on it. Also, don't be afraid to fail as you search for the best path to making the image work.

FIGURE 14.11

Here's the final image with the new eyes in place — quite an improvement over the original in Figure 14.8. I also included the layer stack so you can use it to review my steps.

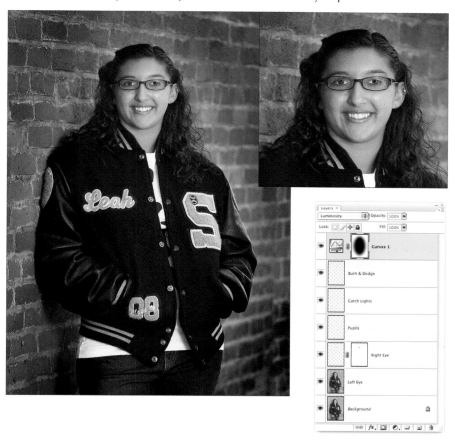

Removing Braces

When it comes to a portrait, teeth are almost as important as eyes. Retouchers are often asked to repair broken and missing teeth. (They're often asked to lighten and whiten them as well, which we cover in Chapter 15.) One of the hardest things a retoucher can be asked to do is remove braces. At least with eyes, it's possible to find donor eyes in another image. With teeth, that's rarely option. It's left to the retoucher to determine what the teeth should look like without braces. (I know a couple of photographer/dentists who would probably be very good at this.)

The young lady in the portrait in Figure 14.12 has a pretty smile that's being obscured by her braces. My job as a retoucher is to use as much of the existing teeth to rebuild the missing teeth. This is a tall order here because some of her teeth are completely hidden. The good news is that the two front teeth are completely free of braces, which gives me plenty of material to sample.

The process for this project is very similar to the process that I detailed in the preceding example, so I'll only hit a couple of high points. First I fix the easy problems, like the teeth next to the clean front teeth, by cloning parts of the two front teeth with the Clone Stamp, as shown in Figure 14.13. I work with a soft brush unless I'm near the edge of a tooth. When I am, I raise the Hardness value closer to 60 percent.

FIGURE 14.12

Braces removal is much like rebuilding eyes. You have to work with what's there to create what isn't there. In this case, I'm fortunate that the two front teeth are braces-free.

Photo by Emily Andrews

FIGURE 14.13

I begin this process by removing some of the easy stuff by sampling the clean front teeth. This allows me to build up new sample areas.

After I have some teeth reconstructed, I begin using them to reconstruct other teeth. This process takes a while because several teeth have to be created from scratch. When everything starts coming together, I make another pass to fine-tune any problem areas.

TIP Because all the retouching is on a separate layer, I can hide it occasionally to compare my retouching to reality.

The first frame in Figure 14.14 shows what the teeth look like when they're mostly reconstructed. They're getting close, but they still look too flat. To remedy this, I add a burn and dodge layer and use a small, soft brush with the Brush tool to shape the teeth by darkening the shadow sides with black paint and lightening the highlight sides with white paint. This helps to make them look more believable, as shown in the second frame of Figure 14.14.

FIGURE 14.14

The reconstructed teeth look too flat in the first image. A burn and dodge layer is used to shape them by darkening the shadow sides and lightening some of the highlight sides of the teeth. They look more three-dimensional in the second image.

Figure 14.15 shows the finished portrait. Like the project with the glass-glares, this one requires lots of time and patience. When you're doing a project like this, be sure to step away from it once in a while to give yourself a chance to see it from a different perspective. Don't be afraid to try again if you don't like what you get the first time.

When you get drawn into a complicated project like this, it's easy to lose your point-of-view and go past the point of what's needed. Keep the final use of the image in mind as you work. If you bite off more than you can chew and find it's beyond your current ability, be willing to chalk it up to the learning process and move on.

FIGURE 14.15

Here's the finished portrait without the braces. Though a project like this can be difficult, when it works, it's worth the effort.

Fixing Wrinkled Clothing

So far, we've focused on facial retouching. But a complete retouching job covers the entire image. Sometimes, the clothes in a portrait require more attention than the face. The portrait in Figure 14.16 looks great, except that the woman's shoulder looks funny because of the wrinkle in her jacket. Fortunately, this is easy to fix. All I need to do is copy a piece of jacket, drop it into the shoulder area, and then blend it all together.

TIP Portrait retouching isn't just about the face. Anything that can be done to improve the image should be addressed.

FIGURE 14.16

The face in this portrait only needs a little retouching. The more important issue that needs addressing is the fold in the woman's jacket along the shoulder. It makes her shoulder look out of place.

Photo by Dan Christopher

1. First, I draw a selection outlining where I want the sleeve to be, as shown in the first frame of Figure 14.17. The line from her shoulder to her collar has to approximate what I want the shoulder line to look like. The inner part of the selection doesn't have to be as exact. Because the shoulder line is a bit soft, I feather the selection 1px.

FIGURE 14.17

First, I create a selection that is close to the shape I need to fill. Next I drag the selection to an area of the jacket that's suitable for duplicating.

2. I then drag the completed selection to a fairly clean part of the jacket, as shown in the second frame of Figure 14.17. I'm looking for an area that doesn't have lots of detail like seams or shadows. When the selection is in place, I copy it to a new layer (Command/Ctrl + J). Now I have a piece of jacket that I can use as a patch.

3. I use the Move tool to drag the new layer into position so it's covering the space I want to fill, as shown in the first frame of Figure 14.18. I'm careful to line it up because I'll be merging it down in the next step.

FIGURE 14.18

When the selection is in place, I copy the selected area to its own layer and use the Move tool to position it in the area where I first drew the selection. When I like the way everything lines up, I merge the duplicate layer back into the Background layer. Then I use the Patch tool to quickly clean up any traces of the merge, as shown in the second image.

4. After the new layer is in place, I merge it back into the background layer, (Command/Ctrl+E). Now I just need to use the Patch tool to clean up any seams that are left, as shown in the second frame of Figure 14.18. When I'm finished blending, the image looks like Figure 14.19.

A few minutes work makes all the difference in this portrait without even touching the face.

This simple fix took only a few minutes, yet it adds so much to the image. If a pattern on the clothing had been involved, the process would have been more complicated, but still very doable. It would have just taken a little more time and patience.

Smoothing Skin

In the early days of Photoshop, blemish removal was a main topic in books like this. Now Photoshop's retouching tools have become much more sophisticated with the addition of tools like the Spot Healing brush and the Patch tool, so blemishes aren't such a big problem. My guess is that by now you have a clear understanding of how those tools are used to clean up blemished skin. (If not, you'll see them used in Chapter 15.) Instead of talking about how to remove pimples, I want to discuss the question I get asked most when it comes to skin: "What's the best way to smooth skin?"

One thing about modern digital cameras is that they see everything. When someone is photographed with a high-end DSLR, you can see every pore in her skin. Sometimes, this is too much. In the world of portrait retouching, the word *porcelain* has become quite popular when describing the desirable skin texture in a portrait. Lots of portrait photographers want the subjects in their portraits to have skin almost as smooth as porcelain. Naturally, this term means different things to different people. Some retouchers really pour it on, while others only introduce a hint of skin smoothing.

Whether you want a lot or just a little, you essentially have two different ways of smoothing skin in Photoshop. One is to use a blurring filter on a duplicate layer and then mask it so the blur shows only on the skin. The other is to use a plug-in that's specially designed to smooth skin. Let's look at both techniques.

Using the Surface Blur filter to smooth skin

Before you use this technique, or any other skin smoothing technique, be sure to take care of basic facial retouching like large blemishes and bags under the eyes. That way, your retouching gets blended during the smoothing process.

The portrait in Figure 14.20 is one we've already seen in this book. This young woman has nice skin to begin with, but the photographer wants the portrait to have more of a high-fashion look. I use these steps to smooth her skin with a filter and a mask:

FIGURE 14.20

The photographer who made this portrait wants it to have a high-fashion look. Skin smoothing will definitely help achieve the look he's after.

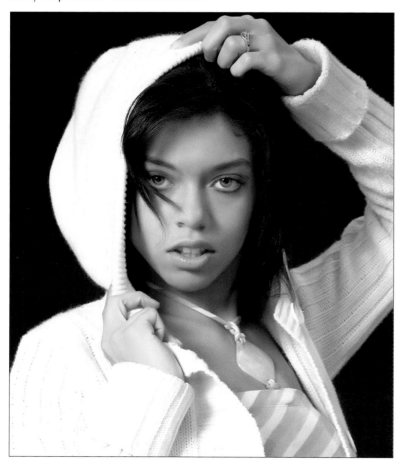

1. I make a duplicate of the main retouching layer — after the primary retouching has been completed — to use for blurring. I rename this layer **Blur**.

2. Photoshop has several blurring filters under the Filter ⇨ Blur submenu, as shown in the first frame of Figure 14.21. We want to use the Surface Blur filter. When I click it, the Surface Blur dialog box opens, as shown in the second frame of Figure 14.21.

FIGURE 14.21

Surface Blur is one of Photoshop's newer filters. It's located at the bottom of the Blur submenu. When the dialog box opens, you use the two sliders to adjust the amount of blur while preserving edge detail.

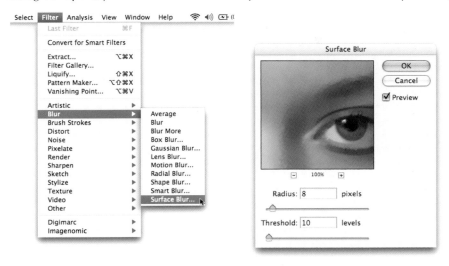

The Surface Blur filter is one of Photoshop's newer filters. It was introduced in version CS2. The filter is designed to protect edge detail while blurring everything else. It has two sliders: Radius and Threshold. (As is the case with most filters, the values used with these sliders depend on the size of the image file.)

- **Radius** controls the amount of blur. It specifies the size of the area being sampled for blurring. Higher values result in more blurring.

- **Threshold** controls the range of tonal values being considered for blurring. Lower values preserve more edge detail.

I set the Radius value to **8** and the Threshold value to **10**. I know this is a little strong, but because the effect is on its own layer, I can tone it down by reducing the layer's opacity.

TIP Alternate between zoom amounts of 100 percent and 50 percent when smoothing skin. The 100 percent view allows you to see the effect on each pixel, while the 50 percent view is usually closer to the actual size of the image. I talk more about this in Chapter 15.

3. The blur on the skin looks better, but everything else is blurred too. To remedy this, I create a layer mask that hides everything on the Blur layer, (Layer ⇨ Layer Mask ⇨ Hide All), and then come back with the Brush tool and white paint to reveal only the areas of skin where I want blurring to show. I have to be sure to paint all the skin — such as hands and

fingers. I also have to be careful around detail like the hair in front of her face and her necklace, as well as her eyes. Figure 14.22 shows the final effect. It's pretty close to what I'm looking for, but it needs a bit of touchup before it's prefect.

> **TIP** This is a good time to use the \ key to see the painting in Quick Mask viewing mode.

This smoothing strategy works well as long as you don't mind doing some masking and a bit of touchup. Experiment with it on a couple of portraits until you get a feel for the effect. After you understand the concept, you'll find many different ways to apply it for softening or sharpening specific areas of an image.

FIGURE 14.22

Here's the final effect of smoothing skin by using the Surface Blur filter with a mask. It looks pretty good but still needs a bit of touchup.

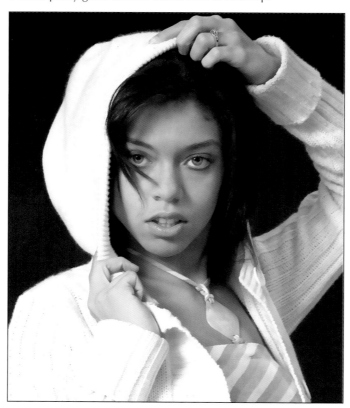

Smoothing skin with a plug-in

As you may recall from Chapter 9, a plug-in is supplementary software designed to work with Photoshop. Plug-ins allow you to do all kinds of things that can't be done as easily — or at all — in Photoshop. Plug-ins works within Photoshop, so using them as part of your workflow is seamless.

My favorite skin softening plug-in is Portraiture by Imagenomic. This software does the best job of skin smoothing I've seen from a plug-in. The dialog box for Portraiture is shown in Figure 14.23. This powerful filter provides a huge amount of control over the smoothing process. For one thing, I can use the eyedropper to select the exact color of the skin. This is important because the filter affects only the range of skin colors I define. That's why its smoothing effect doesn't affect things like eyes and teeth. However, if I don't feel like fiddling with the dials, I can use one of the presets in the pop-up menu at the top left, which is what I'll do now.

FIGURE 14.23

The Portraiture plug-in by Imagenomic provides lots of control over skin smoothing. I tend to start with one of the presets, shown at the top left, and then fine-tune the settings to dial in the effect.

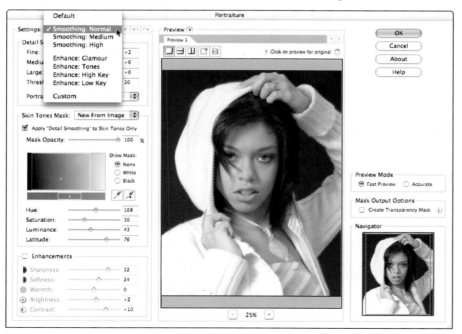

For the project here, I used the Smoothing Normal preset on a duplicate layer. The final effect is shown in Figure 14.24. If you compare Figure 14.24 to Figure 14.22, you'll see that the smoothing is cleaner in Figure 14.24, especially around the hair in front of her face. It also was much faster to create.

The one thing to be aware of with this filter is that it works on similar colors. So any color that's similar to the selected skin tone is affected. You may not be able to see it in this book, but the flesh-colored stripes on the woman's blouse have been blurred along with the skin. That isn't a problem here because I ran the filter on its own layer, so I can go back and do some quick masking to hide the effect on the clothing.

This is intended only as an introduction to this powerful filter. I wanted to mention it here because it's one of the most exciting retouching plug-ins I've run across in a while. If you want to know more, visit the Imagenomic Web site at `www.imagenomic.com`.

FIGURE 14.24

Here's the final effect of using the Smoothing Normal preset in Portraiture. Notice how much cleaner the skin smoothing is around the hair in front of the model's face than the image in Figure 14.22.

Summary

We started this chapter with one of the most common special retouching tasks that portrait photographers are asked to do — a head-swap. In that example, you saw just how easy it is to replace someone's head with a head from another image, creating the perfect portrait. If you're a portrait photographer, keep this in mind when shooting. Always be sure to cover yourself, especially when shooting groups, so that you have plenty of heads and expressions to choose from for every pose you shoot.

Repairing and reconstructing eyes raises the retouching difficulty level several notches. The first eye project we looked at was fairly straightforward. I replaced closed eyes with a set of donor eyes from a similar image. Even though the new eyes were a close match, we saw that they still didn't fit the woman's expression. We were able to scale the eyes and get a usable image, but it would have been better to use donor eyes that more closely matched the expression in the target image.

In the second eye project, we looked at complex glass-glares. This project was extremely difficult because of the lack of raw material. If this image were going to be printed bigger or cropped closer, I may have not even attempted it. The same is true for the braces project. Be willing to explore difficult projects like these, but honor your limits. Know when to pass on a project that's beyond your comfort level.

The project with the wrinkled jacket was a reminder that portrait retouching extends beyond the head. When you're working on an image, look at clothing to see if you can remove any distractions like shiny buttons or distracting wrinkles.

Skin smoothing adds a finished look to a portrait, especially portraits of women. I showed you two ways to approach skin smoothing. Work with one of these methods until you get a feel for it. Experiment until you find the amount of smoothing that works best for you. You don't have to go for the full porcelain effect, but use a little smoothing to blend retouching and give the skin a softer glow.

Each project we looked at in this chapter — except for skin softening — had one major concept in common. Missing information was reconstructed with existing information. You've probably realized by now that using various techniques for "copying" and "pasting" is a main theme in this book. Retouching and restoration are all about utilizing a bunch of sophisticated tools and techniques to leverage what we have to create what we need.

Chapter 15

Hands-on Portrait Retouching Project: The Complete Workflow

In this chapter, we put theory into practice by completing a retouching project together. This project gives you a chance to experience a complete portrait retouching workflow from start to finish. You also get a chance to see my thought process as I move through a retouching project like this one.

As I mentioned in Chapter 13, retouching is used to take a portrait to the next level, finishing what the photographer began when the shutter was clicked. When carried out properly, this process adds much more value to the finished image. When taken to the highest levels, it gives the photographer the opportunity to add another personal touch to the image — making it truly a one-of-a-kind. Before that journey can begin, we need to look closely at the image we'll work on and the requirements of the project.

Evaluating the Project

Figure 15.1 shows the portrait we're working on together in this chapter. It's a standard business portrait of an attractive professional woman who was photographed by one of my clients. The image was shot on film and scanned on a high-end film scanner.

> **NOTE** Yes, some people still shoot film! The grain in the film looks much like noise in a digital file.

I chose this image because it has most of the standard portrait retouching issues like wrinkles and skin that needs smoothing, eyes and teeth that need attention, and flyaway hair that needs to be toned down. This is a nice business portrait, and it won't take much to make it into a very nice business portrait.

FIGURE 15.1

By the end of the chapter, this nice portrait will be transformed into a very nice portrait ready for printing.

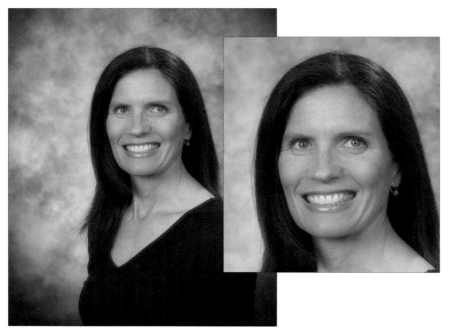

Photo by David Hitchcock

Here's the scenario: The photographer's client wants a print of this portrait to hang in the lobby of her office, next to portraits of the rest of the professionals who work there. That means she needs an 8×10 finished print.

I also know that this image will be cropped closer than it currently is. That means we don't have to worry about anything outside of the intended crop zone like some of the wrinkles in her clothing in the lower-right portion of the image. Fortunately, this image was shot on 6×7 medium format film, so we can get away with cropping quite a bit and still have enough detail to work with.

Even though we know about the intended close cropping, we won't be doing any cropping on this image until we get to the end of the workflow. That way, we can save a master, uncropped file that's been completely retouched. If the client changes her mind about the cropping and decides that she wants looser cropping, we'll only have to address the outer retouching that we're not doing now (the wrinkled clothing in the lower right). If we cropped it close first and then did all the retouching, we'd have to start all over if the client changes her mind about cropping.

The photographer also asked me to limit my time on this project to no more than 30 minutes because that's all he budgets for a business portrait. (I'm pretty fast, so it will probably take you a little longer as you learn the techniques in this chapter.) If this were a family portrait, destined for a large print that would hang above the family's fireplace, then the budget would be much bigger and I would

spend more time on it. However, no matter how much time I spend, I always approach a project like this with the three-phase workflow in mind.

Phase 1 Workflow: Adjusting Image Fundamentals

Before we begin retouching this image, we need to address some fundamentals like brightness and contrast, color, and any rough cropping that needs to be done. Follow these steps:

1. Open the practice file titled biz_portrait.tif from the downloadable practice files from the Web site. Press Command/Ctrl+0 to fit the image on your screen.

> **TIP** **Command/Ctrl+0 is the same as choosing View ➪ Fit on Screen. Command/Ctrl+Alt+0 zooms the image to 100 percent, which is the same as choosing View ➪ Actual Pixels.**

2. Create a Levels adjustment layer by choosing Layers ➪ New Adjustment Layer ➪ Levels. The contrast of this image is quite flat. That's understandable when you look at its histogram. Most of the data is clumped in the middle of the histogram. Hold down the Alt key and adjust the black and white input sliders until they almost cause clipping. Figure 15.2. shows the values I use. It's okay to see some clipping on the teeth here because we will be toning down the brightest highlights later on.

> **NOTE** **If you feel comfortable with Curves, then use a Curves adjustment layer instead.**

 When you look at the highlight side of the Levels dialog box, it looks like there's more room for adjustment toward the data. However, if you go further inward, the highlights on the teeth begin to clip. The second frame in Figure 15.2 shows what happens to the teeth if I move the white input slider to a value of 225. Pushing this value too far also makes the skin look too "crunchy."

 After the two end sliders are adjusted, check the middle (gray) slider to see if you want to adjust the overall brightness of the image. When you're finished, click OK. My final values were 14, 1.00, 241.

3. The Levels adjustment layer worked wonders on this image. Now, it's easier to get a better look at the color. This image has few reference points for color. The hair looks really close to the right color, but the highlights in the skin are a little yellow. The teeth look a little yellow too, but they might look like that in real life so we can't use them as a guide.

 Let's see if we can improve the color. Create a Color Balance adjustment layer by choosing Layers ➪ New Adjustment Layer ➪ Color Balance. Click the Highlights button, and change the Blue value to **5** to add a touch of blue to the highlights. I'm going to leave it there for now. If you want to do any additional color balancing, go ahead and then click OK.

Because this is a scan, we would normally need to check for dust spotting and see if any rough cropping needs to be done. I went ahead and took care of that on this file, so we're done with Phase 1 of our workflow.

FIGURE 15.2

One look at this histogram makes it clear that the black and white input sliders have to be moved inward toward the areas where there's more data. However, the white input slider needs to stop short to avoid highlight clipping. The second image here shows what happens when the white slider is moved all the way to the edge of the data.

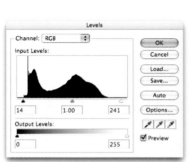

Phase 2 Workflow: Fixing Distractions

Now that the fundamentals have been addressed, it's time to get down to work. Phase 2 retouching is where the rubber meets the road. Here's a list of the things we need to address during Phase 2:

- Remove blemishes and soften wrinkles.
- Do some preliminary smoothing on the skin on her forehead and chest.
- Tone down the shine on her lips.
- Enhance the eyes by cleaning the whites, brightening the irises, and removing one of the catch lights.
- Lighten and whiten the teeth. Also tone down or remove bright reflections on them.
- Remove all the fly-away hair around the outer edges of her head.
- Do final skin smoothing.

With the exception of final skin smoothing, these steps don't necessarily need to be carried out in this exact order. I tend to take care of some of the bigger issues and then move around the image,

focusing on the above issues one at a time. Working this way allows me to solve the big problems and set the tone for the rest of the work to be done on the image.

> **NOTE** Because this is a soft-edge retouching project, we'll mostly work with soft details where smooth edge blending is desirable.

Keep in mind that the goal of all portrait retouching is to make the portrait subjects look the way they think they look. Very few people come to a photographer to get a portrait of themselves exactly the way the camera sees them. When they look in the mirror, they don't see every pore the same way a camera does, nor do they want to. At the same time, the typical middle-aged portrait subject doesn't want to look 21 again either, at least not in a portrait. As retouchers, we have to find the balance in the middle where portrait subjects look better than they do in reality, but not so unrealistic that the retouching becomes distracting.

> **NOTE** The goal of all retouching is to improve the image without drawing attention to the improvements, thereby rendering the retouching invisible to the casual viewer.

To begin Phase 2, pick up where you left off after Step 3 and follow this step:

4. We're all about flexibility, so we need to isolate every major change we make to this image on a separate layer. That way, if we see something we don't like later, it will be easy to modify.

 Duplicate the Background layer by choosing Layer ⇨ Duplicate, and rename it Retouching. This is the layer on which most of the retouching will be done. Your Layers palette should look like Figure 15.3 with four layers.

 FIGURE 15.3

 At this point, you should have the four layers shown here. Most of the retouching will be done on the Retouching layer. We'll use the Background layer as a reference point of what the un-retouched image looks like, allowing us to judge the effectiveness of our retouching while we work.

Softening wrinkles and blemishes

Let's begin by toning down some of the main wrinkles, starting with the eyes. Continue the project by following these steps:

5. Zoom to 50 percent, and use the Hand tool to center the eye on the right on your screen. Select the Patch tool, and make sure that Source is selected in the tool options. The cheeks in this image have the cleanest skin — especially the cheek on the right — so we'll use them as sample material when retouching other areas.

> **TIP** Remember that you can use Command/Ctrl++ (plus) to zoom in and Command/Ctrl+- (minus) to zoom out to standard zoom setting that include 50 percent, 66.6 percent, and 100 percent.

Choose the Patch tool and make sure the Patch option on the Tool Options bar is set to Source. Draw a selection around the dark line under the eye on the right, as shown in the first frame of Figure 15.4. Drag it down to the smooth skin on the cheek, as shown in the second frame of Figure 15.4, and release the mouse button. Before you do anything else, choose Edit ⇨ Fade Patch Selection (Shift Command/Ctrl+F). When the dialog box opens, lower the value to 50 percent, as shown in the third frame of Figure 15.4.

> **TIP** The kind of work we'll be doing here is perfectly suited to a graphics tablet, as discussed in Chapter 6.

We faded the Patch tool because its effect was too strong. If we removed all the wrinkles at 100 percent, this portrait wouldn't look real, so we'll fade much of what we do with the Patch tool.

6. Do the same thing with the dark lines below and to the right of the eye.

7. See the small dark spots just below the eye? Use the Patch tool to remove them completely, this time without fading.

8. Now let's take care of the wrinkles to the right of the eye. We can't remove all of them with one selection without making a mess because the area is too big. We'll break this area down into smaller groups. Draw a selection with the Patch tool around the first set of wrinkles, as shown in the first frame of Figure 15.5. Drag the selection to the clean skin on the cheek to sample it again, as shown in the second frame. Fade the Patch tool to 50 percent.

9. Use the same technique with the rest of the wrinkles. Be careful not to get too close to the dark areas by the corner of the eye. Be sure to fade the effect to 50 percent after each use of the tool.

> **TIP** This is a good time for a reality check. Hide the visibility of the Retouching layer to remind yourself of what the image looked like before you began. Do this often throughout this process to help keep your retouching in perspective. Just remember to turn the layer's visibility back on before beginning again.

FIGURE 15.4

Use the Patch tool to draw a loose selection around the wrinkle under the eye. If you get too close to the wrinkle, it will smear when the patch selection is applied. Drag the selection to the cheek to sample the smooth section of skin, as shown in the second frame. Because the effect of the Patch tool is too strong, use the Fade command to bring back some of the original wrinkle.

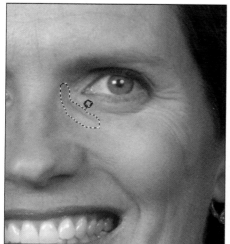
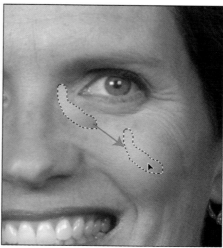
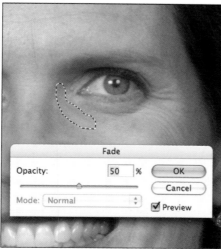

FIGURE 15.5

The area of wrinkles on the right side is too large to handle with one application of the Patch tool. Break it down into smaller areas that fit more easily onto the cheek area that we're using for samples. In the first image, I selected one line and used the cheek area right beside it for sampling, shown in the second image.

10. Repeat the process on the lines and wrinkles of the left eye. Remember to keep your selections loose and to fade every application of the Patch tool. When you get to the lines that run from the corner of the eye to the hair, be careful to sample an area that has a similar dark line at the left edge, as shown in Figure 15.6. Doing this ensures that the dark edge of her hair blends easily with the similar dark edge of the sample area. (If I used the cheek for a sample point for this selection, I would get lots of smearing from the Patch tool.) Fade this application of the Patch tool to 60 percent so the blending effect is a bit stronger, removing more of the line.

11. The wrinkles around the eyes should be looking pretty good at this point. Now let's focus on her forehead. Start by removing the blemishes over the eye on the left. Use the Patch tool, and don't fade it because we want them to completely disappear. Work your way across the brow area to the other eye, removing any blemishes or rough skin above the eyes. Keep using the cheek on the right for sampling. When you're finished, look for and remove any other blemished areas on the forehead. Leave the longer lines for now. We'll take care of them in the next step.

12. Now that the forehead is cleaned up, we can use the clean areas we created to tone down the lines on the forehead. Draw a selection around the lower line, and use the area just above it for sampling, as shown in Figure 15.7. I don't fade this move, but you can fade it a little bit if you want to.

NOTE Notice that we used the cheek to get the forehead in good enough shape so that it can be used for sampling larger sections.

Do the same thing to the other lines. When you get to the vertical line between the eyes, fade it to 40 percent so that more of the original line remains, providing some contours to the facial structure.

FIGURE 15.6

Keeping the sampled area consistent with the target area is the secret to successfully using the Patch tool around areas of detail or sharp tonal distinction.

FIGURE 15.7

We used the Patch tool to remove the blemishes from the forehead before dealing with the long lines. That way, we can use those clean areas as sample points when removing the lines with the Patch tool.

13. Make one more pass over the forehead, looking for any marks from your retouching that need to be blended in and use the Patch tool on them. Remember that we'll be smoothing the skin later, so don't get carried away. We're just knocking the rough spots off right now. When you're finished, turn off the Retouching layer's visibility for a reality check.

14. Move down to the nose, and use the Patch tool to remove the spots on the bridge and right side. Be careful when working on the nose with the Patch tool because you can easily remove too many details, which tends to flatten the nose, changing the character of the subject.

 The shine on the left side of the nose is a little too strong for me. I don't want to completely remove it, but I do want to tone it down. I use the Patch tool and fade it to 25 percent.

15. Now move down to the cheeks. Remove any blemishes you see. If it's a wrinkle, fade it back to about 50 percent.

 I think you're getting the idea. First, we got the lines around the eyes looking good. Then we started at the top of the head, and we're moving down.

16. This woman has very nice smile lines, but they're a little too strong. Use the Patch tool on them one at a time, fading after each use. Use your judgment on the amount to fade them. I used 30 percent on the left and 20 percent on the right. Do the same thing with the little wrinkle near the right nostril.

TIP This would be a good time to save your master file. Name it biz_portrait-edited.psd.

17. Let's use the same technique to tone down the rest of the smile lines on this woman's face. We don't want to completely remove them because the shape of her face won't make sense without them. Begin with the line to the left of the mouth, as shown in Figure 15.8. Use the smooth skin on the cheek for sampling. Fade each area appropriately, usually somewhere between 20 percent and 40 percent.

18. When you get to the large area shown in the first frame of Figure 15.9, select it all as one. Because of the size of this selection, we can't use the cheek for sampling. I found a clean area of skin on the shoulder that can be used, as shown in the second frame of Figure 15.9. Fade the effect to 50 percent.

TIP Remember, the Patch tool sees texture more than it sees color when sampling. If there weren't enough clean skin to sample for a large selection like this, I would use the woman's dark clothing on her shoulder where there aren't many wrinkles. I would just have to fade it more because the effect would be stronger. Remember, you have to be careful when doing this because you don't want to pick up any of the texture of the clothing.

19. Tone down any remaining smile lines as well as the spot of shine on the chin. Make one final pass over the face before moving to the neck.

20. Use the same technique to address the three sets of lines at the back of the neck. We don't want to completely remove them, but we do want to tone them down. Because the skin on the face is in pretty good shape, try to use it for sampling. Also remove any other lines you see just below the chin.

392

FIGURE 15.8

We're still using the cheek for samples. This small area has provided everything we needed to retouch most of this woman's face.

21. Now the face and neck are looking good. We just need to do some blending on the skin on her chest to deal with some blemishes and wrinkles. Use the Spot Healing brush with a diameter of about 30px to remove any obvious blemishes. Work with a soft brush and be careful not to remove any spots that look like moles.

NOTE When you retouch a photograph, you have to be careful to honor the imperfections that are part of the person's normal appearance. For example, a mole or a scar on someone's face is always there. If you remove it, the person will look different than he usually looks.

22. After all the smaller blemishes are eliminated, we can address the splotchy tones on the skin. Increase the size of the Spot Healing brush to 50px, and begin working on the dark and light splotches, blending them with the background. We'll smooth all the skin later. This step gets the skin ready for that process. This blending takes a few minutes but will be worth it later.

TIP Remember to try changing the Type option in the Spot Healing brush tool options if you aren't getting the results you want.

23. When you have plenty of clean skin to work with, you can use it to blend larger areas with the Patch tool. Select the area on her throat, as shown in the first frame of Figure 15.10. Drag it to the shoulder area as shown in the second frame. Then fade the effect to 50 percent. The fading is what makes this technique work without changing the contours too much. Use this technique along the collarbone region and anywhere else you can.

This selection is too big to use the cheek for sampling, but it will work better if I can retouch the entire line with one application of the Patch tool. Fortunately, I was able to find a nice area of skin on the shoulder to use as a sample.

FIGURE 15.10

When you get enough clean skin to work with, you can use it for sampling larger areas with the Patch tool. Here we're selecting a large area on her throat with the Patch tool, (first image), and using the retouched area on her shoulder for a sample, (second image). Be sure to fade the effect so you don't remove important contours.

By now, the skin should look pretty good. Look at it occasionally as we work on the next steps in case something you missed earlier jumps out at you. We'll come back and do final blending in a bit.

Enhancing eyes

This portrait is already looking much better than it did a short while ago. Let's spend a few minutes on the eyes and see if we can make it look even better. Pick up where you left off after Step 23, and follow these steps:

24. Most serious portrait photographers don't like to see multiple eye catch-lights in a studio portrait, so it's standard procedure for a retoucher to remove all but one. Zoom to 100 percent, and use the Clone Stamp with a small, soft brush set to Normal blending mode to remove the catch-light on the left in each eye. Sample the iris or the pupil when needed, as shown in Figure 15.11.

FIGURE 15.11

Use the Clone Stamp tool to remove the smaller of the two catch lights in each eye.

25. Let's get rid of the red. Make sure that the Retouching layer is the active layer. Create a Hue/Saturation adjustment layer, and name it Red Eye. Lower the saturation value of the Reds channel to **0**, and click OK. We only want to desaturate the whites of the eye, but the whole image is being affected. That means that we need to fill this layer's mask with black, and then come back and mask the whites of the eyes back in with the Brush tool.

Select the Paint Bucket tool (G) from the toolbar, and make sure that black is the foreground color. Click the image to fill the adjustment layer with black, hiding the effects of the adjustment layer.

26. Select the Brush tool, and paint the whites of the eyes with white, as shown in Figure 15.12. When you're finished, zoom back to 50 percent and look at the eyes. The desaturation is a little too strong, causing the whites to look gray. To resolve this, lower the Red Eye layer's opacity to 50 percent to allow some of the red to come back in.

FIGURE 15.12

The red in the eyes is toned down with a Hue Saturation layer. The effects of the layer are completely masked out with the Paint Bucket tool and black paint, and then a small brush is used to paint the effect back in with white only on the whites of the eyes, as shown in the first image. Additional retouching is done with the Patch tool to remove some of the blood vessels, shown in the second image. Be sure to use the cleanest skin you can find for this, so you don't add any texture to the whites.

27. Zoom back to 100 percent. Click the Retouching layer to make it active. Use the Patch tool to remove some of the blood vessels on the left side of the eye on the right, as shown in the second frame of Figure 15.12. Try to find a very smooth piece of skin to sample so that you don't add any texture to the eye.

 While you're there, take a moment to do any other retouching around the eyes — such as toning down the reflections at the inner corners.

28. We need to do one more thing with the eyes before we move on. We need to darken the pupils a bit. Create a burn and dodge layer at the top of your layer stack. (Create an empty layer, and change its blending mode to Soft Light.)

 Choose the Brush tool, and lower its opacity to 15 percent. Use a small, soft brush to paint each pupil with black paint, darkening it as you paint. If this woman's irises were darker, I would switch to white paint and use the brush to lighten them to give them a little more of a glow. In this case, it's not necessary. (You can see this effect in Figure 14.24.)

The eyes are looking great. In fact, they look so good that they really make the yellow tint in the teeth stand out. Let's take care of the teeth now.

Enhancing teeth

This woman has really great teeth. We don't have to do any reconstruction on them. All we have to do is remove the bright reflections, and brighten and lighten all the teeth. Let's take care of the reflections first. Pick up where you left off after Step 28, and follow these steps:

29. Make sure the Retouching layer is still the active layer. Use the Patch tool to remove each of the reflections, as shown in the first frame of Figure 15.13. If you want a little reflection to show through, fade the Patch tool. After the teeth have been retouched, use the Patch tool to remove or tone down the shine on the lower lip. Work with small pieces, as shown in the second frame of Figure 15.13, so you can sample other parts of the lip to preserve the unique texture that lips have.

> **NOTE** One of my pet peeves with portrait retouching is shine. I can't stand to see it, so I always do something to remove or at least minimize shine.

30. Okay, now that the teeth are retouched, it's time to take care of the yellow tint. You've probably already figured this out, but we can use the same technique we used for removing the red from the eyes.

 Create a new Hue/Saturation adjustment layer, and name it Teeth. When the dialog box opens, select Yellows and use the eyedropper to click one of the teeth. This targets the exact yellows you're interested in modifying. Lower the Saturation value to -50, and click OK. Now the teeth look much better, but the skin doesn't, so we need to hide the effect on everything in the image except the teeth.

31. Use the Paint Bucket tool to fill the layer with black, and then come back with a small, soft brush on the Brush tool to paint the teeth back in with white at 100% opacity.

FIGURE 15.13

Use the Patch tool to tone down or completely remove any reflections on the teeth by sampling non-reflective teeth, as shown in the first image. Then use the Patch tool to remove any shine on the lips, as shown in the second image. Be careful to sample similar areas of the lips so that the texture looks natural.

Because we used an adjustment layer to alter the color saturation of the teeth, we can come back later and re-evaluate the saturation after we've lived with it for a bit.

> **NOTE** **If the teeth were also too dark, we would repeat the procedure with a Levels adjustment layer to lighten after whitening, which I commonly do.**

This image is looking great. Figure 15.14 shows two close-ups comparing before and after shots of everything we've done so far in Phase 2. Take this opportunity to compare your before and after by turning off the visibility of the Retouching, Red Eye, Teeth, and Burn & Dodge layers.

Taming stray hair

The only problem area now is the hair. The woman in this portrait has lots of fly-away hair. Taming it will be tedious. If this photographer had been a little more careful when shooting the portrait, this step would be easier.

Most of the retouching we do on the hair will be handled by the Clone Stamp. The Patch tool and the Healing brush work well on hair that's far from the head. But those smart tools tend to cause smearing when used on a light area right next to a dark area, which is where most of this problem hair is. That's why we'll be using the more literal Clone Stamp.

Keep in mind as you work that this image will not be printed any larger than 8×10. The goal with the hair is to clean up the edges without going too crazy with it. Continue where you left off after Step 31, and follow these steps:

32. Let's start at the top of the head. Choose the Clone Stamp from the toolbar, and set the brush diameter to 30px. Also make sure the brush's Hardness value is set to 0. (If you need to raise the Hardness value when working close to the head, that's okay. Just remember to lower it again later.) Make sure that the Sample option in the tool options is set to Current Layer and the Retouching layer is active.

 Because the hair is darker than the background, we can get more control over the Clone Stamp by changing its blending mode to Lighten. Make that change in the tool options. Now the tool will affect only pixels that are darker than the sampled area and will lighten them. (If this were light hair against a dark background, we'd want to use the Darken blending mode.)

> **NOTE** **You may have noticed that we are working with a brush size that's larger than a strand of hair. The lighten blending mode is what allows us to use a larger brush because only the dark hair is being affected, speeding-up the stray hair taming process.**

 Zoom to 50 percent or 66.6 percent, and begin removing stray hairs. Sample the background area as closely as possible to the hair you want to work on so that the tones match, as shown in the first frame of Figure 15.15. Resample often, especially if you notice a strand of hair that isn't being affected by the Lighten blending mode. Frequent sampling also helps to prevent a halo pattern from forming around her head.

FIGURE 15.14

This portrait has undergone a major transformation. The skin is cleaner, the eyes are brighter, and the teeth look great. Now the only major issue is the fly-away hair surrounding her head.

FIGURE 15.15

Sample as close to the hair as possible when working with the Clone Stamp. Sample often to avoid copying the background pattern exactly. The second image shows the bottom ends of the hair. When you get to this point, leave most of the ends visible.

33. The hair that sticks out along the bottom edges, at the shoulders, needs to stay. If the ends were removed, we'd see strands of hair that looked like they were clipped and the portrait wouldn't look right. Clean up some of the strays, but leave most of it, as shown in the second frame of Figure 15.15.

34. Make one more pass around the head, looking for any telltale retouching strokes. Use the Clone Stamp or any other retouching tool to remove them. When everything looks good, turn off the Retouching layer's visibility to check your work. This is where you'll notice any halo pattern that may have been created around the woman's head by the retouching.

This image is looking great. We only have one step left in our Phase 2 retouching — final skin smoothing. Let's get to it.

Smoothing skin

In Chapter 13, we looked at two different methods for smoothing skin. One of those methods used a blurring filter and a mask, and the other used special plug-in software. Because most of you probably don't have the plug-in I mentioned just yet, we'll use the blur and mask system here. Continue the project by following these steps:

35. Duplicate the Retouching layer, and name it Skin. Then choose Filter ➪ Blur ➪ Surface Blur. In the Surface Blur dialog box, set the Radius value to **8** and the Threshold value to **200**. I find that a low Radius value and a high Threshold value like this give me better blurring for skin smoothing. Feel free to experiment with different settings. When you like what you see, click OK.

> **NOTE** You could use a Smart Filter here to blur the skin instead of copying the layer. However, as you may recall from Chapter 7, in order to use a Smart Filter, the underlying layer must be converted to a Smart Object. That means you won't be able to retouch it anymore.

36. Choose Layer ➪ Layer Mask ➪ Hide All to create a layer mask filled with black. This mask hides all the blurring on the Skin Layer. (If you look at the layer mask for the Skin layer, you'll see that it's filled with black.)

37. Select the Brush tool, and set the foreground color to white. Lower the opacity of the Brush tool to 50 percent. That way, you can build up the effect where you want it by applying multiple strokes. Use a large, soft brush to paint the blurred skin back into the image. Try not to paint anything else — such as eyes, teeth, and hair. Remember that you can always switch the foreground color to black to go back over something that shouldn't have been painted white.

 This is a good time to try using the \ key to see exactly where your strokes are on the image. Use this preview to help you soften only the skin, as shown in Figure 15.16.

FIGURE 15.16

Pressing the \ key allows you to see exactly what your mask looks like. Use this preview to make sure you're not adding any blur to parts of the image that need to remain un-blurred, like the eyes and mouth.

38. The smoothing is too strong for a business portrait, so we need to tone it down a bit. Lower to opacity of the Skin layer to somewhere around 30 percent. Now the effect looks much better. The eyes, which were a little soft to begin with, look a bit sharper against the smooth skin.

39. Make one more pass to check all retouching. When you're happy, save this master file as biz_portrait_edit.psd. Figure 15.17 shows my new image, along with the current layer stack in the Layers palette.

This portrait is a big improvement over Figure 15.1. The layer stack in the Layers palette shows the layers we created, along with their masks. Each of these layers gives us control over a different aspect of the retouching process.

Phase 3 Workflow: Finishing the Image

All the hard work is done. Now we get to focus on finishing this image. The first thing we need to do is crop and size it for printing. Because this will be a permanent change, you need to be sure that you saved the master image. After you do that, you can flatten the file so that the size will be more manageable. If you notice any retouching errors after cropping and sizing, you can back up to the master file and redo the steps in this section rather quickly.

Cropping and sizing

To begin Phase 3, pick up where you left off after Step 39 and follow this step:

40. Select the Crop tool, and enter a value of **8** into the Width field, a value of **10** into the Height field, and a value of **300** into the Resolution field. Make sure the measurement unit is inches, not pixels. Use the Crop tool to draw a selection similar to the selection in Figure 15.18. When it looks good, press Enter to commit the crop.

FIGURE 15.18

After a master layered file has been saved, the image can be cropped to its final size. This is the cropping I chose. Try to make yours similar to it.

Creative burning and dodging

This image doesn't need much creative burning and dodging, but I do want to darken all the corners — especially at the top and the bottom left — to create a subtle vignetting effect. We'll do it here with an adjustment layer and a mask, instead of the usual burn and dodge layer we used for darkening her pupils. Continue the project by following these steps:

41. Choose the Elliptical Marquee tool from the toolbar, and draw a selection like the one shown in the first frame of Figure 15.19. We want to use this selection to isolate the corners, so we need to invert it. Choose Select ⇨ Inverse.

NOTE Normally, I would have created this layer before flattening and cropping and saved it as part of the master file. However, because we were cropping so much, I didn't know exactly what I wanted it to look like until the crop was done.

FIGURE 15.19

Use the Elliptical marquee tool to draw an elliptical selection around the woman. We'll invert this selection and use it to darken only the corners of the image with a Levels adjustment layer.

42. Now we need to use a Levels or Curves adjustment layer to darken the corners. Before we do that, though, we need to feather the selection. Otherwise, we'll get a hard edge along the selection. Choose Select ⇨ Refine Edge, and enter a value of **100** into the Feather field. Leave all other settings at 0. (If you want to preview the effect, click the last preview button on the bottom right to see it as a mask.) Click OK.

43. We're ready for the adjustment layer. Choose Layers ⇨ New Adjustment Layer ⇨ Levels. (You can use a Curves layer if you prefer.) If you haven't flattened your file, make sure you're on the top layer before doing this step. When the dialog box opens, change the gray slider's value to **.70** and click OK.

44. Everything looks great except that the shoulder on the right is too dark now. Because we used an adjustment layer combined with a selection to create the vignette effect, this is easy to fix. Simply choose the Brush tool from the toolbar, and use black paint to fine-tune the Levels layer mask that was created by the elliptical selection. Paint the shoulder until you like the tonality. Let the tones fade to dark down at the lower corner. Figure 15.20 shows my layer mask on the Levels layer.

FIGURE 15.20

A layer mask was created when we used a selection to create an adjustment layer. This mask can be modified like any other mask by painting on it with black or white paint.

This portrait is almost ready for printing. We just need to take care of any final sharpening.

Professional sharpening strategies

When retouching a portrait, two different kinds of sharpening can be done to the image. They are creative sharpening and output sharpening. Let's consider their differences:

■ Creative sharpening is used to fine-tune an image creatively by selectively sharpening, or blurring, selected areas of the image. When I use the term *sharpening* here, I am also referring to its opposite, *blurring*, which is the lack of sharpness. Creative sharpening is used to blur the background around a subject, as you saw in Figure 13.1. Creative sharpening also can be used to sharpen only the eyes in a portrait.

The main thing to understand about creative sharpening is that its effect is relative to the rest of the image. The goal isn't to make part of the image perfectly sharp. The goal is to make part of the image stand out better from its surroundings by sharpening it or blurring the detail surrounding it.

■ Output sharpening is overall sharpening that's designed to prepare an image for output, such as printing or onscreen viewing. This sharpening is applied to the entire image with the intent of getting it ready for a particular output option. One of the things to understand here is that size matters. A file that's being prepared for printing as a 5×7 requires a completely different sharpening scenario than the same file being prepared for a 16×20. The 5×7 would look great, but the 16×20 would not be sharp enough.

CAUTION Something we want to avoid when possible is sharpening an image for output, changing its size, and then re-sharpening for a new output size. Sharpening on top of previous sharpening can adversely affect the image by introducing unwanted *artifacting*—distortions introduced by the digital process.

This means that any creative sharpening will be further sharpened during the output sharpening process. This is important to know because it means we want to consider this during creative sharpening. Otherwise, if it looks perfect and then we sharpen again, it will be overdone, causing details to look "crunchy" instead of smooth.

Using Smart Sharpen

If you recall the sharpening discussion from Chapter 12, you'll remember that sharpening a digital image is all about enhancing edge contrast. The Smart Sharpen filter (as well as the Unsharp Mask filter) is really an edge contrast filter. It finds edges of contrast and lightens one side of the edge while darkening the other side. This causes a slight haloing effect that enhances the appearance of edge detail, tricking our eyes into thinking the image is sharper. Pretty cool, huh!

One of Photoshop's newer filters is the Smart Sharpen filter that was introduced in version CS2. This filter is considered smart because it treats various regions of the image differently based on the image content in those regions. The Smart Sharpen filter attempts to sharpen only the areas of the image that have detail, without affecting areas that don't. It's the perfect filter to consider here because it sharpens the details without having much affect on the skin that we just smoothed.

NOTE The Unsharp Mask filter, which we discuss in Chapter 16, affects all the pixels in the image equally.

To begin sharpening the image, pick up where you left off after Step 44 and follow this step:

45. Make sure the Background layer is active and then open the Smart Sharpen filter by choosing Filters ⇨ Sharpen ⇨ Smart Sharpen. The dialog box that appears will look something like the second frame of Figure 15.21.

FIGURE 15.21

The Smart Sharpen filter is found in the Sharpen sub-menu of the Filter menu. The only other sharpening filter I use here is the Unsharp Mask. When the Smart Sharpen dialog box opens, you can use the Amount, Radius, and Remove fields to control the effect of the sharpening.

Let's look at the main options in this dialog box:

- **Amount** is just that — the amount of sharpening. Higher values equal more edge contrast, which equals more sharpening.

- The **Radius** value determines how many surrounding pixels are considered when the Smart Sharpen filter finds an edge. Higher values expand the size of the sharpening halo. Extreme values create noticeable halos that detract from the image.

- **Remove** is a cool feature that adjusts the way the filter works, depending on the problem. The pop-up has three options: Gaussian Blur, which is the same algorithm used by the Unsharp Mask; Lens Blur, which is used when the sharpening is used with most digital camera files; and Motion Blur, which attempts to compensate for blur cause by motion during the exposure.

- The **Advanced** button gives you more control by allowing you to work with the shadows and highlights independently of the rest of the image. You can use Fade Amount to adjust the amount of sharpening and Tonal Width to restrict your adjustments to the shadows or the highlights. This is quite useful when you have lots of noise in the shadows that you don't want to sharpen. We'll be using the Basic mode here, but feel free to experiment with the Advanced mode.

- Checking the **More Accurate** box makes the filter provide a more accurate removal of blurring, but the process takes longer.

There's one more issue I need to explain before we sharpen this portrait. Several times in this book I asked you to zoom to 50 percent when evaluating an image. I did this for two reasons. First, Photoshop does a much better job of rendering a file to the screen at zoom ratios of 25 percent — in other words, 25 percent, 50 percent, and 100 percent. You can't really judge an image when it's zoomed to any zoom ratio that isn't a multiple of 25. This is especially important when sharpening an image for print.

> **NOTE** When sharpening for the Web, zoom to 100 percent to display the image at actual size.

Second, the reason for zooming to 50 percent is that this zoom ratio is usually the closest multiple of 25 percent that approximates the actual size of the image on your screen. So, when I'm looking at an image zoomed to 50 percent, I am looking at it under favorable screen rendering conditions (a multiple of 25 percent), and it's close to the size it will be when it's printed. When that's the case I can place more trust in what I see on my monitor while evaluating critical adjustments.

> **NOTE** One would think that zooming to 100 percent would display the image at its actual size. Because a computer monitor isn't capable of displaying an image at 300ppi it has to spread the pixels out to the resolution it can display, usually between 70 and 90 pixels per inch. This causes an image with a resolution of 300ppi to look bigger on the computer monitor.

The optimal zoom ratio is going to vary depending on your monitor and you have it set up Here's how to find out which zoom multiple of 25 percent is best for your particular viewing environment:

■ Choose View ➪ Rulers to turn on the rulers. Figure 15.22 shows our image with the Rulers displayed. If your Rulers are already turned on, you don't have to do this.

FIGURE 15.22

You can use the View ➪ Rulers feature to display a ruler at the top and left side of an image. This is useful when you want to get an idea of how big the display is in relation to the actual size of the image.

■ Now that the rulers are showing, you can hold a real ruler up to the screen while zooming the image. When the file's ruler and the real ruler match up, the file is displayed at its actual size. Because we want a multiple of 25 percent, try 25 percent and 50 percent to see which is closest to reality. On all of my monitors, 50 percent is a little bigger than reality and 25 percent is a little smaller. I use 50 percent because an image that's displaying a little bigger is easier to look at and evaluate.

Some experts recommend that you zoom to 100 percent when sharpening so you can see the actual pixels. This can be helpful, but it also can be misleading. When an image is zoomed to 100 percent for sharpening, it appears much bigger on the screen than it will be in reality — more than twice as big on my system. If you get the sharpening looking perfect at 100 percent, it will look under-sharpened when you see the final print.

Okay, let's get this file sharpened and ready to print. To complete the project, follow these steps:

46. The Smart Sharpen dialog box should still be open. If it isn't, open it. You can view the effects of the filter in two ways: Zoom your image to 50 percent, and position the Smart Sharpen dialog box so you can see your image while you work with the dialog box (my preferred method), or zoom the huge preview window in the Smart Sharpen dialog box to 50 percent by clicking the minus sign located just below the preview area.

Begin by checking the More Accurate box at the bottom of the dialog box. Click the Remove pop-up, and select Lens Blur. Then change the Amount value to 100% for a starting point. Slide the Radius slider to the right until you get to a value of about 30. This is obviously way too high, but I want you to see the haloing effect, as shown in Figure 15.23, that the Radius amount controls. We want halos, but we don't want them to be this noticeable.

47. Lower the Radius value to about 1, and use an Amount value of 100%. Use the Amount slider to increase the effect, while watching your preview. Stop when you see what you like, and click OK. (I stopped at 110 percent.)

TIP I usually leave the Radius value low and increase the Amount slider to apply sharpening. If I can't get the amount of sharpening I want with these values, then I start increasing the Radius value.

This image is now ready for printing. Flatten it and save it as biz_portrait_8×10. You can save it as a JPG or a TIF, whichever is best for your printing purposes. At this point, you should have three different files — the original file, a fully retouched and uncropped master file with all layers intact, and a flattened and sized file ready for printing.

FIGURE 15.23

Sharpening works by creating contrast halos around edge detail. When the halos become obvious, the sharpening is too strong.

Summary

The project in this chapter took us through a typical portrait retouching workflow. We began by evaluating the image and how it will be used. That information allowed us to get a good idea of what needed to be done to the image. We then broke the project down into the three phases of the three-phase workflow.

In Phase 1, we addressed the fundamentals by using adjustment layers to modify the brightness and contrast and the color. Whenever you plan to spend this much time on a project, be sure to use adjustment layers for these kinds of changes. That way, even after all the work is done, the image remains flexible. Fundamental changes like color can be fine-tuned.

The hard work was done in Phase 2 of our workflow. That's where all the serious retouching took place. With this soft-edge retouching project, the focus was on softening blemishes, enhancing eyes and teeth, taming stray hair, and smoothing skin. If you look back at the steps we took, you'll note that a large part of the retouching — excluding the stray hair — was done with the Patch tool. (I told you that it's my favorite retouching tool.) Keep in mind that the amount of work would have increased if this portrait had more than one person in it.

After all the heavy lifting was done, we moved into Phase 3. That's where we did final cropping and sizing. We also used an elliptical selection combined with an adjustment layer to vignette the corners of the image, giving it a more finished look.

We finally took a detailed look at sharpening and how it fits into the third phase of the three-phase workflow. We used the Smart Sharpen filter to sharpen this image for output by creating edge halos that trick our eye into thinking the image is sharper. One of the key things to remember when sharpening is to view the image at a zoom ratio of 25 percent, preferably close to its actual size.

This was a fairly straightforward project. Take a moment to review the steps we took and the overall effects they had on the finished image. Then find some images of your own and take them through this process until you have a feel for how all the pieces fit together.

Chapter 16

Hands-on Architectural Retouching Project

In Chapter 15, we took a nice portrait and made it much nicer by toning down or completely removing distractions such as wrinkles and fly-away hair. Throughout the process, the goal was to create a softer portrait that portrays the woman at her best, rather than exactly the way the camera captured her. The project's goals and the tools and techniques to achieve those goals were typical of soft-edge retouching. When someone looks at the finished print, he won't be comparing it to reality to make sure every wrinkle is accurately portrayed. He'll be viewing it from a more emotional perspective.

With the hotel image, shown in Figure 16.1, that we're working on in this chapter, we have a similar goal of altering the image to make it more pleasing to view. However, those alterations need to be done in a way that keeps the details of the building intact. Our retouching has to be very literal in nature so we preserve the reality of the building. The tools and techniques we use to accomplish this are characteristic of hard-edged retouching. Oddly enough, though, we have to make some serious adjustments to the perspective of this building in order to make it look more realistic — rather than keeping it the way it's portrayed by the camera — and that's something we would never have considered in the preceding chapter.

FIGURE 16.1

This original photo provides us with a good starting point for our project. With a couple of hours of retouching, we can transform it into a professional architectural study that portrays the building at its finest.

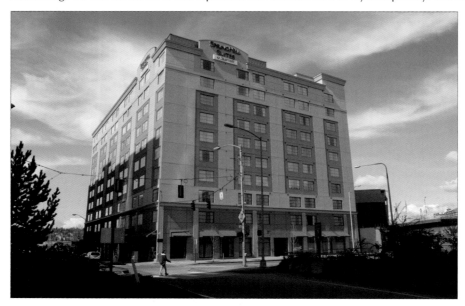

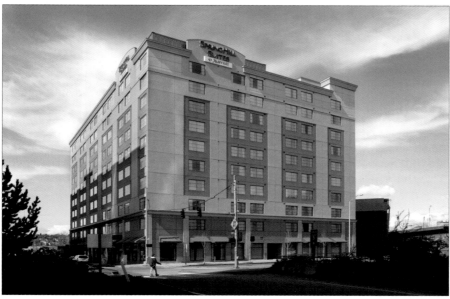

Evaluating the Project

As I mentioned in Chapter 13, this is a nice photo of this hotel. The light on the face of the building is great and the lighting on the left side is workable. The photo has some distractions in the foreground, but not too many — mostly light posts and wires.

The photographer's client — the hotel management — wants all the power lines and streetlights removed. They also okayed any other improvements that will create a better image. One of the first things we need to do is straighten all the vertical lines so the building doesn't appear to lean inward at the top.

This image is currently a little under 8×12 inches at 300ppi (Image ⇨ Image Size). The hotel is planning to use it for a 20×24 print with minimal cropping on each side. We'll have to resize the image and upsample it to the larger print size. We'll keep this large print size in mind as we work because it means that our retouching has to look good up close. That shouldn't be a problem with this image because we have lots of good information to work with.

We're going to approach this project with the same three-phase workflow we used in the preceding chapter. The steps within those three phases are quite different in some cases, especially in Phase 1.

Phase 1 Workflow: Adjusting Fundamentals

Before we can get to the retouching in Phase 2 of this project, something must be done about the building's converging vertical lines. But before we straighten out the perspective of this building, we need to take care of the usual fundamentals — brightness, contrast, and color. To begin, follow this step:

1. Open the practice file titled building_remodel.tif from the downloadable practice files on the Web site. Press Command/Ctrl+Alt+0 to zoom to 100 percent. Quickly scan the image quadrant by quadrant to check for spotting. When you're through spotting, press Command/Ctrl+0 to zoom the image so it fits on the screen.

NOTE Even though this image was captured on a digital camera, it could still have dust — sensor dust, which is dust on the camera's sensor. You'll know when sensor dust is the problem because the dust is in the same spot on every exposure. If you see sensor dust, have a qualified professional clean the sensor so you don't have to keep spotting the same dust in different images.

Using Curves to adjust midtone contrast

In the preceding project, we used a Levels adjustment layer to modify the tonal qualities of the image. In that example, we worked with an image that lacked overall contrast. The image in this chapter is a little different. Figure 16.2 shows its histogram. You can easily see that we can't adjust the black point without clipping some of the blacks. The highlight side of the histogram has a little

room for adjustment, but we'll have to be careful. Lightening the extreme highlights will have an adverse effect on the clouds and the contrasty left side of the building. We need to adjust the mid-tone contrast of this image without affecting the extreme ends of the histogram, which is a perfect job for the Curves command. Pick up where you left off after Step 1, and follow these steps:

FIGURE 16.2

This histogram shows us that we can't adjust the black input slider without clipping some black detail. It looks like there's some room for adjustment on the highlight side, but when the white input slider is dragged inward too far, it has an adverse effect on the highlights in the image.

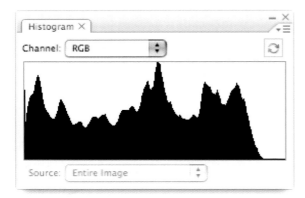

2. Create a Curves adjustment layer by choosing Layers ⇨ New Adjustment Layer ⇨ Curves. Click OK when the New Layer dialog opens so that the layer is named with the default name of Curves 1.When the Curves dialog box opens, check the Show Clipping box. This activates a clipping preview when you click the white input slider (the top right of the diagonal line) or the black input slider (the bottom left of the diagonal line). Clipping shows when either of these points is dragged inward horizontally — it's just like using the Alt key with the black and white input sliders in the Levels dialog box.

 Drag the white input slider to the left until the Input value is 240, as shown in the first frame of Figure 16.3. You'll notice a bit of clipping on the lower-right portion of the image, which is one of the clouds on the horizon. This area most likely will be cropped when this image is sized to 20×24 inches because of the change in aspect ratio.

 You can try adjusting the black input slider, but when you do, you'll notice that the blacks begin to clip immediately. If clipping was occurring only in the shrubs in the foreground, I wouldn't worry about it. However, some of the deep shadows of the building are starting to clip, which is unacceptable.

FIGURE 16.3

In the first frame, the white input slider is being dragged inward to adjust the extreme highlights in the image. In the next frame, the brighter tones in the midtones are being lightened as the line is dragged upward. In the third frame, the darker parts of the midtones are being darkened as the line is dragged downward in this region. This forms a gentle S-curve that enhances midtone contrast.

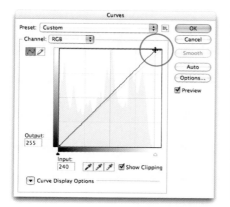 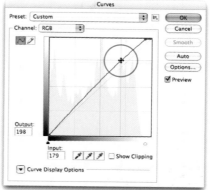

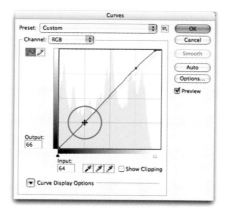

3. With the black and white points set, uncheck the Show Clipping box so we can do something about the midtone contrast of this image. Click the diagonal line at the upper right where it intersects the top horizontal grid line. Drag upward slightly until the Output value is 198, as shown in the second frame of Figure 16.3. This lightens the highlight tones without clipping the extreme highlights.

NOTE The upper part of the building on the left is a little too light now. We'll take care of that later with some burning and dodging in Phase 3.

Now move to the lower left of the diagonal line where the shadows are. Click the line where it intersects the lower horizontal line on the left. Drag it downward until the Output value is 58, as shown in the third frame of Figure 16.3. This darkens the shadows without clipping the extreme shadows. Before you click OK, notice that the middle section of the diagonal line is a little steeper than it was before we added our adjustment points. If you recall the discussion on Curves in Chapter 1, you'll remember that a steeper line means more contrast in the regions where it's steeper.

CAUTION **Notice that these changes were small in value, but they had a profound effect on the image. The key to using Curves successfully is to make subtle adjustments.**

4. Now that the contrast has a little more snap, let's use a Color Balance adjustment layer to warm up the color. Create a Color Balance adjustment layer by choosing Layer ➪ New Adjustment Layer ➪ Color Balance. Click OK on the New Layer naming box so that the layer is named with the default name of Color Balance 1. This image looks mostly cyan, so we need to add red (cyan's opposite). Change the Cyan/Red value to **+15**. When this much red is added, an image can begin to look a little blue, so change the Yellow/Blue value to **-2**. (I also added a bit of red and yellow to the highlights by clicking the Highlight button and changing the Cyan/Red value to 2 and the Yellow/Blue value to -2.) Click OK when you're finished.

Now that the brightness, contrast, and color are looking good, we need to do something about the converging vertical lines. But before we can straighten anything, we need to know just exactly what straight is. We'll find that out by establishing some straight guide lines, known as Guides.

Using Guides for critical alignment

One of the coolest but least used features of Photoshop is the ability to place vertical and horizontal guide lines — or guides — anywhere in the image. I use them all the time when I need a straight reference point or when I need to align layer content from different layers. Continue where you left off after Step 4, and follow this step:

TIP **These guide lines are useful not only for establishing straight horizontal and vertical reference points, but also for aligning image content. When Snap is turned on in the View menu (View ➪ Snap), layer content jumps to any nearby guide when it's positioned with the Move tool.**

5. Make sure your rulers are showing. If they aren't, choose View ➪ Rulers (Command/Ctrl+R). You should now have a horizontal ruler at the top of the image and a vertical ruler on the left side of the image. To create a horizontal guide, click the ruler and drag downward while holding down the mouse button. To place a vertical guide, click the vertical ruler and drag inward. Let's try it.

Click the vertical ruler, and drag to the right, toward the building, until you just touch the lower-left side of it. Release the mouse button. You should now have a vertical guide. Click the ruler again, and drag a second guide all the way across the image to the right side of the building. Then place a third guide somewhere near the middle of the front corner of the building, as shown in Figure 16.4.

FIGURE 16.4

To create guides, click the ruler and drag inward. To move a guide, select the Move tool or hold down the Command/Ctrl key until the double-sided cursor appears.

After a guide is placed, you can easily move it. Simply select the Move tool from the toolbar, and hover the cursor over the guide (or just hold down your Command/Ctrl key). When you do, a double-sided arrow appears. Just click and drag to reposition the guide. To delete a guide, drag it back to the ruler. To delete all guides, choose View ⇨ Clear Guides.

> **TIP** Sometimes, I want to temporarily hide the guides without deleting them so I can get a better look at an image. This is especially useful when making color adjustments because of the bright cyan color of the guides. To hide all guides, choose View ⇨ Extras (Command/Ctrl+H). When Extras is unchecked, all guides are hidden. (This command also hides any active selections.)

When guides are added to an image, they become part of that image and every derivative file that's created from it. For example, if I save this file as a JPG right now and then open that JPG in Photoshop, I'll see the guides in the new JPG file. If I view the file outside of Photoshop, I won't see the guides because they're a feature of Photoshop. Still, it's best to avoid all confusion by clearing all guides before sending a file to someone else.

Another thing to be aware of with guides is that even though you see guides while viewing the image in Photoshop, they won't appear on prints. So you don't have to worry about these funny

cyan lines showing up when you go to print. Now that we've got the basics out of the way, let's put tour guides to use.

Correcting perspective with the Transform command

The vertical lines in this image are converging toward one another at the top of the image. This convergence is caused by the fact that the top of the building is further away from the camera than the bottom is. Our eyes see things in a similar way as a camera, but our brain compensates so we don't notice the convergence. Even though the convergence is to be expected when photographing buildings, in architectural photography, converging vertical lines are a big no-no.

When more professional photographers were shooting film, most architectural photography was done with 4×5 view cameras. These cameras not only use very large format film — four inches by five inches — they also have the ability to swing and tilt the lens axis and the film axis. These swings and tilts are used to straighten all lines and correct the perspective in the camera before the shutter is clicked. This is called *forcing the perspective*.

Now that so many professional photographers are shooting digital, all the perspective correction is done in post-production with Photoshop. You can correct perspective in Photoshop in a couple of ways. The method we'll use here is the most common — the Transform command.

NOTE **Some architectural photographers use shift lenses with their digital SLRs. These lenses allow for some of the shifting that's possible with a view camera. Oftentimes though, some additional perspective control is applied in post-production.**

I introduced the Transform command in Chapter 9 when I discussed how to square up a crooked scan. In that example, I used the Distort function of the Transform command. We use it here too. Pick up where you left off after Step 5, and follow these steps:

6. We like to keep our workflow flexible, so we'll do all transformations on a duplicate layer. Click on the Background layer to make it active. Duplicate the Background layer by choosing Layer ⇨ Duplicate Layer. Rename the new layer **Straight Lines**.

7. Use Command/Ctrl+0 to fit the entire image onto the screen. Press the F key to go into full screen viewing mode. (You might need to press it twice.) Now use the keyboard shortcut Command/Ctrl+- (minus) to zoom out one increment. We did this so we have some room around the image to use while working with the control handles of the Transform command.

TIP **If you want a little more screen real estate, press the Tab key to hide all palettes. Press it again to reveal them.**

8. Choose Edit ⇨ Transform ⇨ Distort. We could use some of the other commands from the Transform submenu — such as Perspective and Scale — but I find that Distort is faster because corners can be addressed individually and scaling can be done without going back to the Edit menu and selecting the Scale command.

Click and drag the handle at the top-left corner; drag the handle straight to the left. Drag until the back edge of the building is parallel to the guide next to it, as shown in the first frame of Figure 16.5. It doesn't have to touch the line; it just has to be parallel with it.

TIP If you want to reposition the guide while the Transform command is active, press the Command/Ctrl key and then click the guide and drag it to its new position.

FIGURE 16.5

Click and drag the handles of the Transform command straight to the side on each side of the image to straighten the vertical lines, as shown in the first image. Once they're straight, click the middle handle at the top and drag it upward to make the building taller, shown in the second image.

9. Do the same thing with the right side of the building by dragging the top right corner straight to the right. This causes the left side to lean in a bit, so you need to go back to the left and re-adjust to compensate. Check the right again to see if it's still in alignment. Continue this back-and-forth until both sides are parallel to their respective guides. Zoom in to check the alignment if you need to. When both sides are perfectly vertical, the front corner of the building in the middle will also be straight.

> **NOTE** The quality of the image may look poor when you're in the middle of using the Transform command. Don't worry; it's only a preview. The quality will look much better once the transformation is complete.

10. I don't know if you noticed this, but the building looks shorter than it did before this transformation. If you zoom in and look at the person crossing the street, you'll see that she looks out of proportion too. We'll have to compensate for this effect.

 Click the handle in the middle of the top of the image. Drag it straight up just a bit to stretch the building's height, as shown in the second frame of Figure 16.5. Check the vertical lines one more time to verify that they didn't shift when you were scaling the height of the building. Then press the Enter key to commit the transformation. Hide the layer's visibility to compare the before and after versions. You won't need the guides anymore, so you can remove them or hide them.

> **CAUTION** When using the Transform command, do all transformations during one application of the command. This command does some serious pixel pushing. If you combine all moves into one application of the command, the pixels are pushed around only once. If you don't like the transformation, undo it and try again, rather than performing a second transformation on top of a previous transformation.

Even though it looks like we removed some of the sky when we stretched the height of the building, the sky is still there; it's just hanging off the edge of the canvas. Let's increase the size of the canvas so we can see everything. Continue with these steps:

11. Choose Image ➪ Canvas Size, and in the Image Size dialog box, enter **15 inches** in the Width box and **10** inches in the Height box. Make sure that the Canvas extension color is White, and click OK. Now the entire image fits on the canvas, as shown in the first frame of Figure 16.6.

12. Now you can see the rest of the sky that was hanging off the side of the canvas earlier. We're only interested in keeping the area at the top, so let's crop the sides. Select the Crop tool from the toolbar. Clear any preset options by clicking the Clear button on the Tool Options bar. Draw a cropping marquee that includes as much of the image as possible, without showing any of the white canvas, as shown in the second frame of Figure 16.6, and then press the Enter key to commit the crop.

13. The image is ready for Phase 2 of the retouching workflow. Save the master file now. Name it building_remodel-edited.psd. Continue to save this file frequently as we move through Phase 2 of our workflow.

FIGURE 16.6

When we expand the canvas, we can see the entire transformed image.

Phase 2 Workflow: Removing Distractions

The work we did on the fundamentals of this image have drastically improved it. However, we still have lots of work to do. Here's a list of the things we need to address during Phase 2, moving from left to right. These items are painted red in Figure 16.7:

- Remove all the electrical lines that come into the frame from the left edge, including the two large traffic lights that hang from them. The section against the sky will be easy. The parts in front of the building will be challenging.
- Remove the small streetlight that points away from the building's lower-left corner.
- Leave the small set of traffic lights; they belong in the scene. However, we'll clip the top of the light pole in the foreground and remove the streetlight from the top. We'll also remove the white sign hanging to the right of the traffic lights.
- Remove the large, dark streetlight and post from the center of the image.
- Remove the large streetlight on the right that points toward the building. I'm leaving the smaller streetlight below it because it isn't very distracting and it helps to balance the two light posts I'm leaving for the traffic light. You can remove it if you want to.
- Remove the large white area (set against black) at the bottom right of the building.

This short list represents lots of work. Some of it is fairly easy, while other parts are a little more complicated.

FIGURE 16.7

We remove each of the distractions highlighted in red during Phase 2 of our retouching workflow.

Retouching hard edges with the Clone Stamp

Let's begin by taking care of some of the easy stuff. Pick up where you left off after Step 13, and follow these steps:

14. Duplicate the Straighten Lines layer, and rename it **Retouching**. We're duplicating the layer so we'll always have a straightened layer without any retouching on it — the Straighten Lines layer — to use as a reference.

15. Use the Clone Stamp to remove everything from outside the boundary of the building — the power lines and streetlight on the left and the streetlight on the right. Use the Lighten blending mode until you get to the top of the light on the right. You'll have to switch to the Normal (or Darken) blending mode to handle it because it's lighter than the surrounding tones in the sky.

 Work with a soft brush when retouching against the sky. Increase the Hardness value of the brush to at least 50 percent when working close to the edge of the building; otherwise, you may have trouble getting close to the building without touching it with the brush.

16. Remove the large white rectangle at the lower right of the building. Use the Clone Stamp to clone the upper dark area onto the lower white area. After all the white is covered with the dark gray, come back with a smaller brush and clone some of the nearby vegetation back on top of it. This helps to break up any hard edges created by your retouching.

Okay, most of the easy stuff is done. Now it's time to get down to the nitty-gritty. Let's begin with the large, dark streetlight in the center of the image. The techniques we're going to use here are the same techniques we use on most of the items to be removed from this image. Continue with these steps:

17. Zoom in to 100 percent. Keep working with the Clone Stamp with a small brush with a Hardness value of between 30 percent and 50 percent. Make sure that the blending mode is set to Normal and that Opacity is 100 percent. Also make sure that the Sample option in the tool options is set to Current Layer.

 Sample the vertical line in the building above the lamp. Begin painting directly below your sample point so you extend the line through the streetlight, as shown in the first frame of Figure 16.8. If you're off in alignment at all, undo (Command/Ctrl+Z), and try again until you get the alignment correct. This trial and error is worth it because after you get one line to fall into place, others will follow.

 Move across the light to the right and keep painting with short strokes. Notice that when you get to the line between the light brown area and the darker brown area, the vertical lines are still in alignment. You don't have to sample again until you get to the window, shown in the second frame of Figure 16.8.

NOTE Finding samples that line up with the area to be retouched is the name of the game when it comes to this kind of retouching. After you get the Clone Stamp's sample point and brush in alignment, you can retouch large areas without taking another sample.

18. Move to the right and down a bit and use the same technique to sample the horizontal line below the window and extend it through the arm that holds the light, as shown in

the first frame of Figure 16.9. Continue retouching without sampling until you're forced to take another sample. The second frame of Figure 16.9 shows how much I was able to remove without sampling again.

FIGURE 16.8

After you get the sample cursor perfectly aligned with the painting cursor, shown in the first image, you can use the relationship to retouch a large area without sampling again. The second image shows how much I was able to remove after sampling only once.

FIGURE 16.9

In the first image here, I sampled the horizontal line and extended it through the light post. Then I used the same sample relationship to remove all of the light post between the two windows, as shown in the second image.

19. Now almost all of the upper part of this light post is gone. Zoom in closer, and remove the leftovers from inside the window frame, shown in the upper left in the second image in Figure 16.9. Work with a small brush, and zoom in to 200 percent if you need to.

> **TIP** If you notice any retouching marks left behind in the neutral brown areas, use the Patch tool to blend them in.

20. Start working your way down the pole with the Clone Stamp tool. Sample the top-center portion of the window frame one story above the window we need to retouch. Begin painting at exactly the same place on the lower window so the sample and paint points are in alignment. Use short strokes to remove the pole all the way down to the top of the next window, one story below, as shown in Figure 16.10.

FIGURE 16.10

In the first image I sampled the top of one window and began cloning at exactly the same point on the lower window. Once this relationship is established, I use it to retouch the entire widow, shown in the second image.

Retouching with Layer via Copy and Transform

Here's another technique that's quite useful for this sort of hard-edge retouching. Instead of using a tool like the Clone Stamp to clone and paint in alignment, we cover the rest of the light post by copying and moving similar areas and then merging them back into their source layer. This

technique is very useful for retouching large areas. Because we're dealing with perspective here, we also need to do some transformations. Continue where you left off after Step 20, and follow these steps:

21. Choose the Lasso tool, and draw a selection around the window on the left, as shown in Figure 16.11. We use this section to cover most of the post in the window to the right. Once the selection is in place, choose Select ⇨ Modify ⇨ Feather. Enter a value of **1**, and click OK.

FIGURE 16.11

Use a loose selection to outline the window we want to copy, as shown in the first image. Then copy the selected area to a new layer. After the copy of the window is on its own layer, drag it into position, as shown in the second image. Because the perspective is off a little, the Transform command is used to scale the height of the window so it matches the size of the window that's being covered, shown in the third image.

22. Copy the selection to a new layer by choosing Layer ⇨ New ⇨ Layer via Copy. Then use the Move tool (or press and hold the Command/Ctrl key) to drag the new layer into position to the right, aligning it at the top of the window frame, as shown in the second frame of Figure 16.11.

23. The piece of window we copied is a bit taller than the area it needs to cover. We'll scale it so it fits. Choose Edit ⇨ Transform ⇨ Scale. When the transformation handles appear, click the one at the center of the bottom and drag it upward until the bottom of the window is in alignment, as shown in the third frame of Figure 16.11. Press the Enter key to commit the transformation, and then merge the layer back into the Retouching layer by choosing Layer ⇨ Merge Down. Do any additional retouching inside the window to hide telltale signs of the light post.

NOTE The Transform command works only on the layer (or layers) that are currently active. If you want to transform two layers at the same time, you have to make both of them active by Shift-clicking them in the Layers palette. You know when they're both active in the Layers palette because both layers are highlighted in blue.

24. Switch back to the Clone Stamp for a moment, and continue to use the techniques we've used to work your way down to the street, removing the pole as you go. When you find a sample point that's in perfect alignment, ride it as far as you can. Just be careful about creating unintentional repetitive patterns. If you see any, clean them up.

This copy, transform, and merge technique is highly useful. It's often much faster than using the Clone Stamp to remove something. Let's use it again to remove the top of the remaining light post. This time, we'll modify it with a mask. Continue with these steps:

25. Choose the Lasso tool from the toolbar, and draw a selection similar to the selection in the first frame of Figure 16.12. Even though we need only a small area, let's copy a large area so we have more choices when working with it.

26. Copy the selected area to a new layer by choosing Layer ⇨ New ⇨ Layer via Copy.

27. Lower the opacity of the new layer to 50 percent. Use the Move tool to drag the new layer into position over the light pole. Try to match the top-left corner of the top-left window. Remember that you can use the arrow keys for fine-tuning the position.

TIP If you hold down the Shift key while you move the layer, movement is restricted to moving in a straight line — up and down or right and left. This helps to keep it in vertical alignment as you drag it downward.

28. You know where we're going with this. Choose Edit ⇨ Transform ⇨ Distort. Work with only the two handles on the right, adjusting them one at a time until you get all the lines to match up, as shown in the second frame of Figure 16.12. When you like it, commit the transformation by pressing the Enter key. (Keep in mind that we'll have the option of masking out much of this layer if we choose to.)

FIGURE 16.12

After selecting a large section of windows in the first frame, we copy it to its own layer and drag it into position over the top of the light pole, shown in the second frame. Lowering the opacity of the layer allows us to see through it for fine positioning. The Distort feature of the Transform command allows us to adjust the dimensions on the right side before merging the new layer back into its parent layer.

29. Create a layer mask by choosing Layer ⇨ Layer Mask ⇨ Reveal All. Choose the Brush tool, and use a large, soft brush to hide most of the new layer with black paint. Be sure to leave a bit of the pole showing above the wires, as shown in the first frame of Figure 16.13.

Return the layer's opacity to 100 percent, and do a quick check to make sure everything lines up. When it looks good, merge the new layer back into the Retouching layer.

NOTE Normally I'd leave this layer separate for a little longer, but in the interest of clarity, I decided to merge it now for this project.

This copy, move, transform, and merge technique was faster than removing the light post with the Clone Stamp. In reality, either technique works just fine. This one is just faster. Continue with these steps:

30. Now all we need is a cap for the top of the pole. It had one that we could have used, but we just removed it. However, the Straight Lines layer still has the original cap. Let's borrow it.

Hide the visibility of the Retouching layer, and click the Straight Lines layer to make it active. Use the Lasso tool to draw a selection around the top of the light post, as shown in the second frame of Figure 16.13. Copy the selection to a new layer.

31. Drag the new layer upward in the layer stack until it's sitting just above the Retouching layer. Turn the visibility of the Retouching layer back on, but don't make the layer active yet. You should now see the cap floating above the light post. Use the Move tool to position it. Use a mask or the Eraser tool (because this is a small thing) to quickly remove any of it that you don't want and then merge it into the Retouching layer. Take care of any cleanup with the Clone Stamp.

FIGURE 16.13

The first image shows what the light post looks like now. It needs a cap. Fortunately, the Straight Lines layer still has the cap. All we have to do is go to that layer and borrow a copy of the cap to replace our missing cap, as shown in the second image. Once we have a duplicate of the cap on its own layer we can place it above the Retouching layer, shown in the third image on the lower left. Once the unnecessary parts of the cap layer are removed the layer is merged back into the Retouching layer and touched up with the Clone Stamp. The fourth image shows the result.

32. Use the Clone Stamp to work on the two pieces of pipe that are still sticking up on the right. Keep in mind that they don't have to be completely removed. They just need to blend in so they aren't noticeable, as shown in the last frame of Figure 16.13.

> **NOTE** The technique we just used to retrieve a piece of information from a backup layer is one of the main reasons we keep these duplicate layers in reserve.

33. Continue using the Clone Stamp to remove the white crosswalk sign and the large traffic light, as well as the wire it's hanging from. Remove the wire only up to the corner of the building. We use a different technique to work on the left face of the building.

Retouching with Vanishing Point

One of the tricks to retouching an image like this is working with the perspective caused by the angle of the building in relation to the camera lens. We just used the Transform command to adjust the perspective of copied layers before merging them so they would be aligned correctly. There's another way to accomplish this much more quickly. Photoshop has a tool in the Filters menu that's specifically designed for retouching in perspective: It's called Vanishing Point.

> **NOTE** When CS3 was released, the Vanishing Point got a couple of upgrades. Because those improvements are mostly esoteric and they don't apply to what we need to do here, I don't discuss them.

The Vanishing Point filter makes retouching easier by allowing you to define a retouching plane. That way any retouching, copying, or pasting is restricted to the angles in that plane. The filter also has its own toolset, shown on the left in Figure 16.14, with its own options bar at the top of its dialog box. These are the more notable of these tools:

- The Marquee (M) tool lets you create rectangular marquees that conform to the perspective of the retouching plane. The Marquee is used to easily copy and paste information while keeping it in-perspective. This tool also has a healing feature that's activated by changing the Heal option in the tool options to On.

- The Stamp (S) tool is similar to the Clone Stamp tool. It allows you to clone in perspective. This tool is great for working on large areas, but can be hard to control when working with details.

- The Brush (B) tool allows you to paint in perspective.

- The Transform (T) tool is used to transform a scale or rotate a selection after it's in place.

We're going to focus on the using this special version of the Marquee tool. (After you see how cool this is, you'll want to learn more about some of the other Vanishing Point tools.) Let's give it a try. Pick up where you left off after Step 33, and follow these steps:

34. Before you open the Vanishing Point dialog box, turn off the visibility of your adjustment layers. Turn off the Curves and Color Balance layers as well.

35. Make sure the Retouching layer is active. Choose Filter ⇨ Vanishing Point, and in the dialog box, select the Create Plane tool — second from the top. This tool is used to define the retouching plane. Use it to click the four corners of the plane we'll be retouching on the left side of the building. When you get to the fourth corner a blue grid, similar to Figure 16.14, appears on the side of the building. (I changed my Grid Size value to 200 in the tool options to open up the grid.)

The new grid has handles on the corners and all sides. These handles are used to fine-tune the grid by grabbing and dragging them, just like the handles created by the Transform command. Use them if you need to do any alignment of the grid.

NOTE After you create a plane, it stays with the image. That way, when you return to the Vanishing Point dialog box, your previous plane is still in place.

36. Zoom in and select the Marquee (M) tool. In the tool options, change Feather to **0**. Draw a marquee around the three windows that are just above the first section of line, shown in the first frame of Figure 16.15. Once you have a selection drawn go back to the tool options and make sure that Move Mode is set to Destination.

FIGURE 16.14

The Vanishing Point filter allows you to define a retouching plane by clicking the four corners of the plane. After this plane is defined, all retouching done with the tools on the left will conform to the perspective of the plane.

FIGURE 16.15

Use the Marquee tool to draw a selection around the windows you want to copy. The selection automatically conforms to the perspective of the retouching plane. Then drag the selection downward to cover the windows below. Use the Transform tool if you need to scale the selection, as shown in the second frame, before deselecting.

37. Hold down the Alt key, and drag the selection downward until it covers the windows below. When you do, you'll notice that the image content inside the original selection is dragged along with the selection. Essentially, we are copying the information inside the selection so we can paste it down below

 This selection is called a *floating selection*. As long as it's in place, the copied information acts like a separate layer. However, as soon as you click outside the selection with the Marquee tool and deactivate the selection, the new content is automatically merged back into the layer.

> **TIP** You can use the Command/Ctrl+H shortcut to hide the selection so you can get a better look at the alignment before deselecting.

38. Use the Transform tool if you need to transform the selected content before deselecting. I had to make it a little taller, as shown in the second frame of Figure 16.15. When you're happy with the alignment, click outside the selection with the Marquee tool to deselect and merge down.

39. Let's remove most of the traffic light next. Draw a new selection with the Marquee tool that encloses the set of four windows (including two of the windows we just replaced), shown in the first frame of Figure 16.16. This time, change the Heal setting in the tool options to On so the new windows selection blends with the mottled reflections on the side of the building. Hold down the Alt key while dragging the selection into place over the windows by the traffic light. Notice how the windows scale to the correct size as they're dragged, as shown in the second frame of Figure 16.16. When you're happy with the alignment, click outside the selection with the Marquee tool to deselect it.

> **TIP** The keyboard shortcut for Undo (Command/Ctrl+Z) works a little differently in Vanishing Point. Normally in Photoshop, consecutive uses of the shortcut cycle back and forth between undo and redo. If you need to back up further, you generally use the History palette. Because the History palette isn't available when the Vanishing Point dialog box is open, consecutive uses of the shortcut keys continue stepping backward. So if I use the shortcut for Undo three times, I back up three steps. If you undo a step and then decide you want to redo it, use Shift+Command/Ctrl+Z.

40. Continue using the Marquee tool to copy and paste, covering as much of the wire and light as possible. Don't worry about removing all of it. Just focus on the easy areas. When you like everything, click OK to apply all these changes to the image.

41. We need to go back and fix one thing. The top of the light post at the corner is obscured. We need to paint it back in. Turn the visibility of the adjustment layers back on. Use the History Brush to paint the top of the post back in from the previous history state. (See Chapter 6 for a discussion of the History Brush.) Or use the Clone Stamp to borrow part of the post to the right that we repaired earlier.

42. Use the Clone Stamp to finish removing any pieces of the wire that still show on the left side of the building.

FIGURE 16.16

Now we use the windows we just retouched to repair a larger section of windows where the traffic light is located. Create a selection around the four windows shown in the first image. This time, though, change the Heal setting to On so that the mottled reflections on the light brown area blend better when the floating selection is moved over the four windows to the left, shown in the second image.

As you can see, this tool is perfectly designed for the type of retouching we're doing here. We could have used it on the front face of the building, though the technique we used worked just fine. However, that copy/transform/merge technique would have been much harder to handle on the left face of the building because of the extreme shift in perspective.

We've barely scratched the surface of what this filter can do. I could easily write an entire chapter on it, but I didn't, because many of its functions are beyond the scope of what we're doing here.

Phase 3 Workflow: Finishing the Image

This project has come a long way. Turn the visibility of the Retouching layer off and on a couple of times to check your work. If you see anything else you want to remove, like the cars or the fire hydrant, go for it. Leave the person crossing the street because she adds a human scale to the image. She also adds some action to an otherwise stagnant scene.

Give yourself a pat on the back for attempting this difficult retouching project. Now it's time to add some finishing touches and prepare the final file for printing. Let's begin with some burning and dodging.

Final burning and dodging

The biggest tonal issue with this image is the contrast on the left face of the building. The dark shadow on the lower half needs to be lightened, and the sunny area on the upper half needs to be darkened. If you recall, this contrast was exaggerated when we created the Curves layer back in the Phase 1 section. Luckily, there's enough detail in the shadows and highlights that we can bring them closer together with a burn and dodge layer. However, before we do that, let's undo some of the damage that's being done by the Curves adjustment layer. Pick up where you left off after Step 42, and follow these steps:

43. Click the Curves 1 adjustment layer to make it and its mask active. Use the Brush tool, with black paint, to mask out the effect of the Curves layer on the upper half of the left face of the building, where the Curves adjustment is lightening these already too light areas.

NOTE We could have done this earlier, but I prefer to do the retouching first so I can see it without the masking.

44. Click the top layer in the Layers palette to make it active. Create a burn and dodge layer, and name it **Burn & Dodge**. (Create a new layer, and change the blending mode to Soft Light.) This layer should be at the top of the layer stack.

45. Choose the Brush tool. Work with a large, soft brush at an opacity of 15 percent. Paint the upper part of the left face of the building with black to darken it, and paint the lower section with white to lighten it. Be careful around the edges and at the seam along the middle of the building where the light and dark meet. Lighten the dark windows along the bottom of the front face too. When the building looks good, switch to a large brush and darken the outer edges of the sky.

 This makes a huge improvement. Turn the Burn & Dodge layer's visibility off and on a couple of times to see how it looks. If you see any of it bleeding into the sky, use the Eraser tool to clean it up. Figure 16.17 shows the retouched image and its layers.

This image is now totally retouched and ready to go. The only thing left to do is to get it sized and ready for printing. Because that means we're going to make some permanent changes, we need to save this latest version of the master file before moving on. Do that now.

FIGURE 16.17

The building is now completely retouched and ready for final sizing. Be sure to save this master file with all its layers before moving forward.

Using resampling to increase image size

This file currently measures 11.64 inches by 7.76 inches at 300ppi. Because we know we need a 20×24 print, we're going to have to increase the pixel dimensions of this image by resampling it. As you may recall, I discussed resampling and interpolation methods in Chapter 9. Let's put that discussion to use now to change the size of dimensions of this image. Begin with the image you saved in Step 45, and follow these steps:

46. First, flatten the image by choosing Layer ➪ Flatten Image, and clear the guides if you haven't by choosing View ➪ Clear Guides.

NOTE You don't necessarily need to flatten here, but doing so makes the file size more manageable, especially after its size is increased to a 20×24. This flattened file will be about 155 megabytes at 20×24, while the layered file will be 612 megabytes. This can make a big difference on a slower machine. Because we're only going to do a couple of things from here on out, it will be easy enough to back up and make adjustments to the layered master file if changes are needed.

47. Open the Image Size dialog box by choosing Image ➪ Image Size. The first frame of Figure 16.18 shows what the current file size and resolution are. Change the Height dimension to **20 inches**. When you do, the Width value changes proportionally to 30 inches, as shown in the second frame of Figure 16.18. Click in the pop-up at the bottom of the dialog box, and change the resampling interpolation method to Bicubic Smoother. Click OK.

TIP The key to effectively increasing image size with the Image Size dialog box is to use the correct interpolation method, as discussed in Chapter 9.

FIGURE 16.18

The first frame here shows the original image size. When Resample Image is checked and the height is increased, in the second frame, the width changes proportionally. Notice how much bigger the new file's size will be at the top of the dialog box. It's going from 23 megabytes to 154 megabytes.

48. Now that the image is a 20×30, all we have to do is remove six inches from the width. Select the crop tool and change the tool option settings to Width = 24, Height = 20, and Resolution = 300. Draw a selection from the top of the image to the bottom so you include as much of the sky and foreground as possible and we use the full 20 inches of height. That way the Crop tool won't resize the image during the cropping process. Position the crop horizontally so the building is centered, as shown in Figure 16.19. Press the Enter key to commit the crop.

Now all we have to do is sharpen this file for output and save it.

FIGURE 16.19

This cropping gives us a 20×24 print that utilizes the full 20 inches of height. Take a moment to remove any branches showing on the left after executing the crop.

Sharpening with the Unsharp Mask

In the preceding chapter, we used the newer Smart Sharpen filter to sharpen the woman's portrait because we were dealing with so much film grain from the scan. In this chapter, we're going to use a sharpening filter that's been part of Photoshop for many years: the Unsharp Mask.

NOTE We could use the Smart Sharpen filter here, but I'm using the Unsharp Mask filter so you can see how its dialog box compares to Smart Sharpen.

People are often confused when it comes to using the Unsharp Mask filter because the name is totally counter-intuitive. Why would someone want to use something named *unsharp* to sharpen an image? The reason this sharpening filter has such an odd name is that it refers to a sharpening method that was used before digital was an option. In that method, a negative that needed to be sharpened was duplicated. The duplicate negative was intentionally created out of focus. The two negatives — the original and the new one — were then sandwiched together slightly out of registration and then printed. The effect increased contrast around edge detail and made the resulting print look sharper. This is the same way the Unsharp Mask and the Smart Sharpen filters work. Pick up where you left off after Step 48, and follow these steps:

49. Zoom to 50 percent, and open the Unsharp Mask dialog box by choosing Filter ➪ Sharpen ➪ Unsharp Mask. This filter's dialog box, shown in Figure 16.20, is very similar to the newer Smart Sharpen filter. It has Amount and Radius settings, just like Smart Sharpen. It also has a Threshold setting that isn't included in the Smart Sharpen filter. The purpose of this setting is to feather the transition of the Radius setting. (Higher Radius settings create larger sharpening halos. Higher Threshold settings soften those halos.) This filter doesn't have some of the features of the Smart Sharpen filter, such as the ability to work with the shadows and highlights independently, or the ability to use different methods for sharpening, such as Lens Blur and Motion Blur. However, it's a good all-purpose sharpening tool.

FIGURE 16.20

The Unsharp Mask filter is an all-purpose sharpening tool. It has only three sliders. I tend to leave the Radius and Threshold values low and use the Amount slider to control sharpening.

50. Change the Radius value to **1.5** and the Threshold value to **10**. When using this filter I tend to leave these two settings low like this and use the Amount slider to control the level of sharpening. Slide the Amount slider to the right while watching the image, not the 100 percent preview in the dialog box. Keep an eye on what this filter does to the edge detail in the windows on the front of the building. (I set the Amount value to 300 percent.) When you like the sharpening, click OK.

> **TIP** I usually begin with low values like this for the Radius and Threshold values and then use the Amount slider to sharpen the image. If I find that I'm not getting the kind of sharpening I like, then I increase the Radius value.

51. This file is now sized, sharpened, and ready to print. Save it as building_remodel-20x24.tif.

Congratulations! You just completed a complicated hard-edge retouching project. If you want to further sharpen your skills, try doing the project again on one of your own architectural photos.

Summary

When we addressed the Phase 1 retouching in the portrait project, we did little more than adjust the overall tonality and color of the image. In this project, the changes we made in Phase 1 were some of the most dramatic alterations we made to this image. The ability to easily straighten vertical lines in architectural photography with the Transform command cannot be understated. You should use this technique whenever a building is photographed to force the perspective and make the final image more professional. In this series of steps, we also saw the value of using Guides to help with aligning straight lines during the transformation.

When we did adjust the tonality of this image, we used a Curves adjustment layer because we needed to address midtone contrast — something that Levels isn't very well suited to doing. We found that a subtle S-curve added contrast to the midtones without affecting the extreme shadows or highlights.

This project raised the level of retouching difficulty because there was very little freedom for creative interpretation. The hard edges of the details had to match up as distractions were removed. Overall, we had very little room for the type of blending we did with the portrait retouching project. That's why our primary retouching tool was the Clone Stamp on this project. We found that this literal tool is most powerful in a scenario like this when the sample cursor is perfectly aligned with the painting cursor.

Another technique we explored for dealing with hard-edge retouching was the copy/transform/merge technique. This worked well on the front face of the building, but we needed something better for the left face because of the extreme shift in perspective. I introduced Vanishing Point and showed you how to use its Marquee tool for retouching within a defined perspective. This tool is extremely powerful and flexible. If you find yourself doing much of this kind of retouching, I strongly encourage you to explore it more deeply.

After the image was completely retouched, we used the Bicubic Smoother rendering intent in the Image Size command to increase the size of the file to accommodate the final print size. We then cropped it to its final size and used the Unsharp Mask to do final output sharpening. We saw that the Unsharp Mask is fairly straightforward, though it lacks the power and flexibility of the Smart Sharpen filter we used in Chapter 15.

Even though this project and the preceding project used the same three-phase workflow, the steps within that workflow varied considerably. That's because the portrait project dealt mostly with soft edges, while the building dealt primarily with hard edges. Be aware of these differences when you approach a retouching project so you'll know which toolset is best for the project. Also, be willing to mix and match these tools and techniques whenever necessary.

This brings us to the end of our journey together. Now you're ready to take everything you learned here and apply it to your own images. Use this book as a reference guide and come explore certain sections whenever you need a refresher. Happy retouching!

Index

Symbols and numerics

A